Deconstruction and the Visual Arts brings together a series of new essays by scholars of aesthetics, art history and criticism, film, television, and architecture. Working with the ideas of French philosopher Jacques Derrida, these essays explore the full range of his analyses, from *Of Grammatology* and *The Truth in Painting* to recent discussions on photography and drawing. They are modeled on the variety of critical approaches that he has encouraged, from critiques of the foundations of our thinking and disciplinary demarcation to creative and experimental readings of visual "texts." Representing some of the most innovative thinking in the various arts disciplines, these contributions offer important challenges to existing disciplinary orthodoxies. Also included in this volume is a long interview with Derrida concerning the visual and spatial arts, published here for the first time.

DECONSTRUCTION AND THE VISUAL ARTS

CAMBRIDGE STUDIES IN NEW ART HISTORY AND CRITICISM

General Editor: Norman Bryson, *Harvard University*

Advisory Board:
Stephen Bann, *University of Kent*
Natalie Kampen, *Barnard College*
Keith Moxey, *Barnard College*
Joseph Rykwert, *University of Pennsylvania*
Henri Zerner, *Harvard University*

Deconstruction and the Visual Arts

Art, Media, Architecture

Edited by
PETER BRUNETTE
George Mason University

DAVID WILLS
Louisiana State University

CAMBRIDGE
UNIVERSITY PRESS

Published by the Press Syndicate of the University of Cambridge
The Pitt Building, Trumpington Street, Cambridge CB2 1RP
40 West 20th Street, New York, NY 10011-4211, USA
10 Stamford Road, Oakleigh, Melbourne 3166, Australia

First published 1994
Reprinted 1994

Printed in the United States of America

Library of Congress Cataloging-in-Publication Data is available.

A catalogue record for this book is available from the British Library.

ISBN 0-521-44271-0 hardback
ISBN 0-521-44781-X paperback

CONTENTS

CONTENTS

ILLUSTRATIONS

CONTRIBUTORS

Charles Altieri has recently begun teaching at the University of California at Berkeley after teaching for many years at the University of Washington. His most recent books are *Painterly Abstraction in Modernist American Poetry* (Cambridge University Press, 1989) and *Canons and Consequences* (Northwestern University Press, 1990). Almost finished is an effort to describe what is involved in our uses of the grammar of the first person.

Mieke Bal is professor of the theory of literature at the University of Amsterdam and adjunct professor of comparative arts at the University of Rochester. Her most recent books are *Reading "Rembrandt": Beyond the Word–Image Opposition* and *On Story-Telling,* both 1991. She is currently working on problems of display and exposition, both in museums and in scholarship.

Jennifer Bloomer teaches architecture and design studies at Iowa State University. She is a practicing architect and also serves on the advisory boards of *Assemblage* and *Architecture New York.* She is the author of *Architecture and the Text: The (S)crypts of Joyce and Piranesi,* forthcoming from Yale University Press. She is currently writing books on beauty and architecture and on the work of Peter Eisenman.

Peter Brunette is professor of English at George Mason University, where he teaches film and literary theory. In 1983 he directed an NEH Summer Seminar for College Teachers on film theory at New York University. He is the author of *Roberto Rossellini* (Oxford University Press, 1987) and coauthor (with David Wills) of *Screen/Play: Derrida and Film Theory* (Princeton University Press, 1989). He has published extensively in *Film Quarterly, Sight & Sound, Cinema Journal,* the *New York Times,* and elsewhere.

Tom Conley teaches French and comparative literature at the University of Minnesota. He is the author of *Film Hieroglyphs: Ruptures of Classical Cinema* (University of Minnesota Press, 1991) and *The Graphic Unconscious in Early Modern Writing* (Cambridge University Press, 1992) and is currently completing a book on literature and cartography.

Jacques Derrida is director of studies in philosophy at the Ecole des Hautes Etudes en Sciences Sociales. His books include *Of Grammatology, Dissemination, Margins of Philosophy, Glas, The Truth in Painting, The Post Card,* and the recently translated *Cinders.*

Richard Dienst wrote a dissertation entitled "The Worlds of Television: Theories of Technology and Communication" at Duke University and is assistant professor at Purdue University. He is an editor of *Polygraph: A Journal of Cultural Studies.*

John M. Ingham is professor of anthropology at the University of Minnesota. He is the author of *Mary, Michael, and Lucifer: Folk Catholicism in Central Mexico* (University of Texas Press, 1986) and various articles on structure and meaning

in the cultures of the pre-Hispanic Aztecs and contemporary Mexican campesinos.

John P. Leavey, Jr., teaches at the University of Florida. He has translated several works by Jacques Derrida, including *Edmund Husserl's "Origin of Geometry": An Introduction, The Archeology of the Frivolous,* and *Glas.* He has written *Glassary,* the companion volume to *Glas,* and essays on translation and deconstruction. He is currently translating Derrida's *Parages* and working on a book on translation and theory.

Jean-Claude Lebensztejn teaches at the Université de Paris–I. His published works include *La Fourche* (Gallimard, 1972), *Zigzag* (Flammarion, 1981), *Chahut* (Hazan, 1989), and a book on Monteverdi entitled *Imiter sans fin: Le Chant de l'aimable Angelette* (Editions du Limon, 1987).

Stephen Melville teaches art history at Ohio State University; he formerly taught in the English and Textual Studies Department at Syracuse University. He is author of *Philosophy Beside Itself: On Deconstruction and Modernism* (University of Minnesota Press, 1986) and has published many articles on art and literary theory in such journals as *Sub-Stance, Critical Inquiry, October, Arts Magazine,* and *Genre.*

Laura R. Oswald teaches in the College of Art, Architecture, and Urban Planning at the University of Illinois at Chicago and has published numerous theoretical articles in such journals as *Semiotica.* She is the author of *Jean Genet and the Semiotics of Performance* (Indiana University Press, 1989).

Donald Preziosi is professor of art history at the University of California, Los Angeles. He is the author of various books and articles on art and architecture, his most recent being *Rethinking Art History: Meditations on a Coy Science* (Yale University Press, 1989). He is currently working on a book on the history of museums and the framing of modernities.

Herman Rapaport is chair of comparative literature at the University of Iowa. He is the author of *Milton and the Postmodern* (University of Nebraska Press, 1983) and *Heidegger and Derrida: Reflections on Time and Language* (University of Nebraska Press, 1989). A new book, *Between the Sign and the Gaze,* is forthcoming from Cornell University Press. The essay in this collection belongs to a book in progress entitled *Is There Truth in Art?*

Robert B. Ray is associate professor of English at the University of Florida and the author of *A Certain Tendency of the Hollywood Cinema, 1930–1980* (Princeton University Press, 1985).

D. N. Rodowick is professor of English and visual/cultural studies at the University of Rochester. His essays on film and cultural theory have appeared in *Wide Angle, Diacritics, Camera Obscura, New German Critique, Iris, Art & Text,* and many other journals. He is the author of *The Crisis of Political Modernism: Ideology and Criticism in Contemporary Film Theory* (University of Illinois Press, 1988) and *The Difficulty of Difference: Psychoanalysis, Sexual Difference and Film Theory* (Routledge, 1991). He is currently completing a book on the film theory of Gilles Deleuze.

Marie-Claire Ropars-Wuilleumier teaches at the Université de Paris–VIII. She has written a number of books on film, including *L'Ecran de la mémoire: Essais de lecture cinématographique* (Seuil, 1970), *Le Texte divisé* (PUF, 1981), and *Ecraniques: Le film du texte* (Presses Universitaires de Lille, 1990).

Gregory L. Ulmer, professor of English at the University of Florida and coordinator of the Florida Research Ensemble, is the author of *Applied Grammatology* (Johns Hopkins University Press, 1985) and *Teletheory* (Routledge, 1989). He has just completed a book entitled *Heuretics: The Logic of Invention,* which will be published next year by Johns Hopkins University Press.

Mark Wigley teaches architecture at Princeton University. He cocurated, with Philip Johnson, the 1988 Museum of Modern Art exhibition on deconstructivist architecture and has written extensively on that topic. He is an editor of *Assemblage,* and his book *The Architecture of Deconstruction: Derrida's Haunt* is forthcoming from MIT Press.

David Wills is professor of French at Louisiana State University. He has published *Self De(con)struct: Writing and the Surrealist Text* (James Cook University Press, 1985) and is coauthor (with Peter Brunette) of *Screen/Play: Derrida and Film Theory* (Princeton University Press, 1989) and (with Alec McHoul) of *Writing Pynchon: Strategies in Fictional Analysis* (Macmillan/ University of Illinois Press, 1990). His new book is entitled *Prosthesis.*

INTRODUCTION

PETER BRUNETTE AND DAVID WILLS

THE essays in this anthology deal with the applicability of the ideas now commonly and collectively known as "deconstruction" to the visual and media arts and to architecture, an array of disciplines that might be grouped under the term "spatial arts." We use "spatial arts" to refer to the common ground that deconstruction has opened between questions of aesthetics and questions of construction – artistic and architectural – as well as to recognize the historical relationship, starting in modern times with the Ecole des Beaux Arts, that exists between the two fields. In the course of writing an earlier book, *Screen/Play: Derrida and Film Theory*,[1] we found that although Derrida's exploration of the problematics of the visual arts had become increasingly important to his project as a whole, scholars and theorists working in that domain had themselves – with a few notable exceptions – only a limited understanding of it. That was true despite the growing interest in the French philosopher's work in any number of fields of study. The passage of a few years, and Derrida's increased visibility in the visual arts and architecture, no doubt have provided a different framework, and it is within those new lines of perspective that the present volume, focused on aesthetics, art history and criticism, film and television, and architecture, is positioned. Although a number of articles clearly influenced by deconstruction have begun to appear in these fields, this anthology brings together, for the first time, a group of previously unpublished essays[2] that will be of interest to scholars of visual theory and the plastic and spatial arts in general.[3]

[1] Peter Brunette and David Wills, *Screen/Play: Derrida and Film Theory* (Princeton: Princeton University Press, 1989).

[2] With two exceptions: Jean-Claude Lebensztejn's essay, which appears here for the first time in English translation, was originally published in French in 1985; Jennifer Bloomer's essay appears in a longer form in *Assemblage*.

[3] It should be admitted that this anthology probably cannot serve adequately, on its own, as an introduction to such a complex field as deconstruction for those with no previous knowledge of it. Interested readers should turn to *Screen/Play*, pp. 3–32, or to any of a number of surveys of deconstruction and Derrida's work, such as the following: Jonathan Culler, *On Deconstruction* (Ithaca: Cornell University Press, 1982); Christopher Norris, *Deconstruction: Theory and Practice* (London: Methuen, 1982), and *Derrida* (Cambridge, Mass.: Harvard University Press, 1987); Vincent Leitch, *Deconstructive Criticism: An Advanced Introduction* (New York: Columbia University Press, 1983); Barbara Johnson, "Translator's Introduction," in Jacques Derrida, *Dissemination* (Chicago: University of Chicago Press, 1982); Gayatri Spivak, "Translator's Preface," in Jacques Derrida, *Of Grammatology* (Bal-

PETER BRUNETTE &
DAVID WILLS

Derrida's essays on painting (*The Truth in Painting*) were published in book form in France in 1978, and in English translation in 1987.[4] Those essays – which take up topics as varied as Kant's use of the idea of the "parergon" in the *Critique of Judgement,* the theoretical implications of the work of artists Valerio Adami and Gérard Titus-Carmel, and an imaginary encounter between Martin Heidegger and art historian Meyer Schapiro on the subject of Van Gogh's *Old Shoes with Laces* – have opened the way for a fundamental rethinking of art history and criticism, along the lines of that which literary history and criticism underwent in the 1960s and 1970s in the wake of structuralism and deconstruction. Besides the studies in that book, there is also "Envois," the long and idiosyncratic first section of *The Post Card,*[5] which can be read as an analysis of an illustration from Matthew Paris's thirteenth-century fortune-telling book. Since then, Derrida has written a commentary called "Right of Inspection" to accompany a photoessay by photographer Marie-Françoise Plissart, published in 1985,[6] and a long essay entitled "Forcener le subjectile" on the subject of Antonin Artaud's drawings.[7] Most recently, at the request of the Louvre, he has mounted an exhibition entitled "Mémoires d'aveugle," and written a long catalogue article, on the motif of blindness and self-portraiture in drawing.[8]

Derrida's articles on architecture, which have important implications for his thinking regarding the visual arts in general, are more recent, appearing in collected form in French in 1987,[9] but the ideas have been quickly taken up by theorists in the field who were already aware of his work. This interest has been further stimulated by press coverage and scholarly treatment given to the so-called Deconstructivist movement in architecture (e.g., the 1988 Museum of Modern Art exhibition) and by Derrida's collaboration with Peter Eisenman, commissioned by Bernard Tschumi, for a garden at the Parc de la Villette in Paris.

★　★　★

In his ground-breaking book, *Of Grammatology* (French ed., 1967), Derrida exposed the untenability of the traditional concept of language as self-enclosed and continuous communication of sense. Rather, as is

timore: Johns Hopkins University Press, 1974); and, especially for the "later" Derrida, Gregory Ulmer, *Applied Grammatology* (Baltimore: Johns Hopkins University Press, 1985).
[4]*La Vérité en peinture* (Paris: Flammarion, 1978); *The Truth in Painting,* trans. Geoff Bennington and Ian McLeod (Chicago: University of Chicago Press, 1987).
[5]Trans. Alan Bass (Chicago: University of Chicago Press, 1987).
[6]Marie-Françoise Plissart, *Droit de regards: Avec une lecture de Jacques Derrida* (Paris: Editions de Minuit, 1985); "Right of Inspection," trans. David Wills, *Art & Text* 32(1989):19–97.
[7]"Forcener le subjectile," in Paule Thévenin and Jacques Derrida, *Antonin Artaud: Dessins et portraits* (Paris: Gallimard, 1986), pp. 55–105.
[8]*Memoirs of the Blind,* trans. Pascale-Anne Brault and Michael Nass (Chicago: University of Chicago Press, in press).
[9]"Point de folie – Maintenant l'architecture," "Pourquoi Peter Eisenman écrit de si bons livres," and "Cinquante-deux aphorismes pour un avant-propos," in *Psyché: Inventions de l'autre* (Paris: Galilée, 1987). The first is translated as "Point de folie – Maintenant l'architecture," trans. Kate Linker, *Architectural Association Files* 12(1986):4–19. The third is translated as "Fifty-two Aphorisms for a Foreword," in *Deconstruction: Omnibus Volume,* ed. Andreas Papadakis, Catherine Cooke, and Andrew Benjamin (New York: Rizzoli, 1989), pp. 67–9. See also the exchange between Jacques Derrida and Peter Eisenman, *Assemblage,* no. 12(August 1990):7–17.

revealed in its more obviously material form, writing, language always entails a "spacing" (*espacement*) that works, by definition, at a remove from its producer. For communication to occur, words must travel.

The idea of spacing might usefully be seen as an operational principle in all of Derrida's work, from *Of Grammatology* to his most recently published pieces, and more specifically as the basis for his interest in the visual arts and architecture. In French, the term "arts of space" is used almost interchangeably with "plastic arts" to denote those forms – architecture, painting, sculpture – that are to be distinguished from the "arts of time" – music and dance. For Derrida, of course, whatever signifies through time and thereby involves a break in self-presence – the spoken word being the classic case – will similarly, and even especially, be susceptible to the effects of spacing.

Once spacing is introduced, as a sine qua non of linguistic expression and of sense-making processes in general, then the philosopher of language necessarily becomes a philosopher of spatial articulation(s). The task becomes, in effect, an architectural one, mapping out the limits and testing the boundaries of communicational space, or that of a plastic artist, exploring the relations among line, form, and shades of meaning.

The negotiation of space inevitably involves the creation of a dwelling place. For the architect, this is presumed to be the most fundamental task. In the case of the visual arts, the work, as Derrida reminds us, is similarly conceived of as a receptacle or dwelling place for meaning, one whose borders are both clearly defined and consistently repressed to provide the spectator with easy access to its center and seat. In this respect Derrida's philosophical inquiry is again exemplary, and the structural resemblance between linguistic and visual or architectural models is reinforced, for the hierarchical relation between speech and writing that deconstruction analyzes and seeks to displace is traditionally described in terms of that between an inside and an outside. Speech is held to remain within the closed circuit defined by speaker and listener, disappearing into the fold of immediate comprehension, forgetting the spacing that constitutes it. Writing, on the other hand, cannot but fall outside, into an unavoidable materiality, and its materiality ensures that it will function outside of the control of its producer, from where it will always threaten the integrity of the supposed intact system of speech. The means by which speech then both rejects and co-opts writing in order to perpetuate its position of priority – indeed, the means by which this operation repeats itself throughout any number of areas of Western thinking – has been referred to by Derrida as an "economy," from the Greek (*oikos*) for "house." What is evidenced in the speech–writing relation is but one example of how Western thinking builds dwelling places for its own positions of privilege, and Derrida's work aims to break down or rearrange the walls of that house, exposing its inside to previously unseen aspects of its outside, reconstructing different accommodations of space, forcing different means of access, reworking its principles of containment.

It is not only in the general terms of the concepts of space and spacing that the visual arts open themselves to the ideas developed in deconstruction. We have already sketched out how, in spite of the priority that

PETER BRUNETTE &
DAVID WILLS

Derrida's notion of "writing" seems to give to verbal discourses, it is marked as much by its spatiality and visuality as by its relation to the idea of the word as truth. Conversely, through its use of codes such as the still-dominant Renaissance perspective, painting, for example, reveals itself to be thoroughly conceptual, if not linguistic, rather than some kind of nonconceptual or anticonceptual, pure figurality. In fact, it may be this very claim of the visual arts to speak "directly" somehow, supposedly avoiding the mediation inherent in verbal language, that is most in need of deconstruction. Even in the most abstract work of art, sense-making visual codes, sanctioned by the history of the medium, codes that tell us, for example, how to read diagonals, jagged lines, circles, and so on (and which, it could be argued, constitute a language of sorts), are always operative. Artistic expression is never the unmediated manifestation of emotion that it wants to pretend it is. If it were, it would be emotion, perhaps measurable as brain waves, breathing rhythms, or sweaty palms, and not art, displayed for spectators to look at, and for scholars to write about.

One might argue that it was attention to the effects of mediation constituting the so-called mimetic arts that led to the developments of modernism and abstraction, for when painters became interested in the play of light and so took their easels outside in an attempt to enter into a more natural relation with the artistic object, they also drew attention to the apparatus that constitutes the medium and that forever prevents such a natural relation. If at first that attention may have been unwitting, it soon became more explicit in the experimentation with the stuff of painting itself, paradigmatic in the case of Van Gogh, that led ultimately to the abstract experience. Though, as we argued in *Screen/Play* following Derrida's "Double Session,"[10] the matter comes into much sharper relief in the case of attempts at "exact" reproduction, such as photography and film, the mediative effect of any art form condemns the mimetic experience to failure even as it constitutes it. In a similar gesture, it deconstructs abstraction's attempt to return to a natural, unmediated expression, an attempt that still remains mimetic in its conception. It is the dynamic of this paradox that opens the visual arts in general to the play of *différance*.

Much of Derrida's writing on the visual arts has concentrated on the *trait*, the never purely figural translation of the trace, a word that is itself synonymous, particularly in his earlier work, with the term "writing." It is through the idea of the trait, referring to whatever is drawn, as well as more specifically in French to the brushstroke, that the graphic emerges, forming the basis for both the visual arts and all forms of writing, even traditionally conceived. The trait might thus be called the trace of integral contamination, mark of the structural heterogeneity that constitutes the act of drawing as much as the act of painting. Apart from the fact that even in its conception there can be no purely pictorial line, any more than a purely verbal line – because the trait is always already a *retrait*, necessarily subject to repetition and subdivision – it must also be remembered that various forms of verbal discourse always accompany

[10]See *Screen/Play,* pp. 68–86.

the figural, from signatures and titles (which themselves demand to be interpreted, that is, to be read as verbal signifiers that will thereby disturb or call into question the purity of figurality) to questions of attribution, museum, archive, and of course the discourses of criticism themselves.

Those latter concerns are highlighted by Derrida in introducing the four essays that he writes "around" painting in *The Truth in Painting:*

Four times, then, *around* painting . . . in the neighboring regions which one au- thorizes oneself to enter, that's the whole story, to recognize and contain, like the surrounds of the work of art, or at most its outskirts: frame, title, signature, museum, archive, reproduction, discourse, market, in short: everywhere where one legislates on the *right to painting* by marking of the limit. . . . [p. 11]

His concern is therefore with all manner of frames and framings, with the border and demarcation disputes that arise as a result of efforts at containment, however necessary such circumscriptions might be for pur- poses of definition and legitimation, for it needs also to be understood that it is by those means that the work is at the same time enabled or constituted and, paradoxically, rendered impossible. The frame – refer- ring back to our earlier discussion, this could be for a house as much as for a painting – is simultaneously the basis upon which we can begin to talk about the work as such (historically it denotes the painting as op- posed to the fresco) and the problematic articulation between inside and outside that means that the work is never clearly distinguishable from what supports it.

In reading the literary text, especially since *Glas,*[11] and including the important studies of Ponge[12] and Blanchot,[13] Derrida has made extensive use of the "signature" as a means to theorize the relation between author and text. However, once again it is the visual arts that bring the signature effect into clearer focus, for there the signature acts as a rigorous internal frame, defining the work as commodity and assigning the limits on the basis of which the whole proprietorial institution will operate. Yet the signature is also foreign to what it defines, a piece of writing within figural space that disturbs the homogeneity of the medium; what seals the work is therefore also what breaks it open to reveal the othernesses that reside within it. Conversely, the authority that the signature rep- resents as marker of authenticity and as institutional inscription is dis- persed within figural space. Just as in Derrida's analyses of literature the proper name is found to operate as a common noun, so the signature in the painting becomes a series of lines or traits, participating in the graphic design, at the extreme evoking the anonymity of the *X.*

Buildings, too, are signed, but in only relatively few cases does the architect's signature survive the mercantile inscription of the occupier. That is not to say, however, that the surrounds in effect in the visual arts are no longer operative when it comes to architecture; it is simply that they borrow different forms and different configurations as the whole private–public relation – carrying with it the structure–function

[11] *Glas* (Paris: Galilée, 1974); trans. John P. Leavey, Jr., and Richard Rand (Lincoln: Uni- versity of Nebraska Press, 1986).
[12] *Signéponge/Signsponge,* trans. Richard Rand (New York: Columbia University Press, 1984).
[13] "Pas," in *Parages* (Paris: Galilée, 1986), pp. 19–116.

and beauty–utility oppositions – comes to dominate the sense of how inside articulates with outside.

On the other hand, by standing at the edge of concepts such as authorship and the art object (while not, for all that, being exempt from the effects of inscription and discourse), by seeming to obey the most rigorously logocentric conception of the foundation and yet opening up the most creative sense of construction, by materially delineating where inside meets outside while introducing a dynamics of space by means of plays of light that might well be defined as writing, the architectural construction and the questions raised by design and building create an outside for the whole deconstructive enterprise: an outside that, in line with that enterprise, needs to be conceived of not as its restricting limit but as its challenge and ultimate possibility, as the site of its most productive articulations. Derrida writes, referring to the meeting between deconstruction and architecture, particularly in the work of Bernard Tschumi, that it "urge[s] us towards . . . the most obligatory route of deconstruction in one of its most intense, affirmative and necessary implementations":

> Deconstructions would be feeble if they were negative, if they did not construct, and above all, if they did not first measure themselves against institutions in their solidity, *at the place of their greatest resistance:* political structures, levers of economic decision, the material and phantasmatic apparatuses which connect state, civil society, capital, bureaucracy, cultural power and architectural education – a remarkably sensitive relay; but in addition, those which join the arts, from the fine arts to the martial arts, science and technology, the old and the new.[14]

The idea of a deconstruction whose limits are constantly being worked at and expanded is discussed at some length by Derrida in the interview (Chapter 1) that opens this collection. Particularly interesting are his comments on deconstruction's relation to high technology, through its critique of theories of communication and coding, for the whole artistic and architectural enterprise of course falls within the sense of the *technē*, which, as what is constructed and in opposition to the natural (*physis*), brings us back to an outside–inside opposition easily as classic as that between writing and speech. Although the question concerning high technology remains, for the most part, beyond the limits we have defined for ourselves here, and indeed beyond our competence, it is clear that it is beginning, through such techniques as the computer-generated image, to impose its relevance on the media arts – film, television, video – as well as on "art" traditionally conceived, and indeed on architectural design. But the increasingly explicit role played by technology in contemporary artistic representation should not obscure the fact that technology has always been a function of the media in general. As Derrida points out in his essay on Titus-Carmel, both pro*duction* and repro*duction,* signifiers of technology and high technology, respectively, remain thoroughly within the network of whatever is *drawn* (Latin *ductus*).

[14]"Point de folie – Maintenant l'architecture," p. 15.

The interview and the essays that follow can be roughly divided into five groups. The first group, which outlines some of the theoretical implications of an "importation" of deconstruction into the visual arts – although, as the reader will appreciate, there can be no clear distinction between what is theoretical implication and what is practical application – begins with the discussion with Derrida. Besides developing some of the matters already referred to, the interview broaches many of the problematics that provide the focus for the later essays: the question of his competence in fields outside of philosophy, "presence" in painting and film, the roles of the artist's signature and the institutional countersignature in our understanding of works of art. Throughout the discussion, Derrida reformulates the visual in terms of the spatial.

Stephen Melville's essay, by means of a specific consideration of the fact of color, succinctly outlines the ways in which deconstruction may alter our approach to the art object and itself be altered by the encounter. Mieke Bal looks at the treatment of light in Vermeer's *Woman Holding a Balance* in order to question art history's search for original intentions and meanings. She does this through an exploration of deconstructive notions of intertextuality, polysemy, and, especially, dissemination and hymen, but provocatively rewrites the last term from a Barthesian and feminist perspective as the "navel." Marie-Claire Ropars-Wuilleumier offers an incisive and rigorous analysis of Derrida's reading of Kant and of the aesthetic and has recourse to the cinematic example of Godard's *Passion* (1983) for what she finds to be a more productive deconstruction of the truth in painting. This section ends with Gregory Ulmer's contribution, a continuation of his "grammatological" project to translate deconstruction onto the pedagogical level as discovery or invention.

The second group of essays can be seen as addressing variations on the theme of the frame (or "parergon") and its attendant problematization of the boundaries between inside and out. D. N. Rodowick follows on from Marie-Claire Ropars-Wuilleumier to argue how Derrida's deconstruction of Kant's *Critique of Judgement* in fact deconstructs the notion of the aesthetic itself, which has always provided the enabling frame for considering art, and suggests the importance of such a deconstruction in the context of recent political attacks by traditionalists and right-wing ideologues against the university and institutions like the National Endowment for the Arts. Jean-Claude Lebensztejn explores the multiple meanings and figurations of the physical frame as it has manifested itself throughout the whole of the history of art. Finally, Donald Preziosi's essay shows the importance of the museum itself as a powerful framing device with widespread political and theoretical consequences.

The essays in the third group offer more explicit applications of deconstructive theory to painting and sculpture. Herman Rapaport provides a counterpoint to Rodowick's essay by juxtaposing Heidegger and Derrida in a reading of the work of site-sculptor Richard Long as a "restitution" of aesthetics and the idea of beauty after the dismantling of Kantian metaphysics. Charles Altieri similarly puts together Derrida and Frank Stella, in an attempt to illuminate the work of each through a

consideration of the other and, more importantly perhaps, to begin laying the foundation for a new ethics on the ruins of the deconstructed subject and a seriously challenged notion of human agency. Lastly, John Leavey's essay – whose unorthodox practice demonstrates that a deconstructive approach to the visual arts may take an impressive variety of forms – is a meditation, inspired by reading Derrida's writings on the visual arts with and against Valerio Adami's painting *Concerto a quattro mani,* on the articulation of painting and writing. At the same time, his piece enacts this articulation in its own practice.

The fourth section consists of two substantial essays on the relation of deconstruction to architecture. Mark Wigley discusses the ways in which "architecture" and specifically the "house" function in Derrida's work, following on from Heidegger and a whole philosophical tradition, well before it became an explicit topic of address. Jennifer Bloomer blends autobiography, feminist theory, and architectural project to give birth to a piece of writing that is as heterogeneous and as much in ferment as the structures she has designed for Chicago street corners.

The essays in the last group manifest several possible applications of deconstruction to film and television. Laura Oswald compares Derrida's and Eisenstein's notions of the ideogram and finds that Eisenstein's cinematic practice is more radical than his writings; along the way she elaborates her concept of "cinema-graphia," which is meant to counter Bazin's privileging of film's ontological relation to reality with a film writing that exceeds the photographic frame. Tom Conley and John Ingham unite deconstructive and anthropological approaches to film in order to politicize their interpretation of a quintessential manifestation of pop culture, *Beverly Hills Cop.* Extending this focus on popular culture back into the 1930s and 1940s, Robert Ray offers an example of an alternative deconstructive practice (employing effects of chance, for example) in the form of an application of the signature effect to Hollywood's Andy Hardy movies. This section closes with Richard Dienst's repositioning of the discourse of television studies by means of Derrida's ideas of the postal, as developed in *The Post Card.*

With the two exceptions mentioned earlier, the articles that follow, including the interview, are published here for the first time and offer the most current thinking in the fields from which they are drawn. They provide excellent examples of both the specific, rigorous analytical emphasis of the deconstructive enterprise, generalizable to cover any number of domains, and the experimentation with and challenge to forms of knowledge and writing that make of it a veritable adventure. It is an adventure whose greatest risk and challenge, perhaps, reside in its advent, in the sense through which it interrogates its own arrival, such that the forms of knowledge and writing that it advances seek to push at the borders that constrain them, without, for all that, imposing rigid new limits for the future. Whatever lines (*traits*) it draws are also both redrawn and withdrawn (*retraits*) in a movement that, as the examples to follow show, is as writerly as it is graphic.

THE SPATIAL ARTS: AN INTERVIEW WITH JACQUES DERRIDA

PETER BRUNETTE AND DAVID WILLS

WILLS: We shall start with an indiscreet question, a question on competence. You have mentioned more than once what you call your "incompetence" in various areas of your work. For example, in your interview with Christopher Norris on architecture[1] you declare yourself "technically incompetent" in that field; in our discussions on cinema you have said the same thing, but none of that has stopped you from writing in a number of areas outside of your training. It is as if you would like to define the limits of what you contribute to each domain without knowing exactly where to place those limits.

DERRIDA: I shall try to make my responses as straightforward as possible. In the first place, when I say that I am incompetent I say it frankly, sincerely, because it is true, because I don't know a lot about architecture, and as far as film goes my knowledge is only of the most average and general kind. I like cinema very much; I have seen many films, but in comparison with those who know the history of cinema and the theory of film, I am, and I say this without being coy, incompetent. The same holds true for painting, and it is even more true for music. With respect to other domains I could say the same thing with as much sincerity. I feel very incompetent also in the literary and philosophical fields, even though the nature of my incompetence is different. My training is in philosophy, so I can't seriously say that I am incompetent in that domain. However, I feel quite unequipped when confronted by a philosopher's work, even the work of those philosophers I have studied at length. But that is another order of incompetence.

Now, in terms of my competence in philosophy, I have been able to devise a certain program, a certain matrix of inquiry that permits me to begin by asking the question of competence in general terms – that is to say, to inquire into how competence is formed, the processes of legitimization, of institutionalization, and so on, in all domains, then to advance in different domains not only by admitting my incompetence very sincerely but also by asking the question of competence, that is to say, what defines the limits of my domain, the limits of a corpus, the legitimacy of the questions, and so on. Each time that I confront a

[1] "Jacques Derrida, in Discussion with Christopher Norris," in *Deconstruction: Omnibus Volume*, ed. A. Papadakis, C. Cooke, and A. Benjamin (New York: Rizzoli, 1989), p. 72.

domain that is foreign to me, one of my interests or investments concerns precisely the legitimacy of the discourse, with what right one speaks, how the object is constituted – questions that are actually philosophical in origin and style. Even if, within the field of philosophy, I have worked to elaborate deconstructive questions concerning it, that deconstruction of philosophy carries with it a certain number of questions that can be asked in different fields. Moreover, each time I was trying to discover what in a determined field liberates it from philosophical authority. That is to say, I have learned from philosophy that it is a hegemonic discourse, structurally hegemonic, considering all discursive regions to be dependent upon it. And by means of a deconstruction of this hegemonic gesture we can begin to see in each field, whether it be what we call psychology, logic, politics, or the arts, the possibility of emancipation from the hegemony and authority of philosophical discourse.

So, each time I approach a literary work, or a pictorial or architectural work, what interests me is this same deconstructive force with regard to philosophical hegemony. It's as if that is what carries my analysis along. As a result, one can always find the same gesture on my part, even though each time I try to respect the singularity of the work. That gesture consists of finding, or in any case looking for, whatever in the work represents its force of resistance to philosophical authority, and to philosophical discourse on it. The same operation can be found or recognized in the different discourses I have developed concerning particular works; yet I have always tried to do it by respecting the individual signature of an Artaud, say, or an Eisenman.

Obviously, because we are starting an interview on the "visual arts," the general question of the spatial arts is given prominence, for it is within a certain experience of spacing, of space, that resistance to philosophical authority can be produced. In other words, resistance to logocentrism has a better chance of appearing in these types of art. (Of course, we would need to ask the question of what art is, also.) So much for competence: It is an incompetence that gives or tries to give itself a certain prerogative, that of speaking within the space of its own incompetence.

Now, it is also necessary to say – maybe as a sort of general precaution for everything that will follow – that I have never personally taken the initiative to speak about anything in these domains. Each time I do, it is because I have been invited to do so; because of my incompetence, I would never have taken the initiative to write about architecture or drawing unless the occasion or invitation had originated elsewhere. That goes for everything I have done; I don't think that I would have ever written anything if I hadn't in some way been provoked to do it. Of course, you may then ask: What is a provocation? Who is the other? So, it's a mixture, an intersection of chance and necessity.

BRUNETTE: In relation to that, how do you feel now that your work has begun to move out to the law, to film, to architecture? Do you have any misgivings about the way your thought – deconstruction, whatever – has been changed, molded in different ways?

DERRIDA: It is very difficult to determine; there is feedback, but each time it comes back in a different form. I can't find a general rule for it;

in a certain way it surprises me. I am, for example, a little surprised by the extent to which deconstructive schemas can be put into play or invested in problematics that are foreign to me, whether we are speaking about architecture, cinema, or legal theory. But my surprise is only a half-surprise, because at the same time the program as I perceived or conceived it made that necessary. If someone had asked me twenty years ago whether I thought deconstruction should interest people in domains that were foreign to me, such as architecture and law, as a matter of principle my response would have been yes, it is absolutely indispensable, but at the same time I never would have believed it could happen. Thus, when faced with this I experience a mixture of surprise and nonsurprise. Obviously, I am obliged, up to a certain point, not to transform, but rather to adjust or deform my discourse, in any case to respond, to comprehend what is happening. That isn't always easy. For example, in the case of legal theory, I read some texts, people tell me things, but at the same time I don't know it from the inside; I see something of what is happening in "critical legal studies," I can follow the conceptual outline of what is happening in that field. And when I read your work on film, I understand, but at the same time only passively; I can't reproduce it or write about it in turn.

I always feel on the edge of such things, and this frustrates me – it really isn't possible for me to appropriate such work – but at the same time what gratifies me is that such work is being done by people who are themselves competent and who speak from within a specific field, with its own givens, and its own relations to the nature of the field, to the political-institutional situation. Thus, what you do is determined for the most part by the specific givens of your intellectual field and also by all sorts of things pertaining to the American scene, to your institutional profile, and so on. All of that is foreign to me, and it keeps me on the edge of things, but at the same time it is extremely reassuring and gratifying, for real work is being done. I am a part of that work, but it is being done in other places.

WILLS: To extend that still further, let me ask you about one of your texts that I admire the most, *The Post Card*,[2] and its relation to technology; less the relation between technology and the thought of Heidegger, and more about what you say in "Envois" and elsewhere, for example, about high technology. For example, every time I hear talk of a computer virus and read how more and more programs are written to defend against such attacks, it seems to me we have an example of logocentrism in all its obstinacy being confronted by what we might call the unavoidability of adestination. That is a very basic question and one that is central to your work. But although scholars have now seen, for example, the fundamentally "architectural" side to your work, I think there remains this whole area of relations between thought and communication, in the most basic sense, where your ideas have hardly even begun to be taken up. Would you comment on that?

[2] *The Post Card: From Socrates to Freud and Beyond,* trans. Alan Bass (Chicago: University of Chicago Press, 1987).

PETER BRUNETTE &
DAVID WILLS

DERRIDA: Yes, you're right, and paradoxically the question is more intimately connected with my work. I often tell myself, and I must have written it somewhere – I am sure I wrote it somewhere – that all I have done, to summarize it very reductively, is dominated by the thought of a virus, what could be called a parasitology, a virology, the virus being many things. I have written about this in a recent text on drugs.[3] The virus is in part a parasite that destroys, that introduces disorder into communication. Even from the biological standpoint, this is what happens with a virus; it derails a mechanism of the communicational type, its coding and decoding. On the other hand, it is something that is neither living nor nonliving; the virus is not a microbe. And if you follow these two threads, that of a parasite which disrupts destination from the communicative point of view – disrupting writing, inscription, and the coding and decoding of inscription – and which on the other hand is neither alive nor dead, you have the matrix of all that I have done since I began writing. In the text just referred to I allude to the possible intersection between AIDS and the computer virus as two forces capable of disrupting destination. Where they are concerned, one can no longer follow the tracks, neither those of subjects, nor those of desire, nor the sexual, and so on. If we follow the intersection between AIDS and the computer virus as we now know it, we have the means to comprehend, not only from a theoretical point of view but also from the sociohistorical point of view, what amounts to a disruption of absolutely everything on the planet, including police agencies, commerce, the army, questions of strategy. All those things encounter the limits on their control, as well as the extraordinary force of those limits. It is as if all that I have been suggesting for the past twenty-five years is prescribed by the idea of *destinerrance* . . . the supplement, the pharmakon, all the undecidables – it's the same thing. It also gets translated, not only technologically but also technologicopoetically.

BRUNETTE: Let's talk about the idea of the "thereness" of the visual object, in painting, sculpture, and architecture, what might be called a feeling of presence. In "+R" you refer to a painting "taking the breath away, a stranger to all discourse doomed to the presumed mutism of the thing itself, [it] restores in authoritarian silence an order of presence."[4] Is there some kind of phenomenological presence that words don't have, that has to be dealt with in the visual object? Is film perhaps an intermediate area because it is sort of present like a visual object, yet it has to be read through like words?

DERRIDA: These are profound and difficult questions. Obviously the spatial work of art presents itself as silent, but its mutism, which produces an effect of full presence, can as always be interpreted in a contradictory fashion. But first let me distinguish between mutism and, let's say, taciturnity. Taciturnity is the silence of something that can speak, whereas we call mutism the silence of a thing that can't speak. Now, the fact

[3]"Rhétorique de la drogue," in *Points de suspension: Entretiens* (Paris: Galilée, 1992), pp. 241–67.
[4]"+R (Into the Bargain)," in *The Truth in Painting,* trans. G. Bennington and I. McLeod (Chicago: University of Chicago Press, 1987), p. 156.

that a spatial work of art doesn't speak can be interpreted in two ways. On the one hand, there is the idea of its absolute mutism, the idea that it is completely foreign or heterogeneous to words, and one can see in this a limit on the basis of which resistance is mounted against the authority of discourse, against discursive hegemony. There exists, on the side of such a mute work of art, a place, a real place from the perspective of which, and in which, words find their limit. And thus, by going to this place, we can, in effect, observe at the same time a weakness and a desire for authority or hegemony on the part of the discourse, notably when it comes to classifying the arts — for example, in terms of the hierarchy that makes the visual arts subordinate to the discursive or musical arts.

But on the other hand, and this is the other side of the same experience, we can always refer to the experience that we as speaking beings — I don't say "subjects" — have of these silent works, for we can always receive them, read them, or interpret them as potential discourse. That is to say, these silent works are in fact already talkative, full of virtual discourses, and from that point of view the silent work becomes an even more authoritarian discourse — it becomes the very place of a word that is all the more powerful because it is silent, and that carries within it, as does an aphorism, a discursive virtuality that is infinitely authoritarian, in a sense theologically authoritarian. Thus it can be said that the greatest logocentric power resides in a work's silence, and liberation from this authority resides on the side of discourse, a discourse that is going to relativize things, emancipate itself, refuse to kneel in front of the authority represented by sculpture, or architecture. It is that very authority that will try in some way to capitalize on, in the first place, the infinite power of a virtual discourse — there is always more to say, and it is we who make it speak more and more — and, in the second place, the effect of an untouchable, monumental, inaccessible presence — in the case of architecture this presence is almost indestructible, or in any case mimes indestructibility, giving the overpowering effect of a speaking presence. Thus there are two interpretations — one is always between the two, whether it is a question of sculpture, architecture, or painting.

Now, film is a very particular case: first, because this effect of presence is complicated by the fact of movement, of mobility, of sequentiality, of temporality; second, because the relation to discourse is very complicated, without even speaking about the difference between silent film and sound film, for even in silent film the relation to the word is very complicated. Obviously, if there is a specificity to the cinematic medium, it is foreign to the word. That is to say that even the most talkative cinema supposes a reinscription of the word within a specific cinematic element not governed by the word. If there is something specific in cinema or in video — without speaking of the differences between video and television — it is the form in which discourse is put into play, inscribed or situated, without in principle governing the work. So from that point of view we can find in film the means to rethink or refound all the relations between the word and silent art, such as they came to be stabilized before the appearance of cinema. Before the advent of cinema there was painting, architecture, sculpture, and within them one

could find structures that had institutionalized the relation between discourse and nondiscourse in art. If the advent of cinema allowed for something completely new, it was the possibility of another way of playing with the hierarchies. Now here I am not speaking of cinema in general, for I would say that there are cinematic practices that reconstitute the authority of the discourse, while others try to do things more closely resembling photography or painting – still others that play differently with the relations among discourse, discursivity, and nondiscursivity. I would hesitate to speak of any art, but in particular of cinema, from that point of view. I think that there is probably more difference among different works, different styles of cinematic work, with respect to the point just made about discourse and nondiscourse, than there is between cinema and photography. In that case it is probable that we are dealing with many very different arts within the same technological medium – if we define the cinema on the basis of its technical apparatus – and thus perhaps there is no unity in the cinematic art. I don't know what you think, but a given cinematic method may be closer to a certain type of literature than to another cinematic method. And thus we need to ask whether or not identifying an art – presuming we can speak of cinema as though we knew what art was – proceeds from the technical medium, that is to say, whether it proceeds from an apparatus such as a camera that is able to do things that can't be done by writing or painting. Does that suffice to identify art, or in fact does the specificity of a given film depend in the end less on the technical medium and more on its affinity with a given literary work, rather than with another film? I don't know. These are, for me, questions that have no answers. But at the same time, I feel strongly that one should not reduce the importance of the film apparatus.

BRUNETTE: What would you reply to somebody who was recalcitrant about the application of deconstruction to the visual arts, somebody who would say deconstruction is fine for words, the written, because what is there is never what is signified, whereas in a painting everything is always there, and thus deconstruction is not applicable?

DERRIDA: For me that is a complete misreading. I would almost take the opposite stance. I would say that the most effective deconstruction is that which is not limited to discursive texts and certainly not to philosophical texts, even though personally – I speak of myself as one agent among others of deconstructive work – and for reasons related to my own history, I feel more at ease with philosophical and literary texts. And it may be that a certain general theoretical formalization of the deconstructive possibility has more affinity with discourse. But the most effective deconstruction, and I have said this often, is one that deals with the nondiscursive, or with discursive institutions that don't have the form of a written discourse. Deconstructing an institution obviously involves discourse, but it also concerns something quite other than what are called texts, books, someone's signed discourse, someone's teachings. And beyond an institution, the academic institution, for example, deconstruction is operating, whether we like it or know it or not, in fields that have nothing to do with what is specifically philosophical or discursive,

whether it be politics, the army, the economy, or all the practices said to be artistic and which are, at least in appearance, nondiscursive or foreign to discourse.

Now, because there cannot be anything, and in particular any art, that isn't textualized in the sense I give to the word "text" – which goes beyond the purely discursive – there is text as soon as deconstruction is engaged in fields said to be artistic, visual or spatial. There is text because there is always a little discourse somewhere in the visual arts, and also because even if there is no discourse, the effect of spacing already implies a textualization. For this reason, the expansion of the concept of text is strategically decisive here. So the works of art that are the most overwhelmingly silent cannot help but be caught within a network of differences and references that give them a textual structure. And as soon as there is a textual structure, although I wouldn't go as far as to say that deconstruction is within it, on the other hand it isn't outside of it either – it isn't elsewhere. In any case, to be quite categorical, I would say that the idea that deconstruction should confine itself to the analysis of the discursive text – I know that the idea is widespread – is really either a gross misunderstanding or a political strategy designed to limit deconstruction to matters of language. Deconstruction starts with the deconstruction of logocentrism, and thus to want to confine it to linguistic phenomena is the most suspect of operations.

BRUNETTE: The effect of presence that always strikes me, and this is perhaps totally idiosyncratic, is the presence of the artist's body – for example, in the impasto in Van Gogh. When I see a Van Gogh I immediately feel his body somehow in a way that I don't with writing. In any "trait," any brushstroke, there is a certain presence of the artist. No?

DERRIDA: I understand what you mean and share your feeling completely. As a matter of fact, for me the body is not absent when I read Plato or Descartes. Having said that, clearly it is there in a different manner, whereas when we look at a painting by Van Gogh, the manner in which the work is, I would say, haunted by the body of Van Gogh is irrefutable, and I think that this reference to what you call the body makes up part of the work, and the experience of the work. But obviously I wouldn't translate that as you have just done. I would say that there is an undeniable provocation we can identify in what is painted and signed Van Gogh, and that it is all the more violent and undeniable by virtue of not being present. That is to say that the very body of Van Gogh that haunts his paintings is all the more violently implicated and involved in the act of painting to the extent that it was not present during the act, for the body itself is ruptured, or, let's say, riven by nonpresence, by the impossibility of identifying with itself, of being simply Van Gogh. So what I would call the body – I am happy to talk about the body from that point of view – isn't a presence. The body is, how should I say, an experience in the most unstable [voyageur] sense of the term; it is an experience of frames, of dehiscence, of dislocations. So I see a dislocated Van Gogh, one who is dislocated in the process of performing something. I relate to Van Gogh in terms of his signature – I don't mean signature in the sense of attaching his name, but in the

sense that he signs while painting – and my relation to or experience of the signature of Van Gogh is all the more violent both for him and for me because it also involves my own body – I suppose that when you speak of the body you are speaking also of your own – and all the more ineluctable, undeniable, and passionate. I am given over to the body of Van Gogh as he was given over to the experience. Even more so because those bodies are not present. Presence would mean death. If presence were possible, in the full sense of a being that is there where it is, that gathers [*se rassemble*] there where it is, if that were possible, there would be neither Van Gogh nor the work of Van Gogh, nor the experience we can have of the work of Van Gogh. If all these experiences, works, or signatures are possible, it is to the extent that presence hasn't succeeded in being there and in assembling there. Or, if you wish, the thereness, the being there [*l'être-là*], only exists on the basis of this work of traces that dislocates itself.

Given that the work is defined by his signature, my experience of the signature of Van Gogh is possible only if I myself countersign, that is to say, if in turn my body becomes involved with it. This doesn't happen in an instant; it is a thing that can last, that can start again; there is the enigma of the remainder, namely, that the work remains, but where? What does it mean to remain in this case? The work is in a museum; it waits for me. What is the relation between the original and the nonoriginal? There is no question that is more topical or more serious, despite appearances. But I can't take it up here. In any case, the question is different for each "art." And this structural specificity of the relation original–reproduction could – at least this is the hypothesis I'm advancing – provide the principle of a new classification of the arts. These questions, as you well know, disrupt the category of presence as it is normally understood. We imagine that the body of Van Gogh is present, and that the work is present, but these are only provisional and insecure attempts to stabilize things; they represent an anxiety, an inability to make things cohere.

But if you were to ask me the same question regarding cinema, how would you formulate it? In the case of Van Gogh we can say there is a work that is apparently immobile, that hangs in a museum, waiting for me, that the body of Van Gogh was there, et cetera. But in the case of a film, the work is essentially kinetic, cinematic, and thus mobile; the signatory is mediated by a considerable number of persons, machines, and actors (which also sign the work), and it is difficult to know whose body we are dealing with when we look at it. For Van Gogh we can say that he was an individual with his brush, but in the case of film, what is the equivalent, where is the body in that case?

BRUNETTE: What would be the equivalent in a painting for the types of signature effect that you explore, say, in terms of Francis Ponge's poetry in *Signsponge*?[5]

DERRIDA: Obviously, what seems at first glance to distinguish the problematic of the signature for discursive or literary works is that in such works what we currently call the signature is a discursive act, a name in

[5] *Signéponge/Signsponge,* trans. Richard Rand (New York: Columbia University Press, 1984).

the general sense of the word "signature," a name belonging to discourse, even though I have shown that in fact the name no longer belongs to language. It does function in the linguistic system as one of its elements, but as a foreign body. Nevertheless, it is something that is pronounced, that can be transcribed into phonetic writing, and which thus seems to have privileged relations with elements of discourse. On the other hand, in a pictorial work, for example, or a sculptural or musical one, the signature cannot be both inside and outside of the work. Ponge can play with his name inside and outside of a poem, but in a sculpture the signature is foreign to the work, as it is in painting. In music it is more complicated, because one can also play with the signature, one can inscribe it as, for example, Bach did. One can transcribe the equivalent of the name in the work, as when Bach wrote his name with letters representing the notes. So one can sign the musical work from the inside just as Ponge can sign his name within a poem. In the case of painting, it isn't possible. There are cases in which painters inscribed their names in their work, but not in a place where one normally signs, thus playing with the outside. But one still has the impression that the body is foreign, that it is an element of discursivity or textuality within the work. It is apparently heterogeneous; we can't transpose the problematic of the literary signature into the field of the visual arts.

However, for me the effect of the signature can't be reduced to the effect of the patronym. We can say that there is a signature every time a particular work isn't limited to its semantic content. Let's return to the literary work and to the signature as an act of commission. One needs to do more than write one's name to sign. On an immigration form you write your name and then you sign. Thus the signature is something other than merely writing down one's own name. It is an act, a performative by which one commits to something, by which one confirms in a performative way that one has done something – that it is done, that it is I who has done it. Such a performativity is absolutely heterogeneous; it is an exterior remainder to whatever in the work signifies something. There is a work there – I affirm it, I countersign. There is a "thereness" [être-là] to the work which is more or less the set of analyzable semantic elements. An event has taken place.

Thus there will be a signature every time that an event occurs, every time there is the production of a work, whose occurrence is not limited to what can be semantically analyzed. That is its significance: a work which is more than what it signifies, that is there, that remains there. So, from this point of view, the work then has a name. It receives its name. In the same way that the signature of the author isn't limited to the name of the author, so the identity of the work isn't necessarily identified with the title it receives in its catalogue. It is given a name, and that naming takes place once only, and thus there is a signature for every spatial or visual work of art, which is finally nothing other than its own existence, its "thereness," its nonpresent existence, that of the work as remainder. This means that one can repeat it, review it, walk around it: It's there. It's there, and even if it doesn't mean anything, even if it isn't exhausted by the analysis of its meaning, by its thematics and semantics, it is there in addition to all that it means. And this excess

visual, or spatial arts. You know that I love words. I have the greatest desire to express myself in words. For me it involves desire and the body; in my case the relation of the body to words is as important as it is with painting. That is my story, the history of my investments and drives. I am often reproached: "You only like words, it is only your lexicon that interests you." What I do with words is make them explode so that the nonverbal appears in the verbal. That is to say that I make the words function in such a way that at a certain moment they no longer belong to discourse, to what regulates discourse – hence the homonyms, the fragmented words, the proper names that do not essentially belong to language. By treating words as proper names, one disrupts the usual order of discourse, the authority of discursivity. And if I love words it is also because of their ability to escape their proper form, whether they interest me as visible things, letters representing the spatial visibility of the word, or as something musical or audible. That is to say, I am also interested in words, paradoxically, to the extent that they are nondiscursive, for that's how they can be used to explode discourse. That is what happens in the texts to which you allude: Not always, but in most of my texts there is a point at which the word functions in a nondiscursive manner. All of a sudden it disrupts the order and rules, but not thanks to me. I pay attention to the power that words, and sometimes the syntactical possibilities as well, have to disrupt the normal usage of discourse, the lexicon and syntax.

So, naturally, all this works through the body of a language. It is obvious that with a word like "subjectile" I can only produce or rather recognize the effects of destabilization within the French language, or at least I give French priority. On the one hand, I really like French and have a great investment in it, while on the other hand I mistreat it in a certain manner in order to make it come out of itself. Thus, I explain myself with the bodies of words – here I think that one can truly speak of "the body of a word," with the reservations mentioned earlier, that it is a body that is not present to itself – and it is the body of a word that interests me to the extent that it doesn't belong to discourse.

So I am very much in love with words, and as someone who is in love with words I treat them as bodies that contain their own perversity – a word I don't like too much because it is too conventional – let's say the regulated disorder of words. As soon as that occurs, language is opened to the nonverbal arts. For this reason it is especially in dealing with painting and photography, for example, that I take risks with such verbal adventures as "subjectile" or with a number of other words in "Right of Inspection." It is when words start to go crazy in that way and no longer behave properly in regard to discourse that they have more rapport with the other arts, and conversely this reveals how the apparently nondiscursive arts such as photography and painting correspond to a linguistic scene. But such words are related to the matter of their signatory – this is evident in the case of Artaud, even in the case of the photographer Plissart. There are words that work on them whether they know it or not; they are in the process of letting themselves be constructed by words.

WILLS: To take the matter a little further, let's discuss music, which is predominantly nonverbal. I note that you haven't as yet written anything on music, but I have the impression that the word "come" [*viens*], discussed in "Of an Apocalyptic Tone," has a thoroughly musical resonance.[10] I can't think of any other way to describe it and so wonder if there isn't a musical force [*une force de musique*] in that word.

DERRIDA: In a certain manner – and here my response will be a little naïve – one can say the same thing about it. The most naïve response is that music is the object of my strongest desire, and yet at the same time it remains completely forbidden. I don't have the competence, I don't have any truly presentable musical culture. Thus my desire remains completely paralyzed. I am even more afraid of speaking nonsense in this area than in any other. Having said that, the tension in what I read and what I write, and in the treatment of the words I just spoke about, probably has something to do with a nondiscursive sonority, although I don't know whether I would call it musical. It has something to do with tone, timbre, voice, something to do with the voice – because contrary to the nonsense that circulates in this regard, nothing interests me more than the voice, more precisely the nondiscursive voice, but the voice all the same.

So, since you mention the word "come" [*viens*], it seems to me that I was trying to say that what counted was not the word "come," the semantics, the concept of "to come," but that the thought of "to come" or the event itself depended on the uttering [*profération*], on the performative call of "come," and that this is not exhausted by its meaning. Addressing the other, I say the "coming" to the other. I say "come," but I mean an event that is not to be confused with the word "come" as it is said in language. It is something that can be replaced by a sign, by an "Ah," by a cry, that means "come." It is not itself a full presence; it is differential, that is to say, it is relayed through the tone and the gradations or gaps of tonality. So, these gaps, this tonal differential, is evidently there, and that is what interests me.

To return to the naïveté of my response, when I write, the most difficult thing, what causes me the most anguish, mostly in the beginning, is to find the right tone. Ultimately, my most serious problem is not deciding what I want to say. Each time I begin a text, the anguish, the sense of failure, comes from the fact that I am unable to establish a voice. I ask myself whom I am talking to, how I am going to play with the tone, the tone being precisely that which informs and establishes the relation. It isn't the content, it's the tone, and since the tone is never present to itself, it is always written differentially; the question is always this differentiality of tone. Within each note there is a differential, but when one writes a text designed to last, whether it be a discursive text, a cinematic text, or whatever, the question is one of tone, of changes in tone. So I imagine that when I write I settle my problems of tone by looking for an economy – I can't find another word – an economy that consists in always pluralizing the tone, in writing in many tones, so as

[10]"Of an apocalyptic tone recently adopted in philosophy," trans. J. P. Leavey, *Semeia* 23(1982):63–97.

not to allow myself to be confined to a single interlocutor or a single moment. I think in the end that what interests me the most in the texts I read and in the texts I write is precisely that. All of this merits further analysis, but that's it, how it shifts, moves from one phrase to another, from one tone to another. Such analyses are rarely performed – I haven't read a lot of work on the subject – but it remains an important question. And it would be an analysis of the pragmatic type, one that doesn't consist of determining what something means, what its thesis, theme, or theorem is, for that is not so interesting nor so essential; what is more important is the tone, and to know to whom it is addressed in order to produce what effect. Obviously that can change from one sentence to the next or from one page to the next.

And since you are asking about my texts, I would say that what they have in the final analysis that is most analogous to spatial, architectural, and theatrical works is their acoustics and their voices. I have written many texts with several voices, and in them the spacing is visible. There are several people speaking, and this necessarily implies a dispersion of voices, of tones that space themselves, that automatically spatialize themselves. But even when it isn't marked in the text by new paragraphs, by grammatical or grammatically determined shifts from one person to another, such effects are evident in many of my texts: All of a sudden, the person changes, the voice changes, and it all gets spatialized. People's reactions, their libidinal investments, positive or negative, their rejection or hatred, can probably be best explained in terms of tone and voice more than in terms of the content of what I actually say. They can put up with the fact that I take this or that position, but what really upsets them is this spatialization, the fact that one no longer knows whom one is dealing with, who signs, how it all comes together [*se rassemble*]; that is what disturbs them, what scares them. And this effect of spatialization – in my texts as well as in others' texts – sometimes scares them even more than do spatial works themselves, because even spatial works that should produce this effect still give the impression of a kind of gathering [*rassemblement*]. We can say the work is there, it's a terrible thing, it's unbearable, it's menacing, but in fact it's within a frame, or it's made of stone, or it's in a film that begins and ends; there is a simulacrum of gathering and thus the possibility of mastery, the possibility of protection for spectator or addressee. But there are types of texts which don't end or begin, or disperse their voices, which say different things, and which as a result hinder this gathering. One can listen but can't manage to objectify the thing. So, with my work, there are those who like it and those who don't. But I think that it is always a question of space, of the nonmastery of spacing, and not only of the voice or something in the voices.

WILLS: Could the idea of tone be related to something more pertinent to the visual arts, the question of beauty?

DERRIDA: The question of beauty is very difficult. I don't know. Naturally we could evoke the canonical discourses on beauty and speak of Kant, and so forth, but that wouldn't be interesting here. Personally, I can't treat beauty as a separate effect, although I'm sensitive to it, whether it's a mat-

ter of beauty within art or outside of art. In neither case can I separate it from the experience of the body we spoke of earlier, and thus from the experience of desire; naturally, it is libidinalized. For the reasons I just mentioned, I am probably more sensitive to what works through the voice, the beauty of tonalities. It is for that reason finally that I must say – still in the naïve register – that I am rarely overwhelmed by the beauty of pictorial or architectural works; that is to say, they don't excite me. I rarely have my breath taken away by a painting. On the other hand, that does sometimes happen with music or when I hear the spoken word or read texts – by listening to the voice, that is – and it often happens in the cinema, but only to the extent that it comes from what works through the voice as desire [*ce qui dans le désir travaille la voix*]. It can happen with silent film, but only because silent film is never silent.

Thus, I would say that for me the experience of beauty, if there is one, is inseparable from the relations to and the desire for the other, to the extent that it works through the voice, through something of a tonal differential – to be more specific, through the voice as something that intensifies desire all the more because it separates it from the body. There is an effect of interruption, of suspension. One can make love with a voice but without making love. The voice separates. And thus it is a matter of whatever there is in the voice that provokes desire; it is a differential vibration that at the same time interrupts, hinders, prevents access, maintains a distance. For me, that is beauty. We speak of beauty in front of something that is at once desirable and inaccessible, something that speaks to me, that calls me, but at the same time tells me it is inaccessible. Then I can say it is beautiful, it exists beyond, has an effect of transcendence, is inaccessible. Thus I can't consume it – it isn't consumable; it's a work of art. That is the definition of a work of art, that it is not consumable. Beauty is something that awakens my desire by saying "you will not consume me." It is a joyful work of mourning, although neither work nor mourning. On the other hand, if I can consume it, I say it isn't beautiful. That's why I would have more trouble saying that a painting or piece of architecture was beautiful. I could say it was, but I wouldn't be captured by it, I wouldn't be moved by the same feeling of beauty. However, I can be moved in the case of a finite discourse, where there are beings who speak, or even in the case of texts, a poem for instance, where there are effects of the voice that call and give themselves by refusing themselves. All you can say is that it's beautiful, and that you are not responsible. It can happen only with you – as is the case with the signature we discussed earlier – and at the same time you have nothing to do with it. Thus you are dead; it does without you [*se passe de toi*]. There is a voice that says that that can happen only with you [*ne peut se passer qu'avec toi*], but it happens without you [*se passe de toi*]. That is beauty; it's sad, mourning. We could in another context have a more scholarly discussion on beauty, but I am trying to say something else here.

BRUNETTE: In the "Fifty-two Aphorisms"[11] you talk a lot about the relation of architecture to thinking or thought, the analogue between dis-

[11]"Fifty-two Aphorisms for a Foreword," in *Omnibus*, p. 69.

23

course and all the spatial arts. What about the relation of line, form, and color to thinking? When you say the "spatial arts" rather than the visual arts, does that change anything? Is the logocentric predominance of the I (eye) in vision denied when you put these works in the realm of the spatial?

DERRIDA: There is an element of chance in my use of the word "visual" – I don't know how to adjust my discourse to your expectations – but if in fact I do say "spatial" more readily than "visual," I would give the following reason: It is because I am not sure that space is essentially mastered by [livré à] the look. Obviously, when I say spatial arts, that permits me in an economic and strategic fashion to link these arts with a general set of ideas on spacing, in painting, speech, and so on, and also because space is not necessarily that which is seen, as it is for a sculptor or architect, for example. Space isn't only the visible, and moreover the invisible – this takes us back to the text I mentioned before we got started, on blindness[12] – the invisible, for me, is not simply the opposite of vision. This is difficult to explain, but in that text I tried to show that the painter or the drawer is blind, that she or he writes, draws, or paints as a blind person, that the hand that paints and draws is the hand of a blind person – it is an experience of blindness. Thus the visual arts are also arts of the blind. For that reason I would speak of the spatial arts. It more conveniently allows me to link it with the notions of text, spacing, and so on.

Now for the second part of your question. Obviously, the word "thought" doesn't work for me in that context, except to the extent that I can, as a matter of usage, count on a distinction made elsewhere between thought and philosophy. Thought is not exhausted by philosophy. Philosophy is only a mode of thought, and thus it is the extent to which thought exceeds philosophy that interests us here. This presumes that there are practical arts of space that exceed philosophy, that resist philosophical logocentrism, and that are not simply natural, or, as some would call them, animal activities – are not simply of the order of instant needs. At this point it is necessary to say that there is thought, something that produces sense without belonging to the order of sense, that exceeds philosophical discourse and questions philosophy, that potentially contains a questioning of philosophy, that goes beyond philosophy. This does not mean that a painter or filmmaker has the means of questioning philosophy, but what she or he creates becomes the bearer of something that cannot be mastered by philosophy. Thus, there is thought there. So, every time there is an advance, an architectural or pictorial event, whether it be a particular work or a new school or architectural style or a new type of artistic event, thought is involved, and not only in the sense I have just described. It involves thought in the sense of the memory of the history and tradition of the work, or of art in general. But that does not mean that artists know history, or that filmmakers must know the history of film, but the fact that they inaugurate something, that they produce a type of work that was not possible,

[12]*Memoirs of the Blind,* trans. Pascale-Anne Brault and Michael Naas (Chicago: University of Chicago Press, in press).

let's say, twenty years earlier, assumes that in their work the memory of the history of film is nevertheless recorded, and therefore that it is interpreted, it is thought. What I call thought is just that; it is interpreted. Hence when I speak of thought at work in architecture, as could also be said with respect to painting or the fine arts, I am making a distinction between thought and philosophy. I am referring to something in excess of the philosophical, something not only of the order of an earthquake, or an animal instinct, as well as to self-interpretation [*auto-interprétation*], interpretation of one's own memory.

What I call thought is a polemical gesture with respect to current interpretations according to which the production of an architectural or a cinematic work is, if not natural, at least naïve in terms of critical or theoretical discourses, which are always essentially philosophical, as if thought had nothing to do with the work, as if it didn't think, whereas elsewhere the theoretician or interpreter or philosopher does think. So the idea is to indicate in a polemical fashion that thinking is going on in the experience of the work, that is to say, that thought is incorporated in it – there is a provocation to think on the part of the work, and this provocation to think is irreducible. Obviously, this is charged with meaning because it assumes a lot of things, such as the Heideggerian distinction between philosophy and thought. It is Heidegger's words I am using when I say that philosophy is only a mode of thought – it is almost a direct quotation from Heidegger that I have appropriated – but at the same time I use it in a way that is anti-Heideggerian. In order to really interpret what I say about architectural thought, it is necessary first to understand the reference to Heidegger, and second to understand that the entire text about architecture is anti-Heideggerian. It is an argument against the Heideggerian notion of habitation, of the work of art as habitation. My objection to Heidegger, in fact, often begins with the spatial arts. That is because I think that the hierarchization of the arts he practices in his discourse on art and painting, or on poetry, repeats a classical philosophical gesture, and that is exactly what I argue against. Thus it is not only an argument against Heidegger that I then apply to the domain of art; it is in fact on the basis of the spatial arts, or starting with the question of space, that I question Heidegger, in particular in the domain of the architectural and what he says about habitation.

WILLS: Can we come back to your text on photography, "Right of Inspection," with Marie-Françoise Plissart? I am referring to what you told me once concerning the problem of its translation, the fact that the piece was not accepted by an American publisher.

DERRIDA: The question of that translation is complicated. First, it is a very difficult book to translate, notably in terms of the problematic we discussed earlier, the way it plays on French words, but more than that, because I try to show that the photographs themselves proceed from a kind of implicit play in French that is untranslatable, that it is as if this photographic work could be produced only in the French language – as if not only my text but also the photographs were untranslatable. I am reminded of what happened in the case of the Japanese translation of the text. Because of the differences between the left-to-right linearity of

Western writing and the right-to-left, vertical progression of Japanese, and the fact that a similar linearity of gazes occurs both within a photograph and from one photograph to the next, it was not possible to reproduce the photographs in the "correct" order in the Japanese text. In fact, the publisher reversed the original order of the photographs, but that only confused Japanese readers, because the gazes still failed to match from one photograph to the other. What I called the text's untranslatability therefore became a fact in Japanese.

So, first of all, it is very difficult to translate for reasons that are given in the text itself. Having said that, however, if it appeared in English only in Australia, I imagine that was also for other reasons – I don't know which, I have only hypotheses formed after speaking with various people. It seems that in spite of everything, in the field of American academic publishing the "obscenity" of the photographs became an issue. That is to say that my American publishers, respectable university presses, either did not want to publish it or did not want to associate my name with photographs of lesbian lovemaking, and so forth, and thus said it didn't interest them. For instance, I was informed by one of them, through the intermediary of an editor who claimed to know something about photography, that the photographs weren't interesting. I don't know what his evaluation is worth, if it was sincere or not. I am not able to judge, I don't know what to think of it. Maybe he was right, but the work consisted of more than just the photographs. In this case there was a reluctance that I can't explain. I can only conjecture that resistance to this type of image in the field of academic publishing is greater than I thought. I was very naïve, because in my confused evaluation of what is happening in the United States I did not think it was possible that this sort of prudishness would be so prevalent. From that point of view this country remains very enigmatic to me. An almost unfettered sort of freedom coexists closely with the most ridiculous of prohibitive moralities; the proximity of the two is very difficult to comprehend.

BRUNETTE: I want now to ask something concerning the so-called negativity of deconstruction. At the end of the "Fifty-two Aphorisms" you make a call for not destroying things, for finding something affirmative: "The baseless ground [*le sans-fond*] of a 'deconstructive' and affirmative architecture can cause vertigo, but it is not the void [*le vide*], it is not the gaping and chaotic remainder, the hiatus of destruction." You point to this affirmative place in your work, but you never name it. Can this place be named?

DERRIDA: It's not a place; it's not a place that really exists. It's a "come" [*viens*]; it is what I call an affirmation that is not positive. It doesn't exist, it isn't present. I always distinguish affirmation from the position of a positivity. Thus it is an affirmation that is very risky, uncertain, improbable; it entirely escapes the space of certainty.

Before coming back to that, since you quoted that passage, I can say that I insist on this point in the text on architecture for two reasons: first, because in fact people can say that deconstructive architecture is absurd because architecture constructs. So it is necessary to explain what

the term means in the text, that "deconstructive architecture" refers precisely to what happens in terms of "gathering" [in English], the being together [être ensemble], the assembly, the now [maintenant], the maintaining. Deconstruction does not consist simply of dissociating or disarticulating or destroying, but of affirming a certain "being together," a certain maintenant; construction is possible only to the extent that the foundations themselves have been deconstructed. Affirmation, decision, invention, the coming about of the constructum is not possible unless the philosophy of architecture, the history of architecture, the foundations themselves have been questioned. If the foundations are assured, there is no construction; neither is there any invention. Invention assumes an undecidability; it assumes that at a given moment there is nothing. We found on the basis of nonfoundation. Thus deconstruction is the condition of construction, of true invention, of a real affirmation that holds something together, that constructs. From this point of view, only deconstruction, only a certain appeal to or call by [appel de] deconstruction, can really invent architecture.

So the passage you cite was meant to respond to those who are frightened by the idea of a deconstructive architecture, those who think it ridiculous, but in the second place it was also meant to respond to discourses within the architectural field that are a little negativist, discourses such as Eisenman's, for example. A letter I wrote to him on that subject was recently published.[13] In his theoretical discussion of his work he often presents a discourse of negativity that is very facile – he speaks of the architecture of absence, the architecture of nothing [du rien], and I am skeptical about discourses of absence and negativity. This also applies to certain other architects like Libeskind. I understand what motivates their remarks, but they are not careful enough. In speaking of their own work they are too easily inclined to speak of the void, negativity, absence, with theological overtones also, and sometimes Judeo-theological overtones. No architecture can be called Judaic, of course, but they resort to a kind of Judaic discourse, a negative theology on the subject of architecture. Thus my allusion is to be understood in that sense.

Now what is this call? I don't know. If I knew, nothing would ever happen. The fact is, in order for what we conveniently call deconstruction to get off the ground [se mettre en mouvement], that call is necessary. It says "come," but come where, I don't know. Where this call comes from, and from whom, I don't know. That doesn't simply mean that I am ignorant; it is heterogeneous to knowledge. In order for that call to exist, the order of knowledge must be breached. If we can identify, objectify, recognize the place, from that moment on there is no call. In order for there to be a call, and for the beauty we spoke of earlier to exist, the orders of determination and of knowledge must be exceeded. It is in relation to nonknowledge that the call is made. Thus I do not have a response. I can't tell you "this is it." I truly don't know, but this "I don't know" doesn't just result from ignorance, or skepticism, or nihilism, or obscurantism. This nonknowledge is the necessary condition

[13]"A Letter to Peter Eisenman," Assemblage, no. 12(August 1990):7–13.

for something to happen, for responsibility to be taken, for a decision to be made, for an event to take place.

It is necessary that we be unable to respond to that question, and each event – whether it consist of an event in someone's life or an event such as a work of art – each event takes place there where there was no place, where we didn't know the place was, takes (the) place where there was no place. It provides the venue and in doing so prescribes that the venue not be known in advance, that it not be programmable. Afterward we can imagine or determine the programs, we can do the analysis. If an art form appears at such and such a moment, it is because the historical, ideological, and technical conditions render it possible, and thus after the fact we can determine the place of waiting, as it were, "the expectation," the structure of waiting, the structure of reception [*structure d'accueil*]. If we could do this in an exhaustive fashion, it would mean that nothing had happened. I believe that it is always necessary to take the analysis of the historical, political, economic, and ideological conditions, to take that analysis as far as possible, including the history of the specific art form. But if the analysis of all those conditions is exhaustive, to the point where the work is ultimately only there to fill a hole, then there is no work. If there is a work, it is because, even when all the conditions that could become the object of analysis have been met, something still happens, something we call the signature, the work, if you wish. If all the conditions necessary to produce, let's say, *A la recherche du temps perdu* have been met, and we can analyze those conditions in general and in the specific case, and if that analysis in fact no longer needs the work, then it is because nothing has happened. If there is a work, it means that the analysis of all the conditions only served to, how shall I say, make room [*laisser la place*], in an absolutely undetermined place, for something that is at once useless, supplementary, and finally irreducible to those conditions.

BRUNETTE: Let me ask you a question about the future of what might be called an alternative deconstructive critical practice. It seems that if people write in a more conventional deconstructive mode, they say that it's already been done. But if it's more autobiographical and self-foregrounding, or relies more on chance and puns, they become hostile. It's too narcissistic, they say, or it's okay when Derrida does it or when Barthes used to do it, because they're Derrida and Barthes, but when others do it, it's self-indulgent. Given the enormous institutional constraints on discourse, do you think there is any future for that kind of practice?

DERRIDA: If it is "that kind of practice" then it won't have a chance. Its chance is that it will be transformed, that it will be disfigured. It's obvious that if it were an identifiable and regulated practice, the same thing being recognized each time, then it would not have a chance. It would be stillborn, dead from the start. If it has a chance, it is to the extent that it moves on, that it gets transformed, that it is not immediately recognized, that it is recognized without being recognized. We must be able to recognize it, but it is also necessary that in the process of this recognition, something else happens in the form of a contraband [*en contre-*

bande]. People must be able to recognize it and at the same time recognize that they are dealing with something they can't identify, something they don't know. So it takes or it doesn't; there's no general rule. To put it in rather formalist terms, I would posit the paradox as follows: The chances that X – let's call it deconstruction, but it could be anything – will proliferate and last are inversely proportional to the fact of its being recognized as X, that is to say, directly proportional to the possibility of its producing effects that cannot be continuously reproduced in deconstruction. Thus it needs to be transformed, to move elsewhere.

BRUNETTE: Do you have any comment on Gregory Ulmer's attempt, in his recent book *Teletheory: Grammatology in the Age of Video*,[14] to develop an alternative critical practice, what he calls "mystory"?

DERRIDA: With respect to Greg Ulmer, his work seems to me to be very interesting, very necessary; it opens another space that we can evaluate in a different manner. We can evaluate it with regard to deconstruction – I am personally unable to do that – or with regard to what I do, and people may or may not be in agreement about it. But there needs to be discussion about these objects – television, telepedagogy, and so forth – and such questions will produce a new discourse that a lot of people, myself included, won't understand. Already I am not sure that I understand Greg Ulmer very well, or not sure I have worked enough on him to know what he means. I see it from afar, I see it in outline, but it's already beyond me. That means that the object called deconstruction has moved elsewhere and that under its name something is happening that has no relation to the word. And so it gets displaced and deformed. That is the condition for the future. If there is to be a future, it is on the condition that it not be "that," that it be elsewhere. It is clear that the production of new technological capabilities – in communications, for instance – such as I could never possibly have imagined, will displace things completely. The political situation is changing radically; the same goes for computers, for biology, and all of that will necessarily produce discourses that are not totally translatable in the code or language of the deconstruction of twenty years ago, or ten years ago, or of the present time. That is the future, by definition. If there is a future, we can say nothing about it.

In terms of what I can predict from what is close at hand, during the coming years the war over deconstruction will probably continue to rage in the American academy. In my opinion the war reserves are far from depleted. I don't know how much longer it will go on, but the political argument will continue to fuel the debate. It is not only the affairs of the past, those of Heidegger or de Man, that are raising the stakes. For a certain time the temperature will remain fairly high, and for political reasons, but that doesn't only relate to things that are difficult to interpret, such as the case of de Man, but to the whole framework that the detractors of deconstruction operate within. There will be a great deal of uncertainty that will increase the tension, especially because of what is now happening in the geopolitical sphere, notably what we call the

[14]Gregory Ulmer, *Teletheory: Grammatology in the Age of Video* (New York: Routledge, 1989).

democratization process in the Eastern countries; all that will make the interpretive machines very restive. And, as always, the polarization will increase the tension, for there definitely is polarization around deconstruction – those who say it is reactionary and those who say it is revolutionary, conservative or not conservative.

WILLS: Do you think it works in the same way in France?

DERRIDA: No, in France it is more complicated. There are always similarities, but in France there exist different milieus. In the United States, deconstruction is restricted to the academic milieu, even though that milieu is not a homogeneous field. As it happens, these things are starting to overflow the academic field. Someone told me that a colloquium that involved deconstruction recently took place in the army or navy. The other day Hillis Miller told me he had received a call from Phyllis Franklin at the MLA, who had had a request from a senator for information on deconstruction. So it is clear they want to know what is going on. In general, though, American intellectual culture is restricted to the academic field. Things are different in France. The university milieu is not the same as the cultural milieu or the literary milieu.

BRUNETTE: I was thinking of the university milieu, because when French university professors come here and we tell them we are interested in your work, they have a tendency to say that, yes, deconstruction was something important that happened fifteen or twenty years ago, but they claim not to understand why it still interests us.

DERRIDA: That is both true and false. It is true that deconstruction appeared in a certain form at a certain time in France, and that there was a delay in its transmission. There was a process of assimilation and thus apparently of digestion and evacuation that occurred in France between 1966–7 and 1972–3, and from that point of view it is said to be finished. At the same time, it often amounts to disavowal or resentment in terms of something that, in my opinion, has *not yet* arrived in France. I can say that in many respects it has not yet arrived in France. So it is true and false, and deserves a detailed analysis. It is also necessary to bear in mind the subject position of French intellectuals who come here, who have their interests, who have a certain background, who want to see things in a certain way. In general it makes them nervous, for obvious reasons, that deconstruction interests people here. That concerns me a lot, because I'm right in the middle of it, and it often comes home to me that way.

BRUNETTE: I have a related question that is a bit more difficult, perhaps because it's more fundamental, but it's a question that is very important to me in my own intellectual life. The problem is that I find that I am unable to listen to a lecture on almost any subject, no matter how expert, since I've been "ruined" by deconstruction.

DERRIDA: So am I.

BRUNETTE: All thinking, at least at present, seems to depend upon the making of distinctions, the ordering of hierarchies. As soon as someone giving a lecture divides his or her topic into three parts, say, I immediately see how number one could really be considered part of number

three, or that number two and number one actually overlap. So, given the fact that deconstruction seems to threaten the production of knowledge in such a fundamental way, I wonder if you were not being a little naïve when at the end of the *Limited Inc.*[15] interview you did with Gerald Graff you said that what bothered you the most was that people seem to deliberately misread your work and seem to be so irresponsible when they discuss it. But since your ideas are so threatening to the production of knowledge as it is presently constituted, isn't their response in some ways understandable? And if it *is* true that deconstruction blocks the production of knowledge, where can we go next? This is perhaps a very naïve question, but I feel I have to ask it: What's next?

The second part of the question is what you think the outlook is, institutionally speaking, for the future of deconstruction in America. Will it continue to exist, and if so, will it begin to take different forms beyond what might be called the "Yale school" undecidability, the finding of aporia in texts? I'm thinking, for example, of *Glas,* the performative text that tries to "go beyond" logocentrism. Do you think there is any future for that in the American academy?

DERRIDA: There are a lot of questions there. To come back to what we were discussing before we started the interview, it just so happens that yesterday and the day before I was at a colloquium on the Holocaust, and I spoke for two and a half hours on a text by Benjamin, dealing with the 1, 2, 3 distinctions, and so forth. I spent my time demonstrating how this text of Benjamin's, "Critique of Violence,"[16] which produces a series of distinctions like that between "founding violence" and "conserving violence," itself constantly deconstructs its own conceptual oppositions. So I spent my time delineating Benjamin's distinctions, then questioning them. For me, a reading is bearable only when it does that work. That said, I don't believe that deconstruction is essentially or solely that which, as you said, destroys the production of knowledge. No. Or rather, it does and it doesn't. On the one hand it can in fact disturb or block a certain type of work; on the other hand it indirectly produces knowledge – indirectly it provokes work. Those who consider themselves deconstructionists and those who are opposed to it all work in their own manner, and I think this accelerates the production of knowledge. For example, the New Historicism, which presents itself as a producer of knowledge, appears in a field that is all the same marked by deconstruction. While being sensitive to the fact that deconstruction can paralyze the tranquil, positive accumulation of knowledge, on the other hand it's also productive.

Then you ask what's next. Frankly, I don't know. I'm not here to sing the praises of deconstruction; nevertheless, I believe that the fact that deconstruction is not limited to what you call the "Yale school" effect has already been confirmed. In saying that, I am not speaking of my own work. What is happening in architecture, in law schools, and

[15]Jacques Derrida, *Limited Inc.,* trans. S. Weber and J. Mehlman (Evanston, Ill.: Northwestern University Press, 1988).
[16]Walter Benjamin, "Critique of Violence," in *Reflections: Essays, Aphorisms, Autobiographical Writings,* trans. Edmund Jephcott, ed. Peter Demetz (New York: Harcourt Brace Jovanovich, 1978), pp. 277–300.

so on, shows that deconstruction has not been limited to that context. Even supposing that at a given moment – though that was never true – it came together in the so-called Yale group, that's over. And it always was, even at Yale. So it can't remain there. But it is necessary to distinguish between the fate of the word "deconstruction," or deconstructionist theory, or a so-called school – which never existed – and other things that, without the name or without reference to the theory, are able to develop as deconstruction. For me, deconstruction does not limit itself to a discourse on the theme of deconstruction; for me, deconstruction is to be found at work [*il y a la déconstruction à l'oeuvre*]. It is at work in Plato, it is at work in the American and Soviet military commands [*les états-majors*], it is at work in the economic crisis. Thus deconstruction does not need deconstruction, it does not need a theory or a word. Now if we restrict the thing, if we limit it to the discursive and institutional effect that has developed throughout the world, but mostly in the United States, and in the academy, and we ask "What's next?", then I don't know. We're used to changes in fashions and schools and theories and hegemonies. We are not going to use the *word* indefinitely. One day we will think back that during the sixties, seventies, and eighties there was a thing [*un truc*] called deconstruction that was represented by . . . I don't have any illusions about that, no more than about our own longevity. We know that, generally speaking, we live for sixty to seventy years and then we die. In that sense, "deconstruction," as a word, or a theme, will disappear. What will happen before its disappearance, or what will happen after, I don't know. I really don't know. I find that it has already had a rather long life, precisely because it was never a theory able to be contained within a discipline, neither philosophical nor literary, and so forth. It follows a different temporal rhythm and hence takes more time to move into architecture and other fields. And it gets deformed; it is a rather monstrous phenomenon, each time different and thus unidentifiable. Obviously, if certain people want to identify it by the type of literary theory that was developed at Yale, which is a reductive gesture, then it is easier to find its limits. But it is more like a virus; it is a form of virus, of which we will lose the trace. It is inevitable that at a given moment the trace identifiable within the name "deconstruction" will be lost; that is obvious. The word will wear itself out. Beyond the word "deconstruction" or other words associated with it, this process will be a little different; it may take longer. There will continue to be little organisms with their independent lives, whose trajectories we may be able to follow, but that is true for anything that happens in a culture. How does one follow the trace of philosophy through history? I don't know.

Laguna Beach, California *Translated by* Laurie Volpe
April 28, 1990

COLOR HAS NOT YET BEEN NAMED: OBJECTIVITY IN DECONSTRUCTION

STEPHEN MELVILLE

So we begin in the midst, with Jacques Derrida's words and writings. It is a well-known characteristic of these writings that they are everywhere marked by a variety of neologisms, neographisms, and what he calls "paleonymies" or, following the psychoanalysts Nicolas Abraham and Maria Torok, "anasemies": One thinks easily enough of *différance,* "supplement," "graft," "trait," as well as more obscure formulations like "+R" or "gl," and so on. These coinages and turnings are invariably accompanied by warnings to the effect that what they register is "neither a word nor a concept" and that they ought not be hypostatized beyond the terms of the reading in which they are set to work.[1] These graphemes presumably are themselves offshoots or refractions of the major coinage of "deconstruction" and are justified at least in part as attempts to at once underline and enact the consequences of a fundamental instability within the name of "deconstruction," itself a term that Derrida has, at least at times, never meant as a noun. What matters is the activity, and that activity is chameleon, in and of itself hostile to nomination and fixity. Derrida thus frequently insists on speaking of deconstructions, in the plural. At the same time, and despite certain obvious and interesting affinities, deconstruction is not dada. Derrida's writings surely mean to make something happen – to exert, as he puts it, effects, and these effects are not conceived as simply random. Nor is the event they set in motion anything so apocalyptic as an end to meaning *tout court;* Derrida has been vigorous from the outset in refusing any simple ascription of "nihilism" to the various things, his own and others, that he calls "deconstructive."

The term "deconstruction" is itself willingly less than novel; it has, in fact, both a legitimate French history, given in Littré, and a particular philosophical pedigree that makes it an aggressive translation of a nest of terms in the work of Heidegger, most signally *Abbau.*[2] This inherent conservatism within the term is the obverse of what Derrida has always known within, and despite, his insistent attempts to outflank that knowledge: that "deconstruction" and all its dispersed refractions will end as

[1] One moral of the controversy with Lacan would be the further caution that these things also are not "pure signifiers."

[2] On both the relation to *Abbau* and the choice of *déconstruction* to render it, see Derrida's "Letter to a Japanese Friend," in *Derrida and Différance,* ed. D. Wood and R. Bernasconi (Evanston, Ill.: Northwestern University Press, 1988).

nouns and names. More particularly, "deconstruction" cannot avoid –
but only delay – the moment in which it comes to name a project and
a more or less stable practice.

This moment has – the American academy has played no small part
in this perverse testimony to the strength of what Derrida aims to contest
– come exceedingly quickly. "Deconstruction," worn to transparency
and beyond, is widely taken as a project and a method: "We all" know
how to find the binary, reverse its hierarchy, and decenter the opposi-
tion. Some of "us" have indeed already begun to imagine writing and
teaching "after deconstruction," as if some project had been completed,
or at least sufficiently elaborated that one might imagine what things will
look like on the far side of its completion.[3] Others – presumably in-
cluding all or most of the contributors to this volume – look to the
extension of that project to new regions – film, the visual arts, and so
on.

All of this comes inevitably with the practice of deconstruction; the
fate of its name is of a piece with the more general fate of writing, and
the name cannot be recalled from its dispersion or corruption through
any appeal to some meaning held to be stable and secure apart from it.
All that was already in ruins; "deconstruction" can look to make this
explicit but cannot exempt itself from all it displays and diagnoses.

All of this has, of course, been said before, by Derrida and by others.
But that hardly makes it irrelevant to an enterprise as strongly nominative
and projective as a volume dedicated to "deconstruction and the visual
arts." What, after all, is one to expect under such a title? The decon-
struction of visual works? Visual works that are deconstructed? A ruin-
ation of the visual as such? Should one expect an account of a new
method? A new art? The collapse of disciplines? What extraordinary
transformations are in the offing here? And what is to be transformed?

One plausible response to these questions – perhaps the one most
native to our thinking about such matters – would be to imagine the
arts or the discipline of their history as the object of some deconstructive
transformation. There are serious, inviting, and finally inevitable possi-
bilities here. But if Derrida's resistance to method, project, and so on is
serious, we should also imagine that "deconstruction itself" might be
what is transformed in this encounter.

MATTERS OF METHOD

We begin again, then, gazing through the late transparency of decon-
struction at the possibilities of method it seems to offer:

1. If deconstruction now presents itself above all as a method that art
history might take up, that method seems susceptible to a number of
different descriptions, each of which will give rise to a significantly dif-
ferent understanding of its possible purchase on the visual arts.

There is, for example, a very widespread understanding of decon-
struction as a practice of demystification, usually in service to a larger

[3]I think most notably here, of course, of Gregory Ulmer's *Applied Grammatology* (Baltimore:
Johns Hopkins University Press, 1985).

project of ideology critique, and this understanding presumably would renew itself within art history by continuing the project of rereading realism already well established in literary studies. One might look here to Catherine Belsey's use of the example of painting in the opening pages of her *Critical Practice*.[4] Insofar as it seems repeatedly oriented to undoing the apparent epistemological authority of fiction, the work of Paul de Man might appear to offer a more "rigorous" model for this kind of activity (although it is not intuitively clear exactly how de Manian analysis might be carried over to, say, paintings – certainly one might imagine a de Manian undoing of various programs of iconographic interpretation).

There is also an understanding of deconstruction in which language plays a crucial role (*il n'y a pas d'hors-texte* seems on this view to mean that "everything is language"[5]). The extension of deconstruction into the visual arts here would depend on the prior reduction of those arts to the status of linguistic or semiotic practices. This general path has, of course, been opened for art history by Meyer Schapiro, but undoubtedly the leading contemporary version of it is that found in the work of Norman Bryson.

Then there is an understanding of deconstruction that ties it directly to the aporias of self-reflection and a concern for the limits of self-consciousness, offering a route toward visual art that would bypass semiotic considerations and move more or less directly to the scrutiny of those moments in which visual works can be said to place themselves *en abyme*. A couple of years ago at a conference in Irvine, J. Hillis Miller took this path, scrutinizing the representation of the sun on the sail in Turner's *The Sun of Venice Going Out to Sea*.[6]

Clearly, none of these projects is in general illegitimate; the worst that can be said of them is that they are all "theoretical" – that is, they take deconstruction to be first of all a method and then seek to find within the visual arts the site or sites at which the method can be put most productively to work. And, of course, each of these approaches will have its particular shortcomings and problems. The demystificatory approach is overtly an appropriation and takes up deconstructive maneuvers only so long as they serve the ultimate ends of a project defined elsewhere and itself withheld from deconstructive attention.[7] The lin-

COLOR HAS NOT YET BEEN NAMED

[4]C. Belsey, *Critical Practice* (London: Methuen, 1980), pp. 7–10.
[5]The inadequacies of this translation have been more than adequately discussed, particularly by Barbara Johnson in her translation of Derrida's *Dissemination* (Chicago: University of Chicago Press, 1981), pp. xivff. In this context, though, it may be worth stressing that Derrida's general interest in "textuality" is more fully caught through his notion of "spacing" than through any explicit theory of language as such.
[6]An expanded version of this talk has recently been published in *Illustration* (Cambridge, Mass.: Harvard University Press, 1992). Michel Foucault has famously addressed similar issues in his treatment of *Las Meninas* in the opening section of *The Order of Things: An Archaeology of the Human Sciences* (New York: Random House, 1973), and Michael Fried brings a similar interest to bear on Courbet's *Studio* in his *Courbet's Realism* (Chicago: University of Chicago Press, 1990).
[7]De Man would seem to need separate treatment here, but it seems fair to say that his work unfolded in a frequently difficult relation to projects of ideological critique, and that late in his career he became increasingly willing to articulate the motives of his work in such terms.

35

guistic or semiotic approach demands a prior semiotization of art that looks at present to be bound to a particularly narrow cultural and historical range[8] and is further troubled by questions of color, which would appear to lend itself to semiosis only on the grounds of a return through more obdurately art-historical facts – for example, that what painting for the most part knows is not "blue" and "red" nor even, at least until very recently, "cobalt blue" or "alizarin red," but "Giotto's blue" and "Titian's red" – so the semiotic construal never quite fights its way free of the art-historical ground it means to undo or overmaster.[9] And finally, the chasing down of the odd *mise en abyme* seems motivated only by a sense that reflexivity is the name of the deconstructive game and does not appear justified by anything parallel to the sustained meditation on the materiality of writing that gave rise to deconstructive practices in literary and philosophical contexts. What we will count as either reflexivity or, more crucially, its disruption within the contexts of painting or sculpture remains unclear.

2. One might then choose to back off from these methodological construals of deconstruction in favor of raising questions about visual artifacts that might be said to be deconstructive. In doing so, one would, in effect, pass out of art history and enter instead into the contemporary, more or less "postmodern" arena of artistic production and criticism. Here the questions one would pose would not be on the order of "What constitutes a deconstructive (or deconstructed) art history?" but that of "What constitutes a deconstructive (or deconstructed) art object?" And, of course, behind such questions would be the further question of whether or not there is any sense speaking of objects in this way.

Derrida's own writings seem to suggest there is. In the work of Valerio Adami, Gérard Titus-Carmel, and François Loubrieu,[10] he seems willing and able to find acts of deconstruction. But his attention in these cases seems more occasional and less fully developed than usual (the essays on Adami and Loubrieu arose directly from their presentations of themselves as illustrators of Derrida's writings). If there has been a sustained encounter between Derrida and the stuff of the visual arts, thus far it has taken place above all in relation to architecture. It seems not wholly unfair to compare this engagement with Martin Heidegger's at-

[8]Bryson is thus methodologically "at home" with, for example, certain tendencies within eighteenth-century art and art theory in a way he is not with nineteenth-century French painting or with the genre of still life. This is, however, not to suggest that he does his strongest work where he is at home; the reverse seems to me more nearly the case – *Looking at the Overlooked: Four Essays on Still Life Painting* (Cambridge, Mass.: Harvard University Press, 1990), in particular, threatens everywhere to break with its semiotic frame.

[9]That a purely semiotic construal of color may become possible and even central in twentieth-century art is something a Brysonian approach would be obliged to overlook just insofar as that semiotic availability depends upon both a radical shift in the material conditions of painting and the availability of an understanding of art history in which that shift could be actively registered. On these matters, see the writings of Thierry de Duve, most notably "The Readymade and the Tube of Paint," *Artforum* (May 1986):110–21.

[10]For Adami and Titus-Carmel, see J. Derrida, *The Truth in Painting,* trans. G. Bennington and I. McLeod (Chicago: University of Chicago Press, 1987); for Loubrieu, see "Illustrer, dit-il" in J. Derrida, *Psyché: Inventions de l'autre* (Paris: Galilée, 1987), pp. 105–8. The reader may also want to consult *Mémoires d'aveugle: L'autoportrait et autres ruines* (Paris: Réunion des Musées Nationaux, 1990), the catalogue for the drawing show curated by Derrida at the Louvre.

tachment to poetry. In each case – and despite significant differences – the art form taken up appears to offer the actual happening of a concrete truth the philosopher can only claim to preserve and prolong.[11] The privilege of architecture, for Derrida, arguably arises from the way in which it is the direct manifestation of what deconstruction is obliged to speak only as metaphor – the language of building and dwelling in Heidegger (*bauen, Ab-bau*) as it is translated into construction and deconstruction, and as both Heideggerian and Derridean constellations are explicitly recognized as themselves translations or revisions of a deep-seated philosophical self-apprehension caught in the prevalence of words like "ground" and "foundation" within philosophical writing as they are taken up or refracted in Kant's "architectonic," the crucial exemplarity of the tomb in Hegel, or even the founding play of inner and outer, *agora* and *oikos,* in and around Plato. Inside–outside has always been a privileged topos within deconstruction, and the passage to architecture seems at this level inevitable.

There are, however, at least two kinds of difficulties one might have with this way of placing deconstruction into relation with the visual arts. The first, most clearly signaled by what Eisenman takes to have been the failure of his collaboration with Derrida in the Parc de la Villette, is quite simply that it is not obvious that there has been any extension into the visual or architectural here at all. Derrida can appear to have too simply ensconced himself within the textual, contributing a merely programmatic reading of Plato's *Timaeus.* As Eisenman remarks, "We finally forced Jacques to draw something"[12] – as if Derrida had been unwilling to lose his practice to this alien act or region.[13] Derrida's attitude here is far from indefensible, but it is important, I think, that any defense of it will depend on some notion of what remains for Derrida philosophical – that is, some notion of the necessity Derrida takes to underlie his activity.

[11]"I thought at first that perhaps [deconstructive architecture] was an analogy, a displaced discourse, and something more analogical than rigorous. And then – as I have explained somewhere – then I realised that on the contrary, the most efficient way of putting Deconstruction to work was by going through art and architecture. . . . Deconstruction goes through certain social and political structures, meeting with resistance and displacement as it does so." "Jacques Derrida, in Discussion with Christopher Norris," in *Deconstruction: Omnibus Volume,* ed. A. Papadakis, C. Cooke, and A. Benjamin (London: Academy Editions, 1989), pp. 71–2.

[12]"The failure of the work in a certain way was that I was not contained, that I was not played out of my position into some new position. Jacques contributed an unfinished text that he was working on from Plato's Timaeus. We took this as the programme. We then worked with the idea of chora as the programme. Jacques would criticize it until we got to the point where he was more comfortable with what we were doing: I think really more comfortable with architecture than any particular part of the work. I was probably and not coincidentally doing chora before I read his text. I think it is a collaboration that will happen some day; it has not happened yet. We finally forced Jacques to draw something." *Omnibus,* p. 145. Derrida's role, as described here, is essentially that of a client, not a collaborator. Eisenman's more recent exchanges with Derrida are still more stringent in their ascription of failure to the project; see J. Derrida, "A Letter to Peter Eisenman," and P. Eisenman, "Post/El Cards: A Reply to Jacques Derrida," both in *Assemblage,* no. 12(August 1990):7–17.

[13]In general, Derrida's remarks on architecture – for example, "Fifty-two Aphorisms for a Foreword," *Omnibus,* pp. 67–9 – seem oddly committed to trying to imagine an architecture adequate to the work of deconstruction.

Perhaps more centrally problematic is the basic notion that there is some "deconstructive architecture" to be recognized over and against some other architecture. This topic has recently been fairly widely discussed in England; in America, where "deconstructivist architecture" does not seem to have gained the same purchase, one finds similar discussions in and around the practice of what might be called "postpainterly postmodernism" – the work of image appropriators in the late 1970s and early 1980s and their later, often more Baudrillardian, followers in the contemporary art world. Does it make sense to speak of one object as deconstructed or deconstructive over and against another? Can something be a "deconstructed building"? Can a photograph be said to "deconstruct" something? If they can (and I do think there is a degree of sense in such formulations), are there any constraints on them?

3. One may well find oneself unhappy with the possibilities sketched so far – perhaps because they divide too neatly into questions of method over and against questions about objects. In such a mood, one may be tempted to cast the question of deconstruction and the visual arts in terms of a rereading of the "discourses of the visual." This is, I suspect, the dominant move in contemporary theory in general, and although it remains close to the project described earlier in terms of a thoroughgoing semiotization of art, it holds itself apart from that through a refusal to take the availability of the visual object for granted. Instead, it contends that vision is always "constructed," and it thus reads the (apparently) visual through a more embracing cultural grid. The general strengths of such an approach are obvious: In particular, it frees one of the art-historical equivalent of New Criticism's bondage to a certain understanding of the autonomous text. The visual is now to be understood from the outset as thoroughly caught up in an order of signification that opens it to the world and the full range of analyses that come with such openness – psychoanalytic, sociological, and so on.

Such discursive analysis promises as well the kind of antagonistic relation to the disciplines of the visual that we have come to expect of "advanced theory" in the face of any disciplinary formation.[14] "Art history," as a major instance of such disciplining, might be shown to be founded on a series of binary oppositions – for example, the haptic and the optic in Riegl, or the classic and baroque in Wölfflin – that can themselves be submitted to an aporetic reading capable of shifting or overthrowing those foundations.[15]

[14]To pursue this topic further would entail a discussion of the influence of Foucault's *Discipline and Punish: The Birth of the Prison,* trans. Alan Sheridan (New York: Vintage, 1979), on our general notions of the work of theory. I will simply note that my own use of the word "discipline" aims at activity fundamentally alien to the modes of surveillance examined by Foucault. Foucault's linkage of vision, discipline, and surveillance certainly has played and will continue to play a strong role in one's general imagination of the poststructuralist stake in the visual; it is a more or less tacit thesis of this essay that this can be, and has been, deeply misleading. I have taken up some of the issues involved here in a reading of Lacan; see S. Melville, "In the Light of the Other," *Whitewalls,* no. 23(Fall 1989):10–31.

[15]Donald Preziosi's *Rethinking Art History: Meditations on a Coy Science* (New Haven: Yale University Press, 1989) is perhaps the example nearest to hand, and the fundamentally Foucaultian parameters of the book are worth noting. I approach the examples of Riegl and Wölfflin within what I take to be a more Derridean frame in "The Temptation of

With this last formulation, we may feel ourselves moving into a region in which deconstruction might recognize itself. These are regions of which deconstruction does well to be wary; the cost of self-recognition, as always, may be the inability to recognize or touch what is other – in this case, deconstruction's presumed objects, which would be regularly replaced by their discursive representation and a certain critique of that representation (simply for being a representation).[16] It is an important fact about the shape of contemporary theory in its various forms that this cost either will not be perceived as such or will be considered eminently worth paying by any number of theorists, historians, and critics. Indeed, many will claim that this transformation of the structure of the field of study from objects to discourses is the signal advance made by theory. This essay, in contrast, does see it as a cost, and as a high one.

NOTES ON A CONVERSATION

Not too long ago, the Tate Gallery sponsored, around the notion of "deconstructivist architecture," a series of events, among which were the showing of a videotaped interview of Jacques Derrida by Christopher Norris and a subsequent panel discussion among a number of those interested in the implications of deconstruction for the visual arts.[17] Norris's expression of his own doubts about the viability of the claim to deconstructivist architecture led Andrew Benjamin to a statement that reflects some of the kinds of unhappiness I have tried to sketch out in the preceding section:

Part of the difficulty with this is trying to locate Deconstruction in an object. In other words, to say of a specific work of art or a specific architectural form that this is an instance of Deconstruction. . . . The question of the object returns in another way and it goes back to the point put to Derrida as to whether or not Deconstruction is something that comes to be enacted within an object or a way of reading objects or a way of reading texts. As is always the case with these things, it's clearly both; the question of enactment is problematic.

Commenting on this, Geoff Bennington added a notable extension: "Finally, I want to endorse Andrew when he says that Deconstruction is not in objects. I want to add the corollary that objects are in Decon-

New Perspectives," *October,* no. 52(Spring 1990):3–15. See also Marshall Brown's "The Classic Is the Baroque: The Principle of Wölfflin's Art History," *Critical Inquiry* 9(December 1982):379–404.

[16]This is not the place to spell out or defend in detail a deconstructive sense for a phrase like "critique of representation," but it is worth the reader's recalling that Derrida's most characteristic description of his activity is in terms of a "critique of presence" and that it is not clear what this entails for our understanding of "representation." It may then seem that my own invocation of something like "touch" in phrasing deconstruction's relation to its objects falls short of the standard implicit in "the critique of presence." The questions raised here demand separate and lengthy argument, so I will simply assert that I do not understand deconstruction's critique of presence to entail skepticism in any normal sense and that I do understand deconstruction as always called for by something other than itself: something that is there – object, event, text.

[17]The participants were Andrew Benjamin, Geoff Bennington, Christopher Norris, and Michael Podro.

struction.''[18] In a separate essay in the same volume ("Deconstruction is not what you think"), Bennington repeats this observation within the particular context of painting – "Colour is, in Deconstruction"[19] – and in making the punctuation explicit he attaches the question of the object firmly to Derrida's Heideggerian inheritance. The question of the object in and for deconstruction is a question not about *what* the object is, but about *how* or, even more simply, *that* it is. It is only on the basis of this recognition that we can understand why deconstruction refuses our ordinary grammars of criticism and knowledge and can insist justifiably on something those grammars can register only as, in Benjamin's phrase, "clearly both."

"In deconstruction" is not a methodological or theoretical place (as would be apparently the case with a phrase like "the object in psychoanalysis"), nor is it a particular state of some one object as opposed to others, nor is it simply a way of saying "in discourse." It is a name for how an object is – how, as it were, it *does* its being.[20] We may have reason to say under one circumstance or another that some objects are more explicit about their ontological stakes than others, or have at least been received with greater ontological explicitness. But this contrast, however useful, does not dig very deep; our urge to take it as significant is by and large continuous with the urge to recognize deconstruction as a mode of demystification.

When Heidegger reads Kant, he reads not a report on the world, but a "thought of Being," which is to say he reads Kant's text not as authored by a subject in the face of an object but as the production of a being that is peculiar insofar as it *is* only *as* the question of its Being, a being thus at once subject and object and, above all, the space between. It is this understanding of *Dasein* in its relation to thought and Being that licenses such interpretive violence as Heidegger's reading exercises (here as well as in his encounter with Van Gogh's *Old Boots with Laces*). Derrida's procedures and justifications are in the first instance not different from this; he too engages his objects just insofar as they are defined by – constituted by – their relation to the conditions of their appearance. The issue between Heidegger and Derrida is about how this is to be accomplished. Where Heidegger is repeatedly tempted by the notion of moving beyond the "merely ontic" (the region in which beings are as if simply present) to the ontological (the region in which we are obliged to speak of Being), Derrida is insistent about not letting the ontological emerge anywhere other than in and as the ontic: There is thus, for him, no prospect of a breakthrough to something that would be called "fundamental ontology,"[21] and the clearest marker of this in his writing is the rejection of Heidegger's talk of Being and its (self)forgetting in favor of the apparently more contingent and metaphysically modest talk of

[18] The complete discussion can be found in *Omnibus,* pp. 76–8.

[19] *Omnibus,* p. 84.

[20] The secondariness and relative passivity of human agency in relation to such formulations seem deeply characteristic of deconstruction.

[21] Nor is there the same structure of apocalyptic hope that emerges in the work of the later Heidegger; but see J. Derrida, "Of an Apocalyptic Tone Recently Adopted in Philosophy," trans. J. P. Leavey, Jr., *Semeia,* no. 23(1982). One might say that for Derrida, "writing" names the impossibility of what Heidegger calls "thinking."

writing and its "repression." But it remains the case that to ask of a text how it understands its relation to its material conditions is to ask of it how it is – and it is to do so within the Heideggerian frame in which "to be" is always understood as "to be as . . . ," a phrase that turns the apparent solidity of a thing always over to the fluidity of relation.

Recognition of this Heideggerian thread in Derrida's writings can make a major difference when one attempts to raise the question of deconstruction and the visual arts. Because Heidegger's thought moves relentlessly toward Being and its truth from each of its starting points, he is able to imagine a certain derivative project of regional ontologies organized by derivative modes of truth, and on this basis he can project a certain hierarchy of regions. Within the arts, for example, Heidegger is explicit about the privilege of poetry insofar as it is the very stuff of how things are for us: Language is "the dwelling house of Being," and the poet is the prime artificer of that house.[22] These are the figures that determine Derrida's stake in architecture, and his moves in this arena are best taken as attempts at reversing and undoing – or fundamentally complicating – them.

Deconstruction as I have described it cannot have the same access to notions of regional ontology because it does not have the same access to ontology *überhaupt*. What might count as "regions" are necessarily disseminated into the multiplicity of objects that might be found "in deconstruction," and no particular object or region of objects can in principle be privileged over another. Every object must appear as an occasion for a reinvention of deconstruction: Every object is different(ly). Within Derrida's work this demand is embedded in his own practice of renaming his enterprise and its key terms with each new text he reads, as well as in his recurrent expressions of unhappiness about the ways in which that mobility will inevitably be undone – the whole nexus of cautions and problems from which this essay began. If one were to stop here, deconstruction might be imagined as a peculiar and radical empiricism (and sometimes it is indeed taken as if it were just that). But this assumes a settlement of the meanings of "object" and "objectivity" for deconstruction to which we are not yet entitled. In particular, it forgets the Heideggerian conflation of "being" and "being as. . . ."

RENEWING THE QUESTION

If what we are asked in the encounter of deconstruction with the visual arts seems to be neither "How (can, should, ought) one deconstruct art?" nor "How can one make (what counts as) deconstructive art?", then the question might seem better given a form like "What deconstructions can one recognize within the visual, and how is one to acknowledge those deconstructions?" Each part of this new question has its own difficulties, but it is at least worth being clear about the general tendency of the whole. Again I cite Geoff Bennington at the Tate exhibition:

[22]Heidegger's thought – and this I take to be the central burden of Derrida's critique of it – continues to grant a certain demystificatory privilege to philosophy/poetry.

[T]he most traditional philosophic views of art as mimesis, and its most academic practice, have always necessarily left uneasily open a sense of art as a dangerous event in which something happens to disturb the integrity of "nature herself" (and not just respond to her), somewhere resisting the grasp of concept and commentary, and through the insufficiency of attempted explanations of this event in terms of talent, inspiration or genius, something of this deconstructive edge or "point," as Derrida says, has always been at work. To this extent, art has always already been in excess of its concepts, already deconstructive, and deconstruction the motor or movement or element of art. . . . "Deconstruction" . . . is in any case a provisional and necessarily improper name of the movement one of whose traditional names has been "art."

Bennington's implicit opposition of mimesis to event is perhaps closer to the work of Jean-François Lyotard,[23] a figure who necessarily haunts the region in which we are moving, than to Derridean problematics, which incline – as, for example, in the work of Philippe Lacoue-Labarthe[24] – more toward an opposition of mimesis to itself.[25] This, however, takes nothing away from Bennington's central point: Deconstruction does not in any direct way offer either an approach or an alternative to something we might call the tradition of art – it (re)names that tradition. The peculiar difficulty is that in so doing, it is itself renamed, refigured, or reworked by that tradition: What is asked of deconstruction by art is something like self-recognition, and this "something like self-recognition" will have to be articulated in terms that do not undo deconstruction's refiguring of selfhood and its concomitant incapacity or refusal to reduce questions of recognition to questions of self-knowledge. This might mean that what is asked of deconstruction is that it lose itself in a new way.

It is just here that what we have earlier sketched as a demystifying and antidisciplinary analysis of the founding terms of art history can take a crucially different turn. Just insofar as the things we have described as founding binaries are not simply imposed on the brute stuff of art history but grow out of its own theoretical and artistic polemics – the *paragones* of sculpture and painting, the struggles of *disegno* and *colore,* Poussiniste and Rubéniste – they appear to offer an entry not simply into the arbitrariness of a discipline but into something we have to call its object. Such an approach would, in its fullest extension, pay off in a sustained investigation of the stability of the visual as such and not simply of its presumed discursive construction.[26] Such work would be friendly to Bry-

[23]Although Lyotard works in considerably greater proximity to art and art history than Derrida, he is equally clear about the determining role of the name of philosophy for his writing. The relation between Derrida and Lyotard is difficult: Are we to understand it as offering us a choice? Or is it more nearly the case that to choose one must be also to choose the other, despite or even because of their differences? No doubt something of this ambivalence marks this essay.

[24]Recently translated works by Lacoue-Labarthe include *Typography: Mimesis, Philosophy, Politics,* ed. C. Fynsk (Cambridge, Mass.: Harvard University Press, 1989), and *Heidegger, Art and Politics: The Fiction of the Political,* trans. C. Turner (London: Basil Blackwell, 1990). Lacoue-Labarthe's essay on the work of Urs Lüthi, *Portrait de l'artiste, en général* (Paris: Christian Bourgeois, 1979), is of special interest in the context of discussions of "postmodern" appropriation.

[25]Or to "mimetologism," the appropriation of mimetic supplementarity to a prior logos and the consequent thinking of mimesis as appropriation or participation rather than as permanent disappropriation.

[26]I have tried to explore some of these issues in a preliminary way in "The Temptation of

son's investigations without feeling constrained to a semiotization of art and would, in principle, be interested not so much in spotting the *mise en abyme* as in asking what in a given conjuncture carries the force of that problematic.

It will be clear that I find this way of working between the texts we know as deconstructive and the visual arts potentially extremely powerful, and the best work we have of this kind – I think especially of the writings of Rosalind Krauss and Michael Fried in English and those of Hubert Damisch and Thierry de Duve in French[27] – is some of the most powerfully deconstructive writing art history has produced. And just as I earlier suggested that it was important in reading Derrida on Adami and others to recall the philosophical grounds and motives of his activity, it seems to me equally important to invoke the properly art-historical grounds for the activities of these writers. In particular, it seems crucial to speak of what I will call their objectivity, by which I do not mean anything like the submission of their analyses to overarching logical or empirical criteria of verifiability but more simply their aim at objects and their willingness to assume the demand to think or write them as such. It is important about these writings and about deconstructive writing in general that the demand to think objects "as such" is made within the context of a sharp distinction between "individuality" and "uniqueness,"[28] a distinction that follows from the identification of "being" with "being as . . ." and that steers the writing away from radical empiricism, at least as it is normally understood.

The recognition of the discipline of art history as a problematic prolongation of the *polemos* internal to its object – problematic just because that *polemos* is already a registration of the purloining of the object from itself – forces a reconstrual of the writer's relation to the object and does not permit any imagination of that relation as external or optional. Art history and the history of art write from within one another, binding art history to the actual and ongoing production of art (and vice versa). The choice between deconstructive approaches and deconstructive objects dissolves, and does so as a consequence of the deconstructive claim to objectivity.

Deconstruction is objective: It is committed to things and does not take place apart from their taking place. If it evinces a certain systematic

New Perspectives." See also Georges Didi-Huberman, *Devant l'image: Question posée aux fins d'une histoire de l'art* (Paris: Minuit, 1990).

[27] For Krauss, see (among a great many other things) "The Im/pulse to See," in *Vision and Visuality,* ed. H. Foster (Port Townsend: Bay Press, 1988), pp. 51–75; "The Blink of An Eye," in *States of Theory: History, Art, and Critical Discourse,* ed. D. Carroll (New York: Columbia University Press, 1990), pp. 175–99; and "The Story of an Eye," *New Literary History* 21(1989):283–98. For Fried, see especially *Courbet's Realism.* For Damisch, see *L'Origine de la perspective* (Paris: Flammarion, 1987), and for de Duve, see *Pictorial Nominalism* (Minneapolis: University of Minnesota Press, 1991), *Au Nom de l'art: Pour une archéologie de la modernité* (Paris: Minuit, 1989), and *Essais datés I: 1974–1986* (Paris: Editions de la Différence, 1987). See also Yves-Alain Bois, *Painting as Model* (Cambridge, Mass.: MIT Press, 1990).

[28] Lyotard regularly registers this "uniqueness" within his orientation to the event as "singularity," and similarly insists on a distinction between this "singularity" and mere numerical identity. The intellectual groundwork for both Derrida and Lyotard on this topic is well displayed in M. Heidegger, *Identity and Difference,* trans. J. Stambaugh (New York: Harper & Row, 1969).

43

and argued hostility toward the terms of modern science, and if it argues in the face of hermeneutic constraint for the permanence and significance of effects unthinkable in any register of recovery or integration – if, that is, it refuses to let its notion of objectivity be constrained by the dominant paradigms of truth – it nonetheless does not and cannot happen apart from the claim to read something other than and prior to itself.[29] The best general model we have for such an objectivity is that of a "discipline," which is to say a set of principles and an object that claim to pick each other out. Deconstruction does not sit comfortably within such a model – indeed it everywhere pushes it to and beyond its limits – but this is the model it recognizes in Hegel's temporalization of philosophy and Heidegger's hermeneutic radicalization of it, and the practices, motives, and effects of deconstruction remain incomprehensible apart from its assumption of such a disciplinary construal of objectivity.[30] If it knows that no thing takes place apart from language, it knows also that talk of linguistic "construction" does not exhaust our engagement with things (which is why it first finds or founds itself as a critique of semiology conducted within semiology, as if on behalf of – in the name of – the thing cryptically enfolded within what imagines itself a science constructed in the absence of things).[31] As deconstruction extends itself out from the explicitly textual terrain of philosophy and literary criticism, it runs in a new way up against what shows itself at the limit of any directly linguistic grasp – color, for example – and so exposes itself in a new way to the materiality of things. It cannot be imagined to simply extend its aegis over unclaimed or contested territory. It offers not a theory so much as a peculiar discovery of the impossibility of the terrains we nonetheless inhabit. If a certain image of "regionality" recurs here, it is one that has passed through the Nietzschean and Saussurian transformations of the thing from substance to relation. The space of the thing is neither a neutral void we cohabit with it nor a construction we impose upon it, but the complex structure of our attachment to and detachment from it. Thus the urgent complexities of Bennington's comma: "Color is, in deconstruction."

FOR EXAMPLE

We know how to describe color in strictly physical terms. We know also something about how to analyze it semiotically, and indeed color can easily appear a prime candidate for semiological investiture, displaying the full force of "cultural construction." The physical phenomenon

[29] The priority and alterity claimed here are in some sense simple analytic truths about what it is to read. But because they are themselves always (re)discovered in reading, one should not make any easy assumptions about what these terms mean. The play of "logical" and "temporal" priority that informs the tradition in which Derrida writes is extremely complex and does not permit any easy reliance on chronology and the like.

[30] Here, as also in Lacoue-Labarthe's treatment of mimesis, deconstruction betrays a markedly Aristotelian orientation.

[31] Put somewhat differently, deconstruction refuses to take nature and culture as opposed terms. This clearly informs Derrida's early interest in Rousseau; see *Of Grammatology*, trans. G. Spivak (Baltimore: Johns Hopkins University Press, 1976).

in its relation to our nomination of it seems to map directly onto Saussure's diagrammatic representation of the double continua of world and sound into which language cuts, freeing the prospect of articulation, and the arbitrariness of this cutting seems readily evident in the variety of color terms found in existing natural languages.[32] But color can also seem bottomlessly resistant to nomination, attaching itself absolutely to its own specificity and the surfaces on which it has or finds its visibility, even as it also appears subject to endless alteration arising through its juxtaposition with other colors. Subjective and objective, physically fixed and culturally constructed, absolutely proper and endlessly displaced, color can appear as an unthinkable scandal. The story of color and its theory within the history of art is a history of oscillations between its reduction to charm or ornament and its valorization as the radical truth of painting. From these oscillations other vibrations are repeatedly set in motion that touch and disturb matters as purely art-historical as the complex interlocking borders among and within the individual arts and as culturally far-reaching as codings of race and gender and images of activity and passivity. This movement of color in painting is a movement in or of deconstruction. And if deconstruction can in some sense feel at home in reading the texts of color as they pass from the Renaissance through de Piles and Goethe and Chevreul, it is in a much harder place when it comes to actually speaking the work and play of color – not because that work and play are ineffable but because its "speaking" just is the work of art and its history.

We also know color only as everywhere bounded, and we may think to register this boundedness as its necessary submission to the prior constraint of design. But color repeatedly breaks free of or refuses such constraint,[33] and where it does so it awakens questions of frame and support as urgent issues for painting just insofar as they show themselves to be not prior to but emergent within color itself. Color is then no longer simply contained within the painting but is also that which, within the painting, assigns it its frame, even as it conceals itself as the source of that assignment. Insofar as color is and is not the historical bearer of a certain truth of painting that is and is not the truth of the frame in which it is contained, color bids to pass beyond itself. Color, in deconstruction, may appear as color-without-color, a hitch or problem in what one might call the look of things. Duchamp, in de Duve's powerful account, would be a central pivot here, but the problematic perhaps becomes fully explicit only with the postmodern move that seeks to pass definitively beyond painting in the name of drawing – only to turn itself over to Lacan's belated inheritance of Goethe and Hegel on light and the ontogeny of color. This could count as a history: We

[32]On these topics, see, in addition to F. de Saussure, *Course in General Linguistics,* trans. W. Boggs (New York: McGraw-Hill, 1969), Umberto Eco's "How Culture Conditions the Colours We See," in *On Signs,* ed. M. Blonsky (London: Basil Blackwell, 1985), pp. 157–75, and C. L. Hardin, *Color for Philosophers: Unweaving the Rainbow* (Indianapolis: Hackett, 1988), esp. pp. 155–82 (which argue against the linguistic construction of color).

[33]Julia Kristeva's "Giotto's Joy," in *Calligram: Essays in New Art History from France,* ed. N. Bryson (Cambridge University Press, 1988), pp. 27–52, is a well-known version of this argument. More interesting, for my purposes, is the case Greenberg and Fried have argued for the postpainterly abstraction of Morris Louis, Kenneth Noland, and others.

would, passing from Morris Louis through a certain engagement with sculpture to the postmodern centrality of photography, still be in the midst of a negotiation with color that we can only barely recognize as such.[34]

Insofar as we recognize color as an object-in-deconstruction, we recognize its discipline (perhaps "art history," perhaps but one history among those we are obliged to count as the histories of art) as the on-going demonstration of its radical lability and dispersion in, or as the prolongation of, its very objectivity, which is to say its necessary division from and transgressive framing of itself. Art history, we would say, constitutes itself by constituting an object (we are calling it "color" here) that lends itself to the discipline only as it is already in excess of any constructed or constructable punctuality and simplicity. The point is general: That by grace of which a discipline can imagine itself to be closed upon its object is, prior to that imagination, an openness "in" itself, a slippage, a parergonal unity in which rift and frame, differing, coincide.

The necessarily abyssal ground of deconstruction lies in that moment at which the intradisciplinary framing of the object is recognized as not so much an imposition *on* the object itself as a not wholly proper effect *of* the object itself. And at that point the discipline is obliged to pass beyond itself – to become interdiscipline. In so doing, it does not leave its own ground, neither passing over into some fuller science nor dissolving into sheer, unframed empiricity. One might say it ceases to own "its" ground. One might also say – a certain view of deconstruction would lead one to say – it becomes writing; and surely this is right, except that there is no general writing just as there is no inhabitable general economy: There is only the demand for restriction (the fact of economy) and the necessity of its overrunning. We do not know what art history calls writing. We do not know in advance and from the outside how to recognize what will count that way within the histories of art. Deconstruction cannot tell us this; it offers art history, as it offers philosophy and as it offers criticism, nothing other than its self. But the self thus offered is one that art history may not recognize, one that it will in any case not have in the mode of return or reappropriation.

What the postmodern polemics of the late 1970s and early 1980s valorized as "appropriation" is what Lacoue-Labarthe (and others) equally valorize as "depropriation," reserving "appropriation" for Platonic logics of participation. The problem of deconstruction and the visual arts is the problem of the absolute justice of this apparent misfire. At issue, finally, is not vocabulary, but grammar, and what transpires between the texts of deconstruction as they currently stand and the visual arts, their criticism and history, is neither appropriation nor depropriation

[34]These remarks sketch an understanding of the current conjuncture in which a certain interest in deconstruction might arise. This understanding relies heavily on the work of Michael Fried and Rosalind Krauss, as well as on an interpretation of their differences along the lines advanced in my "Notes on the Reemergence of Allegory, the Forgetting of Modernism, the Necessity of Rhetoric, and the Conditions of Publicity in Art and Criticism," *October,* no. 19(Winter 1981):55–92, although that essay is blind to the questions of color raised here.

of the one activity or object to the other, but a warping in the grammar of propriety itself. One might then say that the demand is for the visual arts and their discipline to appropriate themselves otherwise. But the deeper demand is for them to acknowledge that they have always done so.

BY WAY OF A CONCLUSION

The bundle of practices that have emerged over the past two decades under the general term "theory" are finally quite diverse, and many of them clearly carry interesting implications for art-historical study that will, no doubt, be worked out over time. Some of these implications are quite direct (feminists are, to take a central example, noticing in detail certain things, both formal and thematic, about pictures that have not been noticed before), and others appear to belong to a level of "metareflection" (history of art history and so on). I suppose that what I have tried to work through in these pages – what interests me about deconstruction in art history or art history in deconstruction – is that it refuses (one might also say "they" refuse) to separate observations about the discipline from observations about objects within the discipline, and that it does so, on my understanding, not by claiming to dissolve art history into some broader field – cultural studies and semiotics are certainly leading candidates – but by entering more deeply into how it is that there is a field: what it is that our knowledge can never take the final shape of some clear view across the whole terrain but must be built always out of a thick interplay of language, object, and discipline in which no one of the terms stands wholly inside or outside any of the others. These things then turn within and through each other, creating complex pockets and interlacings, skeins and foams and knots. (There are times when it is important to me to call this perfectly ordinary.)

If deconstruction promises something to art history, that promise remains bound to the conditions that bind all our promises: A promise is not made when I say "I promise" but when the other to whom I make that promise secures it from me. I have tried to sketch a strange movement of promising between what has been called deconstruction and art history. It is not, on the face of it, the kind of movement that will end in something one could comfortably call "the new art history," but at the same time it is clearly not "the old art history," whatever we might imagine that to be. It is tempting to say that the same logic of fidelity and betrayal that governs the relations between an "old" art history and a "new" art history also governs the relations between deconstruction and art history in general – that is, a complex double movement of loss and rediscovery that Derrida sometimes describes as a movement of "contraband" and at other times discusses in terms of the necessity for both "signature" and "countersignature," neither one capable of closing accounts on its own and for itself, with the result that the account remains permanently open and divided.

I have tried in these remarks to hold myself to clarifying the sense and motives of deconstruction over and against certain other practices

with which it is often linked. That is, I suppose, my moment of fidelity to deconstruction, but what follows from that clarification is always a demand for something like loss or infidelity: Deconstruction in art history cannot be known in advance; art history in deconstruction remains art history. What difference does deconstruction make, then?

One way to answer this would be to go on at some length about what deconstruction means by "difference," and so on. It's a serious answer, but perhaps a blunter approach can serve as well: Presumably, on my account at least, it does not make the kind of difference that leads one to say, "Once I was an art historian, but now I know better" (just as it has not led Derrida to say, "Once I was a philosopher, but now I know better"). Perhaps it is closer to the kind of difference one reports as something like self-discovery ("Now I know what it is that I am – have been – an art historian"). But of course it's hard in the event to tell the difference between these two – so maybe it's best to say that deconstruction is interested in the relations among such versions, conversions, and diversions of our selves and our objects.

That at least seems to move toward something I have been trying to do throughout, which is to indicate something of the way in which discipline and object, say art history and postmodernity, must sign and countersign for one another. There is no color outside of such double writing, and in that writing its name divides. Color has not yet been named.[35] But then nothing has. This is what it is that things happen, in art history and elsewhere.

[35] And here I am quoting Derrida. How far in this essay have I also been reading him? And how faithfully?

"Color has not yet been named. At the moment of writing, I have not seen the color of *Chimera*. Why show drawings? What is Adami's drawing [design]? An explanation is necessary.

"Before the finished quality of a production the power and insolence of whose chromatic unfurling is well known, is it that one might want to open his studio on *work in progress,* unveil the linear substratum, the intrigue under way, travail in train, the naked *trait,* the traject or stages of a 'journey'? That would be a little simple." *The Truth in Painting,* p. 169.

LIGHT IN PAINTING: DIS-SEMINATING ART HISTORY

MIEKE BAL

LIGHT

Light is a typical parergon[1]: Both outside, illuminating the object represented, and inside, constituting the very visibility of that object, it is marginal and yet centrally important, the final touch that makes the painting glow and an indispensable beginning, necessary and irrelevant. "To see the light" is a strange expression: One does not see the light, but the light makes one see. Let me see.

Vermeer's *Woman Holding a Balance,* in the National Gallery in Washington, represents a woman in a blue dress, holding a balance, with a painting of the *Last Judgment* on the wall in the background. Light streams in from a stained-glass window at the upper left. It is a strikingly still painting. It avoids narrative – both the anecdotal and the dynamic. Instead, it presents an image in terms of visual rhythm, equilibrium, balanced contrasts, and subtle lighting (Fig. 1). As Arthur Wheelock, Jr., remarks, the painting stands in marked contrast to other works on related themes.[2] In those other works, the woman tends, for example, to look greedily at the precious objects on the table, whereas here she is self-absorbed. In those others, the pans of the balance, here empty, tend to be heaped with gold or pearls, so that action is implied.[3] Those other

[1] Jacques Derrida, *The Truth in Painting,* trans. Geoff Bennington and Ian McLeod (Chicago: University of Chicago Press, 1987). In this essay I will concentrate mainly on the concept of dissemination and the theory of signs with which it is engaged. But it needs to be clear that most other Derridean concepts are embedded within the same opposition against classical semiotics; in the end, concepts like *supplément, différance,* parergon, and, indeed, deconstruction itself tend to converge in the one major project of undermining from within the status of meaning in traditional Saussurian semiotics.
[2] Arthur J. Wheelock, Jr., *Jan Vermeer* (New York: Harry N. Abrams, Inc., 1981), pp. 106–7.
[3] X-raying and examining these painted pans microscopically seem compulsory actions for art historians; all recent publications I have read mention this. This particular X-raying comes to stand as a sign for the meaning "serious research," "empirical methodology," or "original." I wonder, however, what conclusion might have been drawn from a different result of that inquiry, what exactly the status of any hidden content of the pans would be: Invisible riches, erased by artist or followers or accumulated varnish, hardly stand up against the careful balancing of the surface of this painting, articulated by the light. For an overview of current interpretations, as well as a new one, see Nanette Salomon, "Vermeer and the Balance of Destiny," in *Essays in Northern European Art Presented to Egbert Haverkamp-Begemann* (Doornspijk: Davaco, 1983), pp. 216–24. Salomon is quick to draw the conclusion from the emptiness of the scales: There is as yet nothing to weigh; the state of expectation is one of perfect balance.

MIEKE BAL works are more narrative, have more movement. In this work, the parallel between the *Last Judgment* hung on the wall behind her and the woman's act of weighing/judging is elaborated on the basis of similarity, not of narrativized contrast.

Light here is fluid, dense (in Goodman's terms), soft. It is also pointing, marking, signifying: Like an arrow, a Peircean index, it directs our gaze. How can this light illuminate the major issues of art history?[4] I will argue that the light does precisely that by disseminating this painting, thus undermining art history's search for origins: original meanings, original audiences, original intentions. Derrida's concept of dissemination is a powerful tool for breaking open the monolithic discourse of origins that appears to be the stronghold of the discipline, whether in iconography (origin of motifs), connoisseurship (origin of the work as art), or patronage studies (origin of the conception of the work).

Light takes over, but it can do so only through the language of philosophy, such as this Derridean concept, used to make the light do its work. But why would the visual field obey the rules imposed by language? I would at least like to give Vermeer's light a chance to talk back, to challenge in its turn the concept just proposed to ground its own importance. The concept of dissemination implies such a challenge to itself by virtue of its supplement, the hymen.

Rather than comment on Derrida's own work on visual art, in this essay I would like to "do" Derrida: work with this one concept that I consider central to his critical practice and theory, and develop its radical implications. Dissemination is based on three tenets of the interplay of contemporary semiotics and deconstruction that challenge art history's pursuit of origins: intertextuality, polysemy, and the wavering location of meaning. Commonplace in literary criticism, they have a slightly different status in the practices of art history.

INTERTEXTUALITY

Intertextuality is the ready-made quality of signs that the maker of images finds available in the earlier images and texts that a culture has produced. Three features distinguish intertextuality from iconographic precedent. In the first place, iconographic analysis takes the historical precedent as a source that virtually dictates to the later artist what forms can be used. By adopting forms from the work of a predecessor, the later artist declares allegiance and debt to, and eventually competition with, a prestigious historical predecessor whose trace is inscribed in the later work.[5]

[4]The tone for a sense of crisis in art history is set by books like Hans Belting's *The End of the History of Art?*, trans. Christopher S. Wood (Chicago: University of Chicago Press, 1988), and Donald Preziosi's *Rethinking Art History: Meditations on a Coy Science* (New Haven: Yale University Press, 1989). I have discussed the state of art history within the humanities in "On Looking and Reading: Word and Image, Visual Poetics, and Comparative Arts," *Semiotica* 76, no. 3/4(1989):283–320, and in *Reading "Rembrandt": Beyond the Word–Image Opposition* (Cambridge University Press, 1991).
[5]This is how H. Perry Chapman explains Rembrandt's use of forms taken from Raphael and Titian in his self-portraits of the middle period. See *Rembrandt's Self-Portraits: A Study in Seventeenth-Century Identity* (Princeton: Princeton University Press, 1990). Other, more pervasive "sources" for these self-portraits are, according to this argument, cases of inter-

Michael Baxandall has already pointed out that the passivity–activity relation implied in this perspective should be reversed. The work of the later artist should be seen as an active intervention into the material handed down to her or him. This reversal already challenges the idea of precedent as origin and thereby makes the claim of historical reconstruc-

discursivity, like the discourse on melancholia of the sixteenth and seventeenth centuries in medicine, philosophy, and art, with Dürer's famous woodcut as the prime example. No direct quotation, but a use of standarized discourse, is at stake here.

1 Jan Vermeer, *Woman Holding a Balance*. National Gallery of Art, Washington, D.C., Widener Collection.

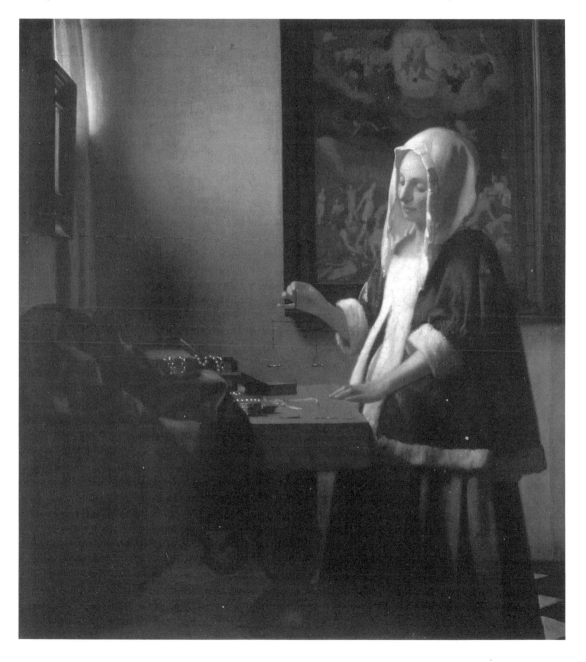

tion problematic.[6] This line of argument affects the discipline of art history profoundly.

Second, iconographic analysis generally avoids making statements about the meaning of the borrowed motifs. Visual artists may borrow motifs without borrowing meaning. The concept of intertextuality, in contrast, indifferent as it is to authorial intention, implies precisely that the sign taken over necessarily comes with meaning. This meaning may be changed, and the new meaning that replaces it will carry the trace of its other. The later artist may reject or reverse, ironize or deconstruct, pluralize or marginalize the meaning of the borrowed motif, but it cannot be undone, ignored, and canceled out. Thus, referring to Dürer's *Melencholia I* in the pose of the aggressive elder in his *Susanna* in Berlin, Rembrandt cannot help bringing in the *possibility* of the quite unsettling meaning of that precedent – say, that melancholy is paralyzing – suggesting that illegitimate and abusive looking paralyzes the transgressor himself.[7]

A third difference resides in the *textual* character of intertextual allusion.[8] By reusing forms taken out of earlier works, an artist also takes along the text out of which the borrowed element is broken away, while also constructing a new text with the debris. Reusing a pose used earlier in a self-portrait, Rembrandt inserts the discourse of self-portraiture into his *Bellona* of 1633 (New York, Metropolitan Museum).[9] Thus the image of a female figure that another iconographic tradition signifies as formidable is traversed by an identificatory meaning that breaks up the monolithic tradition of misogyny. The new text, say a mythography, is contaminated by the discourse of the precedent, and thereby fractured, ready at any time to fall apart again. The fragility of the objectifying, distancing device of mythography is displayed by this taint of "first-person" subjectivity. In Benveniste's terms, the historical narrative is infected by subjective discourse.[10] Such a view has obvious consequences for the interpretation of this painting in terms of gender.

Vermeer's *Woman* stands in a dense network of interconnected discursive practices. The parergonal light articulates it. The very presence of a represented painting of a *Last Judgment* borrowed from a representational paradigm different from the painting itself, which complicates its generic position as a household interior with an allegiance to realism from the start, can be taken as a guiding principle suggesting intertextual relations.[11] Svetlana Alpers, I assume, would call this a descriptive paint-

[6]Michael Baxandall, *Patterns of Intention: On the Historical Explanation of Pictures* (New Haven: Yale University Press, 1985), pp. 58–62.

[7]This argument is more extensively developed, and the example analyzed, by Mieke Bal and Norman Bryson, "Semiotics and Art History," *The Art Bulletin* 73(1991):174–208, and by Bal in *Reading "Rembrandt"*.

[8]Textual, not verbal; images are also texts precisely in that they constitute a network of discursive practices, albeit visually shaped.

[9]Gary Schwartz, *Rembrandt: His Life, His Paintings* (Harmondsworth: Penguin, 1985), puts forward this and other similar references.

[10]Emile Benveniste, *Problèmes de linguistique générale*, Vol. I (Paris: Gallimard, 1966).

[11]This is not to say that Vermeer's painting is unique in this respect. In fact, among students of seventeenth-century Dutch art in general, the opposition between realists (Alpers, Hecht, *Fijnschilders*) and allegorists (e.g., de Jongh, *Lering*) is a typical case of binary thinking alien to the paintings. The principle of either–or itself denies the most central feature of the whole body of painting, which is precisely an integration of the exclusive pair. Taking

ing.[12] It stands within the discursive clashes between seventeenth-century epistemologies, and it seems to side with the descriptive positivists. Hence, it already makes an interdiscursive claim for a certain conception of realism. But no conception, in turn, stands isolated. Hence, in addition, it makes a case for Alpers's opposition to Italian infatuation with narrativity. Any attempt to read the painting as a narrative can only misread it. Binding up realism and description, the light, sparsely shearing the painted surface, inscribing details and darkness, articulates a proposition concerning the bond between these two modes of representation, which is, of course, by no means inherent but only semiotically signified, repeated, and in the end naturalized. It is a surface carefully balanced for visual experience, where the appeal to visuality is worked out in the tiniest details, thus marking realism.

The light works to mark the syntax of this proposition concerning visuality as bound up with realism, thus inscribing the materiality of the work through an "excess of syntax over semantics."[13] At the upper left part of the painting, in the white wall near the represented *Last Judgment,* is a nail, and near that nail, a hole in the wall. The minutely detailed work of painting is so highly emphasized in these tiny details that both inside the hole and next to the nail we can see shadows. The soft, warm light streaming in from the window at the upper left touches these two irregularities in the wall, as if to demonstrate that realistic description of the world seen knows no limits. Intertextually, the light fixed at this *point de capiton* thus brings in other cases of extreme realism, from the anecdote about Zeuxis's competition to the two-sided lemon peel in Dutch still-life paintings.[14]

But here we lose our grasp; intertextuality cannot be traced anymore for being so overwhelming, and dissemination begins, for the light that I hold responsible for my seeing the hole and the nail also generates other details in the overall darkness of the painting. To begin with, it makes the darkness itself visible. Most obviously, it foregrounds the woman's dress underneath her mantle. Between the two fur rims, a slice of orange tissue protrudes, showing the dress's color, which is otherwise in shadow.[15] Although the dress may be in keeping with the fashion of

either side in this conflict is also, I think, denying the painterly status of the works as visual texts. The paintings must either mean something else than what they "say" (allegorists), so that their visual presence is denied, or mean nothing at all, just "be descriptive" (realists), so that meaning is denied; hence the works' status as semiotic objects. For a discussion of this debate, see Norman Bryson, *Looking at the Overlooked: Four Essays on Still Life Painting* (Cambridge, Mass.: Harvard University Press, 1990), chap. 3.

[12]Svetlana Alpers, *The Art of Describing: Dutch Art in the Seventeenth Century* (Chicago: University of Chicago Press, 1983).

[13]This is how Barbara Johnson in her introduction to the English translation of the book describes Derrida's moves in "The Double Session," the essay from *Dissemination* that is most central for my argument. See Jacques Derrida, *Dissemination,* trans. Barbara Johnson (Chicago: University of Chicago Press, 1981), p. xxix.

[14]Much ink has been spilled over the Zeuxis anecdote, most recently and relevantly by Stephen Bann in *The True Vine: On Visual Representation and the Western Tradition* (Cambridge University Press, 1989). Also on this anecdote, and on realism in Dutch still-life painting, see Bryson, *Looking at the Overlooked.*

[15]The syntactical insistence on the woman's womb has been remarked upon by Salomon ("Vermeer and the Balance," p. 217): "It [the light] particularly strikes her stomach, which, like an annunciate Mary's, glows almost as if from an internal light source." How so, "almost," "as if"? This is precisely how the syntactical light is parergonal: Its stroke on the womb where it becomes internal is a *mise en abyme* of this parergonal status.

the day, as Salomon affirms, "the woman's pregnancy is an undeniable fact of the painting and one which cannot be dismissed as a misunderstanding of costume or fashion."[16] Hence, for some viewers today, a few questions keep nagging: Why this soft light? Why this striking color and shape? Why does the light fall *there?*

POLYSEMY

This leads to the second issue, that of polysemy. It has been convincingly argued that because viewers bring to the images their own cultural baggage, there can be no such thing as a fixed, predetermined, or unified meaning. Attempts to fix meaning provide, if anything, the most convincing evidence for this view. Most characteristic are such attempts that take an obvious meaning that is unpleasant and then firmly insert notions like irony or contrast. For this painting, for example, the obvious similarity in position between the woman and the divine judge, almost continuous to each other, is frequently inverted into a contrast, condemning the woman, who frivolously weighs pearls while God weighs souls. Or, even more convoluted an argument, the woman's position in relation to God being similar to Saint Michael's, the latter's role as weigher of souls is replaced by her own less lofty weighing.[17] In such cases, the denial of polysemy goes together with the practicing of it.

The field in which struggles over meaning are being fought is a social arena where power structures are at work. A good example of this mechanism is allegory, the interpretation of, say, a mythical story and its representation as referring to something other than itself.[18] On the one hand, allegory demonstrates the fundamental polysemous nature of signs. If images and stories can mean something entirely outside of themselves, then, one would think, there is no limit, no constraint. This freedom is viewed positively by Paul de Man, for example.[19]

But the same stories and myths tend to come up regularly as "allegorical": Stories of rape, for example, are more often than not alleged to "really" be about tyranny and the establishment of democracy. Intertextual analysis will bluntly refuse such abdication of the meaning imported by the borrowed sign: If rape means political tyranny, then the bodily, subjective experience of the woman raped cannot be divorced

[16]Salomon, "Vermeer and the Balance," p. 217.

[17]The former inversion is performed by Herbert Rudolph, " 'Vanitas': Die Bedeutung mittelalterlicher und humanistischer Bildinhalte in der niederländischen Malerei des 17. Jahrhunderts," *Festschrift Wilhelm Pinder zum 60. Geburtstag* (Leipzig, 1938), p. 409; the latter is by Lawrence Gowing, *Vermeer* (London: Faber & Faber, 1952), p. 135, Wheelock, *Jan Vermeer,* p. 106, and others.

[18]For different views of allegory, see Paul de Man, *Allegories of Reading: Figural Language in Rousseau, Nietzsche, Rilke, and Proust* (New Haven: Yale University Press, 1979); Joel Fineman, "The Structure of Allegorical Desire," *October* 12(1980):47–66; Craig Owens, "The Allegorical Impulse: Toward a Theory of Postmodernism," in *Art After Modernism: Rethinking Representation,* ed. Brian Wallis (New York and Boston: Museum of Contemporary Art and David R. Godine, Publisher, Inc., 1984), pp. 203–35; and, of course, Angus Fletcher's *Allegory: The Theory of a Symbolic Mode* (Ithaca, N.Y.: Cornell University Press, 1964). For a more elaborate critique of allegory, see my *Reading "Rembrandt",* chap. 2.

[19]De Man develops his argument around the root *allos,* other, and thus allegory becomes itself an allegory for the acceptance of otherness within.

from the politics at stake. The *allos* of allegory is, after all, not only "other" but also "within." In this Vermeer painting, the allegorical reference to *vanitas* represents a denial of the woman's central place in the picture, and of her possibly positive role. The basis of such interpretations, the act of weighing, is significantly empty: The scales are empty; there is, precisely, no act of weighing, no narrative, but only balance.

This problem with allegory is in its turn allegorical for a larger problem implied by polysemy. And Derrida's concept of dissemination being the most radical endorsement of the view that no interpretation can be privileged over any other, it is that concept I will take to task. This concept is very attractive, especially as a corrective to the remnants of positivism still pervasive in art history. The question to which I will return, however, is whether the free play of meanings, semiotically inevitable, is really so free.[20]

But let me play the game first, and return to Vermeer's light. Because the part of the woman's dress that is illuminated is the part that covers her womb, it may come through metonymy to represent the slit that opens the womb – her navel. And if we focus particularly on this element, we may come to associate the woman in this painting with the pregnant Madonna as represented in the Italian Renaissance – a case of interdiscursivity.[21] The woman's headdress and the blue color of her mantle then may be taken to underline the visual similarity in the distribution of surface space between her and God in the represented *Last Judgment* – a text whose embedded position underlines the intertextual status of the embedding work. An ordinary Dutch woman for some, an allegorical figure representing *Vanitas* for others, she may become Mary for those who pursue the interpretive game further. The point is not to convince readers of its appropriateness or its truth, but to offer the speculative possibility in order to demonstrate the polysemy in principle. But the affirmative tone of proponents and opponents of the pregnancy theory demonstrates the Lacanian truth of the invisibility of the obvious: Poe's positivist prefect was no more able to *see* the hidden/exposed letter than are the participants in this debate to see their opponents' views.[22] This lesson against positivistic notions of visuality is of great importance for a disseminating perspective on painting that will let syntax overtake semantics: Where the pregnancy could pass unnoticed, the light – and the color it generates – makes such a denial futile.

[20]Derrida himself argues convincingly against the misunderstanding, often held by opponents of deconstruction, that theoretical polysemy implies unaccountability. His most perceptive text on this is the afterword to the paperback edition of his *Limited Inc.,* trans. S. Weber (Evanston, Ill.: Northwestern University Press, 1988). My endeavor here, therefore, is not to nail Derrida nor his concept, but, on the contrary, to reinsert his politics within theoretical discourse.

[21]See Mary Jacobus's fascinating discussion of Raphael's *Sistine Madonna,* with reference to the Arezzo *Pregnant Madonna* by Piero della Francesca. Jacobus discusses the Raphael as it is read by Freud's patient "Dora." See "*Dora* and the Pregnant Madonna," in Mary Jacobus, *Reading Woman: Essays in Feminist Criticism* (New York: Columbia University Press, 1986), pp. 137–96.

[22]The pieces of the debate around this central Lacanian–Derridean text have been collected by John P. Muller and William J. Richardson in *The Purloined Poe: Lacan, Derrida, and Psychoanalytic Reading* (Baltimore: Johns Hopkins University Press, 1988).

These examples confirm the (non)logic of polysemy, but they also demonstrate that the affirmation of single meaning is profoundly motivated by socially relevant power positions. In agreement with Wittgenstein's concept of the language game, signs can be seen as *active,* and required both to be deployed *according to rules* and to be *public.*[23] A sign, then, is not a thing, but an event that takes place in a historically and socially specific situation. Sign events take place in specific circumstances and according to a finite number of culturally valid, conventional, yet not unalterable rules. The assumption of polysemy and the radical version of it in dissemination do not ignore power relations but, on the contrary, emphasize them: Because the signs have no definitive limitation on their meanings, the responsibility for what meanings win the game is entirely social. Interpretive behavior is socially framed, and any interpretive practice will have to deal with that framing, *on the basis of* the fundamental polysemy of signs and the subsequent *possibility* of dissemination. In accordance with the concept of the parergon, the frames, including the social and institutional forces, are *semiotically* part of the work. Thus, they check the theoretically unlimited dissemination.[24] And as we know from Derrida's *Truth in Painting,* the frame is, like the parergon, also inside. Therefore, dissemination is ultimately limited from within. This is so because, deferred as it is, the production of meaning takes place not as an ulterior supplement but as already inscribed, not in some complete work but in its semiotic status.

MEANING

For me it was the nail and the hole that the light made visible, that it *produced;* that instigated a burst of speculative fertility. When I saw this nail, the hole, and the shadows, I was fascinated. I could not keep my eyes off them. Why are they there? I asked myself. Are these merely meaningless details that Roland Barthes would chalk up to an "effect of the real"? Are these the signs that make a connotation of realism shift to the place of denotation because there is no denotative meaning available? Or do they point to a change in the significance of the *Last Judgment?* Do they suggest that the represented painting – which, according to Wheelock, is there to balance the work, to foreground the similarity, the rhyme, between God and this woman – has been displaced from an

[23]In the *Tractatus Logico-Philosophicus,* trans. B. F. McGuinness (New York: Humanities Press, 1961), first published in 1921, Wittgenstein gives a visual dimension to verbal propositions and regrets language's cloudiness, thus suggesting that density is by definition visual, which it is not. In the later *Philosophical Investigations,* trans. G. E. M. Anscombe (New York: Macmillan, 1958), first published in 1953, he rejects his nostalgia for purity in the early work and argues that language is no less dense than pictures are. Here, he endorses language's ambiguity as one of its most basic features. See Allen Thiher's *Words in Reflection: Modern Language Theory and Postmodern Fiction* (Chicago: University of Chicago Press, 1984) for an account of Wittgenstein's views on language and for the transition and break between modernism and postmodernism in literature. The assumed visuality of language plays a key role in that change.

[24]For a wonderfully clear argument in favor of this view, see Jonathan Culler, "Author's Preface," in *Framing the Sign: Criticism and Its Institutions* (Norman: University of Oklahoma Press, 1989), pp. xii–xvi.

earlier, "original" position to a better, visually more convincing balance, leaving only the telltale trace of a nail hole? As it is, the woman stands right below God, a position that emphasizes the similarity between judging and weighing. Also, the separation between the blessed and the doomed is obliterated by her position, suggesting, perhaps, that the line between good and evil is a fine one. But in the midst of this speculative flourish, I am caught up short by the remembrance that we are looking at a painting of this balance, not at a real room. The painter surely did not need to *paint* the nail and the hole, even if, in setting up his studio, he actually may have displaced the *Last Judgment*.

If the room were a real room, the hole and the nail would be traces of the effort to hang the painting in the right place – inscriptions of balancing and the value attached to it, indices of writing, *grammata*. As such, they demonstrate the materiality of the difficulty and delicacy of balancing. Hanging a painting in exactly the right place is a delicate business, and the result is of the utmost visual importance. For the representation of this statement on visual balance, the nail alone would not have done the trick; the failure of the first attempt to balance the represented painting correctly had to be shown through an attempt still prior to it. The hole is the record of that prior attempt. The suggestion that the *Last Judgment* was "initially" if not "originally" unbalanced, with balancing as its very subject matter, threatens to unbalance the painting as a whole. While the metaphoric connection between the idea of judgment and this woman's activity is tightened by the final result, the difficulty of balancing and of judging is thus foregrounded. And that difficulty, in turn, is related to the similarity between the woman whose womb is illuminated by the light and the difficulty of balancing itself, which is, too.

I have been led to use the first-person pronoun more often in this section than in the preceding ones, and that is because I was speaking about meaning. At the moment I got really excited about the painting, "I" became a factor in its game. What does this imply about the location of meaning? As is well known, attempts to locate meaning either in the text or in the viewer end up flipping over to their opposites, as Culler has so eloquently demonstrated.[25] In reader-response criticism, for example, although meaning is located in the critic, the critic "at work" protects herself or himself by claiming that the meanings put forward are more "plausible" than others, because the text "lends itself" to these particular meanings. The opposite is true as well: Textual critics, when defending their views, ultimately need to claim that their meanings are the most "adequate" because the text "suggests" them to the reader, who then is the one to actualize them.

This is convincing, and yet it fails to account for the responsibility for "meaning production." According to Van Alphen, the theoretical problem here is the untenable monolithic character of such concepts of meaning, which leaves accountability evasive. Denying the innocence of both text and reader, he begins by stating, in the wake of speech-act

[25]Jonathan Culler, "Stories of Reading," in *On Deconstruction: Theory and Criticism After Structuralism* (Ithaca: Cornell University Press, 1982), pp. 64–83.

theory and perverting it, that both *perform* something. The danger of speech-act theory is that it returns to intentional criticism and to confining categories.[26] Van Alphen extends performativity to the act of reading, without, however, positing a false symmetry between text and reader. It is in the collaboration, the conflicting struggle for coherence between text and readerly response, that social reality, both framing and acted upon, is affected. *Effect* becomes the key notion, but no coincidence, no symmetry, no equality between text and reader can be reached.

Therefore, Van Alphen proposes to distinguish two "moments of meaning production." The text as produced by its author responds to and brings order into the collection of possible meanings couched in the pre-text: the set of previous discourses that impel the new text while also being an excuse to do something different with them. This sheds new light on Vermeer's struggle with order. The difficulty of balancing, so far referred to the act of the judging God, now becomes also a metaphor for the creative performance of the painter. Between the woman and the deity, balanced on the vertical axis of the painting, a third person comes in to share the polished surface of this painting on the horizontal axis. The pre-text is the historical, biographical, and ideological reality from which the text emerges. The reader can try to adopt the attitude of modest "listening" or "just looking at what is there," but the text itself is the result of an act of listening or looking. Performativity, then, is cut off from any "original intention" and becomes a response.

The second moment of meaning production occurs when the reader articulates an ordering and reworking of the collection of possible meanings offered by the text and additional possibilities brought in by himself or herself. In this moment of meaning production, the text is the occasion for, not the cause of, meaning: a lateral signifier, rather than signified. The central notion becomes, now, *reflection*. The author reflects upon the pre-text, and the reader reflects upon the text, which is her or his pre-text. Both subjects are directed by the conventions of reading of their time and social group. In order to grasp the process of meaning production, it is crucial to analyze the conventions underlying the acts of reflection inherent in reading. And these conventions are by no means limited to the documents left by contemporary educated art critics.

So the event of meaning production between Vermeer and me, partly a clash, partly a dialogue, illuminates how nondocumented reading can participate and be taken seriously – must be, in fact, by a genuinely historical art history. To simplify yet again: Vermeer's painting brings in the light; I bring in Derrida's parergon and thus set the light in motion, allow it to take over. In the painting, narrativity, so blatantly absent on first (and second) glance, is found to have been inserted by means of a

[26]The argument is developed by Ernst Van Alphen in a book in Dutch, *Bij wijze van lezen: Verleiding en verzet van Willem Brakman's lezer* (Muiderberg: Coutinho, 1988). A shorter version exists in English as "The Complicity of the Reader," *VS/Versus* 52–3(1989):121–32. I have discussed this problem in more detail in the introduction to *Anti-Covenant: Counter-reading Women's Lives in the Hebrew Bible,* ed. M. Bal (Sheffield: Sheffield Academic Press, 1989), pp. 11–24. Derrida's well-known critique of speech-act theory is most concisely articulated in *Limited Inc.*

sign that makes a statement on visuality. The visual experience that encodes the iconic association between woman and God is not displaced but, on the contrary, underlined by this narrative aspect. We imagine someone trying to hang the painting in exactly the right place. We are suddenly aware of the woman's artificial pose: Instead of changing the painting, the artist arranging his studio could simply have changed the woman's place, or his own angle of vision. All of a sudden something is happening, the still scene begins to move, and the spell of stillness is broken.

The nail and the hole, both visual elements to which no iconographic meaning is attached, unsettle the poetic description and the passively admiring gaze that it triggered and thus dynamize the activity of the viewer. Whereas before the discovery of these details the viewer could gaze at the work in wonder, now one is aware of one's imaginative addition in the very act of looking. The work no longer stands alone; now the viewer must acknowledge that he or she makes it work and that the surface is no longer still, but tells the story of its making. Attracting attention to the work of representation, as well as to the work of reading or viewing, the nail and the hole are traces of the *work* of art, in all senses of that expression and in all its specificity.

This, then, raises questions about the place of narrative in visual art. Narrativity is generally considered an aspect of verbal art that can be mobilized in visual art only under great representational pressure.[27] Something comparable is alleged for visual imagery, which literature strives for but can never completely realize. I propose to shift the terms of these questions and reconsider the typically medium-bound terms of interpretive scholarship – like spectatorship, storytelling, rhetoric, reading, discursivity, visuality – as aspects rather than essences, and to consider each art's specific strategies to deal with these aspects as modes rather than systems. The foregoing interaction wherein meaning was produced turned the painting into a statement about meaning as work, and work as meaning. Dissemination has now affected even the neat distinction between visual and discursive, the very basis of the disciplinary boundary between art history and the other humanities. Or did the light do that?

WOMAN

God is high up, and the artist's masterstroke of light – hole and nail – at the same level, and the woman's womb is down there. But if Vermeer is closer to God, "she" is closer to "us." As I have argued, the object of a reader-oriented analysis of art is *our relation to the image*. The "our" in this statement needs further analysis. Although this phrase is meant to suggest how deeply entrenched we are in any act of interpretation of

[27]A recent version of this view is presented by A. Kibédi Varga, *Discours, récit, image* (Brussels: Pierre Amanda, 1989). See also Wendy Steiner, *Pictures of Romance: Form Against Context in Painting and Literature* (Chicago: University of Chicago Press, 1988). For a critique of these views, which go back to Lessing and romanticism, see W. J. T. Mitchell, *Iconology: Image, Text, Ideology* (Chicago: University of Chicago Press, 1985).

images stemming from other times and places, "we" is emphatically not a monolithic subject. Within a psychoanalytic framework, this collective subject can be further differentiated. With "us" I mean a subject traversed and fraught by the unconscious, including the superego and its social implications, narcissism and its defensiveness against affect, desire, and the fantasy character of response. The way we perceive and interpret images is based on fantasy, and fantasy is socially based. Thus there is dissymmetry between men and women before male and female figures. But this dissymmetry is also unstable, varying according to which aspects of the unconscious are more or less strongly implicated in the act of looking. For example, the responses to Rembrandt's *Danaë* are more likely to differ according to gender, whereas the responses of women and men to his *The Blinding of Samson* might differ less strongly or at least in a different way, because this painting appeals to a pre-Oedipal fantasy.[28] The differentiation, here, occurs not so much directly according to gender lines but primarily according to other divisions, like narcissistic fulfillment and the relative solidity of the ego.

Thinking about the uneasy fit between psychoanalysis (a basically verbal discourse) and visual art, and the equally uneasy fit between psychoanalysis (an overwhelmingly masculine discourse) and feminism, the strategies and concepts of deconstruction are indispensable. This is obvious when we look at a traditionally narrative as well as gendered painting like Rembrandt's *Danaë* (Fig. 2). This painting shows the defects of a traditional concept of narrative, with its fixed relation between sign and meaning, its hierarchical structure, its suppression of details, of the marginal, of the "noise." It is to such an oppressive notion of text that Derrida opposed the concept of dissemination, which enhances the slippery, destabilizing mobility of signs in interaction with sign users, viewers.

But dissemination, like every other concept of contemporary theory, is inevitably bound up with the Freudian legacy and its pervasive set of bodily metaphors. Derrida replaces the masculinist metaphor of the phallus as the ultimate meaning with that of the hymen, which, through speculations around all kinds of figures of penetration and articulation, also stands for the sheet – or canvas – on which meaning circulates without fixity. Fully dressed as she may be, Vermeer's woman, whose female body is syntactically foregrounded, is inevitably caught up in a viewing tradition that has the female nude as its privileged subject, voyeurism as its dominant semiotic mode, and the body as the sheet on which writing on art is done. As the debate around the woman's role, meaning, and womb demonstrates, this is emphatically the case; unfixed, the body fixes. These are speculations that remind one of another Derridean phrase: "spelunking in the antre."[29]

The female body, not only as having the (protective) hymen but also as being the disseminating hymen? There might be more coherence to

[28] I argue for such an interpretation in detail in *Reading "Rembrandt."*
[29] The phrase is used by Johnson in her introduction to *Dissemination* (p. xxvii) when speaking about Derrida's discussion of Plato's second mimetic paradigm, the cave. Needless to say how strongly gendered both of Plato's mimetic paradigms are: the always inferior bed and the obscure cave.

this Derridean network than appears – and than, perhaps, the author would like. But an alternative to the hymen as the central bodily metaphor presents itself, and that alternative is the navel – the very site hit by the light in the Vermeer.

In the *Danaë,* too, the light comes in. The divine lover who is supposedly welcome is visible only as a sheen. But the sheen, the border of light, so crucially "Rembrandtish," dissolves into futility, for in spite of deceptive appearances, Zeus's gold does not illuminate the woman. Rather, the sheen delimits the space in which the woman is enclosed; it demarcates her private space, emphasizing the form of the opening in which the woman's feet disappear – her opening. In this way her sexuality is also the locus of the metaphor that kept creeping into the vocabulary of my analysis: It is the navel of the text. But between sex and navel lies a difference: It is the difference between voyeurism and its deconstruction.

The metaphor of the navel could replace – supplement – that of the hymen for the deconstructed image; diluted into a multiple textuality, it is a false center attracting attention to its void of semes – to its dissemination. Following Derridean practice, the metaphor of the navel, as a Derridean *trace,* pushes Derrida's concept of dissemination to its limits, and beyond. Whereas he undermined the phallic view of the sign and of meaning inscribed in Saussure's semiotics, Derrida is also implicated in it, for his dissemination, meant to dissolve the penetrating power of the dualistic sign, sometimes comes to look like an overwhelming dis-

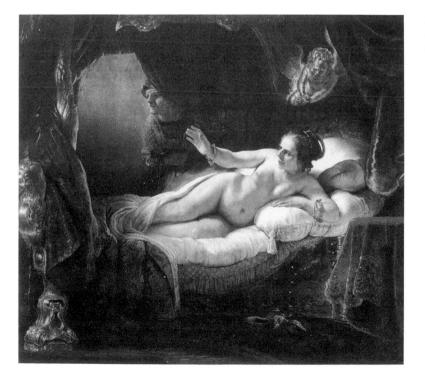

2 Rembrandt van Rijn, *Danaë.* Hermitage Art Museum, St. Petersburg.

person of semen; coming all over the text, it spreads out so pervasively, so biblically, that it becomes like the stars in heaven or the sand at the seashore: a promise to global fatherhood.

In a word of caution, Derrida writes something like this when he specifies the status of his own moves in the interpretation of Sollers's *Mimique:*

What counts here is not the lexical richness, the semantic infiniteness of a word or concept. . . . What counts here is the formal or syntactical *praxis* that composes and decomposes it. . . . If we replaced "hymen" by "marriage" or "crime," "identity" or "difference," etc., the effect would be the same. . . .[30]

Trying to evacuate semantics and allow syntax to take over through praxis, the examples of alternatives to "hymen" are semantically strongly overdetermined, and bound up with gender.

The concept of dissemination itself is bound up with the concept of the hymen, the veil that protects from penetration as an alternative for the phallic privileging of the invisible signified. And this genders it, ruthlessly, for by invoking Hymen it also embraces the moment when the virgin bride is torn open and pervaded by semen. Invoking Hymen invokes marriage. And marriage imperialistically prevails, threatening to become the metaphor for semiosis.

Deconstructing this metaphor with the help of visual images read as texts, the navel can supplement it: not to get rid of the hymen nor of gender, but by pushing the hymen aside and shifting gender to an altogether different moment. The navel: both *gramme* of the mother and token of autonomy of the subject, male and female alike; a center without meaning, it is yet a meaningful pointer that allows plurality and mobility, that allows the viewer to propose new readings to meet his or her needs, but without letting those readings fall into the arbitrariness that leads to isolation and irrelevance.

The navel leaves room for the specificity of the visual, which it also betokens; indeed, it builds the reading it suggests upon the image's visuality. In addition, the navel has the same quality that Poe's hidden/ exposed letter had: It is too obvious for words. On the other hand, this metaphor enhances the irreducible textuality: its play between story and static image, its visual mobility and the indispensable collaboration between the work and its socially and historically positioned viewers. The navel, then, is a metaphor for an element, often a tiny detail, that hits the viewer, is processed by her or him, and textualizes the image on its own terms. In the *Danaë*, it is not the woman's "real" navel, but her genital area; in the Vermeer, it is the nail and hole.

NAVEL

For a deconstruction of voyeurism as the dominant mode in the Western tradition of visual art, the navel is particularly productive. Innumerable images start to move away from unproblematically gendered visual pleasure toward a self-reflective folding back onto the navel when movement

[30]Derrida, *Dissemination,* p. 220.

itself is endorsed and decentering assumed. This play with metaphors should not be taken for a meaningless linguistic game. Using bodily metaphors is one way of acknowledging the impossibility of disentangling myself from the discourse to which I was, as it were, born. Here the navel is the symbolization of a body part just as the phallus is, and it, too, is loaded with the connotations of gender. Yet these are radically different in status. The phallus refers to gender in terms of "haves" and "have-nots," or "to have it" versus "to be it." So too, I am afraid, does the hymen. The navel, in contrast, though fundamentally gender-specific – the navel is the scar of dependence on the mother – is also democratic in that both men and women have it. And unlike the phallus and its iconic representations disseminated throughout post-Freudian culture, the navel is starkly indexical.

The metaphor of the navel as the detail that triggers textual diffusion, variation, and mobility of reading is therefore a tribute not only to an antiphallic semiotic but also to an antiphallic genderedness that does not assign to women a second-rate position. This position toward gender, then, is comparable to the attitude toward "high art" implied in Vermeer's balancing of high and low illumination and ordering. In both cases, the hierarchy is not denied, but it is shifted and thereby undermined. The woman, mediator between the ordering creators up there and the ordering viewers down here, becomes the center of meaning production. No wonder the light illuminates the place of her navel before anything else.

Using Derrida's critical mode to bump against his concept – which, I wish to emphasize, does not eliminate it but pushes it off center – I wish to propose readings in the mode of the navel: readings that acknowledge visuality and do not shy away from discursive elements, that recognize where cultural commonplaces are mobilized and yet leave room for the marginal other, that endorse the "density" of visual signs and let that density spill over into literature, while not fearing to point out specific, discrete signs in visual works and the loci of density in literature. Such readings can no more than traditional art-historical readings be full, comprehensive descriptions of what we see in the paintings, nor are they narratives reconstructing the pre-texts that give the works meaning. Instead, such interpretations start at the navel, the little detail that doesn't fit the "official" interpretation: the view of the work put forward by the terms of agreement among readers before me,[31] for invariably those official readings leave a rest, a lack. They have one thing that isn't there and should be, or that is there but shouldn't be, and thus they trigger the alternative reading. What the classical narrative readings cannot accommodate unproblematically sets in motion another narrative, via the suspenseful encounter between the narrative and the visual. In this way, the concept of the "navel of the text" is programmatic: It proclaims an interaction, not an opposition, between discourse and image.

Vermeer's light directs our gaze to the place of the navel. Protruding

[31]In the background of my interest in the navel, one should always see Naomi Schor's wonderful book *Reading in Detail: Aesthetics and the Feminine* (New York: Methuen, 1987).

as this invisible navel is, the thought of pregnancy is not interesting in itself, but for what it does to the visible but displaced navel: the hole illuminated by the light on the condition that we let it do its parergonal work. Procreation, "low" creation, is thus elevated to a place next to the judging God and the balancing artist. Woman's role in creation is what this painting illuminates: This role is not, as the cliché has it, a natural, material process that men subsequently need to take in hand, but a creation that orders, balances, and judges, on the same level. Unexpectedly, this reading is not incompatible with art-historical interpretations of the painting.[32] It is, however, incompatible with art-historical dogma, insofar as that dogma denies intertextuality, polysemy, and the dynamic location of meaning – and, of course, a certain importance of women. Only a dis-seminated art history can give the light and the woman their due.[33]

[32]With all the difficulties of translation, pointed out by Derrida himself as well as by his translator Johnson, my reading of the Vermeer painting could, as far as semantics is concerned, be translated into that proposed by Salomon. It would, however, lose its syntax.

[33]Fortunately, dis-seminating analyses of art history are beginning to appear. The most effective of these are analyses that question the discourse of art history in conjunction with an authoritative position for the image that is *not* based on positivistic truth-claims but on the idea that images are discursive, too. One of the best deconstructions of art history in terms of relations between discourse and image is Michael Ann Holly's "Past Looking," *Critical Inquiry* 16, no. 2(1989):371–96.

THE DISSIMULATION OF PAINTING

MARIE-CLAIRE ROPARS-WUILLEUMIER

> The play's the thing
> wherein I'll catch the conscience of the King. – *Hamlet*

How does one speak of painting without referring to it by means of a discourse of truth that remains foreign to it because it remains exterior to the idiom of art? But how can one let it be thought that the truth of painting belongs only to painting, whereas it never ceases giving a voice to the opinions of those who think they possess that truth? Either discourse masks painting or else the silence becomes the "voiceperson" (*porte-voix*) of the subject. This is the dilemma that the Kantian enterprise comes up against in attempting to found objectively an aesthetic derived from subjectivity. Derrida responds to it with the ruse of a discourse *en abyme* that dismantles the discourse of truth in painting by making painting the mirror where the abyss of truth is reflected. He doesn't speak *on* painting, because it is a matter of working through discourses that already exist, but neither does he give it a voice, except through the logic of a reverse mimesis, according to which painting would redirect – by rendering its traces visible – the image of truth it pretended to imitate.

"I owe you the truth in painting."[1] Of the four senses that, according to Derrida, Cézanne's enigmatic formula authorizes – unadorned truth or painted truth, truth by means of the painting or truth on the subject of painting – only the last in fact involves the order of the pictorial and its possible truth. But by a clever trick (*jeu de passe-passe*) that conforms to the principle of mobility that regulates how Derrida's passe-partout is mounted, this fourth sense finds itself caught in the grasp of a truth that would in fact concern only truth itself, and not painting. A single sentence takes us from "I owe you the truth in painting" to "I owe you the truth about the truth," through the paralogical device of a gloss ("as painting ought to be the truth") that reverses the duty of truth with respect to painting, turning it into the obligation of painting itself toward truth.[2] Certainly the "parasitism" is as quickly uncovered as it is effected;

This text was written before the opening of Derrida's Louvre exhibit (October 26, 1990). The question of relations between the pictorial work and the gaze, which is the basis of my analysis of *The Truth in Painting*, figures literally in the paintings of that exhibit. But the theme of blindness, which Derrida's reflection also exposes, concerns the painter's gaze and the blind spot of vision much more than it involves the unsettling of the work by means of the actual operation of the shot (*prise de vue*).

[1] Jacques Derrida, *The Truth in Painting,* trans. Geoff Bennington and Ian McLeod (Chicago: University of Chicago Press, 1987), p. 2.

[2] Ibid., p. 7.

in fact, it allows for a calling into question of whatever claims a system makes to being self-sufficient, whether one is speaking of art or philosophy. For this reason it is part of a procedure that seeks to deconstruct a theory of the frame that proves to be lacking in the framings by which aesthetics or philosophy delimits the field of its investigation. By means of the movement toward the edges, to where the outline (*tracé*) of closure is drawn, the system becomes permeable to its outside. But this outside of painting, where the impossibility of limiting things to painting opens up in response to truth's retreat, could not of course be defined as the symmetrical inverse of an interiority – of a space proper to painting – whose frame it would be content to turn around. A property of the outside is precisely that it breaks down the opposition between inside and outside, and the operation always tends toward an exteriority that comes to ruin the identity of the proper term, even that of an exterior space. The truth in painting thus leads painting into the orbit of a truth that is outside of painting, because it is incumbent upon truth to decenter what it describes. In order to unfold, the truth in painting supposes a dissimulation of painting; the demand for an unveiling (of truth) can be realized only by the logic of a diversion (of painting), by means of which, and in order to respond to the truth it brings to light, painting would be led to give up reflecting its own visibility.

Captured in the mirror of painting, the truth will see the abyss of its discourse open up; but painting, in subscribing to the obligation of truth, will have to give in to the rule of exteriority that makes the truth of painting pass through the breaking open of its propriety. The reflection of painting in truth is both reciprocal and asymmetrical, and if painting resists anyone who claims to speak the truth about it, it is nonetheless caught in the originary attraction of a truth that occludes it. The obliteration of the traits of painting – the face of which is erased from the picture – belongs in this sense to the truth of painting. The dilemma thus changes into a paradox, according to which painting, while serving to deconstruct the discourse of truth, would surrender to the truth, a truth that already receives a response from the discourse that is to be deconstructed rather than entered into. The thinking of the outside, from where the alterity of painting would be posited, thus closes onto the outside of philosophy, which is so fond of defining its own exteriority.

★ ★ ★

"The philosophical encloses art in its circle but its discourse on art is at once, by the same token, caught in a circle."[3] In assigning itself the objective of deconstructing the circle that encloses the discourse on art, can Derrida's discourse escape the gesture by which that same discourse pronounces the philosophical capture of art? How does one deconstruct without redrawing the outline of a construction, thus reinvoking the abyss of the circle? Derrida does not ask the question, for he considers it to have been answered in the negative by his analysis of Heidegger, paralleling that of Hegel. Moreover, the question is not to be asked

[3] Ibid., p. 23.

because it is contrary to the process of deconstruction that Derrida has henceforth taken upon himself, assuming both the term that returns to him from the far side, from across the Atlantic, and the task that he programs even as he puts it into effect. If Kant's procedure imposes on the analytic of the beautiful a conceptual framework that amounts to a real "forcing,"[4] then "deconstruction" must neither "reframe" – that would suppose a belief in the truth of good framing – nor "dream of the pure and simple absence of the frame"[5] – that would be to succumb to the transcendental ideality of the beautiful, which is definitely the ultimate aim of Kant even though he wants to demonstrate the possibility of objectification in the judgment of taste. The work of deconstruction, henceforth written into the text where it operates – "deconstructive labor"[6] – thus requires a theory of the theoretical framework of thought, but its function will be to analyze the effects of the contradictions produced, particularly in the case of Kant, by the lack of a theory of the frame that leads him to affirm at the same time the concept (the relation to understanding) and its opposite (the nonrelationship to knowledge) in aesthetic judgment. The theory of the frame is in fact constructed only from the negative symptoms that its absence allows to surface; if, in a second theoretical moment, it aims to uncover the place of lack in a theory of the frame – that is to say, if it proposes to enunciate positively an essential component of the theory – that will only be to the extent that, in order to constitute itself, theory must recognize the aporia that founds it, namely, the impossibility of a conceptual identity. Whether one is speaking of the Kantian parergon – the frame, precisely, that Kant makes alternately an ornament and an element of the painting – or of the trap of identification that Van Gogh's shoes close around Heidegger (the painting speaks of the being of the existent [*l'être de l'étant*]) as around Meyer Schapiro (the painting offers the *parousia* of Van Gogh), the analysis will be content to show the paradoxical law of the frame of truth, which either excludes from the painting that which gives it its force or else, in order to comprehend a work of art, calls for the neglect of the painting that comprises it.

The dissimulation of painting is thus a response to the multiple logic of the parergon, whose deconstruction must clarify the action by gearing it down (*en la démultipliant*). Nevertheless, the parergon does not easily let itself be framed, because it acts precisely on the border of the frame. In the context of Kant, it designates, by analogy with the ornamentation of the painting, the subjective attraction that specifies the aesthetic and that, however, must be excluded from the beautiful in order to objectively found the possibility of an aesthetic. It falls to Derrida to take the difficulty of Kant's proposal to its maximum point of impact, presuming at one and the same time to recognize the subjective singularity of taste and to give to the sentiment of beauty a universal objectivity. It is on the borders of the painting that the impossibility of such a division is played out, a division that would delimit the territory of the object and

[4]Ibid., p. 71.
[5]Ibid., p. 73.
[6]Ibid., p. 71.

the space of the subject and that would thus authorize, despite affect (*aisthesis*), the constitution of the aesthetic. Pleasure or understanding – the role of the parergon will thus be to designate the failure of the oppositions by means of which the two concepts are assured. But when it is taken to the limit in the debate that Derrida orchestrates between Meyer Schapiro and Heidegger, concerning in this case the sense of the work of art and not the judgment of the perceptible, the parergon detaches itself from any assignable content; it becomes the very figure of the supplement that makes the origin of the work of art the principle of its exclusion. The relation of exteriority may thus be understood according to a twofold point of view – that of the visible work, which in defining itself divides itself from itself, and that of being, whose word (un)veils itself by fixing the work in its gaze. But the role vested in the parergon, which Derrida has set up as a critical operator in the Kantian study, will first involve dislodging – by disturbing it – the internal order of the discourse that art allows to exist. Ontological deconstruction will thus win out over the expropriation of the aesthetic: The unveiling of the discursive trap supposes the refolding of the reflecting image, which, in being a mirror, becomes the abyss itself. The major consequence of this concerns the status of reserve that the painted work henceforth receives: Because Van Gogh's painting includes the discourse that frames it, it turns the search for an origin back upon itself, and what is proper to the work – the pictorial work as it happens – derives from the movement by which it frees itself from the discursive frame it has nevertheless set up. The dissimulation of painting that Derrida's text leads to must thus be understood in the double sense of a genitive that on the one hand suggests that it is the philosophical act that is responsible for the trait of dissimulation – no painting proper within the logic of the truth in painting – and that, on the other hand, ends up imputing to painting itself the responsibility of a retreat (*retrait*) – of a step on this side (not on this side [*un pas en-deçà*]), one might say – by means of which the painting, by concealing itself from the truth of discourse, would return to the borders of the discourse that deconstructs the truth of the discourse. That would be the truth no longer *in* painting but rather *of* painting: to escape the truth whose simulation it permitted. Would this be the dream of "painting without truth"[7] or that which would only be its truth: returning to itself, at the expense of its inaugural exteriority?

★ ★ ★

The law of the parergon is both expansive and reversible. By playing with the double scene (*tableau*) – that of truth and that of painting – Derrida risks the reversal of his own perspective: the parergon of painting – the edge of the frame through which the Kantian attraction, as well as the Heideggerian origin, and, in a larger sense, every delimitation of the aesthetic, is required to pass – is inverted in a painting that itself becomes the parergon and closes around its own border. This amounts to a "deframing," which, although controlled, nonetheless calls the law of the parergon into question, by referring it back to the very inside of

[7]Ibid., p. 9.

the work, within the fold of the frame. The truth in painting is accomplished by this "secret"[8] that is required to render to painting its "occult strangeness."[9] Such would indeed be the ultimate propriety of the painting, henceforth exempt from the paradox of exteriorization. That the restitution works through Artaud's voice serves only to defer the formulation of the new dilemma that ends up inscribing itself in the polylogue of voices echoing opposing possibilities: "to render this secret yet legible"[10] (hence to restore the opacity by letting it go, literally and intrinsically), or "to render nothing" and "bet" only on the "trap" (to deceive by having the double game of opposites play in the mirror). Despite its decisive character, the alternative amounts to the same logical trap: Either painting as such is excluded from the philosophical field in which it is reflected (in this case the expropriation of painting belongs to its truth, which invalidates it), or painting returns intact as pure pictorial space, reflecting the rejection of philosophy by allying itself once more with its own intimacy (and in that case the deconstruction of truth gives over to the truth of painting, and thereby invalidates itself). In dismantling the Kantian dilemma founded on the nature of aesthetics, Derrida substitutes for it a dilemma deriving from the very enterprise of deconstruction, a dilemma that in order to be maintained as critical activity would need to be developed on the extreme border of the circle, without the expectation of any resolution of the antinomies.

How does one bet on the trap? How does one trace its outline and at the same time escape it? Because it protects what is said from ever being attributed to a subject, the proliferation of voices authorizes the perpetuation of the dilemma. Like a chastised clown, the philosopher, from behind the mask of a divided voice, can continue replaying the scene of dissimulation interminably. At the same time, he can keep painting at a distance through the analysis of the gesture that possesses it, and also dispossess discourse by designating, without subscribing to it, the supplement that ruins it. This last point, nevertheless, requires recourse to the supplement itself: in this case the series of paintings – Van Gogh or Van Eyck, Gobelins or Goya – that are offered for view and that, outside of the voice, cross the frame of the text without its commenting on them directly. As a result, the text can as easily include them in its operation as make of them the image of exclusion that inspires the same operation. If the dilemma is fully exposed in the proliferation of voices of the last essay of *The Truth in Painting,* it does not cease being dissimulated – exhibiting and refusing itself at the same time – in the general assemblage (*montage*) of the text that has recourse to the image in order to provide a backdrop (*faire écran*) for its own argument: It is represented (*figurer*) and in the same gesture shielded. The dissimulation of painting, which effaces itself from discourse by occupying its margins, belongs in this case to the very writing of a project that is less concerned with making painting speak than with preserving the ambiguity of its silence,

[8] Ibid., p. 382.
[9] Ibid., p. 381.
[10] Ibid., p. 382.

that ambiguity alone being capable of sustaining the dilemma without either giving in to it or unraveling it.

★ ★ ★

Could writing, as unbound image and multiplied voice, make itself into the hieroglyph of theory,[11] as in the *Front Benjamin* constructed by Adami? It is to writing that the frontal approach to painting in fact returns, once painting stops hiding in the margins of discourse and becomes, directly, the object of a statement. It is known that two artists occupy the center of the assemblage, undermining from the inside the philosopher's framework that the work provides for itself. In the discourse on Adami or Titus-Carmel, the deconstructive gesture need pass through no mediate word. The voice meets the image head-on (*à vif*) and risks repeating its opacity, unless it find in the very matter of the visible the mirror image of the scriptural outline that takes account of it. Adami's painting, as the graphic and pictorial rewriting of fragments taken from *Glas,* opens the way to a dispersion of writing in and by painting, authorizing even Derrida, who in turn rewrites Adami, to inscribe his own texts – *Margins* or *Positions*[12] – in the movement of a rewriting in which the signature is dissolved. Here the image illustrates the text, but only by reflecting the text that is caught in the trap of the image, which in turn represents the trace of that text. Materializing the hieroglyph, the painted page unites letter and graphic in the unfolding of the trait. There, pictorial identity falls (dies [*tombe*]). In this case the dissimulation of painting finds the rule of its retreat (*retrait*) in the dissemination of writing. If painting has become the supplement of the discourse that treats of it, that is because painting's task is to restitute, through the discourse of supplementarity, a writing that the discourse excludes in order to speak. The letters that Adami's hand retraces, the numbers and signs that set the rhythm for Titus-Carmel's series, decenter the framing of deconstruction, but only in order to render legible the trace of a trace that the detour through the visible allows to be put back into play in the space of the writerly. "The paintings are written" – that is what the painting writes when it represents, word for word, the secret of painting. When the silence of painting is broken, it carries as the mark of its rupture only the words of writing.

★ ★ ★

By following thus the logic of the Derridean passe-partout, the analysis comes up against two questions. The first concerns the internal fault within an assemblage by means of which one can hear, in the center of the circle that takes apart the discourse on art, a voice specific to the works, capable of taking up the bid (*porter la relance*) of art. A hiatus is opened between deconstruction, which retraces the aporia of the aesthetic logos, and dissemination, which opens through painting a new passage for the trace. Is it that, by a singular reversal of the hypothesis,

[11]Ibid., p. 179.
[12]Jacques Derrida, *Margins of Philosophy,* trans. Alan Bass (Chicago: University of Chicago Press, 1982); idem, *Positions,* trans. Alan Bass (Chicago: University of Chicago Press, 1981).

the grammatological enterprise is led to make writing an agent (*facteur*) of truth, thereby removing painting from the dilemma of the four truths that always reduce to two? Even if the truth of writing has the effect of taking away from the painting its pictorial quality, it remains for all that the arbiter of a procedure that presumes to treat painting no less as a work of art than as a critical operator of the truth in art, which is to say in painting. As a bridge thrown over an abyss – that is the role that Derrida detects in the Kantian sublime, giving the very measure of the infinite by its immensity – writing breaks the circle of (the) critique, introducing the recourse of a grammatic (*grammatique*) theory that has become the emblem of a truth that is itself critical. In the center of the text, just like on the cover of the book, the unveiled letter becomes the password allowing passage across the frame, answering simultaneously to the demands of the painting – the framing – and to the originary law of writing – the outside of the frame. In that way the dilemma would be resolved in the generalization of a scriptural reference whose heterogeneity, reinstated by a theoretical acquittance, would permit empirical specificity to be foreclosed without disrupting the postulate of the work.

The second question follows from the response implied in the formulation of the first. If the letter alone can force the painting, and designate its strangeness, what is to be said for the image (*figure*), presuming that it is not absorbed in the tracing of the trait, once the analysis has changed it into a retreating (*retrait*) of the trace? As a totality unbroached (unbreached [*inentamée*]) except by the assemblage or the series, the image lets itself be filtered through the text as a residue of sight, irreducible to writing's reprise. Outside of drawing, painting persists, even if only within the gray form of reproductions, and it resists the pull of the graphic. Not the least paradox of this expansion of the scriptural from an iconic base is that the image is forced to break with the sign, whose hieroglyphic vocation it had on other occasions upheld. If the graphic (*le graphe*) invades drawing, if the title comes to cipher the casket, nothing on the other hand returns from the image to act on writing, which henceforth seems to contain in itself alone all the hieroglyphic power. In *Of Grammatology* the figural acted within the very matter of the sign, bringing to light, by means of the constellations (*étoilement*) of the letter, the dissociation of signifying entities. With *The Truth in Painting* the visible enters into the field of analysis only in order to conceal itself from the scriptural interpretant that allows that analysis to be brought to a close.

★ ★ ★

Sight remains to be seen. And almost nothing is said about this residue except from the oblique angle of a fascination that undergoes variation without being put to the test. "We *fascinate*."[13] The intransigence of the verb covers over the force of attraction, of this "bad attraction"[14] whose relegation is attributed to Kant but is perpetuated under the mask of a deconstruction that remains attached to the terms of Kant's distinction

[13]Derrida, *The Truth in Painting,* p. 12.
[14]Ibid., p. 64.

between object and subject. "You see"[15] – this time the verb relates to the visual communication of the work, and hence to sensory matter, offering itself to the subject at the same time as it differs from it. But can an appeal be made to the gaze without disturbing the entire space of visibility? What is the status of the gaze when it is reflected in sight? The Derridean gesture does not ask these questions,[16] either because it refuses to interrogate the eye's relation to aesthetics or – and this is another way of saying the same thing – because it implicitly reinstates the confusion Kant is responsible for between perception and subjectivity.

"[A]esthetic [judgment] . . . means that it is one whose determining ground *cannot be other than subjective*."[17] Kant's inaugural definition institutes the misfortune of an aesthetic that is placed under the sign of the subject, even though it would consist of looking for the rules of conceptualization and thus of objectification. By assimilating the operation of the senses to the reaction of the emotions, Kant relates to taste and pleasure something that is an act of sensorial, in this case optical, perception. Clothed by the sentiment of beauty, the attraction of the image changes into a pleasure of the soul. At the same time, the materiality of the visual apparatus by which the image becomes visible only in its relation to sight, and which deprives it of its transparency, disappears. The dissimulation of painting derives first from the reflecting of the eye by the image, for the opacity of the image comes about as a result of being approached. If the theory of writing remains foreign to this machination of sight, it is because it attaches more importance to resisting allegiance to the subject – something that is inherited from Kant – than to restituting a fascination for vision that would by itself ruin visibility. In deconstructing Kant, Derrida retains certain of his postulates: first the privilege given to drawing over color, even if it consists in having ideographic material stand out within the eidetic contour, but more important, the dominance of an ideal (*idéelle*) definition of the subject, which leads him to neglect the difference between the materiality of sight and the subjectivity of feeling within pictorial space.[18] "The enigma of pleasure,"[19] the return of attraction that Derrida's fascination invites, remains caught in the conceptual schema of a seduction that was rejected by Kant but whose paradigm Derrida takes up, however obliquely. His deconstruction will work through the dislocation of the concept of the

[15]Ibid., p. 152.
[16]"Who looks at and de-picts the other?" (*The Truth in Painting*, p. 166). The reciprocity of the gaze and of the painting will cause the poles of the exchange to turn without, for all that, touching the apparatus of vision itself.
[17]Immanuel Kant, *The Critique of Judgement*, trans. James Creed Meredith (New York: Oxford University Press), pp. 41–2.
[18]Despite the analysis that Derrida reserves for the ambivalence of color in Kant, "revalorized as formal purity or as relation, devalorized as sensory matter, beauty on the one hand, attraction on the other, pure presence in both cases" (*The Truth in Painting*, p. 77), his choice of Adami and Titus-Carmel prevents him from taking into account the role of color in the work of attraction. We can note here that Derrida situates attraction on the side of sensory matter, opposed to formal beauty; but that distinction does not lead him to study the relation to the sensory outside of the dominant field constituted by his reflection on the erasure of the subject.
[19]Derrida, *The Truth in Painting*, p. 43.

subject without affecting the subjective frame assigned by Kant to his
own definition of the aesthetic apprehension. Kant's equation between
attraction and subject will thus be negated only by the critique of the
subject, not by the analysis of attraction.

★ ★ ★

It is by mobilizing the gaze that painting escapes the subject – not be-
cause it escapes its control, but because it explodes in the fixing of sight
(*prise de vue,* also "[camera] shot"). Only an operator of the visual can
bring to light the solidarity linking the attraction of the eye, which is
foreign to the emotions, and the explosion of the object, which comes
apart under the impulsion of sight. When the film *Passion*[20] attacks paint-
ing – "hold-up in Tintoretto" the *Scénario*[21] of the film will say – the
title brings together two series of utterances at the same time as it causes
them to overlap: one that concerns the pleasures and pains of a director
intent on filming from life the secrets of certain painters and giving up
when he is unable to succeed, and the other working at the dispossession
of the artist, whose point of view disappears behind a camera that dis-
members the painting by the same gesture with which it appropriates it:
on the one hand, the weakness of the impassioned subject, conveyed by
such negative statements as "no, that doesn't work," "the light isn't
working," "it's not the right path," "we must find the opening," and
on the other hand, the actual movement, the trajectory of a blind and
silent lens whose attraction draws the figures out of the painting by
effacing the contours of each scene. There is no possible model for a
mobile restitution of a Goya, mixing within the same but constantly
remodeled frame the forward movement of *The Love Letter* and the
crossing movement of *The Third of May;* the circular movements of the
camera precipitate the opening of a space where Ingres's memories give
way to the invasion of Delacroix; and if the framing is fixed on the
decor of *The Entry of the Crusaders into Constantinople,* it is by arranging
in the center of the painted canvas the disunity of the two parts that
compose it, whereby the only thing that remains is a disconnected white
rectangle, rupturing the unity of the picture plane and offering to the
gaze not the unified vanishing point where the sight of the subject is
projected but instead the tear produced in the painting by the projection
of a machine that doubles the gaze of which it has taken possession.[22]
The frame folds, the canvas shrinks or overflows, spacing (*l'intervalle*)
appears at the very heart of the image – all such operations that can be
imputed to a movie camera become the emblem of the optical apparatus.

[20]Jean-Luc Godard, *Passion* (1980). My analysis concerns only the series of six restitutions
with which the filmmaker Jerzy experiments, using the *tableaux vivants* borrowed from
Rembrandt, Goya, Ingres, Delacroix, El Greco, and, obliquely, Watteau.

[21]Jean-Luc Godard, *Scénario du film Passion,* notes to video, 1983. See also the description
in *L'Avant-scène cinéma (Spécial Godard),* no. 323–4 (1984).

[22]The perspective point thus becomes the opening point for the perspectivist system: not
because it opens onto infinity – in fact it only refers back to the gaze, as Hubert Damisch
emphasizes in *La Théorie du nuage* (Paris: Seuil, 1972) – but because by reflecting the work
of the eye it dislocates the cohesion of the system. In that sense, the task of the filmmaker
would be to make readable, even in the scene painting has inherited from the quattrocento,
the disunity of image and sight that pictorial modernity has adopted.

Immobile, painting offers the image to the gaze. When it is staged by the simulation that is film, it finds itself subjected to the test of movement: Its insufficiently fixed gestures, its trembling poses, its blinking eyes – all that is captured and enlarged by the movement of the camera and the disruptions of the editing. But far from betraying the pictorial identity, this supplement of mobility engineered by Godard becomes the very sign of the paradox in which the presence-to-itself of the image is abolished. By penetrating visible matter, the condition of visibility – in other words, the impulse of sight – comes to confuse the possibility of seeing. By means of light, line, and posture, the disorganization threatening *The Night Watch* (*Ronde de nuit*) is shown to depend first and foremost on the round of the eye outside of which nothing can be seen. The pictorial contemplation that the immobility of a painting implies is thus broken into multiple fleeting bursts, brief glimpses that the glance tears from an absent whole: Such is the end of *Passion,* where the erratic insertion of a fragment from Watteau overflows the frame of an abandoned reconstitution and flows through the space of the filmic fiction. The figural imprint becomes all the more active when it is no longer distinguishable, except by occluded memories, from the cinematic illusion that pursues it. Captured by film, painting gives in to the attraction of a filmic contamination that becomes the index of a pictorial erosion within painting itself. There is no stopping the image, even if it be immobilized: no visible painting without the inscription, through its dispersal, of the trace of vision through which that painting escapes.

There is no way to confront painting other than by means of the point of view that explores it from all sides and causes it to explode: at the top of the frame, where the crane is raised to shoot from above, from the bottom of a perspective barred by the rails of a dolly, and in the discovery of volumes whose excessive amplification brings back to the meandering of the camera the depth that had been improperly lent to sight. At all points a space is opened that, by offering itself to sight, reflects the passage of the visual. What disappears is the mastery of the eye over an object that is approached, dismembered, erased, so that there remains only the memory of an uneventfulness (*désoeuvrement*) wherein even the traits of the work (*oeuvre*) that was borrowed have been forgotten. On the other hand, the work was never presented for representation in that way: Disfigured in its very figuration, it abolishes the model even as it convokes it. In erasing what is not inscribed – following the formula by which Blanchot defines rewriting[23] – filmic writing gives to the dissimulation of painting the extreme form of an originary radiation. "This must not leave traces"[24] – such is the step of a trace (the "not a

[23]Translator's note: See Maurice Blanchot, *L'Entretien infini* (Paris: Gallimard, 1969).

[24]By means of these words from the mouth of the female protagonist of the film, I approach, although not from the same point of view, the analyses by Jean-Louis Leutrat ("Des Images qui nous ressemblent") and Jacques Aumont ("Godard peintre") published in a special issue of the *Revue belge du cinéma, Jean-Luc Godard (le cinéma),* no. 22–3 (1988). Concerning the work of the interval in *Passion,* Leutrat insists on the double sense of the trace, index of what was, as well as of the negation of the idea of origin; Aumont, on the other hand, indicates the relation that Godard's work establishes between reference to painting and a search for the informal and the unfinished. Without refuting these proposals, which also concern the filmic-pictorial writing of Godard, I give priority to the reversal

trace" [*le pas de la trace*]), impelled by the passion of seeing, in the place
where the trace is eclipsed.

The dissimulation of painting belongs neither to the outside of a truth
that would be foreign to it nor to the inside of an interiority that would
return to it to the exclusion of all else. In this respect Godard's object
lesson joins the side taken by Derrida. But if only writing can make the
parergon stand forth within the pictorial frame, the writing that the film
of painting puts into play acts first upon the substance of the image, on
this side of and beyond all graphic supplements. The interest of this
detour through film is derived from the unveiling it performs on a dis-
semination that comes to ruin the imaging entity itself: The "just an
image," which Godard opposes to all ideas of a true image, leads to an
interrogation of this little something that takes away from the image its
possibility of unity. There is no image in itself that does not presume
another image. Furthermore, there is no image that does not finish by
succumbing to the attraction of a reflection that comes from the gaze
that reflects it. If the image is not in the mind, if the mind itself is an
image,[25] in this case the mechanism of vision arises from a trompe l'oeil
that is by definition deceptive, through which sight is exchanged with
the thing viewed. Even though painting works toward the advent of art
as a singular object, it belongs to the domain of visual technique that is
subjugated to an exorbitance of the senses. Divided between the memory
of art and the event of sight, the simulacrum that is film designates the
paradox of the stolen painting[26]: The expropriation of the work is de-
pendent on the gesture of its appropriation by perception. Such is the
discourse of the filmic truth of painting, where film – movement, mon-
tage, and reflection of the eye – intervenes as the pictorial hieroglyphic,
imputing the retreat of the visible to the laying bare of the very principle
of visibility.

★　★　★

"To make seen what makes one see, and not what is visible"[27] that is
the task that Lyotard assigns to painting after Cézanne, and Marc Le Bot
discovers in it a constant of pictorial figuration: that which causes there
to be seen an eye that does not see itself.[28] Thus what is proper to art
would be revealed in the modernity of an approach by which the seeing
principle becomes the visible. But if seeing prevents sight, according to
the rules of the cinematic game exposed by Godard, then the reversal
can be played out only to its own detriment: The attraction of the eye
is materialized, made perceptible and active, and leads as a result to the
dislocation of the thing; the seduction of form falls back into a failure
of form itself, and the painting explodes in proportion to the level of its

of perspective by imputing to the actual experience of painting the paradox of the effacing
gaze that the film puts into play.

[25]Henri Bergson, *Matter and Memory,* trans. N. M. Paul and W. S. Palmer (New York:
Macmillan, 1929), p. 35.

[26]Translator's note: Cf. the film by Raul Ruiz and Pierre Klossowski, *L'Hypothèse du tableau
volé* (1978).

[27]J.-F. Lyotard, "The Sublime and the Avant-garde," in his *The Inhuman,* trans. G. Ben-
nington and R. Bowlby (Stanford: Stanford University Press, 1991), p. 102.

[28]Marc Le Bot, *L'Oeil du peintre* (Paris: Gallimard, 1982).

attraction. As we know, Kant distinguished the sublime in its relation to beauty by means of the term *Formlosigkeit* – the lack of form.[29] The domain of sublime spectacle, irreducible to a formal quality, accepts the subjectivity that the aesthetic was required to separate from the object in order to found itself legitimately, and in it the subject is projected toward an Idea of the supersensible, whose principle is in us even if it leads us outside of ourselves. By separating the beautiful from the sublime, Kant means to resolve the antinomy that constitutes aesthetics: The impression of pleasure and subjective attraction that found the sentiment of the beautiful will be withdrawn from the object without, for all that, being rejected. Beauty will thus be able to give way to an objective deduction, whereas emotion, preserved and transferred to the sublime, will come to guarantee within fixed terms the existence of a faculty of judgment "without limits," whose subjectivity, become transcendental, mitigates the absence of a concept that constituted the initial aporia of inquiry into aesthetics.[30] The key to this apparatus set up to resolve the antinomies depends on the principle, constantly reaffirmed by Kant, according to which the formal failing that is characteristic of the sublime – in other words, the passage to the limit of art – cannot be referred back to the artistic object. If form is lacking, that lack does not belong to form, but to an object that defies form, whether it be the colossal, the terrible, or the unformed, whose examples are to be found in nature. It amounts at one and the same time to saving the objectivity of art and preserving – elsewhere – the subjectivity of the approach to art: in short, maintaining the demand for an intelligible totality in aesthetics while at the same time giving to the primacy of the sensory its due, because the sensory is always evanescent and so can be easily sublimated.

Such an apparatus of conciliation is today exploded by a reevaluation of art that is argued in terms of the sublime. The philosophical reinvestigation invited by the work of Jean-Luc Nancy[31] seeks in the sublime the path back to an art conceived of as thinkable to the extent that it can surmount the obstacle of the aesthetic. Art is made into a question by being approached from the point of view of a limit that would be consubstantial to it and that would not imply a surpassing, by a questioning not of its presence but of its presentation of a failing through which it offers itself. In this sense, the sublime, far from distinguishing itself from the beautiful, becomes the rule of its exposition and its end. From a similar perspective, Philippe Lacoue-Labarthe sees in the sublime the collapse of aesthetics, the supplement that dispossesses it and prevents it from maintaining its discourse to the end: Through the sublime, beauty is unveiled as a principle of veiling – "the veil that things must wear for us" – according to Benjamin's formula recalled by Lacoue-Labarthe.[32] In both cases, whether it be its heart or its abyss, the sublime designates the internal fault of the Kantian aesthetic; but whether it consist of "the

[29]Kant, *Critique of Judgement,* p. 93.
[30]Ibid., pp. 106–8, 133–4.
[31]J.-L. Nancy et al., *Du Sublime* (Paris: Belin, 1988). See, for Nancy, the preface (pp. 7–9) and "L'Offrance sublime" (pp. 37–75).
[32]Philippe Lacoue-Labarthe, "La Vérité sublime," in J.-L. Nancy et al., *Du Sublime,* pp. 97–147.

sublime offering" (Nancy) or "the sublime truth" (Lacoue-Labarthe), what is proper to the sublime, and what so ruins the autonomy of the aesthetic, is its invitation to seek in art something surpassing art itself, even if it consists of only a passage to the limit that art includes within itself and that it exposes to the subject. Offering and truth appeal to an internal overflow, in terms of which art would become the vector for a criticism of ontology, thus a return to philosophy in art. In this way the sublime truth concerns the "sublime" nature of truth, and the sublime offering refers back to the experience of the subject the offer of limit-lessness that is made to it in the very limit of the work. Even though it is intrinsic to the meeting with art, the overflow will not refer to the image in which art is formed: The presentation of the unpresentable that defines the sublime leaves representation once again safe from lack. In order to reinscribe upon the object the internal break in aesthetics that thinking on the sublime produces, one would need to conceive of what Lyotard calls an "aesthetic of the sublime"[33] – an aesthetic that is by definition paradoxical because it would attribute to the object itself the failing experienced in contact with the object. That would lead, at the same time, to the destruction or at least to the alteration of what supports such an experience, for, as Godard has shown, it is rent in the very élan that allows it to be proposed.

★ ★ ★

The extreme form of dissimulation is probably that which makes the relation to the work the motive of a dissemination whereby the effect of the work, and thus the possibility of a relation, comes to be abolished. By exposing the double logic of the gaze, which breaches (broaches) what it touches, Godard's film installs a vicious circle, deriving from the actual nature of art, and whose impact excludes the idea: There is no beauty separate from the sublime, as Kant's critical take (*reprise*) has it, but the actualization of the sublime keeps separate the advent of the beautiful. If art cannot define itself without contradicting itself – the thesis of *The Truth in Painting* – it is because it is experienced only by becoming absent – a hypothesis with which *The Truth in Painting* does not deal. Only Kant's double distinction, between object and subject, and between the beautiful and the sublime, can keep intact not only the foundations but above all the domain of an aesthetic judgment whose exercise requires the assured presence of the thing to be deduced, in addition to the rationality of deduction – in other words, the certainty that art can be thought of as such, even if it be in the aporia of its definition. By successively deconstructing the terms of those distinctions, and in the order in which Kant constructed them, Derrida preserves a chance for art to exist. That the conceptual delimitation of aesthetics arises from a framing imposed by force, that the treatment of the sublime introduces a quantitative criterion that is foreign to its nature but nec-

[33]Lyotard, *The Inhuman,* p. 102. Lyotard situates this aesthetic on the side of the "unde-termined" in representation – for example, in the case of Cézanne – and he develops it according to the avant-garde perspective of "the work-event." What I wish to retain here, in order to take it to its limit, is simply the paradox involved in the presentation of the unpresentable, independently of any factual resolution.

essary to its mediating function – such contributions to the argument made by deconstruction undermine the theoretical assemblage of each of its terms without directly calling into question their separation. The Derridean critique may well denounce the role of an appendix attributed to the sublime – the supplement of attraction that serves as a prosthesis to the thinking of the Infinite – but it does not turn the analysis against the law of art that is presupposed by the autonomous requisitioning of the beautiful. Not only does the gaze remain ignored in the attraction that beauty exerts over the subject, but beauty itself remains sheltered from the gaze, dissimulated in the folds of a dissimulation. However inaccessible beauty be, that dissimulation maintains the possibility of its principle under the cover of the attraction it exerts.

The risk taken by Nancy and Lacoue-Labarthe – the idea of a failing that passes through the object – is refused by Derrida, who preserves the object as guarantor and as mirror for a critique of the subject. But the decisive gesture that would transfer to art the defeat that is involved in our relation to art does not take place in any of those analyses. The reinvestment in the sublime and the deconstruction of aesthetics both mark the limits of an approach through which a perpetuation of philosophy is reflected in art. Only a way of thinking otherwise, a thinking of the other, a way of thinking that is neither philosophical nor aesthetic, would be able to trace the path allowing the renouncement of artistic identification: a path of passage and not of access, a path that comes from art, through which art would be exposed as a principle of alteration, having no subsumable identity other than that of a *différance* from itself. It is a form of beauty that is shaken by the sentiment of the beautiful, a principle of art that is threatened by the attraction it calls forth; the erosion here amounts to the actual tracing of a contour. In displacing the sense of the limit, the extreme logic of the sublime will have the interval fall no longer between the terms to be distinguished, but within the internal delimitation of each term, including that of the sublime.

★ ★ ★

Neither truth in painting nor truth outside of painting, but truth of an outside that returns to painting through the evidence by which it removes itself from sight. Certainly, it would be absurd to deny the concrete specificity of a painting – frame, canvas, color, paint, touch and gesture of the outline – but the image forms the point of rupture within the assurance of this propriety, precisely because it carries with it the indication of the gaze, the means by which the invasion of the outside will occur. If the history of painting has never stopped playing tricks with figuration, it is, without a doubt, in order to attain a maximum purity no longer interfered with by the appeal of the outside. But how does one break with the vector of sight when the proposition involves seeing? The pathos of an unattainable rupture derives from this contradictory demand to have done with that by which it all begins; the result is the search for a vision reduced to the pure principle of visibility. But the more the painter renounces the figurative process, the more the mask of the eye that is excluded with the representation comes to be recalled through the presentation. Painting never stops forming images (*figurer*),

even if in the form of an ocular metaphor. In this way, it never stops designating the means by which access to the painting hinders the painting from being. The result is the double game put into play by the modernity of Manet, who makes sight the means of entry and of rejection for the spectator seeking a point of view on the work: A subject in the painting looks at another, who isn't looking at him, turning the gaze back upon the spectator who is looking.[34] A circuit is imposed on the viewer, and its trajectory conceals the scene: moving outside to follow the path, always moving outside of sight, without being able to fix the point from which to master the view. Doesn't the painting's secret lie in the way it sends back to us the image of our own bewilderment? In such a way it is able to touch us, by incorporating the mechanism of its dispossession.

Through painting, the being of painting is abolished. This will be the last turn of a truth in painting that, in the distancing of art, is devoted to recalling a dissimulation deriving neither from critical discourse nor from an aesthetic secret, but from the relation of exile that links the presence of the gaze to the dismantling of the painting. Derrida diverts the gaze by designating the border of the frame, and leaves to the work of sight the ultimate essence that issues from this blindness. The paradox of the philosopher, trapped by the paradoxical logic of his strategy, would thus be to bring the sublimation of art back to the point where art begins to be broken open by the supplement of the sublime. But who would consent to see with Orpheus?

Escaladant la colline que l'on aperçoit dans le lointain, tout au fond du tableau et déjà touchée par les rayons du soleil levant, le chemin que suit Orion resurgit en une ligne claire qui s'élève en serpentant. Il semble cependant que le géant ne doive parvenir jusque-là, puisque à mesure que le soleil s'élève dans le ciel les étoiles pâlissent, s'effacent, et la gigantesque silhouette immobile à grands pas s'estompe peu à peu, disparaît dans le ciel pâle où est suspendu le fuseau métallique de l'avion étincelant au-dessus de la mer stagnante des nuages. . . .[35]

Climbing the hill that can be seen in the distance, in the far background of the painting but already reached by the rays of the rising sun, the path that Orion follows rises in a clear line winding upward. However, it seems that the giant is never destined to get that far, because as the sun rises in the sky the stars become pale, are erased, and the gigantic immobile silhouette fades away little by little with huge strides, disappearing into the pale sky where the metallic taper of the plane is suspended glittering above the sea stagnant with clouds. . . .

Translated by Laurie Volpe and David Wills

[34]Cf. Richard Wollheim's study of Manet, "Le Spectateur dans le tableau," *Cahiers du Musée National d'Art Moderne* 21(1987), in particular pages 18 and 19. However, I draw conclusions opposite from his, because for Wollheim the exclusion constitutes a way of entry to the painting, by pointing out to the spectator the correct way to see the retreat with which he is dealing (*le retrait dont il traite*).
[35]Claude Simon, *Orion aveugle* (Paris: Skira, 1970), pp. 145–6.

THE HEURETICS OF DECONSTRUCTION

GREGORY L. ULMER

ERRIDA suggests that it is possible to think and write otherwise. Other than what? Other than critique; other than hermeneutics. But this other is not unheard of. It has a name: "heuretics" – "The branch of logic which treats of the art of discovery or invention," says the *Oxford English Dictionary* (OED). "Rare." A rare usage, and even rarer in practice. Yet heuretics is what deconstruction is for. It is what happens when one reads Derrida, without being simply his invention, his property. That is why Derrida chose not to speak on the topic "deconstruction in America," there being too many stories to tell: "How could a narrative account for a phenomenon in progress?"[1]

It is better to approach the term "deconstruction" by means of usage rather than definition. Consider this observation:

At present, the most unreconciled avant-garde filmmakers are those who choose to turn popular forms against themselves. The recent work of Chantal Akerman has been exemplary in this sense. Abandoning the commercial art cinema gloss of *Les Rendez-vous d'Anna* (1978), Akerman's *Toute une Nuit* (1981–82) and *The Golden Eighties* (1983) are decentered, deconstructed films, drawing their figures from the commercial cinema and yet subverting the totalizing impulses at work in both the commercial cinema and the New York school.[2]

There it is, "deconstructed," used clearly, naturally, descriptively, to name a quality of a certain kind of filmmaking. The question for me is not how the term entered art discourse, but, taking that fact as a symptom, to explore what it contributes to the ongoing invention of deconstruction. For such is my point of departure – not that deconstruction is already something, finished, complete, and then imported into the arts, but that this importation is heuretic. Thus I will not try to explain what deconstruction is, but to make it into something.

★ ★ ★

"Deconstruction" may be approached through the various terms with which it is often associated, such as "text" and "postmodern." A useful understanding of the postmodern is manifested in the anthology *Art After*

[1] Jacques Derrida, *Mémoires: For Paul de Man,* trans. Cecile Lindsay, Jonathan Culler, and Eduardo Cadava (New York: Columbia University Press, 1986), p. 13.
[2] J. Hoberman, "After Avant-Garde Film," in *Art after Modernism: Rethinking Representation,* ed. Brian Wallis (New York: The New Museum of Contemporary Art, 1984), p. 72.

Modernism (AAM), an authoritative collection in which the term "deconstruction" appears with some regularity.

AAM reads like it was first an essay, but whose citations and allusions were replaced by complete articles. It is textual in that it leaves room for the reader to judge the merits of the argument, after reviewing the entries that add up to an account of a problematic (a "problematic" is to theory what "polysemy" is to literature). For each major theorist included there is a reply, with modernism being fully explained, along with the debate over its legacy and alternatives. The effect thus achieved, with Jonathan Crary's reply to Jean Baudrillard, or Constance Penley's reply to Laura Mulvey, or Robert Hughes's scandalized response to the career of Andy Warhol, is that of a glimpse into how a discipline invents itself.

Like other fields of knowledge, that is, the liberal arts disciplines grow and learn by addressing problems. The problem that most interests me – the invention or discovery of a deconstructive assignment – is, as it turns out, the pedagogical correlative of the problem addressed by the arts after modernism, as defined by Wallis:

> The recognition that the critique of representation necessarily takes as its object those types of cultural constructions (images, ideologies, symbols) with which art traditionally deals, suggests that art and artmaking might be one effective site for such critical intervention. From this point of view, the issue is less how art criticism can best serve art than how art can serve as a fruitful realm for critical and theoretical activity.[3]

In this respect, the relationship between modern and postmodern, as the terms themselves suggest, is cooperative. To do heuretics is to cross the discourses of art and theory.

It is reasonable to expect that pedagogy and curriculum will follow this current turn, just as they did the previous ones, although *how* to follow this lead is something that cannot be taken for granted. Here is where there is much to learn from the arts, which serve as relays, if not models, for an assignment, because the heuretic approach to the materials of the academy could be described in exactly the same terms Wallis used to describe the postmodern artists' new critical possibilities. In the same way that art forms and practices can be used to intervene with critical and even theoretical effect in popular culture, or in the institution of art itself, so too can they be used to intervene in the institutions of the disciplines creating knowledge and learning effects.

★ ★ ★

A deconstructive assignment must be designed so that the student can Write (*write* or "write" – postmodern and heuretic practices are not medium-specific) from the position of reception, composing as an active reader, rather than as an "author" (even an "apprentice author"). The obvious pedagogical value of this position shows that postmodernism is indeed an "academic" art in the best sense of the term, it being historically, in part at least, a consequence of the housing of the arts within the university. What assignments have always sought is a way to facilitate

[3]Brian Wallis, *Art after Modernism,* p. xvi.

the students' interactions with extant works, nor have teachers *desired* the reproduction that analysis shows to have been the ideological consequence of conventional assignments. Now postmodernism, taking up again the goal articulated by Bertolt Brecht and Walter Benjamin – to transform an institution while using it, not to reproduce reality but to experimentally rearrange reality (our reality being extant representations) for critical effect – suggests the style for a deconstructive assignment.

To see why that optimism is not universally shared, one has only to turn to the example Wallis provides of that which I seek – an "essay" by Kathy Acker ("Realism for the Cause of Future Revolution") intended to demonstrate "the displacement of the production of meaning from the artist to the reception or 'completion' of the work by the viewer" (but her text could just as easily illustrate the break with modernist aesthetics in the two other ways Wallis mentions: the death of the author and the loss of aura and "originality").[4] There is no better definition of heuretics than Acker's statement of her relationship to writing as reading:

> I've never been sure about the need for literary criticism. If a work is immediate enough, alive enough, the proper response isn't to be academic, to write about it, but to use it, to go on. By using each other's texts, we keep on living, imagining, making, fucking, and we fight this society of death.[5]

There may be some who would not want to purvey the Acker model, with its supposedly "punk" sensibility. But it is precisely the scandalous dimension of Acker's themes that foreground the radical potential of appropriation. Acker allows one to experience concretely, that is, the point that Umberto Eco argued in the abstract more than twenty years ago, regarding the interventionist as against the reproductive politics of text (while cautioning that the process he was describing was not inherently emancipatory):

> Since context contributes to discovering the codes thanks to which one decodes messages, then semiotics can show us how, in place of modifying the messages or controlling the source of emission, one can alter a process of communication by acting on the circumstances of the reception of the message. Here is the "revolutionary" aspect of semiotic consciousness. . . . Wherever it is not possible to alter the modalities of emission or the form of the messages, there remains the possibility (as in an ideal "guerilla" semiotics) of changing the circumstances by virtue of which the receivers choose their own codes of reading. . . . This pragmatic energy of semiotic consciousness shows how a descriptive discipline can also be an active project.[6]

School may just be one of those situations, not unlike the conditions of mass popular culture, in which the emissions and forms the student receives are not themselves "touchable." And that is why a deconstructive education can and perhaps should begin with the student as producer, even while the professors remain authors.

[4]Ibid.
[5]Kathy Acker, "A Few Notes on Two of My Books," *The Review of Contemporary Fiction* 9(1989):31.
[6]Umberto Eco, *La Structure absente: Introduction à la recherche semiotique,* trans. Uccio Esposito-Torrigiani (Paris: Mercure de France, 1984), p. 409.

Acker's hypotext is one of the most profoundly disturbing series of paint-
ings ever made – the "black paintings," as they are called, executed as
murals on the walls of Goya's home, and not known until fifty years
after his death (reproductions of which accompany the prose). Repre-
senting a summation of his many treatments of human "folly" and "ab-
surdity," and exposing "his intense awareness of the dark forces of panic,
terror, fear, hysteria,"[7] the series of paintings is said to have served Goya
as a kind of self-therapy, exactly of the sort Freud undertook at the end
of the century, attempting to work through a deep depression that had
both public (the horrors of war during the French occupation of Spain)
and private (his obsession with female violence) dimensions. "All artists
live intensely with their work, but until Goya painted these pictures no
one had tried to live *in* his work."[8]

One way to appreciate Acker's composition is as an "immanent"
critique: She takes up the same relationship to the paintings that Goya
had with them, and she uses them for her own struggle with the fun-
damental perplexities of the human condition, seen now from the wom-
an's side, of course, that motivated Goya himself, such an attempt
showing what it is to write from the point of reception. She does not
start in her own position, but begins with descriptions of the paintings
that are similar to the descriptions of works provided by the other com-
mentators in *AAM*. "Similar," but not the same, her manner of seeing
being not formalistic but "amateurish" or quotidian: "Three men are
talking. These're the men who cause war. One man has on a Renais-
sance hat or else has genetically-flawed hair. His right eye is larger than
his left so he's smirking, as his shoulders curve inwards. Except for the
hat, he's naked."[9]

She soon shows us how to make the passage from conventional dis-
ciplinary goals to textual Writing, when she introduces her own strongly
worded narratives of the painted scenes. In *The Witches' Sabbath,* for
example, there is a big "horny" goat: "The woman he wants to fuck,
who's holding a baby (all children should die whenever they open their
mouths), looks longingly at the beast. . . . The moon pukes." The de-
scriptions finally become a meditation on her own sexuality as con-
structed by representations (in the section devoted to the second
hypotext of the piece – Caravaggio): "So the boy's look at me is, beyond
sly, complex: his sexuality is this complex. If I accept him, I am this:
this non-stagnant always burgeoning almost hideous and comic over-
growth. This boy isn't beautiful. Will I be able to accept my own
sexuality?"[10]

Nor is any commentary needed to follow the argument, because the
hybrid is explicitly organized to say what it is doing, beginning with its
own citation of a Goya scholar on the "black paintings" (making my own
reference redundant). More than that, there is an experiment being put
to work, having to do with perception and language. Indeed, the paint-

[7]Richard Schickel, *The World of Goya: 1746–1828* (New York: Time-Life, 1968), p. 172.
[8]Ibid., p. 168.
[9]Kathy Acker, "Realism for the Cause of Future Revolution," in *Art After Modernism*, p.
31.
[10]Ibid., p. 38.

ings are said to be "about" language, which in itself is a modernist move, similar to Laura Mulvey's point in *AAM,* citing a film scholar, that Hitchcock's *Rear Window* is a "metaphor for the cinema. Jeffries is the audience, the events in the apartment block opposite correspond to the screen. As he watches, an erotic dimension is added to his look, a central image to the drama."[11] The difference between Mulvey's article and Acker's text is that Acker tries to do in one piece what Mulvey divided between the two modes of research – heurctic and hermeneutic, between her filmmaking and film theory. Thus Acker states the theoretical problem of the gaze, the mirror, the voyeur, and its related problematic of subject positioning, the gendering function of representations:

Realism: Caravaggio simultaneously shows me this and makes me/my perceptual mode be this; (since the cut-off head isn't looking at me but downward and into himself, I'm not being desired: I'm cut off from the sexuality I see). I'm being totally denied. I scream. I live in this world.[12]

At the same time, she works on a different realism in which her text crosses between art and life, representation and reality, against the facts of representation ("A description can't be that which it is describing"). Her hypertext, that is, is not only a description, like that of the Goya scholar whom she cites, but a reaction that in turn produces in the reader the feeling that the description says is produced by the paintings. Her project is *realism:* "the unification of my perceiving and what I perceive or a making of a mirror relation between my world and the world of the painting." Thus she draws on the discourse of the novelist to create these effects, which may be experienced at full length in such "novels" as *Don Quixote* and *My Death My Life By Pier Paolo Pasolini* (both by Kathy Acker, we need to remember). Such, too, is the new realism of deconstruction.

★ ★ ★

Another name for what Kathy Acker is making is "text," and texts show a deconstructive practice. Text is being invented, in the same way that the essay and the novel were invented for the apparatus of literacy. Within this process there is a place for an assignment with which the student can learn to text ("text" is a verb and a noun), and the designing of this assignment will be a way to demonstrate the heuretics of deconstruction.

Jean-François Lyotard has described the situation of this project:

An artist, a postmodern writer, is in the situation of a philosopher: the text s/he writes, the work s/he accomplishes are not in principle regulated by established rules, and they may not be judged by means of a conclusive judgment, by application to the text, to the work, of known categories. These rules and these categories are what the work or the text seeks. The artist and the writer work thus without rules, and to establish the rules of what will have been made or done. Thus it is that the work and the text have the properties of an event, and thus also that they come too late for their author, or, what comes to the same thing, that their setting down always begins too soon.[13]

[11]Laura Mulvey, "Visual Pleasure and Narrative Cinema," in *Art after Modernism,* p. 371.
[12]Acker, "Realism," p. 41.
[13]Jean-François Lyotard, *Le Postmoderne expliqué aux enfants* (Paris: Galilée, 1986), p. 33.

Artists, postmodern writers, and philosophers make works in this way, Lyotard says, and I would add to this list textualist students. This making enters the problematic of "theory" from a situation not concerned with hermeneutics, with interpretation, or with critique, thus suggesting a possibility of deconstructing the opposition between theory and practice, between pure and applied research. When the student texts, she or he will produce theoretical effects, perhaps produce a theory of text, but not in the manner of an expert or professional specialist. Wlad Godzich describes the nature of this opportunity for rethinking theory:

Paul de Man seems to have adopted another strategy, one that led him to recognize that the mapping of the opposition/dependency of theory and praxis, left aesthetics free standing. In a first movement, he restores the ancient relation between *aesthesis* and *theoria* and problematizes their relation. . . . We ought not lose sight of the fact that de Man's remapping has liberated praxis from the hold that theory has had over it. It is incumbent upon us now to deal with praxis, though it becomes rapidly clear that our old ways of dealing with it, beholden as they were to the supremacy of theory and the autonomy of *aesthesis,* will not do. Praxis thus stands as a rather mysterious entity presently.[14]

★ ★ ★

To learn how to text requires learning this new praxis. One of the inventors of text, it turns out, conducted his invention precisely by exploring this hybrid mode of thought, continually crossing between discourses and categories, which we can now recognize as a making, heuretics, working with the materials of theory and science in the manner of an artisan. Roland Barthes belonged to the world of the artisan, explains Yves-Alain Bois, recalling his years spent as a student in Barthes's seminar: "But an artisan of a strange sort, one who was unfazed by the transformation of the means of production and the advent of the machine. He communicated not knowledge, but know-how: he taught us his experience."[15] What Bois learned from Barthes were "studio techniques," he says, not method but "practical formulations or protocols general enough to address all contexts: 'Always look behind Nature, for History.'" "These recipes I spoke of had to be deciphered by each of us, in our own way, between the lines of his discourse. Because he didn't show us how to write really, but how to put ourselves in a situation to write."[16]

This putting into a situation is just what students must have too. It is what my assignment must do for them. Bois says that Barthes achieved this effect by knowing how to tell a story, as Walter Benjamin describes storytelling – as "an artisanal form of communication": "It doesn't attempt to transmit the pure 'in itself' of something, as does a news story or a report; it locates something within the very life of the narrator, and from that life later borrows it back. It imprints the narrator's sign on the story, as the potter leaves the trace of his hands on the clay."[17] Barthes taught by making, by showing himself "in the act of enunciation," tell-

[14]Wlad Godzich, "Foreword: The Tiger on the Paper Mat," in *The Resistance to Theory* (Minneapolis: University of Minnesota Press, 1986), p. xviii.
[15]Yves-Alain Bois, "Writer, Artisan, Narrator," *October* 26(1983):30.
[16]Ibid.
[17]Ibid., p. 32.

ing the apprentices his story of apprenticeship, and above all *showing* this telling.

Composition and rhetoric classes provide a "natural" home for text, in that they have always attended as much, if not more, to "know-how" statements as to "know-that," with the history of craft reminding us that the former are never reducible to the latter. With text one does not have to choose between "skills" and "content," for when Barthes's metaphors for "text," seemingly so strange when encountered in the setting of academic theory, are read in the context of artisanal craft, they lose much of their obscurity. Barthes described his procedure as a "metaphorical exploration," saying that was the *only* way to approach text, which could be understood not by definition but by fabrication. When he did explain, then, it would be in this manner:

> Thus, on several occasions the seme is "cited"; we would like to give this word its tauromachian meaning: the *citar* is the stamp of the heel, the torero's arched stance which summons the bull to the banderilleros. Similarly, one cites the signified (wealth) to make it come forth, while avoiding it in the discourse.[18]

But this *citar* is just the sort of heuristic imagery for guidance of the mind and body that is typical in the discourse of craft, which has recourse to every manner of gesture, diagram, picture, demonstration, sample, example, model, image, in order to lead the practitioner, to help develop an eye, an ear, a nose for the skill in question. Summarizing the style of craft language, one commentator lists three characteristics for "descriptive showing": "its often fragmentary, metaphoric suggestiveness; its mainly associative patterns of inference or explanation; and its phenomenalistic bias or relatively high degree of observationality of its terms."[19] The heuristic imagination, that is, must build for itself a vivid image of what is to be produced, a procedure for performing that applies as much to skills that are themselves propositional, such as theoretical, philosophical (or postmodern) writing, as it does to physical performances (the studio arts, sports, traditional crafts, and the like).

In his last seminar at the Collège de France (1978–9), entitled "The Metaphor of the Labyrinth: Interdisciplinary Research," Barthes invited a small group to "witness his words," which is to say, invoking Daedalus, "inventor of the maze, patron of skilled craftsmen," Barthes performed *theoria* in its original sense. *Theoria,* in its Greek meaning, referred to a group of individuals (each bearing the title of *theoros*) whose function, on certain occasions of considerable importance, was to "see and tell": "They were summoned to attest the occurrence of some event, to witness its happenstance, and to then verbally certify its having taken place," thus providing a basis of certainty for settling later debate regarding the matter.[20] The goal of the seminar, as reported by one of the students, was to isolate some aspects of a method of research by "questioning our own heuristic proceedings." "The method adopted was that of allowing the imagination to speak freely about the metaphors that might convey

[18]Roland Barthes, *S/Z: An Essay,* trans. Richard Miller (New York: Hill & Wang, 1974), p. 22.
[19]V. A. Howard, *Artistry: The Work of Artists* (Indianapolis: Hackett, 1982), p. 109.
[20]Godzich, "Foreword," p. xiv.

the labyrinth," itself understood, relative to Ariadne's thread, to figure the act of writing.[21]

★ ★ ★

Heuristics and heuretics are not exactly the same thing, but, as Barthes's example shows, they are intimately related. Learning how to text, how to deconstruct, must be done heuristically, by means of images and analogies, evoking in the student a craft for how to go on, of what to do. Barthes provided an important clue for just such a heuristic analogy in "From Work to Text" (included in *AAM*).

The history of music (as a practice, not as an "art") does indeed parallel that of the Text fairly closely: there was a period when practicing amateurs were numerous and "playing" and "listening" formed a scarcely differentiated activity; then the two roles appeared in succession, first that of the *interpreter* to whom the bourgeois public . . . delegated its playing, then that of the (passive) amateur, who listens to music without being able to play. We know that today post-serial music has radically altered the role of the "interpreter," who is called on to be in some sort the coauthor of the score, completing it rather than giving it "expression." The Text is very much a score of this kind.[22]

Brian Eno's discussion of composition in experimental music helps to clarify the relevance of Barthes's comparison of text to postserial music. Indeed, both the assignment and the student's text might be conducted musically, using the new principle of composition Eno describes (citing a cybernetician): "instead of trying to specify it in full detail, you specify it only somewhat. You then ride on the dynamics of the system in the direction you want to go."[23] The score for an experimental piece may be quite modest, or open, indicating only certain parameters, but very few precise constraints on the performer. In contrast with classical composition, which he says ignores or subdues the variety generated in performance, the experimental compositions make this variety the substance of the music.

As an example of such a piece, Eno discusses Michael Nyman's "1–100 (Obscure 6)," in which "four pianists each play the same sequence of one hundred chords descending slowly down the keyboard. A player is instructed to move on to his next chord only when he can no longer hear his last," a judgment dependent on several variables, so that the players fall out of sync. Not the least interesting feature of this piece is the great beauty that results from the accidents of its performance. More immediately important is not only the way it allows for variation in performance, but also the simplicity of its premise, suggesting a basic procedure whose execution produces a work. Nor does the performance require expert skills for its execution; it could be played by amateurs.

Other examples, such as Gavin Bryars's "Jesus' Blood Never Failed Me Yet" (chamber orchestra added to a prerecorded tape loop of a tramp singing a hymn), are based on "found" materials that are then reorgan-

[21]Pierre Rosenstiehl, "The Dodecadedale, or In Praise of Heuristics," *October* 26(1983):24.
[22]Roland Barthes, "From Work to Text," in *Art after Modernism,* p. 174.
[23]Brian Eno, "Generating and Organizing Variety in the Arts," in *Breaking the Sound Barrier: A Critical Anthology of New Music,* ed. Gregory Battcock (New York: Dutton, 1981), p. 135.

ized by the composer. Eno's conclusions derived from such works, which he contrasts with classical composition, are especially relevant to us, because he identifies the instructions given in such hybrid scores precisely as *heuristic,* defined as "a set of instructions for searching out an unknown goal by exploration, which continuously evaluates progress according to some known criterion."[24] This heuristic manner of organization, Eno adds, which regards "the irregularities of the environment as a set of opportunities around which it will shape and adjust its own identity," is undoubtedly generalizable to other activities.

★ ★ ★

The assignment, then, might be a score, as relayed from experimental music, with the environment to be exploited by our students being precisely our disciplinary encyclopedia, including creative and theoretical works. We want to explore these materials, just as Eno says, in a way that could be analogous to performing "Fluxus" music. For what did, or does, Fluxus want to achieve with its scores but the making of music from the position of reception?

Experimental music emphasizes an unprecedented fluidity of composer/performer/listener roles, as it breaks away from the standard sender/carrier/receiver information structure of other forms of Western music. In experimental music the perceiver's role is more and more appropriated by the performer.[25]

The analogy is justified, regardless, to the extent that Fluxus originated, as it did at least in part, in the pedagogy of John Cage, in whose classes, as Michael Nyman himself explains, there was frequent recourse to toys and the simplest activities (a heuristic teaching of composition theory and practice). Text, according to Lyotard, is "event," so the "event scores" composed in the Fluxus frame by George Brecht, such as "Drip Music" – "A source of dripping water and an empty vessel are arranged so that the water falls into the vessel"[26] – could provide a mode of exercises to help the student get the feel of text.

Dick Higgins defined Fluxus events as "intermedia" – occurring between media, hybrids between any two extant or institutionalized forms or modes, which makes Fluxus an excellent model for negotiating the circuit of invention, and for the poetics of digitalized multimedia in an electronic culture. George Brecht defined event scores, in which a typical instruction might be "discover or make; on(to) a piano," as "poetry through music, getting down to facts." Part of the lesson of a Fluxus score is that it is designed to liberate the performance from intention, to be replaced by a procedure or operation. If I think of the assignment as an event score, I might learn how to compose its instructions in the manner of Fluxus using experimental notation:

Many of these notations move further along the road to a completely nonrepresentational situation – no longer is a particular sound heard and translated into a graphic symbol which represents the "image" of the sound to be reproduced. Many in fact represent a certain kind of work to be done so as to arrive

[24]Rosenstiehl, "The Dodecadedale," p. 24.
[25]Michael Nyman, *Experimental Music: Cage and Beyond* (New York: Schirmer Books, 1974), p. 20.
[26]Ibid., p. 64.

at a point of being able to make an action (or actions) to produce a sound (or sounds)![27]

The notations conveying the assignment, then, would not tell the students what to do in the algorithmic way of traditional pedagogy, which reflects the classical organizational form, whose purpose, as Brian Eno notes, is to reduce variety: "it operates accurately and predictably for one class of tasks but it is not adaptive. It is not self-stabilizing and does not easily assimilate change or novel environmental conditions."[28] The algorithmic score or assignment requires "a comprehensive set of instructions for reaching a known goal." The text assignment, rather, must suggest a procedure or process in the performance of which the student will come into contact with – and then and only then understand – text. With its musical framing, Fluxus can show us how to "play" – playing music in this simple way introducing us, heuristically, to the project of playing textually with cultural materials.

★ ★ ★

The precompositional task of any students given Acker's "Realism for the Cause of Future Revolution" as a relay for text would be to identify its generic features by categories derived from the intertext provided in *AAM*. At least three kinds of guides are available: general arguments – such as the debate among Mulvey, Penley, Linker, Baudrillard, and others regarding the problematic of subject construction and positioning within the culture of our society – that offer a rationale for the experiment; descriptions of many works made by artists and critics in relation to this problematic could be inventoried and cross-referenced to find a "concept" of a postmodern style or mode. Most importantly, the discussions in several of the articles may be *read as instructions,* providing ready-made generalizations with which Acker's practice may be paired. The descriptors emerging out of such a reading of *AAM* include principally the terms "text," "hybrid," "deconstruction," "appropriation," and "allegory" – a nuclear family, not to be split.

Perhaps the most useful article in the collection for clarifying the instructional value of these terms is Craig Owens's "The Allegorical Impulse: Toward a Theory of Postmodernism." Indeed, part of the interest of this anthology, considering postmodernism across all the liberal arts, is what it reveals about the dissemination of "deconstruction" outside of literary criticism. The debate about the political nature of deconstruction, with the enemies of poststructuralism insisting that it is at best apolitical, and at worst reactionary in essence (using as ad hominem proof the recent discovery of an anti-Semitic article authored by Paul de Man in 1942), might be altered considerably with an awareness of the heuretic career of the practice. Whatever the political status of deconstruction might be in its present state of development or stagnation in hermeneutics, its heuretic status is explicitly political, being a fundamental aspect of the interventionist project. The assumption of deconstruction, as an immanent critique, is that there is

[27]Ibid., p. 55.
[28]Eno, "Generating and Organizing," p. 140.

no position outside the subject positioning of our culture from which to perform analysis.

The deconstructive strategy outlined in *AAM* is to appropriate the hypotext carrying the myths of the dominant ideology, and to subvert that discourse by introducing into its flow new versions, alternatives that are more liberating, open to the receiver's participation, which is to say that it submits to the necessity to participate in what it denounces. The deconstructive text, then, shows its character most clearly as intermedia when the composer works in the form of popular culture, but with the purposes of critique. This fit between popular formulas and the allegorical impetus of deconstruction suggests the possibility of inventing a genre that is at once popular and scientific, mythical and learned:

> The Western, the gangster saga, science fiction – these are the allegories of the twentieth century. They are also the genres most intimately associated with film; that film should be the primary vehicle for modern allegory may be attributed not only to its unquestioned status as the most popular of contemporary art forms, but also its mode of representation. Film composes narratives out of a succession of concrete images, which makes it particularly suited to allegory's essential pictogrammatism.[29]

In allegory, heuristic images may become theories; studios may become think tanks.

Owens showed that allegory can be used to achieve the text effect, being a way to make a critique that is subversive of the myth of subject construction by exposing and bringing into question the operations of identification. His description of postmodern allegory, defined most simply as occurring whenever one work doubles another, when one work is read through another – palimpsest, in a word – may be mapped easily onto Acker's text, which, as we have seen, performs the allegorical function of doubling back on itself to provide its own commentary. Owens reiterated much of what has already been said regarding text, concerning not only that in postmodernism meaning is constructed from the position of reception, but also that – and this is the key to the genre and to the peculiar quality of heuretic or hypertextual critique – reading in this position is fundamentally problematic. It is not a position of certainty, but is an attempt to continue thinking, to sustain thinking by writing, in a destabilized condition, when neither individualist *self* nor socially constructed *subject* offers any certainty or clear identity.

In short, the composer of text is *perplexed,* as Owens said of the state with which many allegories begin. His example is Laurie Anderson's *Americans on the Move,* in which she uses the image of getting lost while driving as an image of consciousness. This condition of being lost – as a story of the failure of reading, in de Man's terms – of traveling, perplexed, through the signs of a world, which could describe Acker's response to the paintings by Goya and Caravaggio, this is the story the student might use to traverse a hypotext (to borrow Gérard Genette's term for the "source" work), noting and reconstructing not so much the pleasure of this interaction, which anchors one in the dominant ideology, recognizing and identifying with the mythology closing the

[29]Craig Owens, "The Allegorical Impulse: Toward a Theory of Postmodernism," in *Art after Modernism,* p. 230.

contradictions of the tale, or the binary logic of the concepts – not pleasure, but jouissance, the more complex feelings Acker spoke of, demonstrating the effects of reception, granting the receiver of that composition the ability to continue the series, to want to find out for oneself the pragmatics of participation in a culture. The difference between a hermeneutic assignment and a heuretic one is similar to the difference Umberto Eco noted between structural analysis and serial arts:

> The fundamental goal of serial thought is to make the codes evolve historically and to discover new ones, and not to return progressively toward the original generative Code (the Structure). Serial thought envisions the production of history, and not the rediscovery beneath history of the intemporal forms of all possible communication.[30]

★ ★ ★

With allegory in mind, in the context of Fluxus, I want to look at someone who accepted the Fluxus assignment for himself and made something that might count, perhaps provisionally, as an example of text, of what the product of text as event might be. The feeling it evokes is allegorical, remembering that Fluxus works are intermedia, not medium-specific, hybrids. Perhaps I might borrow from the account of the maker's intention, as from an event score, a set of procedures for coming into the zone of text, for a deconstructive assignment.

The work is *Detective* – part of a series called "Lessons of Darkness" – by the French artist Christian Boltanski. It is a kind of "archive," consisting of four crudely constructed wooden shelves holding cardboard boxes and twelve framed collages of photographs with clamp-on lamps (Fig. 3). (In other versions, the photographs are taped to the fronts of the boxes, or the cardboard boxes are replaced by biscuit tins.) The photographs are appropriated from a French crime magazine called *Detective* (he used every photograph from all the issues published in 1972 and 1973). The photos, acquired by the magazine from the family albums of victims and criminals, were used to illustrate the tabloid prose describing the crimes:

> Now it's impossible to know who is the victim and who is the murderer, because half are murderers and half are victims. And in the boxes you have the stories of these people, but you can't open the boxes. If you opened the cardboard box you wouldn't understand anything anyway because the stories and the faces are mixed up. When you see a face on the box, it's not that person's story that's inside, it's another story. The idea of the work is that perhaps we're all both murderer and victim.[31]

Boltanski has been interested in the family photo album for some time, making a variety of works in that mode (and other amateur or public, nonart uses of the portrait photo, such as school year books), but always reworking the materials appropriated from everyday life into simulations, or "docufictions." In *Research and Presentation of Everything That Remains of My Childhood, 1944–1950,* described typically as an "archeological inquiry into the deepest reaches of my memory" (following his practice of couching his simulations in scientific forms, especially imi-

[30]Eco, *La Structure,* p. 352.
[31]Christian Boltanski, "Interview," *Bomb* 26(1988–9):26.

tating the displays found in museums of natural history), Boltanski produced a book of photocopied snapshots of objects from his childhood (most of which actually belonged to his nephew).[32] His goal in such works, he says, is not at all to represent his autobiography, but to explore and evoke familiar cultural types, archetypal gestures, to create an archive or "model images" of generic "normal" or collective life.[33]

The ultimate referent for these "pictures," based on an association of the photograph with death, as memorial, is the Holocaust, with the mass of snapshots, as in *Detective,* suggesting the mass of anonymous victims of the camps. Boltanski need not make any explicit reference to the camps, because, given his textual mode of composition, he counts on the ubiquitous presence of the Holocaust in our collective memory, in our cultural or referential code, to provide inevitably that association. Following the Fluxus example, his "compositions" are not meant as "art," but something else having to do with the problematic relationship between the public and private spheres:

I work with the idea of collective memory. The idea is that a piece of art is always made by the person looking at that art. I send a stimulus so that each person sees something different. If we look at a photograph of a boy on a beach, you and I see something different; while *I* see a beach in France, *you* see a beach in England. I try to send an open message so that everyone can reconstruct a private story.[34]

★ ★ ★

Must the textual assignment be allegorical? Must it persist in performing what it has shown to be impossible to do (the way Roland Barthes exposed himself in the midst of enunciation, denying as he went the generalizability of his inventions)? Or will it come in the style of a problem, even an enigma, which will be the source of the seeming impossibility, accompanied by the institutional imperative to perform, placing the students thus in a double bind that sets their heads to spinning gold out of straw, caught between a king and a dwarf?

Because text is a process, it is desirable not to assign it for its own sake, directly, but as a problem-solving strategy. Text is not so much a way to solve a problem in the conventional sense, but a way for the student to enter into a working relationship with a problem in the discipline. It is a heuretic way to address a problem – to perform the problem, and thus experience or feel the features of the materials in their resistance to understanding (in their nature as problem). Precisely because they do not know how to proceed in the face of this enigma, the composers will have to text, bringing to bear the full organizing force of their perplexity on the materials, guided by the statement of the problem.

In principle, any problem, or rather any problematic, currently addressed in the discipline will work, as long as it is truly a problem for which as yet there is no solution, or regarding which there is no con-

[32]Lynn Gumpert, "The Life and Death of Christian Boltanski," in *Christian Boltanski: Lessons of Darkness* (Chicago: Museum of Contemporary Art, 1988), p. 63.
[33]Mary Jane Jacob, "Introduction," in *Christian Boltanski,* p. 11.
[34]Christian Boltanski, "Little Christians: Interview," *Artscribe International* (Nov./Dec. 1988):48.

sensus. This proviso poses no difficulty, because the sorts of problems distributed to the humanities, within the present cognitive jurisdictions permitted by scientific hierarchy, are precisely those without any answers.

Consider the intelligence of *Detective* in this context. The title tells us (or tells the original audience − the French public − but we have our own equivalents of the genre) that we are dealing with a product of popular culture, whose operations of sublating the documents of family life (snapshots) into the mythology of crime narrative are part of the purpose of the work to expose, and then to continue the circulation in its own turn, by a collage process, remotivating the doubly found images to resonate with another set of meanings, more critical, or more reflec-

3 Christian Boltanski,
Detective.

tive, with quite different overtones. The simplicity of the construction is important, too, the simplest version being the one made for the catalogue for the traveling exhibition ("Lessons of Darkness"), consisting of the title and seventeen pages of the collage of snapshots.

Why does *Detective* seem so textual? It could have something to do with the proximity of the piece to the emotion of *Camera Lucida,* in which Barthes set out to learn how to think with his feelings – to feel his way, we might say, thinking of our heuristic strategy. Knowing of the association of the Holocaust with Boltanski's various photographic displays, we could also think of Lyotard in this context, and his notion of the "differend." The question he takes up, in his turn, is how to think, how to reason, how to make art, after Auschwitz. A differend "would be a case of conflict, between (at least) two parties, that cannot be equitably resolved for lack of a rule of judgement applicable to both arguments,"[35] the chief example being the legitimacy of the "final solution." In the absence of any such rule, we are left with an absolute heterogeneity or discontinuity that disrupts logic and puts rationality itself in jeopardy. Lyotard's project, in such a situation, attempting to continue rational discourse that does not simply deny or ignore the challenge put to it by Auschwitz, is to discover the necessary rule by writing about it. His genre "is that of Observations, Remarks, Thoughts, and Notes which are relative to an object; in other words, a discontinuous form of the Essay. A notebook of sketches? The reflections are arranged in a series of numbers and grouped into sections."[36]

Lyotard's strategy is to try to reply to one of those who, in fact, deny that the Holocaust actually took place. Can such a position even be addressed? His search for a genre, for a set of rules capable of linking the incommensurable phrases in this argument, one of the grandest themes of our times, has many lessons for others working on more humble problems, but who find (and this is what makes Lyotard's project exemplary) that the old linkages and syntaxes have dissolved everywhere, creating a radical crisis of "genre." Nor is it a matter of deciding whether or not to reason through the crisis using objectivist conceptuality, because there is no concept for the condition. What remains, however, even as knowledge falls silent, is "a feeling" that is "a sign for the common person":

They will say that history is not made of feelings, and that it is necessary to establish the facts. But, with Auschwitz, something new has happened in history (which can only be a sign and not a fact), which is that the facts, the testimonies . . . , all this has been destroyed as much as possible. Is it up to the historian to take into account . . . not only the testimony, but also what is left of the testimony when it is destroyed (by dilemma), namely, the feeling?[37]

The witnesses, in the group called *theoria,* are of no help in the circumstances of the differend. The testimony, then, must be replaced by a simulation, a heuristic sample, letting the people judge for themselves the claims of the *theoros.* The value of something like Boltanski's *Detective*

[35]Jean-François Lyotard, *The Differend: Phrases in Dispute,* trans. Georges Van Den Abbeele (Minneapolis: University of Minnesota Press, 1988).
[36]Ibid., p. xiv.
[37]Ibid., p. 57.

is that it provides an event score for doing the work of this simulation, filling the silence of knowledge with the materials of everyday life, in the way that art has always been able to work without concept, as Brian Eno says, to "give us a feel" for the new organizational structures that are needed in a world of which Auschwitz and the differend are just symptoms.

"But then," Lyotard continues, "the historian must break with the monopoly over history granted to the cognitive regimen of phrases, and he or she must venture forth by lending his or her ear to what is not presentable under the rules of knowledge." Boltanski and Fluxus demonstrate at least one way to undertake this "venturing forth," for bringing into some kind of organization and thus making available for thought, and for further articulation, the materials of a culture that is losing its rules of coherence. Thus the genre of our assignment may not itself be the genre that replaces the differend, but it can make accessible to our students the project of an invention in which something real is at stake.

How to state the assignment? Why not begin with the fable that Derrida borrows from Francis Ponge, entitled "Fable":

FABLE
By the word by commences then this text
Of which the first line states the truth
But this silvering under the one and the other
Can it be tolerated?
Dear reader already you judge
There as to our difficulties . . .

*AFTER seven years of misfortune
She broke her mirror.*[38]

The fable shows an allegory of invention, of the peculiar temporality and syntax of timing operating in the making of something new. Consider it as an event score, not just for one text, but for the text as a mode with the same level of generality possessed by the terms "drama" or "poetry." Rather than confining the instructions to "Fable," have the students consult *Vicious Circles and Infinity: An Anthology of Paradoxes,*[39] coedited by Flux-person George Brecht, as a kind of guide to the possibilities of visual and verbal self-reflexive productions. What do the entries in such a collection demonstrate? The steps of a method; they are to deconstruction what mythology is to literature.

[38] Jacques Derrida, "Psyche: Inventions of the Other," trans. C. Porter, in *Reading de Man Reading,* ed. Lindsay Waters and Wlad Godzich (Minneapolis: University of Minnesota Press, 1989), p. 30.
[39] *Vicious Circles and Infinity: An Anthology of Paradoxes,* ed. Patrick Hughes and George Brecht (Garden City, N.Y.: Doubleday, 1975).

IMPURE MIMESIS, OR THE ENDS OF THE AESTHETIC

D. N. RODOWICK

> └─ tout fleurira au bord d'une tombe désaffectée . . .
> – Jacques Derrida, *La Vérité en peinture*

WITH respect to the activity of aesthetic judgment, we are living in an age of reaction. Not only do the writings of the "cultural literacy" movement represent a reactionary politics, but also their views indicate a palpable withdrawal from history. Paradoxically, within their ranks this phenomenon is cause for both celebration and mourning. In political economy, the end of History, with capitalism triumphant, has been proclaimed; at the same time, neoconservative educators agonize over the end of the aesthetic.

As recent challenges to NEA funding for "controversial artists" demonstrate, in question here is what can be counted as "artistic" or "aesthetic" activity. The appeal to the universality of Western European values in this respect is curious, because the modern use of the term "aesthetics" – a product of Enlightenment philosophy – is less than 200 years old. According to the *Oxford English Dictionary,* it had no widespread acceptance in English until the latter half of the nineteenth century. A history of the transformation of the Greek term *aisthesis* – referring generally to problems of sense perception, and having its own complex history – into our modern sense of the term "aesthetic," as well as the range of meanings and activities it defines, would be of inestimable value, but beyond the limits of my present argument. As Raymond Williams points out, our modern idea of the "aesthetic" developed over time as a systematic retreat in philosophy from understanding the social and historical meanings of representational practices.[1] Thus a critique of the "political economy" of art would have to confront two interrelated ideas: first, the autonomy of the aesthetic as an interiorized,

I dedicate this essay to the memory of Craig Owens, who offered so much to a contestatory criticism, thus fulfilling Nietzsche's motto: *Was fällt, das sollt Ihr stoßen!* I would also like to thank Dana Polan, Peter Brunette, and David Wills for their comments and criticisms of earlier drafts of this essay.

[1] *Keywords* (Oxford: Oxford University Press, 1976), p. 28. For a concise account of *aisthesis,* see F. E. Peters's *Greek Philosophical Terms* (New York: New York University Press, 1967), pp. 8–15 passim. This problem has been addressed recently in important and different ways in David Wellbery's *Lessing's Laocoön: Semiotics and Aesthetics in the Age of Reason* (Cambridge University Press, 1984), Terry Eagleton's *The Ideology of the Aesthetic* (London: Basil Blackwell, 1990), and Howard Caygill's *Art of Judgement* (London: Basil Blackwell, 1989).

subjective activity, as opposed to social and collective ones; second, the value and self-identity of autonomous art as free of monetary value. The emergence of the aesthetic in the eighteenth and nineteenth centuries is intimately linked both to problems of epistemology – deciding cognitive relations between subject and object – and to the theory of signs – the problem of representation, how signs differ from each other and in their mediate relation to knowledge. A deconstruction of the "aesthetic" might hasten the dissolution of this concept, already pushed to the extreme limits of its internal contradictions by the demands of contemporary capitalism, thus liberating new concepts for understanding transformations in the semiotic environment that are already taking place.

Jacques Derrida has introduced a number of questions that this genealogical critique should address in his reading – in "Parergon," in *The Truth in Painting* and "Economimesis"[2] – of Kant's analytic of aesthetic judgment in *The Critique of Judgement*.[3] Derrida demonstrates how Kant's conception of the ends and activities of art strategically obscure the inability of Enlightenment philosophy to bridge or to resolve distinctions between mind and nature, subject and object. From the eighteenth century, the problem of hierarchical distinctions among the arts is based on an interiorization of subjectivity that identifies "discourse" with speech and pure thought, as distinguished from external perceptions derived from nature. This particular division of the verbal and the visual simultaneously elevates poetry as the highest art (because it is closest to speech and thus to thought), while identifying and ranking other artistic forms through an analogy with speech and linguistic meaning.

The question of aesthetic value is also paramount. Derrida's reading of Kant through the condensation "economimesis" elaborates the central issues that a genealogical critique of the idea of the aesthetic in Enlightenment thought must address. This is not simply a question of conjoining the "aesthetic" (mimesis as a process of imitation in relation to nature) and the "economic," thereby demonstrating the allegiance of art to ideology as well as its reliance on capital. Derrida examines how the idealist elaboration of the aesthetic as an ontological question increasingly excludes consideration of the material and historical forces that are continually transforming representational practices and aesthetic experience. Idealist philosophy serves – through the elaboration of the aesthetic – to

[2] The former first appeared in book form as "Parergon" in *La Vérité en peinture* (Paris: Flammarion, 1978), pp. 21–168. I will cite mostly from Craig Owens's translation of pp. 41–94, which appeared as "The Parergon" in *October* 9(Summer 1979):3–40. [Excerpts here are reprinted with permission from the University of Chicago Press.] An alternative translation by Geoff Bennington and Ian McLeod has appeared in *The Truth in Painting* (Chicago: University of Chicago Press, 1987), pp. 34–82. "Economimesis" was initially published in Sylviane Agacinski et al., eds., *Mimesis des articulations* (Paris: Aubier-Flammarion, 1975), pp. 57–93. I will cite from R. Klein's translation, which appeared in *Diacritics* 11(1981):3–25. [Excerpts here are reprinted with permission from the Johns Hopkins University Press.]

[3] Owens uses J. C. Meredith's translation of the *Critique of Judgement* (Oxford: Oxford University Press, 1952 [1928]), p. 85. In his translation of "Economimesis," R. Klein uses the 1892 translation by J. H. Bernard (New York: Hafner Press, 1951). When in my text I cite Derrida citing Kant, readers can assume that I am following Owens's and Klein's choices. On occasion I will also use Werner S. Pluhar's translation (Indianapolis: Hackett, 1987), which will be referred to as *COJ*. I have compared all translations to the version of the third *Critique* published in German as *Kritik der Urteilskraft* (Frankfurt am Main: Suhrkamp Taschenbuch Verlag, 1974).

create an inverse ratio between the ontological and the historical. Derrida explores only one side of the question, namely, a critique of the onto-theological foundations of the "aesthetic." However, he does open the possibility of understanding how assertions of the autonomy and universality of the aesthetic become ever more strident, as representational practices become increasingly dominated by patterns of consumption and exchange governed by the logic of commodities and the emergence of a mass public. In the current stage of development of capital, it is not that the aesthetic is now threatening to disappear, as the critics of reaction fear. Rather, it has never in fact existed, except as an ideology, in the terms elaborated since the eighteenth century in Western philosophy.

Derrida's reading of Kant is not about the interpretation of artworks, nor is he concerned with the goals and objectives of aesthetics. Instead, he performs a critical reading of the way in which an idea of the aesthetic emerges in philosophy as one of its specific areas of inquiry. Kant is a predecessor as well as an adversary in this respect. In order to claim a specific territory for aesthetic judgments as essentially different from moral and scientific judgments, Kant critiques both Lord Shaftesbury and Francis Hutcheson, who equate moral and aesthetic judgments with matters of feeling, and Alexander Gottlieb Baumgarten, who attempts to ground judgments of the beautiful in rational principles, thereby elevating aesthetics to the rank of a science. Thus Kant's third *Critique* is privileged for its exemplarity: its demonstration of how the conceptual identity of the artwork, and the organization of the domain of aesthetics, emerged in modern philosophy. By the same token, Derrida finds the problem of the example itself to be the most important and most fragile element of Kant's argument.

In *The Truth in Painting,* the chapter on the parergon in particular traces how the domain of aesthetic inquiry emerges in Kant's philosophy – that is, how the aesthetic attempts to define itself, to mark off its borders, and to give itself activities and ends distinct from other forms of philosophical work. In his opening paragraph, Derrida establishes a historical topography, beginning with the *Critique of Judgement,* which insists that the question of art be asked ontologically. As Derrida explains, this paradigm demands that,

> We must know of what we speak, what concerns the value of beauty *intrinsically* and what remains external to our immanent sense of it. This permanent demand – to distinguish between the internal or proper meaning and the circumstances of the object in question – organizes every philosophic discourse on art, the meaning of art and meaning itself, from Plato to Hegel, Husserl, and Heidegger. It presupposes a discourse on the limit between the inside and the outside of the art object, in this case a *discourse on the frame.*[4]

Kant opens the terrain that modern aesthetic inquiry occupies. But the paradox of Kant's analysis is that his solution to the specificity of aesthetic judgments *creates* the dilemma it was designed to resolve. The very insistence on enframing – defining on one hand the self-identity of art, and on the other the specificity of aesthetic judgments – is what in fact *produces* the divisions between object and subject, inside and outside,

[4]Derrida, "The Parergon," p. 12.

mind and nature, that the third *Critique* claims to transcend. While enclosing and protecting an interior, the frame also produces an outside with which it must communicate. If the third *Critique* is to complete its teleological movement, this externality must also be enframed – a process creating a new outside, a new necessity for enframement, and so on ad infinitum. For Derrida, this is the *energeia* of parergonal logic.

For Kant, the principal goal and problem of the *Critique of Judgement* is to identify a bridge between his first two critiques, those of pure and practical reason. Derrida cites Kant's own assessment of the problem:

[B]etween the realm of the natural concept, as the sensible, and the realm of the concept of freedom, as the supersensible, there is a great gulf fixed, so that is it not possible to pass from the former to the latter (by means of the theoretical employment of reason), just as if they were so many separate worlds, the first of which is powerless to exercise influence on the second: still the latter is *meant* to influence the former. . . . There must, therefore, be a ground of the *unity*. . . . [5]

Kant poses two separate, absolutely divided worlds across the following concepts: object–subject, nature–mind, external–internal, outside–inside, sensible–supersensible, natural concept or understanding–concept of freedom or reason.

In this respect, Kant's approach to *aisthesis* must be distinguished from that of Greek philosophy. Where the latter elaborates a complex continuum between nature and mind, the material body and immaterial soul, *aisthesis* and *noesis,* Kant views them as divided worlds separated by an abyss. Yet some communication must exist between them. This abyss is not to be bridged by pure reason, however, that is, by determinate concepts, because that would make aesthetic and scientific judgments equivalent. A judgment of pure taste requires instead a logic of analogy, of telling examples, of symbols and figures – in other words, a discourse of/on the aesthetic that is governed ultimately by the logic of logocentrism. Here Derrida's reading of "economimesis" is paired with another special condensation: "exemplorality." Through the rhetoric of "as if" introduced in Kant's third *Critique* by the discursive structure of the example, and a logic of semblance without identity originating in analogies referring to the model of speech, a bridge is extended between these discontinuous worlds. Although aesthetic judgment belongs to neither pure nor practical reason, Kant asserts nevertheless that it links them in a metaphysical system by demonstrating what is common to all three.

In a work of pure philosophy, which should stand alone as a complete system of thought, "examples" define one instance of parerga. Indeed, Kant's first use of the term appears in the section on "Elucidation by Examples" (§14) in "The Analytic of the Beautiful." Simply speaking, for Kant, parerga include all of those things that are "attached" to the work of art but are not part of its intrinsic form or meaning: the frame of a painting, the colonnades of palaces, the drapery on statues. They are ornamental – an adjunct or supplement to the intrinsic beauty of the artwork. Parerga border the work (as identity and activity) but are not part of it, they resemble the work without being identical with it, and they belong to the work while being subsidiary to it. As such, the par-

[5] Ibid., p. 4.

ergon encloses the work, brackets it on four sides; yet it also communicates with the outside, attracting or focusing the senses so they may better intuit the work at hand.

The nature of this communication is significant. The object of Kant's *Critique* is not art per se. Art or the making of art has no place in Kant's philosophy. The philosopher has nothing to say, and should have nothing to say, to the painter or poet about the exercise of their arts. The role of the philosopher is to articulate, within her or his proper field, the conceptual foundations that make artistic activity possible and permit it to be intuited and judged. This is a question of the analytic of aesthetic judgment — the specificity of judgment rather than the specificity of art. Just as the analytic of the beautiful must enframe the work of art, defining what is proper to it as an object of pure taste, what is proper to the subject in this experience must be exactly delimited in the conditions of aesthetic judgment.

Aesthetic judgment, therefore, requires a specific formalization of the object–subject dilemma; it concerns the delimitation of the proper objects of pure taste and an analytic of the subjective feeling of pleasure or displeasure arising in relation to them. Kant's meticulous delimitation of the conditions of object and subject in aesthetic judgment, however, has not yet answered the fundamental question of the third *Critique:* How does judgment define the base or foundation of philosophical inquiry by constructing a bridge between pure and practical reason? Derrida notes that for Kant,

Understanding and reason are not two disjunct faculties; they are articulated in a specific task and a specific number of processes, precisely those which set articulation, that is, discourse, in motion. Between the two faculties, in effect, an articulate member, a third faculty comes into play. This intermediary, which Kant rightfully calls *Mittelglied,* middle articulation, is judgment (*Urteil*).[6]

The modality of aesthetic judgments is similarly tied to the forms of speech. Derrida writes that

We are familiar with the example: I stand before a palace. Someone asks me whether I think it is beautiful, or rather whether I can say "this is beautiful." It is a question of judgment, of a judgment of universal validity, and everything must therefore be in the form of statements, questions, and answers. Even though the aesthetic affect is irreducible, judgment demands that I say "this is beautiful" or "this is not beautiful."[7]

Judgment formulates itself as statements, questions, and answers. It is a kind of dialogue, but of what sort? Across a series of divisions — between interlocutors engaged in "aesthetic" conversation, between the subject (spectator) and the object (palace), and within the philosophical subject internally divided in its faculties — a filigree of words is woven. Within the space of the statement, universal communication must occur freely between spatially detached and isolate parts.

Everything eventually returns to the power of *logos* to breathe life into judgment and harmonize the faculties. The key to understanding how aesthetic judgment illuminates the process of philosophical judg-

[6]Ibid., p. 5.
[7]Ibid., p. 11.

ment, however, is expressed in the following question: How can aesthetic judgments appeal to a *universal* consensus and communicability when their origin is radically subjective, individual, and nonconceptual?

This appeal to universality informs Kant's famous emphasis on the disinterestedness of aesthetic judgments, which is defined on the one hand by freedom, and on the other by a noncognitive pleasure: the *Wohlgefallen* proper to the object of pure taste. Freedom, as the realm of the concept of the supersensible, is especially important in Kant's attempt to unify his philosophical system. This indicates, first of all, that aesthetic judgments are detached from all contingent demands or extrinsic motives, especially economic ones. There must be an absolute lack of interest in the object's existence; otherwise the critic cannot operate with perfect freedom. The spectator must have nothing at stake. If the critic invests in the object, as it were, his or her judgment cannot transcend its subjective origins and pretend to universal communicability.

The criterion of universality is also tied to the way Kant uses the idea of freedom to divide and differentiate the activities and ends of the work of art from those of nature, quotidian labor, and science. In this respect, it defines the aesthetic subjectivity of those who create as well as those who judge.

The division of art from nature is the greatest and most important territorial border in the third *Critique*. Doubtless, Kant preserves the classical distinction between *physis* and *technē*, where nature as mechanical necessity is opposed to art as the arena where human freedom is most clearly exercised. Ultimately, the Kantian definition of mimesis – which weaves a bold analogy between how God represents himself in nature, the artist in Fine Art, and the philosopher in judgment – attempts to bridge these oppositions by deriving its "rules" from nature, but only as a free production, rather than mechanical repetition. Like every freedom protected by "laws," however, these rules restrict more than they allow. They instigate hierarchies of rank and privilege, empowerment and disfranchisement, elevated and lowered beings. In this respect, freedom is first of all human freedom; the work of art is always the work of "man" (*ein Werk der Menschen*). In Kant's example, despite their order and symmetry, the works of bees ("cells of wax regularly constructed") cannot be considered works of art. This is the first move in a parergonal logic that divides humanity from animality – raising "man" and his productions above nature, while not being strictly separate from it – in order to bring humanity in general by degrees closer to divinity.

In this hierarchy, mechanical repetition and ends-directed labor are not restricted to animals alone. Derrida points out that Kant's comments on the relations among nature, art, and imitation are placed between two remarks on "salary." The first, in "On Art in General" (§43), divides liberal or free (*freie*) art from salaried or mercenary art (*Lohnkunst*). The second, in "On the Division of the Fine Arts" (§51), declares that "in the Fine-Arts the mind must occupy itself, excite and satisfy itself without having any end in view and independently of any salary." Art appears only in the absence of economy; its significance, value, and means of circulation may not be defined by money. "By right," Kant states, "we

should not call anything art except a production through freedom, i.e., through a power of choices that bases its acts on reason" (§43).

Thus the hierarchy that orders beings in nature according to the relation of humanity to animality replicates itself as a scale evaluating the activity and labor of individuals. As "mercenary" art, craft is based on a vulgar economy and quotidian use. For Kant, however, the artist is no common laborer, as Derrida summarizes in three points. The first is Kant's suggestion that "free art is more human than remunerated work."[8] Just as the play of freedom in artistic activity elevates humanity above the instinctual activity of bees, the "liberal" artist is more fully human than the wage laborer. Second, Kant implies that just as man's elevation in nature empowers him to enlist the utility of animals toward his ends and "higher" labors, so too may the freer individual, the artist, enlist the mercenary work of the craftsperson, or use the vulgar tools of craft, without the value of art being implicated in an economy of usefulness and exchange. Oppositions deriving from nature–man and animal–human are thus reproduced as hierarchies defining the relative value of individuals and their labor, subordinating remunerated work and the lesser freedom of the craftsperson to the higher ends of the artist.

Similar criteria divide art from science and in turn reproduce hierarchical distinctions between mechanical and aesthetic art on one hand, and in aesthetic art between agreeable and fine arts (schöne Kunst) on the other. Here we return to the problem of noncognitive pleasure in aesthetic judgments. For Kant, there is no law applicable to the imagination save what is derived from understanding. When the imagination proceeds only according to a determinate law, the forms produced are determined by concepts. This is the ideal of scientific knowledge where the imagination is subordinated to the elaboration of concepts of understanding. The Wohlgefallen appropriate to scientific statements, for example, derives only from a formal perfection in harmony with concepts; it is experienced as the "good" and has nothing to do with the beautiful as such, which, for Kant, is resolutely nonconceptual.

Unlike the scientist, the pure artist (Genius, in Kant's account) does not require reflexive conceptualization to accomplish exemplary works of fine art. By the same token, the lesser forms of art, and the pleasure defining them, are all characterized by their relative proximity to the conceptual. In Derrida's gloss,

An art that conforms to knowledge of a possible object, which executes the operations necessary to bring it into being, which knows in advance that it must produce and consequently does produce it, such a mechanical art neither seeks nor gives pleasure. One knows how to print a book, build a machine, one avails oneself of a model and a purpose. To mechanical art Kant opposes aesthetic art. The latter has its immediate end in pleasure.[9]

In a similar way, aesthetic art divides into two hierarchic species, for aesthetic art is not always fine or beautiful art. Pure taste has, in fact, a literal meaning for Kant. It elevates or lowers the aesthetic arts according to the criterion of whether their pleasures are empirical or spiritual.

[8]Derrida, "Economimesis," p. 6.
[9]Ibid., p. 8.

Within aesthetic art, the "agreeable arts" – for example, conversation, jest, the art of serving and managing dinner as well as an evening's entertainment, including music and party games – seek their ends in enjoyment (*Genuß*). The *Wohlgefallen* appropriate to fine art, however, involves pleasure without "enjoyment" – at least in the sense of an empirical, if incommunicable, sensation. Being purposive only for itself, it can have no finality in the sense of satisfying a physical appetite or filling an empirical lack, thus yielding Kant's basic definition:

Fine art . . . is a way of presenting [*Vorstellungsart*] that is purposive on its own and that furthers, even though without a purpose [*ohne Zweck*], the culture of our mental powers to [facilitate] social communication. The very concept of universal communicability carries with it [the requirement] that this pleasure must be a pleasure of reflection rather than one of enjoyment arising from mere sensation. Hence aesthetic art that is also fine art is one whose standard is the reflective power of judgment, rather than sensation proper [§44].[10]

Pure pleasure and pure taste belong only to judgment and reflection; at the same time, judgment and reflection must be without concepts. Only on this basis do the criteria of freedom and noncognitive pleasure assure the universality of aesthetic judgment as particularly human by subtracting out the creaturely distractions and temptations of worldly life. If fine art involves the "production of freedom," this is freedom from economic or political interest, and from the finality of scientific investigation or ends-directed labor, as well as a pleasure free of physical appetites.

If the experience of fine art is resolutely without *concepts,* then why should philosophy take an interest, if only the moral interest involving practical reason and concepts of freedom, in the beautiful? This is linked to a second question: Because the definition of judgments of pure taste seems to recede from both the social and the creaturely toward an interiorized, immaterial subjectivity, how does the experience of fine art advance "the culture of our mental powers [with respect to] social communication"? In other words, how is the pleasure – without enjoyment or concept – of art returned to the space of philosophical communication in the predicate "This is beautiful"?

These questions are answered by considering the curious role of mimesis in the third *Critique.* The version of mimesis that Derrida reads in Kant is governed not by a logic of semblance or imitation, but rather by a logic of analogy. For example, Kant defends philosophy's moral interest in the beautiful because, despite its lack of conceptual grounding, the judgment of taste nonetheless *resembles* logical judgment because of its universality. Thus, in aesthetic judgment, the philosopher may

talk about the beautiful as if [*als ob*] beauty were a characteristic of the object and the judgment were logical (namely a cognition of the object through concepts of it), even though in fact the judgment is only aesthetic and refers the object's presentation [*Vorstellung*] merely to the subject. He will talk in this way because the judgment does resemble [*Aehnlichkeit hat*] a logical judgment inasmuch as we may presuppose it to be valid for everyone. On the other hand, this universality cannot arise from concepts. For from concepts there is no transition to the feeling of pleasure or displeasure (except in pure practical laws; but these

[10]*COJ*, p. 173.

carry an interest with them, while none is connected with pure judgments of taste). It follows that, since a judgment of taste involves the consciousness that all interest is kept out of it, it must also involve a claim to being valid for everyone, but without having a universality based on concepts. In other words, a judgment of taste must involve a claim to subjective universality [§6].[11]

By similar criteria of "universality," and despite the abyss that essentially divides humanity from nature, Kant renders art and nature as equivalent, because they share the lawfulness without a law, or purposiveness without purpose (*Zweckmässigkeit ohne Zweck*), that governs their beautiful forms. In both cases, logical relations of identity and nonidentity rest side by side like discordant notes that nevertheless ring with a strange harmony.

In this way, Kant's theory of mimesis asserts the superiority of beauty in nature and derives the beautiful in art from its relation to nature. But that relation is defined not by a logic of the copy but rather by a rhetoric of production and reproduction. In finding common ground between art, nature, and genius, mimesis requires a logic of equivalent activities, not one of mirrors. This implies a third distinction that divides the artisan from the artist as the difference between a reproductive imagination and a productive imagination that is originary, spontaneous, and playful. In Derrida's view, the value of play in Kant defines a form of productivity that is purer, freer, and more human, as opposed to work, which is ends-directed, unpleasant, and exchanged against a salary. Reproductive imagination is therefore a vulgar realism – reproduction in the form of likeness, or repetition as identity. In contrast, productive imagination – regardless of whether it applies to acts of creating or of judging aesthetic objects – is characterized by a paradoxical freedom that is the imagination's "free conformity to law."

The liberties implied here, as well as their limitations, are central to how Kant's notions of mimesis mediate difficulties of subject and object. On one hand, the free play of imagination is limited by the forms of the object intuited: "[A]lthough in apprehending a given object of sense the imagination is tied to a determinate form of this object and to that extent does not have free play (as it does [e.g.] in poetry), it is still conceivable that the object may offer it just the sort of form in the combination of its manifold as the imagination, if it were left to itself [and] free, would design in harmony with the *understanding's lawfulness* in general."[12] A judgment of beauty becomes possible, then, when the harmony of form in the object is intuited as analogous to a harmony in the subject that the imagination would form with respect to the understanding if, paradoxically, the former were left in perfect freedom to conform itself to the lawfulness of the latter.

Resemblance, then, limits the freedom of the imagination, if for no other reason than that it may function as an aim, purpose, or end. And the more semblance between sign and referent, the more extreme are these limitations. On the other hand, without an underlying "lawfulness" there would be no ground for uniting understanding, moral judgments, and judgments of taste, and no language with which to communicate

[11] Ibid., p. 54.
[12] Ibid., p. 91.

them. By a process of analogy this sense of lawfulness without a law and purposiveness without purpose, whose original territory is that of nature, informs and "naturalizes" every reference in the third *Critique* to representation, signification, or language.

Through mimesis, then, art does not imitate nature in the sense of reproducing its visible signs. Art does not reproduce nature; it must *produce like* nature, that is, in perfect freedom. And paradoxically, for Kant the moment in which an artistic production is most fully human – in other words, most clearly and unnaturally fabricated by human hands – is the moment when it most clearly replicates the effects of the actions of nature. Thus Kant writes:

> In [dealing with] a product of fine art, we must become conscious that it is art rather than nature, and yet the purposiveness in its form must seem [*scheinen*] as free from all constraint [*Zwang*] of chosen rules as if [*als ob*] it were a product of mere nature. It is this feeling of freedom in the play of our cognitive powers, a play that yet must also be purposive, which underlies that pleasure [*Lust*] which alone is universally communicable, although not based on concepts. Nature, we say, is beautiful [*schön*] if it also looks like art; and art can be called fine [*schön*] art only if we are conscious that it is art while yet it looks to us like nature [§45].[13]

In their most ontologically pure forms, artistic productions resemble nature most clearly when they have most clearly liberated themselves from natural laws. Art and nature are most analogous in the purity of their freedom from one another. This is Kant's most daring move in the teleological orientation of the third *Critique,* because it turns the chasm between mind and nature, subject and object, into the ground for their unity.

At this point Derrida reemphasizes how a divine teleology, in fact a process of ontotheological naturalization, underwrites the logic of economimesis, securing the identification of human action with divine action. However, this identification does not necessarily subordinate humanity to a God in whose image it has been fashioned. Rather, like the identification with an other on the stage – or, better yet, like a good method actor – the artist produces in his or her activity a divine subjectivity. In this way the logic of economimesis secures the figure of Genius as the exemplar of a divine agency in art where the artist creates – without concepts, as a pure and free productivity of the imagination – in a fashion analogous to the way God produces his works in nature. For Kant, fine art is the art of genius, and genius is a gift of nature, an endowment of its productive freedom. And what nature gives to genius, genius gives to art in the form of "nonconceptual rules." In so doing, genius "capitalizes freedom but in the same gesture naturalizes the whole of *economimesis.*"[14]

The same divine teleology that ranks and orders artistic labor and subjectivity also organizes a hierarchy within the fine arts. According to the logic wherein art and nature are most clearly alike when, in their beautiful forms, they are most different, Kant asserts that poetry is the highest form of expression, as well as the most mimetic, because it most

[13]Ibid., pp. 173–4.
[14]Derrida, "Economimesis," p. 10.

radically rejects imitation. Because the factor of resemblance in signs limits the freedom of the imagination, the imagination is most free and open to play in contemplation of linguistic signs because of their arbitrariness, their noncontingent relation to the natural world, and because the gift of language most clearly marks the abyss separating the human from the instinctual and creaturely. Because of their relation to language, among liberal artists poets are the most free and, in conferring the freedom of the imagination to humanity, are most like God. This relation between God and genius defines the "immaculate commerce" informing Kant's theory of aesthetic communication, and Derrida recognizes the tautology:

An infinite circle plays [with] itself and uses human play to reappropriate the gift for itself. The poet or genius receives from nature what he gives of course, but first he receives from nature (from God), besides the given, the giving, the power to produce and to give more than he promises to men. . . . *All that must pass through the voice.* . . .

Being what he is, the poet gives more than he promises. More than anyone asks of him. And this more belongs to the understanding: it announces a game and it gives something conceptual. Doubtless it is a plus-law [*un plus-de-loi*] . . . , but one produced by a faculty whose essential character is *spontaneity.* Giving more than he promises or than is asked of him, the genius poet is paid for this more by no one, at least within the political economy of man. But God supports him. He supports him with speech and in return for gratitude He furnishes him his capital, produces and reproduces his labor force, gives him surplus value and the means of giving surplus value.

This is a poetic commerce because God is a poet. There is a relation of hierarchical analogy between the poetic action of the speaking art, at the summit, and the action of God who dictates *Dichtung* to the poet.[15]

At the origin of all analogy, then, is the word of God; in the third *Critique* everything returns to *logos* as origin. And for this reason, Derrida argues that the "origin of analogy, that from which analogy proceeds and towards which it returns, is the *logos,* reason and word, the source as mouth and as an outlet [*embouchure*]."[16] Kant's privileging of oral examples, the "exemplorality" of the *Critique of Judgement,* underwrites the crucial function of mimesis in Kant's attempt to resolve the dilemmas of subject and object formulated in his philosophical system.

I have already discussed how Kant's portrayal of "pure" judgments of taste relies on a rejection of empirical sensation and a withdrawal of the physical body. Curious, then, how the centrality of the mouth figures in the *Critique of Judgement.* Above all, in the section "On the Division of the Fine Arts," it organizes a hierarchy among the arts, and in the terms of aesthetic value (taste or disgust), by defining them with respect to the expressive organization of the human body. For Derrida, the figured circle of the mouth, and the circularity of immaculate commerce in spoken communication, organizes a parergonal logic of the subject in Kant. Just as the "frame" of painting had both to protect the intrinsic purity of art and to open up commerce with the outside, the mouth establishes a privileged border between the interiority of the subject and

[15]Ibid., pp. 11–12.
[16]Ibid., p. 13.

an outside that must be represented and communicated to others, whose purest form of expression is speech. For Kant, those individuals who lack any "*feeling* for beautiful nature" are those who "confine themselves to eating and drinking – to the mere enjoyments of sense," or who would prefer the trick of imitating a nightingale's song "by means of a tube or reed in [the] mouth" to the song of the poet celebrating nature in lyric. Therefore, the purest judgment of taste, the truest art, and the purest *Wohlgefallen* passes through orality, but only in a nontactile, nonsensuous fashion. Singing and hearing thus represent "the unconsummated voice or ideal consumption, of a heightened or interiorized sensibility," as opposed to "a consuming orality which as such, has an interested taste or as actual taste, can have nothing to do with pure taste."[17]

The purest objects of taste, as well as the best judgments, pass in and out of the subject on the immateriality of breath, rather than through vulgar consumption or emesis.[18] Similarly, in Kant's *Anthropology,* hearing prevails over sight among the "objective" senses, that is, senses that give a mediate perception of the object. Unlike sight, hearing is not governed by the form of objects that may yield a determinate relation, a restriction of freedom in the play of ideas. Conversely, both voice and hearing have a sympathetic relation to air, which passes outside of and into the subject as communicative vibrations. As Kant writes in his *Anthropology:*

It is precisely by this element, moved by the organ of voice, the mouth, that men, more easily and more completely, enter with others in a community of thought and sensations, especially if the sounds that each gives the other to hear are articulated and if, linked together by understanding according to laws, they constitute a language. The form of an object is not given by hearing, and lin-guistic sounds [*Sprachlaute*] do not immediately lead to the representation of the object, but by that very fact and because they signify nothing in themselves, at least no object, only, at most, interior feelings, they are the most appropriate means for characterizing concepts, and those who are born deaf, who conse-quently must also remain mute (without language) can never accede to anything more than an *analogon* of reason [§18].[19]

This identification of speech with reason and a pure interiority of thought assures that a logocentric bias organizes the division and ranking of the fine arts in the *Critique of Judgement.* Kant bases his categorization of the fine arts – speech (*redende*), the visual or formative (*bildende*) arts, and the art of the play of sensations (*Spiel der Empfindungen*) – on an analogy with verbal communication whose fundaments include word, gesture, and tone. Where aesthetic value is concerned, the decisive cri-terion is a nonsensuous similarity where lyric, because of its relation of nonidentity with the signs of nature, is most like them because it allows the imagination to respond freely and without determination. Despite his potential iconoclasm in this respect, Kant ranks painting higher than music because of its ability to expand the mental powers that must unite in the activity of judgment. The problem here is the temporality of music. Kant disparages music not only because it is ephemeral but also

[17]Ibid., p. 16.
[18]Of great interest here is Derrida's reading of disgust, negative pleasure, and the sublime in Kant. See, for example, Derrida, "Economimesis," pp. 21–5.
[19]Derrida, "Economimesis," p. 19.

because temporally and spatially it undermines the freedom and autonomy of subjective contemplation. Whereas the spectator can interrupt the temporality of painterly contemplation by averting his or her eyes, he or she cannot interrupt a musical performance, which often "extends its influence (on the neighborhood) farther than people wish, and so, as it were, imposes itself on others and hence impairs the freedom of those outside the musical party."[20] Returning to the *Anthropology,* Kant argues that sight is the most noble of the senses because it is the least tactile and least affected by the object; therefore, one assumes that among the plastic arts, painting will benefit from this nobility. However, though sight may be the most noble sense, hearing, for Kant, is the least replaceable, owing to the intimate relation between speech and concepts. Here again Kant refers, in a rather objectionable way, to the situation of deaf-mutes, who, because of the absence of hearing, will never attain "true" speech and thus reason:

> [H]e will never attain real concepts [*wirklichen Begriffen*], since the signs necessary to him [gestures, for example] are not capable of universality. . . . Which deficiency [*Mangel*] or loss of sense is more serious, that of hearing or of sight? When it is inborn, deficiency of hearing is the least reparable [*ersetzlich*] [§22].

For similar reasons, among the discursive arts, poetry (*Dichtkunst*) is superior to oratory (*Beredsamkeit*) because the latter, especially as a public art, potentially deceives and machinates, treating men "like machines" (§53). It is a mercenary art that promises more than it gives, while expecting something in return from its audience, namely, the winning of people's minds. Therefore, in the third *Critique,* poetry is the highest art because "it is the art which imitates the least, and which therefore resembles most closely divine productivity. It produces more by liberating the imagination; it is more playful because the forms of external sensible nature no longer serve to limit it."[21] By the same token, poetic genius is the highest form of aesthetic subjectivity because, in its analogous relation to the divine *logos,* it is the most free and confers the most liberty on the imagination of individuals:

> It expands the mind: for it sets the imagination free and offers [*darbietet*] us, from among the unlimited variety of possible forms that harmonize with a given concept, though within that concept's limits, that form which links [*verknüpft*] the exhibition [*Darstellung*] of the concept with a wealth of thought [*Gedankenfülle*] to which no linguistic expression [*Sprachausdruck*] is completely adequate [*völlig adäquat*], and so poetry rises [*sich erhabt*] aesthetically to ideas [§53].[22]

In Kant's view, by freeing us from the limits of external, sensual nature, poetry binds linguistic presentation to the fullness of thought,

[20]*COJ,* p. 200. Music's public character, which potentially impinges on the private and autonomous situation of aesthetic contemplation, is treated by Kant with mild distaste: "The situation here is almost the same as with the enjoyment [*Ergötzung*] produced by an odor that spreads far. Someone who pulls his perfumed handkerchief from his pocket gives all those next to and around him a treat whether they want it or not, and compels them, if they want to breathe, to enjoy [*genießen*] at the same time. . . . " *COJ,* pp. 200–1. This is additional evidence for the recession toward an absolute interior that marks the third *Critique* and informs its parergonal logic. The purest experience of the aesthetic is not a public one; rather, the purest objects of taste are those that render the most private experience, encouraging the freedom and autonomy of the individual as detached from the mass.
[21]Derrida, "Economimesis," p. 17.
[22]*COJ,* p. 196.

rendering the presence of ideas to thought, in a way that no other art can. And even if, as a figured ''aesthetic'' language, it is inadequate to the absolute plenitude of the suprasensible, it is nonetheless closer to truth. Unlike rhetoric, which uses the figurative potential of language to deceive purposely and to limit freedom of the imagination, poetry fully discloses that it is mere play that nonetheless can be used to extend the power of understanding.

Thus Derrida rightly insists that Kant derives a theory of value from the arbitrariness of the vocal signifier, that is, its difference with respect to external sensible nature. The difference, immateriality, and interiority of the vocal signifier align it with the realm of freedom:

Communication here is closer to freedom and spontaneity. It is also more complete, since interiority expresses itself here directly. It is more universal for all these reasons. . . . And once sounds no longer have any relation of natural representation with external sensible things, they are more easily linked to the spontaneity of the understanding. Articulated, they furnish a language in agreement with its laws. Here indeed we have the arbitrary nature of the vocal signifier. It belongs to the element of freedom and can only have interior or ideal signifieds, that is, conceptual ones. Between the concept and the system of hearing-oneself speak, between the intelligible and speech, the link is privileged. One must use the term hearing-oneself-speak [le s'entendre-parler] because the structure is auto-affective; in it the mouth and the ear cannot be dissociated.[23]

The nature of this freedom is marked in every case by a profound interiorization, a retreat from the external signs of nature into a purely subjective autonomy whose measure is the autoaffective structure of logocentrism. Here we must try to bring together the analytic of judgments of pure taste and the analytic of the beautiful, while rethinking the relation between subject and object, as well as mind and nature, implied by Kant's theory of signification in the third *Critique*. In this manner, the circle of orality passes again through three otherwise autonomous realms: those of nature (God), art (poetry), and philosophy (judgment).

The self-identity of judgment as a mental power separate from cognition (understanding or pure reason) and desire (practical reason) derives only from the feelings of pleasure or displeasure that belong to it. Nevertheless, Kant insists that the philosopher should take a moral interest in the beautiful in nature in spite of the nonconceptual and disinterested pleasure devolving from judgments of pure taste, for this *Wohlgefallen* would not be explicable if there were not a principle of harmony (*Uebereinstimmung*) between what nature produces in its beautiful forms and our disinterested pleasure in them. Whereas the latter is detached from all determined ends or interests, there must be some means of demonstrating the analogous relation between the purposiveness of nature and our *Wohlgefallen*.

This demonstration cannot take place through pure concepts of understanding. However, for Kant this harmony is legible, or perhaps it would be better to say audible, in the impure mimesis, the relation of identity in nonidentity, that determines the autoaffective structure of *logos* as the origin of analogy in the third *Critique*. There must be ''language'' in nature, or at least the traces of a formalization organizing the apparent disorder of nature as legible signs. Otherwise the beautiful in

[23]Derrida, ''Economimesis,'' p. 19.

nature could never be intuited. The experience of *Wohlgefallen* itself, which binds imagination and language in the predication "This is beautiful," is evidence enough for Kant that there is poetry in nature of which God is the author, even if a theological proof is ultimately insufficient for him. Through his insistence on an analogy between moral judgments and judgments of taste, Kant asserts the superiority of natural beauty and attests to its aesthetic legibility in a judgment of pure taste, that is, our ability to "read the 'ciphered language' [*Chiffreschrift*] that nature 'speaks to us figurally [*figürlich*] through its beautiful forms,' its real signatures which make us consider it, nature, as art production. Nature lets itself be admired as art, not by accident but according to well-ordered laws" (§42).[24] Later, Derrida summarizes this idea by stating that, for Kant,

Beautiful forms, which signify nothing and have no determined purpose are therefore *also, and by that very fact,* encrypted signs, a figural writing set down in nature's production. The *without* of pure detachment is in truth a language that nature speaks to us. . . . Thus the in-significant non-language of forms which have no purpose or end and make no sense, this silence is a language between nature and man.[25]

This analogy between nature and art is parergonal, forging an identity between otherwise exclusive realms, those of humanity and nature: Nature speaks, but silently; it writes, but figurally; it is endowed with interest that can only be taken in a disinterested way. With the controlled indeterminacy that marks every parergon, the realms of nature and humanity are given a common language, and yet denied the space of reciprocal communication; they must remain extrinsic to one another. But this does not mean that a dialogue will not take place. Finding the beautiful in nature and art, we may experience them both aesthetically. However, the extrinsic form of aesthetic objects, activities, and situations has less to do with the power of judging than with the peculiarities of an internal (silent) dialogue between imagination and the understanding that arises in the subject, but only on one necessary condition: that the purpose or ends of this experience remain indeterminate and inscrutable, and therefore without finality. While intractably dividing object and subject, the "disinterestedness" of the aesthetic nonetheless inspires communication by inscribing the circle of the mouth on the (philosophical) body of the subject. The purposelessness of both nature and art opens up a dialogue in the necessary interiority of aesthetic judgment. In Derrida's assessment of Kant, this

purposelessness [*le sans-fin*] . . . leads us back inside ourselves. Because the outside appears purposeless, we seek purpose within. There is something like a movement of interiorizing suppliance [*suppléance intériorisante*], a sort of slurping [*suçotement*] by which, cut off from what we seek outside . . . , we seek and give within, in an autonomous fashion, not by licking our chops, or smacking our lips or whetting our palates, but rather . . . by giving ourselves orders, categorical imperatives, by chatting with ourselves through universal schemas once they no longer come from outside.[26]

In this way, the nonconceptual pleasure inherent in judgments of pure taste is associated with the play of freedom as "a lawfulness without a

[24]Ibid., p. 4.
[25]Ibid., p. 15.
[26]Ibid., p. 14.

law, and a subjective harmony of the imagination without an objective harmony,"[27] in a movement of idealizing interiorization. Everything recedes – from the extrinsic, the empirical, and the corporeal – into the subjective, the internal, and the spiritual. This is why one must not consult the aesthetic object with cognition in mind. Rather, it is a subjective, interiorized investigation of the origin of a pleasure that is nonconceptual and thus nondiscursive.

This is the final ground for the essential disinterestedness of aesthetic judgments. In order to say that an object is beautiful, and to demonstrate that the philosopher has pure taste, everything returns to the meaning that the subject can give to the representation (*Darstellung*), excluding any factor that would make the subject dependent on the real existence of the object. For this reason, Derrida states that the *Wohlgefallen,* the pleasure affect that is proper to art in the Kantian sense, takes the form of an autoaffection, an interiorized and self-authenticating dialogue. In *Of Grammatology,* the logocentric circle of autoaffection is critiqued as a self-producing and self-authenticating movement that identifies reason and fullness of being with the temporality of speech. Thinking, at least the pure thought of philosophy, is represented as "hearing oneself speak," a formula Derrida reprises in relation to Kant's *Critique of Judgement.* The comparative authenticity and veracity of poetic speech, its capacity for mimesis without semblance, the indissociable relation between the mouth and the ear, the irreplaceability of hearing, the association of speech with interiority, with concepts, and with internal sense – all of these factors mark an insistence that the position of *logos* in Kant's system is not one analogy among others. The linguistic signifier is that "which regulates all analogy," writes Derrida, "and which itself is not analogical, since it forms the ground of analogy, the *logos* of analogy towards which everything flows back but which itself remains without system, outside of the system that it orients as its ends and its origin, its *embouchure* and its source."[28]

In Derrida's chapter on the parergon, this internal speech also represents a discursive invagination of the aesthetic. Something in the pure alterity of the beautiful initiates a silent, internal dialogue between the mental powers of imagination and understanding that in turn externalizes itself as speech, assuring its communication in judgment. This is not a dialectic, but rather a series of discrete exchanges rendered as equivalent because they share a common modality. In this manner, autoaffection, in the proper *Wohlgefallen,* becomes for Kant the possibility of mastering the opposition between mind and nature, the inside and the outside, and the subject's relation to the object. Similarly, though the *Wohlgefallen* that breathes life into aesthetic judgment is the property of the subject, it is itself not intrinsically "subjective":

Since this affect of *enjoying something* remains thoroughly subjective, we may speak here of an autoaffection. The role of imagination and thus of time in the entire discourse confirms this. Nothing which exists, as such, nothing in time and in space can produce this affect which affects itself with itself. And nevertheless, *enjoying something,* the *something* of enjoyment also indicates that this autoaffection extends beyond itself: it is pure heteroaffection. The purely subjective affect is

[27] *COJ*, p. 92.
[28] Derrida, "Economimesis," p. 19.

provoked by that which we call the beautiful, that which is said to be beautiful: *outside,* in the object and independent of its existence. From which, the indispensable, critical character of the recourse to judgment: the structure of autoaffection is such that it is affected by a pure objectivity about which we must say, "This *is* beautiful," and "This statement has universal validity." Otherwise there would be no problem, no discourse on art. *The wholly other affects me with pure pleasure while depriving me of both concept and enjoyment.* . . . Utterly irreducible heteroaffection inhabits – intrinsically – the hermetic autoaffection: this is the "*grosse Schwierigkeit*": it does not install itself in the comfortable arrangement of the overworked subject/object couple, within an arbitrarily determined space. . . .

And all the same time it is there, pleasure, something remains; *it is there, es gibt, ça donne,* pleasure is what is given; for no one, but it remains and it is the best, the purest. And it is this remainder that gives rise to speech, since it is discourse on the beautiful that is primarily under consideration once again, discursivity with the structure of the beautiful and not only a discourse arising out of the beautiful.[29]

Just as there could not be beauty in nature if there were not, by analogy, a poetry of nature, a discourse could not emerge from the beautiful if the beautiful were not itself discursive. This is why the orality of poetry has the most pure affinity with that of aesthetic judgment – not only because they are the most purely internal and autoaffecting, but also because art and judgment share the same frame (i.e., the circle of the mouth). Judgment must speak or state the beautiful, even if the beautiful eludes it conceptually, in order to supplement beauty's nonconceptual lack and return it to the space of philosophy. The autoaffective circle that produces the judgment of pure taste also informs how God figures his order in nature, how the gift of "natural" creativity is transmitted to genius, how genius bestows the gift of form on poetic language, and in turn how a judgment of pure taste is engendered by contemplation of the beautiful forms of poetry or of nature. As parerga, there is an essential relation here between the frame and the signature, on one hand, and the circle of the mouth in relation to exemplorality, on the other. Just as the inscription of the signature ensures an external authorizing presence within the purportedly pure aesthetic interiority delimited by the frame, the figure of the mouth and the circularity between speech and hearing ensure a passageway between mind and nature, the inside and the outside, subject and object, where heteroaffection and autoaffection fly into and out of one another, gliding on the wings of speech.

This peculiar oscillation in the analytic of pure taste replicates exactly that of the analytic of the beautiful, defining the status of both as parerga. The frame is supposed to decide what is intrinsic to the artwork, defining its ontological character as such. The frame is there to divide and exclude, separate the outside from the inside, and to control any commerce between them. Yet it must also be a bridge, for the whole point of the third *Critique* is an extrinsic appeal – the relation between the spectator and the artwork and how that confrontation between two unique identities, between subject and object, produces a unity in the form of judgments of pure taste. The parergon is therefore a logic of "controlled

[29]Derrida, "The Parergon," pp. 13–14.

indeterminacy" or of a ceaseless vibration between inside and outside, the intrinsic and extrinsic, subject and object, the reflective and the determinant, the singular and the universal, the conceptual and the nonconceptual, mind and nature. In short, the ontological question of "what is," which is meant to define the integral being of art and of aesthetic subjectivity, seems paradoxically to appeal to, and be infected with, the outside in the very asking of the question. The frame of Kant's analytic thus functions itself as a parergon. In Derrida's words, it is "summoned and assembled like a supplement because of the lack – a certain 'internal' indetermination – in the very thing it enframes."[30] This indetermination is, in fact, the ontological uncertainty of the very idea of the aesthetic:

> The analytic *determines* the frame as *parergon,* that which simultaneously constitutes and destroys it, makes it hold (as in *hold together,* it constitutes, mounts, enshrines, sets, borders, assembles, protects – so many operations assembled by the *Einfassung*) and fall at the same time. A frame is in essence constructed and therefore fragile, this is the essence or truth of the frame. If such a thing exists. But this "truth" can no longer be a "truth," it defines neither the transcendent nor the contingent character of the frame, only its character as *parergon.*
>
> Philosophy wants to examine this "truth," but never succeeds. That which produces and manipulates the frame sets everything in motion to efface its effect, most often by naturalizing it to infinity, in God's keeping. . . .[31]

As Derrida insists, a parergon is added only to supplement a lack in the system it augments. No simple exteriority defines the space of parerga, for they also constitute an "internal structural link . . . inseparable from a lack within the *ergon.* And this lack makes for the very unity of the *ergon.*"[32] (Indeed, the *Critique of Judgement* is itself parergonal, which is why Derrida decides to read a work of philosophy as if it were a work of art. It is a detachable volume within Kant's system of philosophy, while being at the same time functionally inseparable. The third *Critique* must bridge the gap opened between the first two and thus complete Kant's system of transcendental idealism, enframe it from inside, making the system visible in its entirety.) The frame is summoned to give an ontological presence and shape to a space that otherwise threatens to dissolve in aporia; the circle is there to give form to what is otherwise an absent center, and to provide a concept for an otherwise conceptless blank space. This is another way of saying that the aesthetic is an imaginary concept, but in the psychoanalytic rather than Kantian manner. Feeding a regressive fantasy of presence and autonomy, it detaches the work from the field of history by resolutely excluding any social meaning, including the economic and the political. Thus the frame functions as "the invisible limit of (between) the interiority of meaning (protected by the entire hermeneutic, semiotic, phenomenological, and formalist tradition) *and* (of) all the extrinsic empiricals which, blind and illiterate, dodge the question."[33]

In this respect, I would like to conclude with some brief remarks on the division between the verbal and visual in Kant, as well as Derrida's

[30]Ibid., p. 33.
[31]Ibid.
[32]Ibid., p. 24.
[33]Ibid.

D. N. RODOWICK

rather cryptic but frequent references to the work of mourning in the Kantian experience of pure taste and the *Wohlgefallen* appropriate to it.

I have argued elsewhere that the eighteenth century produced a hierarchical opposition between the verbal and the visual, linguistic and plastic representation, as ontological categories that can no longer be sustained, if indeed they ever could.[34] Kant does not produce this hierarchy in as definite a way as Lessing before him or Hegel after him. Kant's ideas concerning the division of the fine arts are not specifically iconoclastic, nor is he concerned, as Lessing is in the *Laocoön,* with defining and preserving territorial borders among the arts, thereby reproducing the ontological drive of the aesthetic within a definition of the *differencia specifica* of various artistic media. There is one exception – poetry. Here an ontological imperative unites object and subject, the question of the aesthetic and that of judgment, in the autoaffective identification of speech, reason, and freedom that defines the logocentrism of the third *Critique.* In Derrida's gloss,

Kant specifies that the only thing one ought to call "art" is the production of freedom by means of freedom [*Hervorbringung durch Freiheit*]. Art properly speaking puts free-will [*Wilkür*] to work and places reason at the root of its acts. There is therefore no art, in a strict sense, except that of a being who is free and *logon ekon* [has speech].[35]

Although poetry is the highest art for Kant, because, imitating the least, it is the most free, the principle of nonsensuous similarity is not the only criterion for ranking the arts. If it were, music would have to be ranked higher than painting. But here the preference for private as opposed to public experience emerges at the same time that sight (though being the noblest sense) is subordinated to hearing as the least replaceable. Both the privilege of the poetic and the exemplorality of the third *Critique* point to what amounts to a transcendent principle, ranking the arts according to their ability to exhibit "aesthetic ideas." For Kant, Spirit (*Geist*) is the animating principle that defines the purposiveness of mental life. "By an aesthetic idea," writes Kant, "I mean a presentation of the imagination [*Vorstellung der Einbildungskraft*] which prompts much thought, but to which no determinate thought whatsoever, i.e., no [determinate] *concept,* can be adequate, so that no language [*Sprache*] can express it completely and allow us to grasp it" (§49).[36] Further on, Kant summarizes:

In a word, an aesthetic idea is a presentation of the imagination which is conjoined with a given concept and is connected, when we use imagination in its freedom, with such a multiplicity of partial presentations that no expression that stands for a determinate concept can be found for it. Hence it is a presentation that makes us add to a concept the thoughts of much that is ineffable, but the feeling of which quickens our cognitive powers and connects language, which would otherwise be mere letters, with spirit.[37]

The intervening example entails Kant's reading of a poem by Frederick the Great, about which Derrida has much to say. I restrict myself to

[34]See my "Reading the Figural," *Camera Obscura* 24(1991):11–44.
[35]Derrida, "Economimesis," p. 5.
[36]*COJ*, p. 182.
[37]Ibid., p. 185.

114

pointing out that the graphic presentation of speech in writing finally combines all the elements adhering to a judgment of pure taste. Lack of semblance produces a surfeit of freedom; the wider the abyss between an external *representamen* and its internal apprehension, the higher the pitch of mental powers whose agitation breeds concepts. Through the eye, the noblest and least tactile sense, comes the purest, the most immaterial, and most interior hearing. All interest has finally withdrawn: The poet withdraws into writing, itself the best representation of speech, if only a supplementary one, because of its nonsensuous similarity. Yet only this pure, interior speech animates it as *Geist,* gives meaning and value to language that would otherwise be mere letters, just as, paradoxically, the king returns political economy to the third *Critique* through his patronage. In sum, lack of semblance, maximization of freedom and the subjective powers of desire, absolute interiorization – this is the formula that only poetry provides. And despite the implied preference for poetic writing and the silence of reading, only *logos* can return meaning to spirit as "hearing oneself speak," and in the third *Critique* this is true for every art, spatial or temporal, plastic or linguistic.

Thus Kant participates importantly in forging the division between the verbal and the visual as it emerges in eighteenth-century thought. But the ontological surplus that adheres in the former is so powerful that Kant seems indifferent to the latter. The formal status of the plastic and musical arts is taken for granted. They can be dispensed with quickly to move on to more pressing business. However, this absence of reflection on the "lower" arts – despite the process of division and hierarchy that seems to demand it – nonetheless continues to function through a sort of repression. It returns in the third *Critique* through the supplementary logic of examples (for example, verbal images like that of judgment as a "bridge" over the abyss separating understanding and reason), but more importantly in the square of the frame and the circle of the mouth. The square and the circle as figured spaces are crucial to Derrida's reading,[38] for in the *Critique of Judgement* the figural incessantly inhabits and haunts the logocentric space that attempts to exorcise it, and the more the space of *logos* attempts to purify itself in the language of philosophy, the more figural and analogical that language becomes. While representing the drive for enframing and enclosure that informs the ontological imperative of the aesthetic, the parergon simultaneously presents its empty center, in fact, the absence of a center as ontological lack. In this manner, Derrida's genealogical critique demonstrates the breadth and complexity of what must be deconstructed in the idea of the aesthetic. This does not mean restoring to philosophy the task of assessing the meaning and value of the visual arts. That would only overturn the hierarchy by restoring the ontology in another way; it would not deconstruct it. What is most important is understanding how philosophy has produced the problem of the self-definition of the arts, as well as the autonomy of fine art and

[38]See, in particular, Derrida's reading of the four "sides" of the analytic of aesthetic judgment as a categorical "frame" for the analytic of the beautiful, as well as the function of the table or tableau (*Tafel*) in Kant's logic, in "The Parergon," pp. 29–30 passim.

of aesthetic meaning, as a response to the very indeterminacy or unde-cidability of all ontological questions.

The earlier references to the *revenants* haunting the third *Critique* lead finally to Derrida's comparison of the *Wohlgefallen* of pure taste to the work of mourning. According to psychoanalytic theory, mourning is a process wherein the subject mentally replaces the loss of a loved object. The death of the object is what gives rise to mourning, which is why the idea of the aesthetic appears in an era marked by ever increasing reification, culminating in our own age. The work of mourning is also characterized by a process of interiorization, in fact, a process of in-corporation that erects the lost object within the subject as an idealized image. The historical irony of the idea of the aesthetic derives from understanding that the rise and decline of an ideal of Art do not develop across a continuum; rather, they are two sides of the same process. Der-rida is correct in reading in this irony the tautological orientation of transcendental idealism. It is not that Art dies and therefore must be mourned; this is the anxiety of the cultural literacy movement. Rather, it is the unconscious fear that Art may never have existed – and will never be able to exist in the economic age that desires it as a supplement to alienation and lack of freedom – that accounts for the ideologies subtending transcendental idealism.

But everything blossoms beside a deconsecrated tomb. I thus offer in conclusion the following funereal image. In a simply but elegantly ap-pointed auditorium, two Old Master paintings, in identical gold frames, lean uncertainly against an off-white background. They are neither at-tached to the space nor hung from it, for their stay here will be a short one. Indeed, they may never be seen again, for although they are too large to fit in your wallet, they will store easily in a vault. They are in transit, and above them hangs a sign not unlike the ones found in railroad stations and airports the world over. It reads "Sotheby's Founded 1744" and records the value of these works, which shifts second by second, in dollars, pounds, francs, marks, lira, and yen. The caption to this image reads "Dede Brooks Makes Her Bid: Sotheby's president wants her auc-tion house to be a stock exchange for art."[39]

This image presents the ultimate irony of the cultural literacy move-ment, as well as the affectations of taste and connoisseurship that have so profoundly marked the institutional development of art history. We are in the last stage of the era of the aesthetic. The split in consciousness that attempts to repress the economic and the political in the aesthetic has never been so severe. Similarly, we now occupy an age when the economic has almost completely possessed what is called the aesthetic, as well as the most advanced technologies of representation available to us. It is hard to comprehend how this dialectic can develop further, although there is no guarantee that it will not. Nonetheless, it renders ironic in ever more powerful and visceral terms the hue and cry for the restoration of traditional concepts of "value" and hierarchies of evalua-tion, of the self-identity of the artist and of aesthetic work as free from value, and of the necessary relation between beauty and nature. Para-

[39] *New York Times Magazine* (2 April 1989):27.

doxically, this work of mourning is possible only because the political and economic society that neoconservatives most fervently pray for has reached an advanced stage of development. And if Art is finally and incontrovertibly being converted into capital, this is because the ideology of the aesthetic was itself seeded and nurtured by a capitalist political economy. This is the historical lesson that Derrida's philosophical deconstruction of the aesthetic enables us to examine and work through. The contradictory consciousness of the neoconservative movement derives from the refusal to understand that their ideology of the aesthetic, whose disappearance they fear, derives from the political economy they celebrate as globally triumphant. This has been true for nearly 300 years. Thus, the more they cheer on the triumph of capitalism, the deeper they dig their own cultural graves.

This conclusion should cheer those interested in a contestary art, and a contestary cultural criticism, to the extent that they themselves can work through and indeed liberate themselves philosophically from the idea of the aesthetic.

STARTING OUT FROM THE FRAME (VIGNETTES)

JEAN-CLAUDE LEBENSZTEJN

How can one not start out from what frames this research? Thinking the frame teaches us that everything is framed, visibly or not, even thinking itself – all the more thinking the frame. It is therefore significant that cultural institutions – the museum, the university – funded by the Ministry of Research are now interested in what no one wished to pay attention to even a short time ago.[1] But what does it mean to be interested in the frame? Where does this interest stop? That is to say, where does the frame stop? The power of the frame is to a large extent linked to our inability to answer this question, as well as to its invisibility and the continuous transition from the physical to the metaphoric or symbolic that renders the frame limitless.

The frame constitutes the painting and, generally speaking, everything else. Its function is decisive and normative; it regulates, filters, compresses, crops, rejects. How many publishers, when politely rejecting a manuscript, have said that "it didn't fit into the framework" of the collection! How many governments obsessively cultivate the idea of the importance of containing public posters within definite framed spaces? Indeed, official posters that themselves are "forbidden to go beyond the frame" (Fig. 4)[2] are enthusiastically countered by unofficial posters and illegal graffiti. These graffiti show unruliness, proliferation, an ever-present anarchy, while the official posters indicate a bureaucratic order whose excesses of pretense exhale, even outdoors, the mustiness that lurks in the offices of petty bureaucrats. The placement of a gray frame on this gray wall and the derisory inscription in old-fashioned letters framing that frame naively betray the secret of the frame: that it works and is able to contain something only when it is as discreet and as nearly invisible as possible.

A frame that is too present, too rich, or too eccentric will disturb the framing more than would the absence of a visible frame. Everyone loves a masterpiece. Yet, in reproduction, masterpieces are often cropped and missing their edges, almost always missing their frames, even when that

[1]This text was originally published in French, with numerous errors, in the catalogue *Le Cadre et le socle dans l'art du XXe siècle* (Université de Bourgogne, January 1987). It was part of a research project at the Pompidou Center sponsored by the French Ministry of Research and included both curators and scholars.
[2]I would like to thank Didier Semin for bringing this town-hall wall (recently cleaned) to my attention.

frame seems inseparable from the work it surrounds,[3] with no other frame than the sheet of paper where it will live ever after. Even the photographic service of the Consortium of National Museums in France continues to publish a retouched slide of Ingres's portrait of Mademoiselle Rivière (ref. no. 78) without its original frame; the lunette at the top has disappeared, and the blue of the sky now fills the entire celluloid image up to the rectangular edges of the cropping marks – a little rounded at the edges, a tradition that is perpetuated by television (Figs. 5 and 6). One could cite numerous similar examples.

When Poussin sent his painting of the *Manna* to Chantelou and asked him to frame it with a *corniche* "gilded simply with matte gold," he had two specific requests: Frame the work so that "the gaze is contained and not scattered outside receiving other neighboring images pell-mell and confusing them with what is in the painting,"[4] and frame it discreetly

[3]For example, Max Ernst's *Katharina Ondulata* (1920), reproduced without its neo-Baroque frame in cast iron(?) in the recent catalogue *German Art in the 20th Century: Painting and Sculpture 1905–1985* (Royal Academy, London, 1985, no. 146); cf. John Russell, *Max Ernst, Life and Work* (New York: Abrams, 1967), p. 45.

[4]Letter to Chantelou, 28 April 1639, in *Correspondance de Nicolas Poussin,* ed. C. Jovanny (Paris: F. de Nobele, 1968), pp. 20–1; see Louis Marin, "Du Cadre au décor ou la question de l'ornement dans la peinture," *Rivista di estetica* 12 (1982):18–20. "Corniche," in Poussin's words, is an Italianism; the usual word in France was "bordure." "Cadre" existed already in the sense of a square (i.e., rectangular) border, then as a border in general; but in Watelet and Levesque's *Dictionnaire des arts,* published in 1792, it is under "bordure" that one finds the discussion of the frame. Chantelou specified that "M. Poussin always asks that his paintings have only very simple frames (*bordures*) without burnished gold."

4 Paris, Mairie du 13e Arrondissement, 1984. Photo Christian Lassalle.

so that the absence of confusion does not seem artificial, but natural. Between anarchy and an enforced overframing, whether administrative or artistic, order dictates that the machinery of order not reveal too much of its implied violence and constraint.

The classic requirement of a discreet frame is seen throughout the history of painting, as well as the other arts that presuppose similar devices – base, margin, screen, applause at a concert, limit, parergon. One thinks, of course, of Kant and section 14 of the *Critique of Judgement,* whose redoubtable and perverse logic Jacques Derrida has so incisively commented upon.[5] But one also thinks of Degas affirming that "the frame is the pimp of painting; it enhances it, but it must never shine at the painting's expense."[6] One should have the least amount of frame possible. However, a frame is necessary, not only to protect and enhance the work but also to separate it from the world it imitates. And in all periods of history – in some more than others – contrary and not always predictable demands have sometimes disturbed this constraint of mimesis.

It is this very subject that this essay addresses: the play between the two spaces that the frame separates. Establishing a positive history of the material object called "frame" is certainly necessary, but it behooves us as well to examine the frame as the place, or nonplace, of a differentiation that is very complicated and is not to be taken for granted: that between the space of the work and that of the viewer – between "art" and "life," "art" and "nature," "art" and "reality," and so forth (these terms do not always coincide). First of all, Poussin's discreet frame presupposes an already constituted, relatively stable, and "natural" mimetic space.[7] When such a space was established, in the fifteenth century, for example, when painting was no longer defined as the iconic symbol of the divine but as a planar imitation of the visible, that visible sustained an enormous shock (*un coup de force de taille dans ce visible*). Alberti writes that "I first draw a rectangle of right angles, where I am to paint, which I treat just like an open window through which I might look at what will be painted there" – adding that the surface of the image is like a piece of transparent glass.[8] The frame contrives (*échafaude*) the visible, and this

[5]Jacques Derrida, "Parergon," *La Vérité en peinture* (Paris: Flammarion, 1978); *The Truth in Painting,* trans. Geoff Bennington and Ian McLeod (Chicago: University of Chicago Press, 1987).

[6]Cited in Jean A. Keim, "Le Tableau et son cadre," *Diogène* 38(1962):111. I have not found the source, but it is a classical idea. Watelet, in the *Dictionnaire des arts:* "the frame (*bordure*) of a painting, just like the finery of a woman, should not attract the gaze by distracting one too much from the object it embellishes; but both should set off the beauties which they decorate" (I, p. 261). André Félibien, *Des Principes de l'architecture, de la sculpture, de la peinture et des autres arts qui en dependent. Avec Un Dictionnaire des termes propres à chacun de ces arts* (Paris: Coignard, 1676), p. 712, under "Quadre": "In addition to the fact that frames serve as ornament to paintings, they also make them stand out. Thus dealers and collectors are in the habit of never showing their paintings without frames, so that they make a better impression. That is why the Italians say that a beautiful frame (*bordure*), which they call a *corniche,* is *il Rufiano del Quadro;* because for them the word *quadro* means a painting."

[7]Poussin himself presented the need for order as a force of nature: "My disposition forces me to seek out and love things which are well ordered, fleeing confusion which is as foreign and inimical to me as is light to deep shadow" (to Chantelou, 7 April 1642, in *Correspondence de Nicolas Poussin,* pp. 134–5).

[8]Leon Battista Alberti, *Della pittura* (1435), I, §19 and §12; English translation from *Italian Art: 1400–1500,* ed. Creighton E. Gilbert (Englewood Cliffs, N.J.: Prentice-Hall, 1980),

comparison of frame to window was used over and over at the time, especially in fresco and in manuscript illumination, where the frame is painted *upon* the work of art. Often, as Meyer Schapiro has stated in a thought-provoking reflection on the frame in painting – and thus on painting itself – the limits of the spectacle represented were rendered by a door or a window.[9] In the San Brizio Chapel of the Cathedral of Orvieto, Signorelli shows Empedocles looking through an oculus at the wall upon which he is painted, and toward the end of the world above (Fig. 7).

After about 1500 the frame-window comes to be naturalized, but also self-divides. On the one hand, the window is inscribed in the painted scene; it becomes a *veduta,* an opening that is no longer simply adjacent but is integrated into the space of what is represented. On the other hand, the frame is exterior to what is seen, no longer framing anything but the painting as signifier. It loses its architectural character. Until then, the frame, especially in altarpieces, was part of the painting and was

p. 57. The motif of perspective as a transparent glass was also used by Leonardo da Vinci: *The Literary Works of Leonardo da Vinci,* ed. Jean Paul Richter (London: Phaidon, 1970), vol. I, p. 150, no. 83 (originally published 1883). See, among others, A.-M. Lecoq and P. Georgel, "Le Motif de la fenêtre d'Alberti à Cézanne," catalogue *D'un Espace à l'autre: La Fenêtre* (Annonciade Museum, Saint-Tropez, 1978), p. 21.
[9] "On Some Problems in the Semiotics of Visual Art: Field and Vehicle in Image-Signs," *Semiotica* 1, no. 3(1969):241.

5 (*left*) J. A. D. Ingres, *Portrait of Mlle. Rivière.* Musée du Louvre, Paris. Photograph version. Cliché des Musées Nationaux, Paris.

6 (*right*) J. A. D. Ingres, *Portrait of Mlle. Rivière.* Musée du Louvre, Paris. Slide version.

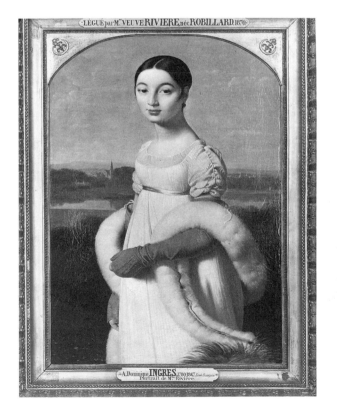

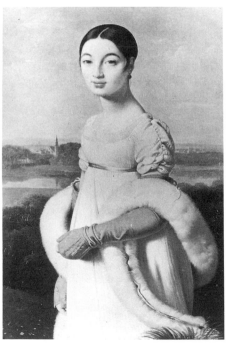

7 Luca Signorelli,
Empedocles. San Brizio
Chapel, Orvieto Cathedral.
Art Resource.

constructed first.[10] Afterward, it became an independent accessory, added after the fact. The play (*les jeux*) of the frame is reduced except in fresco and manuscript illumination. On the ceiling of the Farnese Palace, real and illusory white and gilt frames surround the fictive paintings, and in the interstices, herms in simulated stucco overlap them, on the model of the Sistine Chapel, but with a decorative play that announces a new age without truly arriving there, for the heterotopies of Michelangelo or Carracci accentuate the isolation of different spaces, while Baroque representation tends to blur them, to create confusion between the imitating and the imitated, between the space of art and that of nature.

The frame is the privileged vehicle of this confusion and can choose its tactics:

1. On a ceiling, in engraving, or in manuscript illumination the frame is infringed upon and must thus mark its presence overtly (Fig. 8). In the work of Poussin the frame is discreet but efficient; in the Gesù ceiling in Rome, the insistence of the frame is in proportion to the transgression of the frame; the edge must be strongly there so that the souls of the blessed and the damned can overlap it, and so that the name of Jesus

[10]Creighton Gilbert, "Peintres et menuisiers au début de la Renaissance en Italie," *La Revue de l'art* 37(1977):9–28.

TAB. II.

GENESIS cap. I. v. 2.
Opus primæ Diei.

I. Buch Mosis Cap. I. v. 2.
Erstes Tagwerck.

J. G. Pin. sculp.

8 Johann Andreas Pfeffel, *Kupfer-Bibel* (Copper Bible). Private collection.

can emerge from its celestial and fictive home to invade the world of the living faithful who look at it.

2. In the trompe l'oeil of easel painting, the frame can be eliminated. The shaped canvases of Gijsbrechts or Fort-Bras, representing an easel with paintings, drawings, engravings, a palette, and so forth, were meant to be set up as sculpture in the corner of a room. The absence of background and frame adds to the illusion, as President de Brosses remarked upon discovering with enthusiasm the painting by Fort-Bras in the Charterhouse of Villeneuve-les-Avignon: "The painting is without a frame and not square, but cut according to the contours which really describe the group of things represented, which contributes a great deal to the illusion."[11] However, the utmost in trompe l'oeil is not this accumulation of complicated contours; it is the canvas by Gijsbrechts that represents its own reverse. This simple painting was meant to be placed nonchalantly in a corner; a chance visitor, faced with this back of a painting, would infallibly be tempted to turn it over to discover the hidden painting. The back would then appear, identical with the front, except that the front would also show the painted reverse of a frame. "What vanity is painting," he would say as he put it back.

3. The frame is maintained, but there is a play on its two semiotic roles: to set the limits of the work of art and to set the limits of the part of the world that it depicts. The frame does not confuse the two, as in fifteenth-century painting, but without warning it slides from one to another. *Two Dogs in a Park* by Abraham van den Tempel (1672): A painted frame, which duplicates the true frame, surrounds the painting on three sides, but on the bottom it becomes a sill where one of the baskets carrying the two little dogs is placed. Jean-Jacques Bachelier, *Trompe-l'oeil* (1753): A wild duck is hung on a plank upon which its dead body casts a shadow; the plank is on the picture plane, as is indicated by the painted piece of paper slipped in at an angle to the real frame, linking the imitating to the imitated.[12]

Baroque or not, the best examples of trompe l'oeil each play around a frame that articulates its artifice. The one I like best is the invisible trompe l'oeil by Pontormo in the Capponi Chapel, Santa Felicità, Florence. On the frescoed wall of the Annunciation, the angel and the Virgin occupy an architectural space around the real window that simulates the space of the chapel. The steps mounted by the Virgin deepen the space a bit and place the painted wall behind the true wall that it covers. However, the painted moldings framing the window articulate this painted and distant wall and the real and close-up window. The "real" lighting of the window accentuates the play of space. That's all: not much, nothing but a slight uneasiness about the space disturbing this truly mysterious story – nuanced by a barely sensed irony that is the hallmark of great visionaries. This Pontormo is very close, but only very

[11]*Lettres familières écrites d'Italie en 1739 et 1740,* "Mémoire sur Avignon." The painting is now exhibited in the Calvet Museum in Avignon; see Georges de Loÿe, "Le Trompe-l'oeil d'Antoine Fort-Bras," *La Revue des arts, Musées de France* 1(1960):19–24; Miriam Milman, *Le Trompe-l'oeil* (Geneva: Skira, 1982), p. 93 (reproduced in color).
[12]See the catalogue *La Peinture dans la peinture* (Museum of Fine Arts, Dijon, 1982–3), pp. 237–8 (the little dogs), pp. 268–9 (the duck).

close, to *The Invention of Morel,* where a real wall and its perfect, total, and indestructible representation coincide.[13]

Indecision about the edge facilitates the heterotopic fantastic. Sliding in and out and from one or the other to neither outside nor inside, from the imitated to the imitating, from the fictive to the real, the frame with its uncertain and unstable status attracts different degrees of space, real and fictive, fictive as real and fictive as fictive, into its abyss. Sometimes it is not the frame but a drop of water or a fly that betrays the illusion by means of illusion itself. Attraction is the name I would give to such a game, such a play of space and mimesis: It is Baroque mimesis par excellence. It tightens the connections between the imitating and the imitated as much as possible, but for that very reason it doubles the imitative relation. "This painting, which does not seem a painting at all, represents a painter's easel with all the implements of the profession," wrote Abbé Soumille about the trompe l'oeil of Fort-Bras.[14] To fool the eye and give the illusion of the truth, a painting will represent that which is closest to itself, a painting or a drawing, something that represents something else on the picture plane. Baroque attraction revolves around this paradox.

On the contrary, the classic frame, and even more the neoclassic frame, is presented as a sober but definitive barrier; between art and nature, all confusion is banned because it is impossible.

When the painter encloses a vast area in a narrow space, when he makes me traverse the depths of infinity on a flat surface and makes air and light circulate around flat appearances, I love to abandon myself to his illusions. But I want the frame to be there; I want to know that what I see is only a canvas or a simple plane.[15]

In other words, a painting is not only a nude woman or a charging horse, but also a flat surface covered with colors. It is both, and the frame affirms its double nature, without any possible confusion. The mimetic space of neoclassicism is a taxonomic space: It rules, divides, apportions. The closure of the frame circumscribes not only the work (the painting-object and the objects it represents) but also the mimetic field that is the property or the proper ground of painting. It separates this art from both nature and the other arts that imitate nature in their own way and in their own space, with their own limits and impediments.

On the contrary, Diderot recommended that the connoisseur (*amateur*) walk through the salon with a glass "which takes in the field of the painting and excludes the border."[16] He wished to be deceived; he wished to be there and to be able to shout: "Oh, what a beautiful

[13]Adolfo Bioy Casares, *The Invention of Morel* (1940), trans. Ruth L. C. Simms (Austin: University of Texas Press, 1964), pp. 135–8. See "Fragments du miroir (II): le tombeau" (unpublished).

[14]Quoted in G. de Loÿe, "Le Trompe-l'oeil," p. 20. From *Le Mercure de France* (April 1744).

[15]Antoine Chrysostome Quatremère de Quincy, *Essai sur la nature, le but et les moyens de l'imitation dans les beaux-arts,* vol. I (Paris: 1823), p. 14 (new edition Brussels: A.A.M., 1980), p. 128.

[16]*Salon de 1763,* articles on "Vernet" (*The Port at La Rochelle*) and "Greuze" (*Portrait of Madame Greuze*).

perspective (*point de vue*)!" But one must still replace the frame of the border with that of the glass. By excluding the frame from the work, a frame outside the work (that, for example, of the mirror in which painters examined their finished works) re-creates the magic that constitutes the vanity of painting.

Between the Baroque and Romanticism, Neoclassic art enclosed the image for a time, dramatically severing the sign from the object and art from nature – at least from individual nature. On the other hand, Romanticism tried to open them up to one another. However, while it adopted certain Baroque procedures, the *mise en abyme,* for example, its intentions were not the same. Romanticism was not particularly fond of the trompe l'oeil, except in the minor art of vaudevillians like Boilly, because trompe l'oeil, after all, proclaims the triumph of art over nature (an idea repugnant to Romanticism); it sets up a difference between the two in order to overcome it. Romantic art tends to erase the difference; it is an effusive art. Not an art of play; if there is play, it is the great and serious play of nature.

If Romanticism means anything, it is perhaps precisely that – effusiveness obliterating the boundaries among the arts, and between art and life. This is why the Romantic work aspires to be a vignette, a fragment, an allusion to the totality, an opening to the outside. Whether its edges are actually blurred and irregular as in a vignette, or whether they are cleanly cut, there is an opposition between the Romantic work with its open (yet closed: the fragment-hedgehog) fragmentedness and the self-sufficiency of the Classical work. In writing about ancient tragedy, A. W. Schlegel compares classical art to a sculptural group, and Romantic art to a large painting, "less clearly circumscribed than the sculpture because it is, in a certain sense, a cut-out piece within the perspective of the universe. But the painter," adds Schlegel, "must nevertheless frame the foreground quite clearly and concentrate the light with enough artistry so that the spectator's eye is not diverted outside of the painting and desires nothing more."[17] All Romantic art tends toward the fragment: not only the vignette, but also large-scale painting,[18] and sculptural or architectural groupings placed in a natural framework, like the *Lion of Lucerne* by Thorvaldsen, Rude's *Napoleon* in Fixin, or the castle of Orianda planned by Schinkel. In Poe's "Oval Portrait," the transfusion between art and life is closely tied to the character of the portrait painted in "a vignette manner": the work becomes a scrap torn from nature and artificially placed in an oval frame "richly gilded and filigreed in *Moresque.*"

Sometimes in the work of Blake, Runge, or Friedrich, the frame itself serves as intermediary between painting and the world; in the Tetschen altarpiece *The Joys of Hunting,* the small version of *Morning,* it provides the hieroglyphic of the work, or inserts it into an ensemble encompassing the various arts. Besides, the landscape included in the image is both hieroglyph and frame. Commenting upon *The Lesson of the Nightingale,*

[17]August Wilhelm Schlegel, *Cours de littérature dramatique* (1808), 13th (25th) lesson; translated from the French version (itself modified), Paris and Geneva, 1814, vol. II, pp. 330–1; ed. Lohner, vol. II, p. 112.
[18]Charles Rosen and Henri Zerner, *Romanticism and Realism* (New York: Viking Press, 1984), pp. 26, 95–6.

whose painted frame imitates a terra-cotta bas-relief (Fig. 9), Runge wrote to his brother:

I show a bit of landscape at the bottom of the painting. It is a dense forest where a brook springs from deep shadow; the brook is in the background just as the sound of the flute is in the shaded tree. And in the bas-relief above, Love reappears with a lyre; then on one side the Spirit of the Lily . . . ; and on the other the Spirit of the Rose. . . . Thus one and the same thing is presented three times in the painting, and becomes more and more abstract and symbolic as it departs from the image.[19]

At the end of the nineteenth century, when painting and all the arts and sciences were undergoing profound changes, the frame again became an object of attention for many painters. "The frame is necessary," declared Manet about his portrait of Antonin Proust. "Without the frame the painting loses one hundred per cent."[20] And Degas said, "The frame is

[19]To Daniel Runge, 27 July 1802; *Hinterlassene Schriften, 1840–1* (new ed. 1965), vol. I, p. 223.
[20]Antonin Proust, *Edouard Manet – Souvenirs* (Paris: Laurens, 1913), p. 101. Again on the subject of this portrait, Manet wrote to Antonin Proust in May 1880: "I have always been horrified by this mania of crowding works of art without leaving space between the frames, just like the latest novelties on the shelves of fashionable stores" (p. 103).

9 Philipp Otto Runge, *The Lesson of the Nightingale,* second version. Kunsthalle, Hamburg.

the reward of the artist."[21] Manet did not specify which type of frame was necessary, but the Impressionists, perhaps in the wake of Chevreul and Delacroix, replaced gilt frames with white or variously colored ones, especially after 1877. The best critics, Huysmans, Laforgue, and Fénéon, were sensitive to this phenomenon:

In their exhibitions, the Independents have substituted intelligent, refined, imaginative frames for the old gilt frames which are the stock in trade of academic convention. A green sunlit landscape, a light winter piece, an interior with dazzling lights and colorful clothes require different sorts of frames which the respective painters alone can provide, just as a woman knows best what material she should wear, what shade of powder is most suited to her complexion, and what color wallpaper she should choose for her boudoir. Some of the new frames are in solid colors: natural wood, white, pink, green, jonquil yellow; and others are lavish combinations of colors and styles. While this new style of frame has had repercussions on official salons, there it has produced nothing but ornate bourgeois imitations.[22]

The shiny gold frame overburdened with molding was rejected not only because of its *nouveau-riche* pretentiousness but also because the shine of the gold would kill the tonalities rendered by the brightness and nuances of light.

Without sharing this *plein-airiste* opinion, Degas was particularly careful about his frames, because of his hatred of bourgeois taste, but also because of the innovative cropping that he imposed upon his subjects. He preferred to sell his works already framed, like Whistler, and could not tolerate people changing his frames.

For matting his drawings he preferred to use the beautiful blue wrapping paper from sugar loaves, and separated the drawing from the matte by a white area of half a centimeter. He always said, "No empty bevel which cuts the subject." As for his frames, one of his favorite models was the "coxcomb" whose indentations imitated its namesake, and whose outline he designed himself.

It was he as well who thought out the tonalities of his frames, using the same colors found in garden chairs. Whistler teased Degas: "Your garden frames. . . ."

One can imagine Degas' anger when the "connoisseur," believing he was increasing the value of the work, substituted a gilt frame for one that had been so carefully thought out. Then there was a falling out. Degas gave back the money and took back the painting.[23]

Of all the independent painters, Seurat was the most attentive to the structural effects of the frame,[24] thus carrying out his chromo-luminist logic and his desire for total control. Because each colored section is influenced by neighboring sections, the shade of the frame must be calculated so as not to destroy the adjoining areas, and thus gradually the

[21]To Moïse Kisling, cited in Henry Heydenryk, *The Art and History of Frames* (New York: J. H. Heineman, 1963), p. 89.
[22]Jules Laforgue, *Selected Writings of Jules Laforgue,* ed. and trans. William Jay Smith (New York: Grove Press, 1956), p. 178 (this last paragraph is called "Framing"). See also J.-K. Huysmans, "L'Exposition des Indépendants en 1881," *L'Art moderne,* Editions 10/18, 1975, p. 251. Huysmans also repeats the comparison with feminine finery.
[23]Ambroise Vollard, *En Ecoutant Cézanne, Degas, Renoir* (Paris: Grasset, 1938), p. 121.
[24]See Henri Dorra and John Rewald, *Seurat* (Paris: Les Beaux-Arts, 1959), pp. xvi (n.), xxii (n.); Didier Semin, "Note sur Seurat et le cadre," *Avant-guerre* 1(1980):53–9.

entire painting. Seurat first adopted the white frame of the Impressionists, then a pointillist frame; from 1889 on, the painted frame was lined with a border painted on the canvas, which served as a buffer and absorbed the "cast shadows" (*barres d'ombre*) of the frame in relief. He progressively replaced the light frame with a dark one, under the innovating influence, according to Verhaeren, of the Wagnerian stage, which "darkened the theatre in order to present the light-filled stage as the sole center of attention."[25] Following Chevreul, Seurat put the border and the frame "in a harmony opposed to that of the tones, tints and lines of the painting."[26] In *Sunday at la Grande Jatte* (1884), the border, painted after the fact, changed because of the adjacent areas, acquiring, according to Fénéon, "an absurd reality,"[27] and in a still more absurd reality the frame effects a countermodification upon the adjoining areas of the painting. Toward the end of his life, Seurat attenuated these local changes; the frame and the false frame of the *Circus* are painted in a blue that lightens toward the outside of the work and is discreetly modulated by additions of violet or green.

The will to eliminate all outside parasitical influences, along with the multiplication of frames, ought to have closed the image doubly and triply. However, the contrary took place. By deciding upon his own frames and doubling them with painted borders or interior frames, Seurat made the limits of the work indeterminate. Where should one place it now? Before or after the frame? Between the border painted on the canvas and the painted frame? In the rare cases in which Seurat's frames have been saved, they have often been lined with a gilt border: *Honfleur, Evening* (MoMA), and *Circus* (Orsay).

The symbolist painters – Moreau, Klinger, Gauguin, Toorop (Fig. 10), Klimt, and many others – not to mention poster art, where play on framing proliferates, are also interested by the frames, but differently. In Thomas Eakins's portrait of Professor Henry A. Rowland (Fig. 11), the frame, painted by the artist, "is ornamented with lines of the spectrum and with coefficients and mathematical formulae relating to light and electricity."[28] In all these cases one finds oneself in the same situation as Runge, following the same principles of symbolic framing and the unity of the arts. With Seurat, the status of the frame is ambiguous; with Toorop, the frame, extending the motifs of the painting, is of a piece with it. In Toorop the representation includes the decorative frame; in Seurat, the interaction between the abstract frame and the scene that it delimits makes the frontiers of representation tremble.

Signac reports that the white frames of the independent painters were

[25]Emile Verhaeren, "Georges Seurat," *La Société nouvelle* (April 1891); reprinted in *Sensations* (Paris: Crès, 1927), pp. 199–200.

[26]Seurat, letter to Maurice Beaubourg, 28 August 1890. Michel Eugène Chevreul recommended a gray frame for landscapes in oil: *De la loi du contraste simultané des couleurs*, §568 [English translation *The Principles of Harmony and Contrast of Colors and Their Applications to the Arts* (New York: Reinhold, 1967)].

[27]Félix Fénéon, "Le Néo-impressionnisme à la IVe exposition des Artistes indépendants," 1888, in *Oeuvres plus que complètes* (Paris: Droz, 1970), vol. I, p. 84.

[28]Eakins's letter cited in Henry Heydenryk, *The Art and History of Frames* (New York: J. H. Heineman, 1963), p. 93 (kindly brought to my attention by Prof. Charles W. Rosen).

JEAN-CLAUDE
LEBENSZTEJN

sufficient reason for their exclusion from the official salons.[29] Since then, dealers and collectors have stubbornly insisted on replacing them with substantial gilt frames, as if they felt that the value of the art was threatened by insufficiently rich and normative frames, as if gold and tradition were necessary to protect these all-precious square inches – but against what obscure aggression? Vibert, the *pompier* artist and specialist in cardinals who had invited Degas to an exhibition, remarked to him: "You may perhaps find our frames, our carpets a bit rich, but after all, is not painting a luxury object?" Degas replied, "Yours may be, sir. Ours are objects of utter necessity."[30]

Interfering with the frame means interfering with Art and with the status our culture bestows upon it. It was logical that at the beginning of the twentieth century avant-garde artists, busy overturning the very aspect, definition, and essence of painting, attacked its limits. Just as the constitution of painting as an open window onto the visible required an already existing framework, its deconstruction again disturbs its edges. The motif of the window frequently recurs in painters who question representation – Matisse, Delaunay, and many others. Often, Matisse mis-frames (*décadre*) the representation by including within the frame at least a part of the window that enframes it. In *Le pont Saint-Michel* (Fig. 12), the vertical restricting the view at the left is counterbalanced by a large void irregularly occupying the right of the landscape; painting and representation are out of sync in this signed and therefore "finished" canvas.

[29]*D'Eugène Delacroix au néo-impressionnisme* (1899), vol. I, p. 14.
[30]Vollard, *En Ecoutant Cézanne, Degas, Renoir,* p. 107.

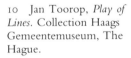

10 Jan Toorop, *Play of Lines*. Collection Haags Gemeentemuseum, The Hague.

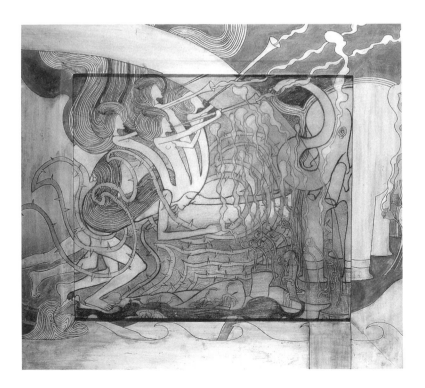

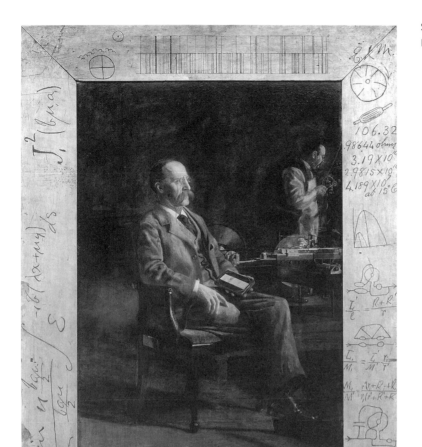

11 Thomas Eakins, *Portrait
of Professor Rowland.* ©
Addison Gallery of American
Art, Phillips Academy,
Andover, Massachusetts. All
rights reserved.

In classical space, the representation is visible and the window im-
plicit. In *The French Window* (1914), the present frame of the window
opens onto a black ground that invades the dark gray of the floor. And
the *Windows* by Robert Delaunay enframe views shattered by the act of
painting itself. In one of them, a large frame made of four pieces of
wood continues the elements of the canvas, like the frames of Toorop
or some of Severini's works (*Plastic Rhythm of the 14th of July,* 1913),
where the painting that spills over onto the frame seems like the sign of
Futurist dynamism. The eccentric forms of several Futurist works move
in the same direction: Balla's screens, for example, or his *Rhythms of the
Bow* (1912), or even the irregular canvases of Ferruccio Ferrazzi in the
Gallery of Modern Art in Rome: *Hotel in Montreux* (1916), *Figures in
Summer* (1915), *Merry-go-round* (1917).

For Matisse, "the four sides of the frame are among the most im-

131

portant parts of a painting."[31] However, he did not seem particularly interested in renewing the appearance of the frame (one could mention the gray frames of the *Moroccan Triptych* [1913]), though the edge of the work was the object of his constant attention. One could evoke the false ornamental frame that used to surround *Still Life with Eggplants,* that of the large *Nude* of 1911 (destroyed), reproduced in *The Red Studio,* those of the *Arab Cafe* (1913), the *Window in Tahiti,* and the *Nymph in the Forest;*[32] the figures cropped by the edges in the Barnes *Dance* (about which Matisse said that "half of it is outside. . . . I give a fragment and I lead the viewer along, through the rhythm, I lead him to follow the movement from the part that he sees"); the collage *The Negress,* which he presented at his home in Nice, with her feet emerging from the wall and advancing across the floor.[33] I will concentrate rather on his unpainted edges, because one sees them less often, and reproductions almost always cut them off. In *Sailor II* (1906), the edge remains unpainted on all four sides for about half an inch; where the sailor's elbow grazes the left margin, the unpainted area attaches itself to the curve of the arm as if by capillary attraction. Sometimes the unpainted border indicates a covered-up first state. In *La desserte rouge* (1908), the right, bottom, and left edges, up to the window, reveal a green band crossed by the chair, the servant's dress, and a blue arabesque above. The background and the tablecloth had at first been painted green, then blue, before being reworked in red, doubtless to accentuate the omnipresence of the color field as well as the contrast with the landscape in the window. The green band seems to be a leftover from the first state, just as the light blue around the arabesque motifs is a trace of the second. In the first state, it seems, the arabesque and the floral motif of the wall were not carried over onto the tablecloth; at the bottom, they stop above the green band.[34] In *The Red Studio* (1911), the edges of the painting, as well as the negative outlines of phantom objects and the craquelure, make it seem that in the beginning the studio was not red – the walls were light blue, the furniture yellow, the floor pink.[35] As is later seen in the work of Brice Marden, the edges are witnesses to a previous state. The idea of a "work in progress" of which the finished work shows traces is very much present in the worried Matisse of those years: The *View of Notre-Dame* (1914), with its three pairs of expanding towers, offers a striking example.

Picasso's interest in the frame was less constant, more Baroque, more clearly semiotic and playful. One recalls the gray relief paintings of 1930

[31]To Gaston Diehl, 1943; *Ecrits et propos sur l'art* (Paris: Hermann, 1972), p. 196.
[32]This painted false frame is not reproduced in the photo of the catalogue *Matisse,* Grand Palais, 1970, p. 241; cf. John Jacobus, *Matisse* (New York: Abrams, n.d.), p. 42; and in a different form, Aragon, *Henri Matisse, roman* (Paris: Gallimard, 1971), vol. I, p. 31. Jacobus's book reproduces in color the cartoon for the tapestry *Window in Tahiti,* p. 173.
[33]See André Verdet, *Prestiges de Matisse* (Paris: Emile-Paul, 1952), facing p. 32; catalogue *Henri Matisse – Paper Cut-Outs* (museums of Washington, St. Louis, and Detroit, 1978), p. 249.
[34]The only photo, unless I am mistaken, that does not cut this edge too much is in Jacobus, *Matisse,* p. 121.
[35]Cf. John Elderfield, *Matisse in the Collection of the Museum of Modern Art* (New York: MoMA, 1978), p. 87.

that show the reverse of the painting covered with sand and various other materials. In one of them, a hand leans upon the stretcher, which serves as a frame, repeating the gesture of Agatha Bas in her portrait by Rembrandt. The semiotic play is all-important in certain collages. In *Pipe and Sheet Music* (Fig. 13), mauve paper serves as the background, strewn with pellets of paint and covered in the middle by two super-imposed sheets of light-brown paper and two crossed pieces of mauve and white paper, where there appear, schematically drawn in charcoal, the pipe and the sheet music with the title *Ma Jolie*. Around the large mauve sheet of paper there is a false ornamental frame made of wallpaper with a pattern of wild grapes. The painter has summarily traced cast shadows on the sides of the brown paper and the false frame, on the right, as if the paper and the frame were separated from the mauve ground. The shadows are drawn in charcoal, with traces of scratching. The signature scroll is another piece of paper glued across the background and the false frame. The play consists of treating the objects depicted (pipe and sheet music) as a barely indicated formal motif, and the signifying elements (paper glued to the surface) as elements of representation that seem to become unstuck from each other. The trompe l'oeil is discovered by its schematic execution, the incoherence of the

12 Henri Matisse, *Le pont Saint-Michel*. © 1992 Les Héritiers Matisse, Paris/ARS, New York.

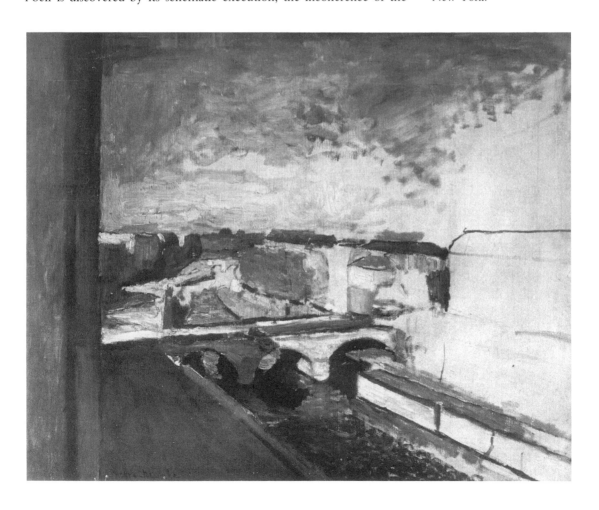

cast shadows, and by the fact that the background in the upper left reappears outside the false frame. (Around all that, in the Houston museum, is a frighteningly real frame.)

Among the artists of that generation, Klee was one of the most attentive in seeking the limits, edges, and frame, framing in the widest sense: curtains both real and false, frames skillfully chosen and manipulated, double and triple frames, double and triple grounds disturbing the closure of the work of art – as well as the scissor cuts that disjoint his body, allowing the outside to invade his heart. (See *Anatomy of Aphrodite, Once emerged from the grey of night*.) Often Klee was inclined to reverse the relation of under and over, of the figure to the background, and the process of the production of meaning. Such was his uniqueness in his own time: He did not see the painted work only as a surface, but as an anatomical body with "skeleton, muscles and skin."[36]

For many early abstract artists, abstraction meant not only the end of naturalistic representation but, in time, "the end of *art as a thing separated from our surrounding environment*."[37] The nature of the frame was rethought, as well as its function, its structure, and its form; it ceased to be a closure between the work and its outside, or the iconization of art

13 Pablo Picasso, *Pipe and Sheet Music*. Museum of Fine Arts, Houston. Gift of Mr. and Mrs. Maurice McAshan.

[36]Paul Klee, *The Diaries of Paul Klee 1898–1918,* ed. Felix Klee (Berkeley: University of California Press, 1968), p. 231.
[37]Piet Mondrian, "Plastic Art and Pure Plastic Art. II," *Circle* (1937):56.

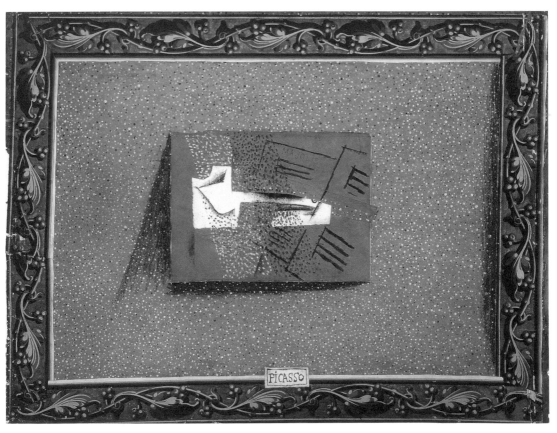

conceived of by Romanticism as an organic fragment of nature. It became an indication of the new status of the work of art: no longer a representation where the visible aspect of a segment of the world detaches itself and carves out a space for itself illusorily, but a fragmentary plane of the essence of the universe, open to the outside and to the future where art and life are joined. As Mondrian wrote several months before his death:

So far as I know, I was the first to bring the painting forward from the frame, rather than set it within the frame. I had noted that a picture without a frame works better than a framed one and that the framing causes sensations of three dimensions. It gives an illusion of depth, so I took a frame of plain wood and mounted my picture on it. In this way I brought it to a more real existence.

To move the picture into our surroundings and give it real existence has been my ideal since I came to abstract painting.[38]

[38]To James Johnson Sweeney, 1943; "Eleven Europeans in America," *The Museum of Modern Art Bulletin* 13, no. 4–5(1946):35–6.

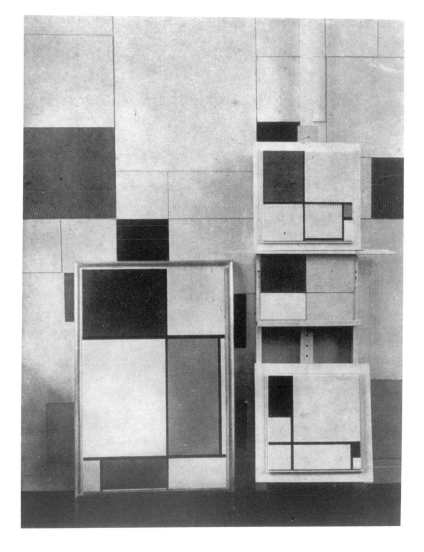

14 The atelier of Piet Mondrian, ca. 1930. Photograph from *Cahiers d'Art* 6, no. 1 (1931):432. The Brooklyn Museum Library Collection.

The majority of Mondrian's neoplastic paintings are framed with thin strips of wood painted white, recessed from the picture plane; often, a second wooden frame, sometimes with a lip, doubles this thin frame from behind. It would be unusual for a post-1920 canvas to have a raised frame; however, that is the case in the large *Composition with Red, Yellow and Blue* (1928), which is featured in several photographs of Mondrian's studio in 1929–30 (Fig. 14).[39] (This painting is fully signed, an equally unusual fact for this date.) The true frame for his works is the studio, conceived of as an experimental prefiguration of the art of the future joined to life.

In 1915, at the "0.10 exhibition," Malevich exhibited his Suprematist compositions without frames, or surrounded by a thin wooden frame; the *Black Square* was hung under the ceiling at the junction of two walls. "Painting has had its day for a long time," he proclaimed in 1920, "and the painter himself is a prejudice of the past."[40] For a long time, at least since Hegel. In the past, art already belonged to the past. It survives outside of its borders. In 1920 Suprematism set out to conquer the city.

In the principal streets, red bricks have been covered with white paint. And on this white background are strewn green circles, orange squares, blue rectangles.

The scene is Vitebsk in 1920. The paintbrush of Kasimir Malevich has covered the walls. "The public squares are our palettes," that is what the walls shout.[41]

Several drawings from 1928 show aerial views of landscapes where Suprematist emblems have taken over the land.[42] With Malevich, utopia is a madness of limitless space. But his post-1930 figurative paintings are framed in the old style, while his Suprematist compositions remain bordered with their thin wooden frames. A 1933 photo shows the portrait of Punin in progress on the easel, surrounded by a magnificent gilt frame. In another we see Malevich painting a portrait of a woman and holding a mahlstick (Fig. 15); the portrait is already framed, as in Flemish fifteenth-century paintings representing St. Luke painting the Virgin. In these anachronistic framings, one detects a note of irony evoked by the signature, a black square. However, these late portraits are perfectly serious and of an unexpected pictorial quality (from beginning to end, Malevich's painting never truly changed; it was always the same texture and color). But those photos by Suetin give us a glimpse of a reserve, of a strangely elegant art able to foil the cruelties of history.

Thus has the division been made in the majority of present-day collections: the sober wooden frame or the absence of any frame has become the norm for abstract or semiabstract paintings; the gilt frame has remained with classical painting (with the exception of Dutch painting) up to and including the Impressionists and the Nabis. Fauvism seems to

[39]See *L'Atelier de Mondrian* (Paris: Macula, 1982), pp. 78, 79. The article in *Les Cahiers d'art* 6, no. 1(1931):43, from which the illustration is taken, also contains Mondrian's reply to an inquiry into abstract art.

[40]"Le Suprématisme, 34 dessins," *Ecrits, I (De Cézanne au suprématisme)*, trans. J.-C. Marcadé (Paris: L'Age d'Homme, 1974), p. 123.

[41]S. M. Eisenstein [On Mayakovsky] (1940), *Mémoires*, vol. 2, trans. M. Bokanowski (Paris: Editions 10/18, 1980), p. 185. The quotation by Mayakovsky comes from his poem *Order to the Army of Art* (1918).

[42]See catalogue *Malevich* (Paris: MNAM, 1978), pp. 69, 71.

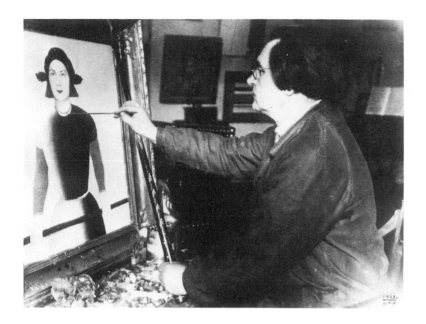

15 Malevich painting *Girl
with a Red Staff.* Photograph
by Nikolai Suetin. Stedelijk
Museum, Amsterdam.

be the boundary. The large frames that once surrounded Matisse's *The
Painter in his Studio* (1916–17) – there were at least three of them in
succession – gave way at an unknown date (1966 or soon before) to the
narrow gilt strip that surrounds it today.

Starting with the 1920s, painters began to play with this new type of
frame. In Friedrich Vordemberge-Gildewart's *Composition No. 16,* four
parallel lines at the edges of the square canvas cross each other two by
two, forming a false frame; the rectangles traced on the painting stop
there. Among these rectangles a real frame attached to the surface in-
tervenes as one of the elements of the painting. The play is between the
painted lines that seem to make a frame and a frame that is a figure.
More recently, artists like Pieter Engels, Stephen Buckley, and Pierre
Buraglio have begun to deconstruct materially the machinery of the
frame. In Engels's *Bad Constructed Canvas* (1967), an articulated frame,
serving as a stretcher, is folded into a hexagon so that the canvas, covered
with transparent plastic, is no longer stretched and hangs floppily.

This play remains a secondary aspect of today's art. The postwar pe-
riod conceived of the work of art as an expansion without limits. Pol-
lock, trained in the discipline of mural painting, declared in 1947 that
his painting did not come from the easel and specified:

I believe the easel picture to be a dying form, and the tendency of modern
feeling is towards the wall picture or mural. I believe the time is not yet ripe for
a *full* transition from easel to mural. The pictures I contemplate painting would
constitute a halfway state, and an attempt to point out the direction of the future,
without arriving there completely.[43]

As opposed to monumental classical painting, large Abstract Expres-
sionist paintings saw themselves as intimate works. In his first one-man

[43]Catalogue *Jackson Pollock* (New York: MoMA, 1967), p. 40.

show in 1951, Barnett Newman put up this notice: "There is a tendency to look at large pictures from a distance. The large pictures in this exhibition are intended to be seen from a short distance."[44] And the same year, Mark Rothko claimed, "I paint very large pictures . . . precisely because I want to be very intimate and human."[45] To see a large surface saturated with color close up is to lose oneself in it, placing the edges outside of one's visual field and producing a feeling of limitless exchange and intimacy. And the paradox of the "narrow" paintings that Newman did in 1950, just after the very large *Vir Heroicus Sublimis* (*The Wild* measures 242 by 4 cm), is that they appear all the more limitless, as if they were zips crossing the infinity of "real" space.

Since about 1960 (the year of the first shaped canvases of Frank Stella), the practical and theoretical deconstruction of the limits of the work of art has assumed a whole new dimension, even if one can find precedents in the experiments of the 1910s and the 1920s. The circular *Disk* by Delaunay in 1912 is a shaped canvas in the strictest sense, with a correspondence between the form of the painting and the forms within the painting – just as the Dada events of 1916 were happenings, the *Merzbau* of Schwitters an environment, and so on. But, according to John Gage, "The 'Disk' was not a picture, but a means of experimentation."[46] (But what is a picture?) The *Disk*, in any case, seems to have been unique in Delaunay's work and time. On the contrary, in the 1960s the bursting of the frame is at the heart of artistic questions, taking all sorts of forms, from plays on the material frame to outdoor works of art, of which Walter de Maria's lightning field (which uses the atmosphere and storms) remains the most striking example. Another recurring aspect of these years is the work of art with changeable elements, Carl Andre's "flat" sculptures, polyptychs by Kelly or Rosenquist. In these examples, and in Minimalist art generally, the work incorporates the space surrounding it without necessarily becoming one with it. A neon tube has precise limits; a work by Flavin does not. Carl Andre says of his flat metal sculptures, "I don't think of them as being flat at all. I think, in a sense, that each piece supports a column of air that extends to the top of the atmosphere."[47]

For about ten years the great expansionist movements, body art, assemblages, environments, installations, which defied the status of art and the limits of culture in this troubled world, have given way to a kind of retrenchment. The foreign bodies have disappeared from the painting of Morley; Sharits, filmmaker and painter, declares that he likes "to pay attention to the classical format of the rectangle," even if such consideration succeeds in deconstructing the frame more certainly than a pure and simple movement of transgression. The "return to painting" is often

[44]Harold Rosenberg, *Barnett Newman* (New York: Abrams, 1978), p. 61.
[45]Declaration published in *Interiors* (May 1951):104; *Readings in American Art since 1900,* ed. B. Rose (New York: Praeger, 1968), p. 160.
[46]John Gage, "The Psychological Background to Early Modern Colour: Kandinsky, Delaunay and Mondrian," in *Towards a New Art: Essays on the Background to Abstract Art 1910–20,* Tate Gallery, 1980, p. 77. The *Disk* is reproduced in color on p. 29; the *Window* with the painted frame on p. 30.
[47]Phyllis Tuchman, "An Interview with Carl Andre," *Artforum* (June 1970):60–1.

marked by the return to the rectangle. Stella, who continues to pursue his eccentric arrangements of painted materials in space, declares that he attaches no importance to the fact that his works are called paintings or something else, as long as they remain art.[48] Marden, who considers himself a painter rather than an artist,[49] likes "the idea of the rectangle being very strong on the wall and looking very much like a painting."[50] His panels are physically separated, but they are not interchangeable; they have a top and a bottom, a left and a right. And if they are not framed, it is not, as in Minimalist art, meant to undo the limit between art and the rest; it is so that the summarily painted edges of the panels will articulate a relation between the painting and the wall, and because these paintings are paintings enough not to need frames (Fig. 16). Is the frame not a crutch to support the weakness of the artwork, to comfort its never truly assured autonomy, to prevent nearby objects (according to Poussin's fear) from "confusing things"? One thinks of the drawing lesson programmed by Rousseau: The weaker the drawings by his student (as well as his own, since the tutor was in competition with him), the more they needed a rich frame, making up for the poverty of the work by the excess of decoration.

On the first, the crudest, of these drawings I put quite brilliant, well-gilded frames which enhance them. But when the imitation becomes more exact, and the drawing is truly good, then I give it nothing more than a very simple black frame. It needs no adornment other than itself, and it would be a shame for the border to get part of the attention the object merits. Thus each of us aspires to the honor of the plain frame, and when one wants to express contempt for a drawing of the other, he condemns it to the gilded frame. Someday perhaps these

[48]Claude Gintz, "Entretien avec Frank Stella," *Artistes* 4(April–May 1980):13.
[49]"Conversation with Brice Marden," *Art-Rite* 9(Spring 1975):39.
[50]From catalogue *Brice Marden,* Pace Gallery, 1978, n.p.; "Mumû," *Avant-guerre* 1(1980): 19.

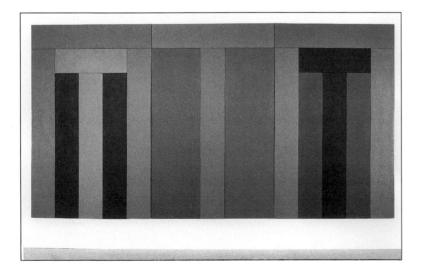

16 Brice Marden, *Thira.* Musée National d'Art Moderne, Centre Georges Pompidou, Paris.

gilded frames will serve as proverbs for us, and we shall wonder at how many men do themselves justice in providing such frames for themselves.[51]

Just like the authentic man, the work of art needs no other ornament but itself; still, neither can appear entirely nude. The frame is always the sign of a lack, like the august paraphernalia of the doctor and the judge, meant (said Pascal) to fool the world for lack of a true science of justice or medicine. Today we know that doctors have accumulated knowledge and left behind their robes and slippers. Judges still have their robes, and in some countries their wigs. Priests, it is true, have for the most part abandoned the cassock. But is it because they have finally found true religion? Could it not be because of the unfavorable view of ornament as a crime? And perhaps their paraphernalia is no longer in fashion because they no longer have so many people to stupefy. Renouncing the frame is not necessarily a sign that the work of art is strong enough to do without it. Because it is clear that finery signifies the insufficiency of that which it decorates, the object will accept denuding itself in order to appear self-sufficient. This is the new illusion of art: The wall, the entire space of the museum, and the discourse of the critics guarantee it the frame that makes it autonomous. And the interest shown today for the frame is not disinterested. Institutions thus make up for what is unmanageable and upsetting in ideas about recent art and its place in our world. Likewise, the authorities have found it judicious to reserve spaces for spontaneous graffiti in public places. Thus everything seems to come back to order. Could it be that in becoming a domain, the frame has ceased to be a problem, at least for a time? Or rather, that the domain in which one currently is trying so hard to enframe the frame itself aims to contain – but what, exactly? From that which forever frames the frame, one can in fact only start out. (*De ce qui à jamais cadre le cadre, on ne peut au juste que partir.*)

Translated by Lynne E. Johnson

[51]Jean-Jacques Rousseau, *Emile*, vol. II; *Oeuvres complètes*, Pléiade, vol. IV, pp. 398–9. *Emile, or On Education*, trans. Allan Bloom (New York: Basic Books, 1979), p. 145.

MODERNITY AGAIN: THE MUSEUM AS TROMPE L'OEIL

DONALD PREZIOSI

> Philosophy wants to arraign it and can't manage. But what has produced and manipulated the frame puts everything to work in order to efface the frame effect, most often by naturalizing it to infinity, in the hands of God (one can verify this in Kant). Deconstruction must neither reframe nor dream of the pure and simple absence of the frame. These two apparently contradictory gestures are . . . systematically indissociable.
>
> – Jacques Derrida, *The Truth in Painting,* p. 73

ABOVE all, museums are social instruments for the fabrication and maintenance of modernity. Historically coterminous with our modernity, they have served as one of its central and definitive institutions and instances. Museums frame history, memory, and meaning through the patterned deployment of artifacts abstracted from our own and other societies, choreographing these together with the bodies of beholders.

In so doing, they labor to stage, define, and discipline desire, erect templates for the composition of our interpersonal selves, finalizing the past as ordered, oriented, and arrowed. Museums have always, everywhere, been teleological machines and landscapes of geomancy.

In the museum, the past is staged as prologue to our presentness, predisposing that presence to a telling and narrative order: in a line of fiction. In producing the past through retroaction, and the future through anticipation, we are storied, movied, and made to reckon with ourselves as subjects in the performance of modern life – as agents of modernity and as celebrants in the service of that sanctimonious aestheticism that in our own time masquerades as History. One of the spaces of memory par excellence in the West since the eighteenth century, the museum is one of our premier theoretical machineries, and in many ways the very emblem of desires set into play by the Enlightenment, providing us with yet another powerfully canny displacement of religiosity.

Typically, we have sought to understand the mechanisms of desire set into play by the modern museum by foregrounding what museological scenographies mask or marginalize – normally in the name of historical fullness or "truth," in the name of restoration and of representation. That this activity inevitably fails highlights a perennial inability to understand just what exactly it is that museums do, and what

they so powerfully achieve in their massively coy ways. The intractability of the institution to critical inquiry or sociohistorical analysis runs like a dissonant chord through the huge body of writing about the museum over the past two centuries.[1] Regardless of attitudes toward its preservation or reform, the modern discourse on the subject remains complicit with the museum's most fundamental programmatic mission – the fabrication and maintenance of modernity.[2] This essay is addressed to these problems both in general and in terms of a specific institution and its relationship to what has come to be the canonical dramaturgy of the modern civic museum.[3]

★ ★ ★

The early growth and development of the civic museum of art in Europe were complexly linked to a variety of what in hindsight can be read as disparate solutions to a number of historical problems attendant upon and precipitating massive social changes in the late eighteenth and early nineteenth centuries. The museum – the *museological* – can be understood as correlative to the following developments:

1. the enormous dissemination of the novel as the romance of bourgeois subjectivity and social definition: in particular, the crafting of novels as spatio-temporal riddles whose resolutions invariably require the literal or figurative repositioning of protagonist or narrator to a panoptic *locus* from which, in hindsight, how and what took place become legible or visible;
2. the growth and standardization of journalism in Europe and America, and in particular the development of newspapers for general readerships, with their increasingly framed or "articled" organization and layout, wherein every "story" is staged as a fragment of some ongoing, narratizable totality, some "history" of current events "to be continued";
3. the increasingly fixed functional zoning of the bourgeois house, wherein interpersonal episodes come to be stabilized and localized in space–time as parts of an ideal, recurrent, "natural" familial story;
4. the massive reorganizations of education in the late eighteenth and early nineteenth centuries and the concurrent articulation of academic "disciplines" – in short, the policing, militarization, and hygienicization of knowledge and inquiry, most especially in the natural sciences;
5. the fragmentation and commodification of labor, and the rhetorical and spatial logic of new industrial processes and technologies;
6. the transformation of a variety of institutions, but most notably hospitals, prisons, and schools, into analytic theaters for distinguishing health and social

[1] A substantial bibliography dealing primarily with earlier institutions may be found in Oliver Impey and Arthur MacGregor, eds., *The Origins of Museums: The Cabinet of Curiosities in Sixteenth- and Seventeenth-Century Europe* (Oxford: Clarendon Press, 1985), pp. 281–312. See also Stephen Bann, *The Clothing of Clio* (Cambridge University Press, 1984); Hubert Damisch, "The Museum Device: Notes on Institutional Changes," *Lotus International,* no. 35(1982):45–8; Louis Marin, "Fragments d'histoires des musées," *Cahiers du Musée nationale d'art moderne,* no. 17/18(1986):17–36; Helmut Seling, "The Genesis of the Museum," *Architectural Review* 141(1967):103–16.

[2] See especially C. Duncan and A. Wallach, "The Universal Survey Museum," *Art History* 3, no. 4(1980):448–69; idem, "The Museum of Modern Art as Late Capitalist Ritual: An Iconographical Analysis," *Marxist Perspectives* (Winter 1978):28–51; Rosalind Krauss, "The Cultural Logic of the Late Capitalist Museum," *October* 54(1990):3–17.

[3] This essay is a condensed synopsis of chapters of a volume in preparation entitled *Framing Modernity,* forthcoming from Yale University Press.

normalcy from disease, criminality, and maladaptation to increasingly codi-
fied and stabilized norms;

7. the increasing theatricalization of the (increasingly firmly bounded) nation-
state as an arena for the display and performance of capitalization, techno-
logical competition, and entrepreneurial violence;

8. the massive mounting of new fairs, national and civic expositions, panoramas,
and other public celebrations, for the collective performance of national or
ethnic heritages, and for the crafting and performance of a "folk."

The resonances of all these with the aestheticist and historicist agendas
of the new civic museums of art should be quite palpable. As correlative
to the aforementioned, the museum nonetheless came to serve as a cen-
tral *evidentiary* institution supportive of the identities and trajectories of
the modern nation-state.

Museums stage synecdochical landscapes, gathering in a common ar-
ticulated space fragments of totalities past, distant, or absent. Their task
has been the judicious assemblage of objects and images deemed espe-
cially poignantly evocative of time, place, personality, or mentality – of
the artisanry or genius of certain societies, groups, genders, classes, races,
or individuals.

In this respect, the museum is a house of part-objects, a tableau or
spreadsheet of evidence for something, an archive of *vedute* or windows
upon time, place, historical moment, ethnicity, or biography. There is
a certain unavoidable resonance here with geomantic rituals wherein the
proper siting/sighting of objects or formations works to guarantee the
preservation of the spirit of the departed or absent person or group. In
the museum, what is guaranteed above all is the spirit of artisanry, of
the aesthetic as a kind of thing, of the existence of such a *thing* as Art
beneath what are staged as its myriad manifestations or exemplars. What
is more deeply at stake, after all, in the labor of this theophanic ma-
chinery, this projective holography, is the maintenance of what we
are prepared to see as quintessentially human, *beneath* what we are also
prepared to see as quintessentially Flemish, Florentine, Polynesian, or
Islamic.

Within this geomantic landscape invoked by the museum, the char-
acteristic task of art history and criticism has been the promotion of a
moral semiology, a system of protocols or "methods" to render these
ruins legible, to cause them to speak, to induce them to *declare* themselves
and tell their tales. The discourse of the discipline of art history is itself
a simulacrum of the topologies of museological space, of its ideal ge-
ometries, made up as it is of metonymies perpetually at work on the
production of a basic, overriding metaphor – that art is to Man as the
world is to God (or, more accurately, that art is to men as the world is
to God).

Museums serve as catalysts for certain kinds of stories, certain tropic
materials that render all but inevitable the predication of a very particular
type of "history" to explain and valorize the presentness we would like
to believe in – that *modernity* by which we distinguish ourselves from
the ancients and from others. Museological space constitutes a remark-
ably powerful theater for the practice of historiographic dramaturgy,
making of the present an anamorphic point for imagining the past.

A second effect of this museological labor is no less important: Museums work on a complementary front to fashion and perpetuate certain ideals of selfhood and subjectivity. Objects are deployed within what may be termed predicative frameworks with respect to a beholder's subjecthood. In their materiality, in their focused and palpable quiddity, museological objects project and predicate a certain individuating gaze, setting into play an inevitable scopophilia: Seduced as we always are into searching for and articulating the unities, the principles of reason in objects and images, we invariably s(t)imulate our own. Here the modern museum shares with its ecclesiastical antecedents the programmatic deployment of emulatory and exemplary imagery, of *imagines agentes*. The seductive palpability of the museum object evokes a desire to mimic and possess its *composure,* its spirit(uality) – which is perforce to say its sexuality – a sexuality that, of course, is invariably gendered as female.

We are dealing, then, with an institution of astonishingly powerful and subtle illusion. Yet the museum is no simple utopic inversion of the world of daily life, not quite an escape from the world. In articulating a space of all times that itself seems outside of time or inaccessible to its ravages – the illusion of the aesthetic as a homogeneous realm of the cognitive, as an "inside" uncontaminated by or mixed with what is thereby enframed as an "outside" – the museum works rather more heterotopically, as one of a series of places within social life that anamorphically provide compensatory relief from the confusions and contradictions of social life – themselves all the more palpable by contrast. In short, museums are not exterior to the world of daily life; they are rather one of the factories for its production.

It will be clear that there are several intermeshed circuits of illusion here. As it has evolved since the eighteenth century, the modern civic museum has worked to sustain the circulation of the following effects:

1. the idea of Art as a kind of thing and of the aesthetic as a distinct realm of the cognitive;
2. the idea of Art as medium, sign, or communicative token;
3. the furtherance of the notion of the Subject as composed of matter and spirit wherein the former is expressive, overtly or covertly, of the latter;
4. the promotion of the idea of the nation-state ("French painting") as a natural entity that is racially, ethnically, culturally, and linguistically distinct; in particular the notion of the nation-state as a Subject writ large;
5. correlatively, the idea of the historical period as homogeneous and unified;
6. the aestheticization of history as narrative teleology; and
7. the historicization of the aesthetic as stylistic index.

All of these museum effects (or artifacts) are mutually defining and comprise a mutually supportive circuit of legitimations; when put into play beneath the surfaces of the discourse of art history and criticism, their internal contradictions are effectively masked. The most notable example of this is the opposition between the view of an artwork as a unique, irreducible entity with a vitality and unreproducible reality of its own and the idea of artwork as medium, sign, or communicative token. It was this conundrum (this trompe l'oeil effect) that lay at the heart of the most fundamental problem facing the design of the new

"discipline" of art history in the nineteenth century – namely, how it might be possible to articulate a scientific, systematic history of otherwise entirely unique objects.[4]

What made such a problem all the more acute was the museological requirement that this "history" be construed teleologically: as oriented, arrowed, as it were, and progressive. The past would have to be staged as that from which we could imag(in)e our descent: as that from which we would desire not to be excluded. Such a requirement is closely connected with what was at stake in the fabrication of modern national identity, for the "past" from which one would not wish to be excluded was, in particular, the legacy of antiquity. The history of the competing claims of various modern European states to that legacy is well known.

The problem facing the modern museum of art would have been that of keeping in play and articulating together a variety of disparate and contradictory requirements. These tasks were accomplished by the evolution of an institution and a professional discourse with remarkably powerful illusory effects. Any accounting for the museological, for the institution of the museum, or for the discipline of art history must be grounded in an appreciation of the extraordinary subtleties and complexities of these trompe l'oeil effects, and in an understanding of their mechanics.

By contrast, much recent literature on the museum has tended to focus on museological *absences:* history, politics, women, the other, minorities, the non-West – the "real" complexities and contradictions of the world(s) "outside" the museum. The assumption has been that if the museum is an instrument for the production of illusion, then what is absent is what is "real."[5] In this regard, much critical writing has in the end been complicit with the illusory effects of the museological, for the effect has mostly been the reaccommodation of whatever has been "absented" into museological space, without alteration to the museum's aestheticist and historicist effects.

Arguments for the inclusion or exclusion of objects characteristically avoid the fundamental question regarding the specificity or "truth" of art at the heart of aesthetic philosophy or of art history and criticism – namely, *where* is it to be found? In relationships with other objects, synchronically or diachronically? In relationships with individual beholders or users? In the life worlds of particular artists? In the evolution of social mentalities? The specificities of history and moment? The circumstances of production and consumption?

Art history has always provided two answers to the question: (a) in the object itself and (b) in the object's environment, its "context(s)" – two sides of the same Kantian coin perpetually kept in circulation by the institutions of art. The genius and power of the museum consist in its continual circulation of the alternatives that both aestheticist and historicist ideologies have imposed upon the question of art and representation. Despite the common assumption that the museum is that which brackets out a separate, pure realm of the aesthetic, it has at the same

[4]This issue is discussed at length in D. Preziosi, *Rethinking Art History: Meditations on a Coy Science* (New Haven: Yale University Press, 1989), pp. 54–121.
[5]This perspective is particularly apparent in the two essays by Duncan and Wallach cited in footnote 2.

time been an instrument for the legitimation of the opposite possibility with respect to art's truth: "History" itself is an artifact of the museological.

As in the famous optical illusion of the Necker cube, there is a perpetual oscillation in the history of art history between two apparently contradictory or opposite solutions. This is the rhetorical economy of the double bind, generated at base by the manner in which the original question is invariably framed with a locative or spatial metaphor – that the "truth" of art must be located some*where*. As if it were a phallus.

If we are dealing with illusion here, it is an illusion of the museum as frame, enframing device, as *Gestell*. In fact, the deeper illusion is that the museum's labor *is* illusory (in contrast to what is equally fabricated as "real"). There is no illusion, for there is only illusion.

The primary task of the museum and of art history has been the staging of the truthfulness of art: projecting environments (whether architectonic or discursive or both) within which objects might be *seen as* conveying (or, in a legalistic sense, conveyancing) their truth; within which the visible is made legible. In this regard, the museum works as an instance of the application of (scientific) method in a manner not unlike that of the early natural sciences, wherein the spatial or visual deployment of characteristic elements or forms in patterned arrays itself *declares* basic truths – those of filiation, evolution and descent, origin, and progression, as well as of the specific transformative effects of given environments (nations, races, classes, genders, landscapes) *upon* Art as such, upon human creativity as such. Every modern museum is a diagrammatic tableau or table in this metamorphic sense.

It will be clear, then, that an accounting of the museum (or of art history) must begin with the paradoxes that perennially keep the historian, critic, or theorist from occupying a secure position on either side of these frames, of that *Gestell* that fabricates the "illusion" of a borderline between inside and outside and which itself in the end subverts the applicability of the inside–outside polarity. The critical study of the museum is perforce the study of the histories of *enframing* – of the practices, processes, and technologies of the frame, as well as, at the same time, all that which works to efface the frame effect.[6]

If museums in fact simultaneously do all the things being described here, then any productive attempt to account critically and historically for the museum, for the museological, must work against the grain of those historiographies that construe signification as a product of relations of exteriority, that construe representation as expression (as representation), and that see artwork as medium or effect.

A "history" of the museological would resemble less a historiography in a conventional sense and more an accounting of certain deconstructive and psychoanalytic processes in which time and memory themselves are foregrounded rather than taken as given, and where "interpretation" is no longer construed as the lifting of veils or the rendering transparent of what seems opaque.

[6]See especially Jacques Derrida, *The Truth in Painting* (Chicago: University of Chicago Press, 1987), part I, pp. 15–147.

Let us leave all this in abeyance and switch to a different register by looking at a particular museum foundation that in interesting ways may be said to stand, at the beginnings of our modernities, as an explicit refusal of what has been enframed by the museum of art history over the past two centuries.

In 1812, Sir John Soane published *A History of My House,* in which, assuming the role of an imaginary antiquarian of the future, he discovered his London house-museum in ruins, offering hypotheses as to the building's original function, "no traces remaining of the Artist who inhabited the place."[7] Over the next two decades, and until his death in 1837, Soane obsessively rebuilt his house-museum in Lincoln's Inn Fields as – to quote his imaginary antiquary of the future – "a great assemblage of ancient fragments which must have been placed there for the advancement and knowledge of ancient Art."

Soane's remarkable text constructs a "history" of his museum from an imaginary vantage point in the future, when the structure is already in ruins. The text was published in 1812; Soane spent the next quarter-century constructing his museum in the image of what its ruins might in the future suggest it had been.

No stranger to "ruins," Soane had constructed sham ruins in his earlier residence in Ealing, Pitzhanger Manor, often wondering aloud to visitors if they were classic or Gothic, and concluding, in a text written in 1802 describing that residence, that "some say they're put up to puzzle the antiquary."[8] Pitzhanger Manor was built, in Soane's own words, to "breed a race of artists," sharing this program with his later residence in Lincoln's Inn Fields. Both houses came to include basement "monk's apartments," and in his writings Soane often alludes to a fictional monk who wandered like a ghost among the basement "ruins." That Soane himself identified strongly with this monk ("Padre Giovanni") emerges in a number of his letters and notebooks alluding to the "Monk's Cell" or Parlour which he created in Lincoln's Inn Fields in the teens (ca. 1815–16) – a section of the building he increasingly haunted, redecorated, and rebuilt.

Whereas many of the elements of his London house-museum reflect attitudes and even models drawn from elsewhere in England and France at the time, what made Soane's Museum so extraordinary was its juxtaposition of many disparate elements, period tastes, and historical and literary allusions. Soane intended the museum as a semipublic institution, an instructive model of taste, and a visual history of art, architecture, decoration, and design. The building was arranged for serious study and

[7]John Soane, *Crude Hints towards a History of My House in L.I. Fields* (London: The Soane Museum, 1812). A detailed description of the museum may be found in *A New Description of Sir John Soane's Museum,* 7th rev. ed., 1986, prepared by Sir John Summerson and published by the trustees of the museum. See also the excellent study by Susan Feinberg Millenson, *Sir John Soane's Museum* (Ann Arbor: UMI Research Press, 1987), with extensive bibliography.
[8]John Soane, *Plans, Elevations and Views in Perspective, of Pitzhanger Manor-House, and of the Ruins of an Edifice of Roman Architecture, situated on the border of Ealing Green, with a Description of the Ancient and Present State of the Manor-House, In a Letter to a Friend. 1802,* n.p.

included original specimens, models, casts, decorations, and illustrations of the possible effects of applying ancient prototypes to the arrangement of modern functional spaces.

The collection of the museum was largely classical in nature, yet the spirit of its arrangement has been said to reflect Romantic and neo-Gothic tastes. Overall, the museum appears to continue the tradition of the private collection or *kabinett/gabinetto* of the late Renaissance collector, with its overwhelming atmosphere of *horror vacui* and of the random juxtaposition of artifacts and objects of *vertù*. And to be sure, Soane's Museum may plausibly be seen as one of the final historical examples of the *Kunst- und Wunderkammern* of the sixteenth and seventeenth centuries, and in many ways perhaps the most remarkable of them all.[9]

To be sure, with its incongruous juxtapositions of the most disparate objects, the arrangement of the collection had all the trademarks of the traditional curio closet: a Sumatran fungus nestled among antique statuary; gemstones alongside metal horse stirrups; contemporary or eighteenth-century paintings (including Hogarth's *Rake's Progress* series); cork models of the Parthenon that could be bought on the streets of London for a few pence; an original Egyptian sarcophagus in proximity to fragments of Gothic church ornament; specimens of American marble from the vicinity of Baltimore; an old wooden-and-leather clog; part of the horn of a deer found twenty-one feet below ground during excavations for the new State Paper Office in London; an Ottoman pistol made in imitation of Napoleonic imitations of English pistols; pieces of elm bark shaped exactly like Ionic volutes; an Elizabethan chopine whose handle, in Soane's own words, had "a remarkable position" (in fact looking quite like an erect penis).

Architectural models were placed on ceilings, and models made for other buildings were used as skylights in part of the house. Among the medieval and classical fragments stood the tomb of the imaginary monk Padre Giovanni, which in fact contained the remains of his (real) pet dog Fanny. In his *Description of the House and Museum,* a text published in 1835, Soane eulogized his faithful canine companion ("Alas, poor Fanny . . . "), noting with nary a pause in his text the benefits of the new central heating system he designed and built, whose machinery stood adjacent to the tomb of Fanny/Padre Giovanni.

The structural fabric of the museum was no less remarkable, with several walls made up of hinged panels of paintings that, when opened up, revealed compositions continuous with views through opened walls into a corridor or courtyard. Changes of level at unexpected points, astonishing juxtapositions of diverse objects of different sizes, scales, or periods, controlled views through the building revealing teasingly "historical" stylistic genealogies – the museum was a multidimensional trompe l'oeil. Indeed, it remains so today, for the museum was preserved essentially intact in its final (1837) form by an act of Parliament.

[9]See Impey and MacGregor, *The Origins of Museums,* on curiosity cabinets in various European countries; J. von Schlosser, *Die Kunst- und Wunderkammern der Spätrenaissance. Ein Beitrag zur Geschichte des Sammelwesens* (Leipzig: Braunschweig, 1908; new edition 1978).

The entire collection surrounds a large, three-storied light well, a domed space at the center of which is a bust of Soane himself, finished and put in place in 1829, standing directly opposite a bust of the Apollo Belvedere. Soane recorded the sculptor's comments upon presenting the bust to Soane: He said that he himself could no longer tell whether he had made a bust of John Soane or of Julius Caesar.

Soane's Museum is widely considered to be a transitional phenomenon, something halfway between the Renaissance cusiosity cabinet and the modern museum: a romantic synthesis of pseudohistorical settings and Soane's own personal, poetic, and architectonic visions. What is absent in such a view is what it is clear that Soane's construction is directly addressing, and standing in critique of – the new public, civic museum of art, in particular the British Museum itself, which was rising in its present form during those years, across town in Bloomsbury.[10]

It was the rationalized, historicist, genealogizing collection of antiquities built around the original bequest of Sir Hans Sloane that was John Soane's very particular object of address. Soane's Museum works to ironicize that project by problematizing aesthetic chronology and rationalized genealogy, by transforming what had become the canonical dramaturgy of the public art museum into a series of intersecting labyrinths: a landscape of ruins and fragments, a museal and sepulchral monument. Soane was a great admirer of Alexandre Lenoir and of not only his Museum of French Monuments in Paris, in the converted convent of the Petits-Augustins (1793–1815), but also his "Elysium," the antecedent of the Père Lachaise cemetery (which Soane regarded as the greatest monument of modern French art).[11]

At the same time, Soane's Museum fragments Soane himself, setting him up as the antithesis of Sloane. In contrast to the founders of most other great private collections, Soane is curiously elusive: He is figured in his museum only in fragments, or only ambiguously, as with his (unlabeled) bust. He is situated, in his own writings, both anterior to the museum (in the guise of the imaginary monk Giovanni) and posterior to its falling into ruins (as in the text whose protagonist is the imaginary antiquarian of the future).

In short, everything about the museum constitutes an opposition to the principles of reason informing the new British Museum and a palpable critique of its agendas. Soane's Museum foregrounds the ficticities of the disciplinary autonomies installed in the new British Museum, ironicizing the historiographic dramaturgies of the nascent professional discourse of art history. Soane's Museum foregrounds what the collection built around Sloane's bequest masks: the impurity, otherness, and ficticity at the heart of the aesthetic, of "history," of modernity. Its subject matter, in fact, is the ironies of the frame, which it articulates architecton-

[10]A useful brief history of the British Museum may be found in Marjorie Caygill, *The Story of the British Museum* (London: British Museum Publications, 1981). In 1823, the government commissioned Robert Smirke to design a Greek Ionic-porticoed building in Bloomsbury to house the expanding collections, which had outgrown various quarters, including Montague House, since the museum's foundation in 1753. John Soane's own design for the new institution was passed over in favor of Smirke's.

[11]Millenson, *Sir John Soane's Museum,* pp. 140–1.

ically, structurally, visually, and textually. It is emblematic of the fact that periodicity is a fiction we tell ourselves in order to dramatize, teleologically, an ahistorical argument. As the antithesis of the British Museum across town, it demonstrates that there is no illusion for there is only illusion. It stages this in the predicative frameworks set up for its users with false and misleading itineraries, sudden disruptions of canonical historical or aesthetic genealogy, and with an astonishingly creative use of the banal, of bathos, of the oxymoronic, of masquerade. It is the first "post"-modern museum: a museum of high camp at the beginnings of modernist museology.

No canonical Temple of Art, no monument of sense, no totalizing theater of memory, Soane's Museum distances itself from panopticism and totalization on every front. It indicates (to say this in another register) that the trope is not a derived, marginal, or aberrant form of language, but rather the linguistic paradigm par excellence: not just one linguistic mode among others, but rather that which characterizes language as such as regards its inescapable heterogeneities. What Soane's Museum foregrounds, then, are the sleights of hand and the technologies of illusion that support the modern museum and its spaces of memory. And it offers its users a view into those technologies by its disruptive and disconcerting refusals of totalization and of the aestheticized "histories" of art becoming canonical in the major civic museums of art in Europe at the time.

Of course, we *see* this only if we view Soane's Museum and the British Museum simultaneously and stereoptically – if we read each against the grain of the other. The one seems odd only in the light of expectations set up by the other. A century and a half later, Soane's Museum seems odd, idiosyncratic, perverse; the British Museum seems canonical, natural, "modern."

It should be clear, if only in shorthand here, that the museological was a highly contested space at the beginnings of the modernist museum, however much the moral semiologies of the latter have come to be seen as natural and inevitable today. By foregrounding the ironies of the frame, Soane's Museum constituted itself as a critical artifact, highlighting the constructivist bases of perception, and refusing complicity with the passive consumerism of imaginary "histories" staged by its sister institution in Bloomsbury.[12]

★ ★ ★

What, then, can we say about art history, about Art, about the "truth in art," if its institution has from the beginning been a trompe l'oeil of astonishing power and complexity? And what can we say about our modernity if it can be so enframed by a device such as the museum? And what, indeed, can we say about our "post"-modernity?

What is realized in (my) history is not the past definite of what was, since it is no more, or even the present perfect of what has been in what I am, but the future anterior of what I shall have been for what I am in the process of becoming.[13]

[12]On the subject of the intended audiences of the British Museum, as well as on the staging of displays for such audiences, see the excellent study by Inderpal Grewal, "The Guidebook and the Museum: Aesthetics, Education, and Nationalism in the British Museum," in press.
[13]Jacques Lacan, *Ecrits* (Paris: Editions du Seuil, 1966), p. 300.

BRUSHED PATH, SLATE LINE, STONE CIRCLE: ON MARTIN HEIDEGGER, RICHARD LONG, AND JACQUES DERRIDA

HERMAN RAPAPORT

MUCH visual art of the twentieth century can be interpreted as a resistance to Kant's *Critique of Judgement*. Dada, surrealism, cubism, constructivism, abstract expressionism, pop art, minimalism, and, more recently, so-called postmodern art can be interpreted as a questioning of Kant's presuppositions about art and aesthetics. Not surprisingly, both Martin Heidegger and Jacques Derrida have had to consider the Kantian tradition, as well, though neither of them, to my knowledge, has written extensively about key twentieth-century work that has challenged the Kantian legacy. I am thinking, for example, of work by Malevich, Duchamp, Ernst, Pollock, Johns, Rauschenberg, Smithson, Frankenthaler, Beuys, Paik, Hess, or Haacke. This is not to say that Heidegger and Derrida have not written essays that use important artistic examples; their writings on Van Gogh, for example, are very important. However, I want to show why the work of Heidegger and Derrida should not necessarily be restricted to the examples they have used and why we should read these philosophers in relation to artists whose work they have not engaged. In particular, I want to consider the earth artist, Richard Long, whose work points to an aspect of aesthetics in the philosophies of Heidegger and Derrida that otherwise would remain unnoticed, namely, its restitution after the dismantling of metaphysics.

Chiefly considered a member of the British land-art movement – other artists include Roger Ackling, Andy Goldsworthy, Chris Drury, Ian Hamilton Finlay, Raymond Moore, and Linda Taylor – Long's "work" takes place outdoors but is on view indoors.[1] He is well known for his linear "walks," such as *A Line of Ground 94 Miles Long* (England, Autumn 1980), as well as shorter circular walks, such as *Granite Stepping-Stone Circle: A 5 Mile Circular Walk on Dartmoor Passing Over 409 Rock Slabs and Boulders* (England, 1980). In addition to his native England, Long has undertaken lengthy walks in Iceland, Lapland, Bolivia, Japan, Nepal, central Africa, and the United States. He has made site-specific

[1] The major reference source is R. H. Fuchs, *Richard Long* (London: Thames & Hudson, 1986). Also see *The Unpainted Landscape,* foreword by Simon Cutts (London: Coracle Press, 1987). For a useful history and overview of earth art, see *Art in the Land,* ed. Alan Sonfist (New York: Dutton, 1983).

sculpture out of driftwood, seaweed, snow, and stone. He has "marked" the land with watermarks, stone scratchings, and the brushing or clearing away of natural debris. Some of his museum installations consist of mud splashings on walls, watermarks, stone circles, and slate lines. The walks themselves are documented with photographs and verbal constructions bordering on poetry. And an overall consideration of Long's work would have to recognize that it ambiguously negotiates performance art, site-specific sculpture, conceptual art, minimalist art, photography, the construction of museum installations, poetry, appropriation art, the artist-book, and, most recently, video art.

Long is controversial within the international art community because in laying aside a Kantian notion of the work of art, he simultaneously recovers or restores familiar appearances of beauty. That is, Long juxtaposes radical antiaesthetic practices with a conventional rehabilitation of beauty that some have equated with romanticism and others with the aesthetic of Zen gardening. Given Jacques Derrida's considerations of the parergonal in art and his interrogation of the problematic of "restitution" within the tradition of painterly expression, it will be instructive to situate such analysis within the context of a highly self-conscious conceptual artist who has, quite independently of Derrida, paid considerable attention to both the enframing of the work of art and the question of "restitution." Indeed, Long's placement of the antiaesthetic in relation to the aesthetic also parallels a major moment in Heideggerian thinking when comments are made on the recovery or restitution of the aesthetic in the wake of its being laid aside during the dismantling of metaphysics. Heidegger, therefore, provides another mode of theoretical access to the work Long has been producing. Yet, given that Heidegger provides no artistic example of what he means by the laying aside and picking up of the aesthetic, it will be useful to consider Long's artistic practices as a means of developing Heidegger's thought, as well as its relation to Derrida's own meditations on it in *The Truth in Painting*. Hence, if Heidegger and Derrida provide theoretical access to the aesthetic questions raised by a contemporary artist like Long, Long will also enable us to better understand what one might mean in the work of Heidegger and Derrida by the restitution of an aesthetic left behind in the wake of the destruction of metaphysics.

★ ★ ★

In "A Dialogue on Language," the Japanese interlocutor says to Martin Heidegger,

Meanwhile, I find it more and more puzzling how Count Kuki could get the idea that he could expect your path of thinking to be of help to him in his attempts in aesthetics, since your path, in leaving behind metaphysics, also leaves behind the aesthetics that is grounded in metaphysics.

Heidegger immediately cautions: "But leaves it behind in such a way that we can only now give thought to the nature of aesthetics, and direct it back within its boundaries [*Aber so, daß wir das Wesen des Aesthetischen jetzt erst bedenken und in seine Grenzen verweisen können*]."[2] For Heidegger,

[2]Martin Heidegger, "A Dialogue on Language," in *On the Way to Language* (New York:

the boundaries do not refer to the limits or borders of the work as object but to the interplay of art within an openness that brings forth what is called stillness of delight (*Stille des Entzückens*).[3] In fact, Heidegger's dialogue does not stress the making of the work of art, but its coming to appear out of concealment as a consequence of "graciousness" or *Huld*. In Japanese this is called *koto:* "the happening of the lightening message of the graciousness that brings forth [*das Ereignis der lichtenden Botschaft der Anmut*]."[4] This definition reflects the moment in Heidegger when the aesthetic is taken up once more, after having been dropped, and it points to the aesthetic as that which comes out of concealment in such a way that it bears on a Saying that allows us to grasp stillness in relation to delight. Such a manifestation of delight could not take place without graciousness, which for Heidegger is synonymous with the "gift" or "granting" of Being. The Japanese speaks of this succinctly when he refers to the petals that stem from *koto* – the gift which springs from graciousness. Heidegger is quick to add that *koto* "names something other than our names, understood metaphysically, present to us."[5] And this suggests, among much else, that in picking up the aesthetic within a Japanese vocabulary, Heidegger is picking it up as something other, as that which names something else than our names name.

Helpful for an understanding of these thoughts is "Conversation on a Country Path" (*Zur Erörterung der Gelassenheit*), in which Heidegger suggests that to grasp stillness in its relation to delight would mean to think beyond representation and objecthood. In this context, therefore, *koto* would name something other than a thinking about the aesthetic which would be understood in the traditional contexts of re-presentation or mimesis. The metaphor for this other way of thinking is the country path which opens onto what Heidegger calls a region. The term "region" is meant to radicalize the Husserlian notion of horizon, which, of course, pertains to an understanding of an object world. Heidegger's notion of region, then, is the path along which some metaphysical baggage can be dropped by the wayside. It is the open, the clearing where one approaches what names something other than what our names name. Of major importance is the following exchange:

TEACHER: The region gathers [*Die Gegend versammelt*], just as if nothing were happening [*gleich als ob sich nichts ereigne*]; each to each and each to all into an abiding [*das Verweilen*], while resting in itself. Regioning [*Gegnen*] is a gathering and re-sheltering [*versammelnde Zurückbergen*] for an expanded resting in an abiding [*zum weiten Beruhen in der Weile*].

SCHOLAR: So the region itself is at once an expanse and an abiding [*die Weite und die Weile*]. It abides into the expanse of resting. It expands into the abiding of what has freely turned toward itself [*des frei In-sich-gekehrten*]. In view of this usage of the word, we may also say "that which regions" [*Gegnet*] in place of the familiar "region" [*Gegend*].

Harper & Row, 1971), p. 42; idem, "Aus einem Gespräch von der Sprache," in *Unterwegs zur Sprache* (Pfullingen: Neske, 1959), p. 138.
[3]Heidegger, *Unterwegs zur Sprache*, p. 143.
[4]Heidegger, *Unterwegs zur Sprache*, p. 142; *On the Way to Language*, p. 47.
[5]Heidegger, *On the Way to Language*, p. 47.

SCIENTIST: I believe I see that-which-regions as withdrawing rather than coming to meet us. . . .

SCHOLAR: . . . so that things which appear in that which regions no longer have the character of objects.[6]

Ever since their inception in the 1960s, Long's walks have remained uniform in conception and execution, perhaps even to the point of single-mindedness. Yet they have remained compelling and elusive as well. His walks have raised numerous questions pertinent to conceptual and minimalist art touching on notions of the objectification, presentation, and situation of the work of art. Some might argue that the walks themselves are not even the work, but that the work comes to appear in the impermanent modifications to the environment which the wanderer makes. On some occasions Long has walked back and forth along a straight line and has, merely by walking, brushed the earth or its vegetation enough so that from a distance one can clearly see the impermanent trace of where the wanderer has been. On other occasions, Long has moved stones or has, at various determined points, gathered and carefully ordered stones into lyrical structures. One wonders: Does the art consist in or as these stone constructions, these monuments to his walks? Does the art consist in the act of making the constructions within the framework of the walk? Or are these modifications to the landscape merely the trace of something which has never come to presence as work but which persists as idea?

Given that Long is a solitary wanderer, how is it possible for his work to appear as work before an other? Moreover, as the one who walks, is Long himself in a position to objectify or constitute the walk as work? Like Christo, Long documents his performance work by providing maps, photographs, and texts. But whereas Christo's photography complements the monumentality of his expensive outdoor drapery, Long's photographs are contradictory in that they are a tracework that does not shy away from supplementing the ineffable with extremely traditional representations reminiscent of commercialized nature photography. In that context, Long's "works" are ironically overly accessible and stand in stark opposition to the conceptual and performative unrecoverability of the walk.

The photographs, then, signal a moment in which the aesthetic, dropped or laid aside by the act of walking, is once more taken up. However, this recovery is far from being an uncomplicated one, since even the photographs participate in the walks' dismantling of an aesthetic tradition. As supplementary documentation, these photographs are merely traces in the wake of a work that remains concealed. Curiously, the traditional mimetic representation – the positive contact print – functions like a photographic negative or negation of the walk as art. But when this negative or negation of the work is displayed in museums or sold to collectors, it functions to affirm and display the work even as it puts the walk as work under erasure. In offering to the collector an object, however supplementary, that can be seen or purchased,

[6]Martin Heidegger, *Discourse on Thinking* (New York, Harper & Row, 1966), pp. 66–7; idem, *Gelassenheit* (Pfullingen: Neske, 1959), pp. 39–40.

Long is suggesting that the walk can be detached from time and place and turned into an art commodity, as so many pictures signed by the artist.

Are the photographs, then, some kind of joke which Long is playing on the art market? And do they, by way of negative example, point to the peculiar condition of the walk as inappropriable and allergic to the traditional mimetic assumptions which inform museums and art markets? Certainly, the photographs must be making some such point, particularly since Long has made remarks deprecating their significance, as if to suggest that the photographs are little more than ancillary souvenirs which only point to the ineffability of the walks as works. To put this in terms of Heidegger's "A Dialogue on Language," the photographs can be seen as the very aesthetic which the walks have dropped by the side of the road. This would account for the deliberate staging of the pictures within a romantic aesthetic which is so commonplace in commercial nature photography. That is, the romantic representation of the outdoors as raw beauty falls away in its appearance as souvenir or document as if to "release" the walk from a certain aesthetic burden. The walk, then, might be comprehensible as detached from the requirements of a Kantian aesthetic in which the work must manifest itself as something intended to be seen or disclosed, as the something consciousness requires in order to be "conscious of." Perhaps Long even takes matters a step further than Heidegger, since for Heidegger the walk imitates thinking as an event or occurrence which is in movement toward and in retreat from, whereas for Long the walk does not address a movement toward or away from an event of thoughtfulness; rather, the movement would be more indicative of what cannot be thought or reflected upon. If the photographs are approximating mere prettiness (some might even say kitsch), they may be doing so in order to mark a "coming into nearness of distance" which is insufficient to disclose or approach the work of the artist as either work or event.

And yet, if these photographs can be viewed as the very aesthetic which the walks leave behind, like some old shoe, Long has also addressed them as being exemplary of high art. In other words, if the photographs suggest the dropping of an aesthetic, they also manifest the very aesthetic which is being picked up in the aftermath of minimalism. The photographs, then, could be seen as an instance of what Heidegger is enigmatically calling the redirecting of the aesthetic within its borders or boundaries. What appears, therefore, in the photographic documentation is a representation of beauty which has returned, after having been put aside, as if to say that when beauty is recovered, it will arrive as if from outside or beyond the work as work – as an accessory to the region which delimits the walk.

This return of beauty does not come in the form of a return of the repressed, since there was nothing traumatic about its having been left behind in the first place. And perhaps this is one more indication that Long's "work" has been released in a Heideggerian sense, since from the standpoint of an agonistic history of art the aesthetic is laid aside and taken up with serenity. In "A Dialogue on Language" the Japanese says, "A stilling would have to come about that quiets the breath of the

vastness into the structure of Saying which calls out to the messenger."[7] The stilling, here, is a moment of the laying aside and the structure of Saying, a moment of reappropriation or return. Something can be said, because something has first been stilled. However, contrary to our usual expectations, the relation between stillness and saying is nonoppositional. Indeed, what speaks to the messenger is not a saying that takes the place of silence, but the coming to attention of silence as that which can be said. No doubt this saying is a modality of *koto,* "the appropriating occurrence of the lightening message of grace."[8] In other words, saying is the event of an appropriation that is released in grace as a "letting be" which radiates.

The photographs of Long are reminiscent of such a saying, for they, too, follow a stilling in ways that are not necessarily to be understood as oppositional. The photographs, from this perspective, do not necessarily supplement in the sense of substituting, but are indicative of an appropriation in which the walk comes to attention as something other than the walk, namely, the region in which the concealed and the unconcealed (i.e., silence and saying, the nonvisual and the visual) come to pass as graciousness, letting be, releasement, or clearing. However, as such, the photographs nevertheless must bear on a saying that can be understood, and therefore they do not necessarily have to say in a way that is unfamiliar.

Whereas art of the avant-garde has struggled to create new languages in order to change the ways we comprehend the world, Heidegger and, by extension, Long suggest that Saying is not essentially tied to the production of new and unfamiliar representations. In fact, Saying may be most radical when it chooses not to take the path of defamiliarization but, instead, reappropriates something familiar that has temporarily been put aside. Of course, to reappropriate in this way is not to return, in our context, to the very aesthetic one has left, but to take up that aesthetic in a way that puts its identity and difference with respect to itself in question. In other words, one would be violating Long's photographs if one merely categorized them as a style which is presumed to be self-identical and historically fixed in terms of an art movement.

Indeed, the photographs concern a turning in which a nineteenth-century aesthetic is put aside in order that an aesthetic of Saying can come about. Such a turn is not agonistic or oppositional but rather a stepping into a region where aesthetics is released or liberated from the stylistic and historical conflicts which have characterized Western perceptions of the arts. Not least important is the release of the aesthetic from the will of the artist. Heidegger writes, "Everything is in best order only if it has been no one's doing."[9] No doubt, as an artist, Richard Long does something; however, he has often attempted to take only minimal actions, many of them quite commonplace and not particular to what we might call "artistry." The walks, for example, are difficult to distinguish from ordinary hiking, and the stone installations in mu-

[7] Heidegger, "A Dialogue on Language," p. 53.
[8] Ibid., p. 45.
[9] Heidegger, *Discourse on Thinking,* p. 71; idem, *Gelassenheit,* p. 47.

seums require actions which any mason might be able to perform. Similarly, the photography is not beyond the skills of any amateur who knows the zone method of light metering. Long might point out further that not only are the actions hard to recover as "art" – contrast this, for example, with brushstrokes by Van Gogh, the handling of line by Gauguin, and composition in the sculpture of Henry Moore – but also the works come to pass largely on their own.

★ ★ ★

In *The Truth in Painting* Derrida has written what is undoubtedly one of his greatest introductions to deconstruction, "The Parergon," and one of his most difficult and breathtaking close readings, "Restitutions." Judging from commentaries on "Restitutions" alone, one might not guess that the essay is, in fact, a dialogue or conversation. Moreover, "Restitutions" is about a debate and concerns the paintings of shoes by Van Gogh over which Martin Heidegger and Meyer Schapiro are debating, though, of course, it is a one-sided debate, with Schapiro taking up all of its length. Somewhat in this vein, Derrida's text mimes a dialogue in which one person plays all the parts, and we are left wondering if it is a matter of dividing one train of thought or if, in fact, two or more different trains of thought are being represented. However, as in Heideggerian dialogue, the dividing of parts may well be done in a nonoppositional manner. That is, even if the representation of the Schapiro–Heidegger debate manifests sharp if not bitter conflict, the setting up of "Restitutions" as a dialogue mimes Heidegger's own genre of dialogue which is noncombative or nonoppositional. This difference between the nature of the debate (as reflected in the writing of Schapiro) and the dialogue (as reflected in the writings of Heidegger) is easily overlooked and constitutes what Derrida in an earlier text called the *double séance*. This "double session" can be a parergonal structure to the extent that it mandates, within a mimetic tradition, some means of properly representing (or doubling) something that has already taken place. "The two faces are separated and set face to face, the imitator and the imitated, the latter being none other than the thing or the meaning of the thing itself, its manifest presence."[10] But Derrida also conceives of a doubling that is not circular and therefore fails to return to its "proper" a priori referent. Such doubling may be a writing which "both marks and goes back over its mark with an undecidable stroke." Such doubling takes place not once but many times as dis-location and dis-placement. "Let us read [Mallarmé's] *Mimique*. Near the center there is a sentence in quotation marks. It is not a citation, as we shall see, but the simulacrum of a citation or explication: – '*The scene illustrates but the idea, not any actual action. . . .* ' "[11] Derrida disabuses us of idealism by remarking that it is not sufficient in this case to imagine that the "idea" can take the place of the referent, actual action. Rather, we must be prepared to realize that the idea is a term which marks absence. The idea is a white page. Hence the mime imitates nothing, reproduces nothing, speaks of

[10] Jacques Derrida, *Dissemination* (Chicago: University of Chicago Press, 1981), p. 193.
[11] Ibid., p. 194.

nothing. But what kind of "thing" results? Derrida replies, with his attention on "what" kind of text Mallarmé is writing:

> A mimodrama "takes place," as a gestural writing preceded by no booklet; a preface is planned and then written *after* the "event" to precede a booklet written *after the fact,* reflecting the mimodrama rather than programming it. This Preface is replaced four years later by a Note written by the "author" himself, a sort of floating *hors-livre.*[12]

The "thing" or "text" is all mimicry: a double that is anticipated by nothing. The mimic or mime alludes, though without referring to anything. Such alluding "alludes without breaking the mirror, without reaching beyond the looking glass."[13] Instead of pointing to reality, there are merely "reality effects," and the real itself becomes akin to death insofar as the real would break the speculum of mimicry. Further, Derrida notes the following:

> In this speculum with no reality, in this mirror of a mirror, a difference of dyad does exist, since there are mimes and phantoms. But it is a difference without reference, or rather a reference without a referent, without any first or last unit, a ghost that is the phantom of no flesh, wandering about without a past, without any death, birth, or presence.

Mallarmé thus preserves the differential structure of mimicry or *mimesis* but without its Platonic or metaphysical interpretation, which implies that somewhere the being of something that *is,* is being imitated.[14]

Let me break off here, for a moment, and return to "Restitutions." It is Meyer Schapiro who wants to maintain an aesthetic high ground by demonstrating that Heidegger has "forgotten" mimesis; after all, did Van Gogh not paint *real* shoes, and not only that, did he not paint his *own* shoes rather than the peasant shoes of which Heidegger speaks? In other words, to recall Plato's *The Sophist,* are these shoes not icastic representations of real objects, and is Heidegger not falsifying the whole issue of analyzing Van Gogh's paintings by dreaming up a fantastic scene which has no reference whatsoever to the "things" Van Gogh painted? "Schapiro tightens the picture's laces around 'real' feet. I underline: '*They are clearly* pictures of the artist's *own* shoes, not the shoes of a peasant. . . .' "[15] Heidegger, on the contrary, is making an attribution to the shoes – he says they are peasant shoes – which is *not* essential but merely accessory or detachable. That is, Heidegger is simply fantasizing and projecting his fantasy onto the shoes that he sees. "Everything that comes down to the 'peasant' world is in this case an accessory variable even if it does come massively under 'projection' and answers to Heidegger's pathetic-fantasmatic-ideological-political investments."[16] In other words, the "analysis" of Heidegger purposely sets aside the mimetic priority of valorizing the image as icastic in order to take up a simulacrum or fantasmatic allusion which has no "proper" reference. Therefore, Heidegger's analysis approaches the kind of doubling which Derrida has noticed in Mallarmé's *Mimique,* a miming that reflects no reality but produces, instead, "reality effects," because mimicry does allow for "a difference

[12]Ibid., p. 199.
[13]Ibid., p. 206.
[14]Ibid.
[15]Jacques Derrida, *The Truth in Painting* (Chicago: University of Chicago Press, 1987), p. 313.
[16]Ibid., pp. 311–12.

without reference, or rather a reference without a referent . . . a ghost that is the phantom of no flesh, wandering about without a past, without any death, birth, or presence."[17]

For Derrida, then, the operation which occurs in *Mimique* is not comprehended within the dynamics of truth, but rather entails the comprehending of truth as a truth-effect. This operation, Derrida notes, is a staging or framing that has no requirement to conform or resemble something present. But how can such a stage stage? Derrida maintains that in Mallarmé this can occur only through a rethinking of difference in terms of what he calls the veil or hymen. In addition to much else, the veil marks the *différance* between "image and thing, the empty signifier and the full signified, the imitator and the imitated." The veil abolishes the "difference" between "difference and nondifference" even as it intercedes in order to establish a gap or space between them.

In the Van Gogh paintings it is the image of the shoes which operates like the veil or hymen in Mallarmé's *Mimique*. The shoes are themselves a "double session" insofar as they are a pair and thus are inherently divided, split, doubled, and so forth. In fact, Derrida questions that the shoes Schapiro and Heidegger discuss are actually a pair and wonders if the assumption that they are paired is not the result of some fantastic projection which assumes that the shoes must support or hold up a "subject," namely, a wearer. In this, the pair of shoes tie Schapiro and Heidegger together. Yet this divided "thing" – in whose pairing the veil comes to pass – comes between Heidegger and Schapiro by suggesting a "double sitting," as it were, in which an absent peasant woman confronts an absent city dweller, namely, Van Gogh. Here the pair/nonpair of shoes calls into question the difference between the icastic and the fantastic, mimesis and mimetology. At a psychoanalytic level it also calls gender into question by taking up sides, the one shoe simulating a vagina, the other a phallus-that-mother-never-had.

Because the shoes are not what Derrida in "The Double Session" (in *Dissemination*) considers a present around which is gathered a unity of temporal relations – Van Gogh painting his shoes at a particular time on a particular date in history – they need to be thought out in terms of "a series of temporal differences without any central present."[18] Derrida suggests this orientation to the shoes in "Restitutions" by discussing them as a series which both brings into relation and holds apart identity and difference, as if these shoes were veils, one substituting for another without ever taking priority, without ever collapsing into a real referent or "truth." This conforms rather well to Heidegger's notion of "correspondence" in the later writings on language, where the question of appropriation and disappropriation is taken up, but it also fits in rather well with Derrida's remark in "The Double Session":

The referent is lifted, but reference remains; what is left is only the writing of dreams, a fiction that is not imaginary, mimicry without imitation, without verisimilitude, without truth or falsity, a miming of appearance without concealed reality, without any world behind it, and hence without appearance: *"false appearance. . . . "* There remain only traces, announcements and souvenirs, foreplays and aftereffects which no present will have preceded or followed and which

[17]Derrida, *Dissemination*, p. 206.
[18]Ibid., p. 210.

cannot be arranged on a line around a point, traces "here anticipating, there recalling, in the future, in the past, *under the false appearance of a present.*"[19]

In "Restitutions" this lifting of the referent by means of interrogating the pairing or divisibility of the shoes touches on the parergonal to the extent that the divisibility or mimetology becomes the support or prop for a content that is merely phantasmic, for the shoes as "reality effect." Derrida touches on this rather squarely when he notes that "what's at stake here is a decision about the frame, about what separates the internal from the external, with a border that is itself double in its trait, and joins together what it splits."[20] These remarks, of course, are themselves playing with a double reference, that is, to the frame of the painting as well as to the shoes themselves. It is the frame of the painting which separates the internal from the external, and so on, but, at the same time, the figure of the "pair" of shoes is mimicking the frame by means of operationalizing a "double session" that similarly deconstructs the difference of interiority (what is proper or attachable to the shoes) and exteriority (what is merely outside, or detachable from the shoes). What one has, then, is the deconstruction of the difference between what frames and what is framed, with the result that the painting by Van Gogh becomes an abyssal mimetology (i.e., the double in its trait) of frames upon/within frames. The shoes themselves accede to a phantasmic series which obeys the abyssal law of the double trait, of the shoe as hymen, or, in terms of the notorious Heidegger passage on the peasant woman, hymn.

For the rhapsodic Heidegger passage on the peasant woman's shoes and the silent call of the earth is a hymn, though, too, a hymen. This is why it is a woman who is wearing the shoes, and not a man, since it is the Heideggerian hymen which is being disclosed.

In the stiffly rugged heaviness of the shoes there is the accumulated tenacity of her slow trudge through the far-spreading and ever-uniform furrows of the field swept by a raw wind. On the leather lie the dampness and richness of the soil. Under the soles slides the loneliness of the field path as evening falls. In the shoes vibrates the silent call of the earth, its quiet gift of the ripening grain and its unexplained self-refusal in the fallow desolation of the wintry field.[21]

One can easily imagine the leather, the furrows, the gift of ripening grain, and an unexplained self-refusal as pertaining to a gynocentric scene which is itself divided or parceled out along the hymen's border as explained by Derrida in "The Double Session," which is to say, the hymen as that which is always already penetrated ("in the shoes vibrates . . . its quiet gift of the ripening grain") and never violated ("its unexplained self-refusal"). As Derrida shows in "Restitutions," the shoes themselves are double-sexed, meaning that they are alluding to both masculine and feminine genders. In the foregoing Heidegger passage, I want to argue, it is the feminine aspect of the shoes which is being constituted in terms of hymn and hymen. But such a reading is, without doubt, entirely fantastic, projected, and, as such, discountable, removable, detachable.

[19]Ibid., p. 211.
[20]Derrida, *The Truth in Painting,* p. 331.
[21]Martin Heidegger, "Origin of the Work of Art," in *Poetry, Language, Thought* (New York: Harper & Row, 1974), p. 34.

Hence the ex-centricity of the hymen, which is to say, its negligibility. In this sense, we could say the hymen achieves a certain Heideggerian releasement. Such a releasement could be said to be the region of the hymen, the region of the unrepresentable (indeed, even the ob-scene) in which a hymn comes to pass in the aftermath of mimesis.

Yet if releasement is the region of the unrepresentable, of the hymen and the hymn, is it not as close as we are likely to get to a taking up once more of the aesthetic? Perhaps. But a close reader of Derrida might prefer to speak of this in terms of the hymen as detachment and reat-tachment, disappropriation and reappropriation. The shoes, we might say, stage this mimetological double session of the late Heidegger in which he anticipates the return of the aesthetic and its redirection within borders, in Derrida's sense, the mimetological border of the hymn/hymen. That the aesthetic returns is beyond doubt, for "there is" (*es gibt*) the hymn. Which is to say, the "hymn" is granted.

★ ★ ★

In the catalogue *Richard Long,* R. H. Fuchs recalls that "in Nepal, where there are many villages throughout the valleys, [Long] made a work by brushing the footpath to leave a dusty line clear of leaves and twigs. Remoteness does not mean the absence of other people." And he notes further that "during a twelve day walk in Ladakh, the Buddhist part of Kashmir and a mountainous land of footpaths, [Long] respectfully walked lines upon the existing footpath, 'Walking within a walk, along the line of shared footprints.' "[22] Walking the paths of others (Fig. 17), the walks of Richard Long take on an abyssal structure reminiscent of the mi-metology of the "double session" or, as is worked out at length in "Cartouches" (in *The Truth in Painting*), a series in which a model is constituted as both intrinsic and extrinsic to the structure of which it is supposedly a part. For Derrida, such a series remains "without example," though it never does so entirely. "That which [the example] it [the series] expels, discounts, or defalcates, it also keeps in its own way, and exhibits the remains of it, it *raises it up* onto this pedestal, the stela, throne or rostrum of its catafalque (*ex cathedra,* once it has climbed up into the pulpit it keeps silent)."[23] Certainly one could make a similar argument for the "brushed paths" and, in general, the "walks" which always pose and depose what Derrida calls the model, paradigm, cartouche, or ex-ample. In fact, one could probably make a similar argument for serial work by Sol LeWitt, Andy Warhol, Mary Kelley, and Joseph Beuys, not to say Van Gogh, whom, of course, Derrida does take up. But what would be missing from such an account would be how the aesthetic is restored or rehabilitated.

From a Heideggerian perspective, the brushing of the path is a letting-be-seen (*sehen lassen*) or unconcealment of the *Feldweg,* the "thereness" of the path, which discloses that there is and has been walking, that someone has passed along the pass, and that the pass is the silent or still abiding trace or track of beings who have come to pass as passing. Hence,

[22]Fuchs, *Richard Long,* p. 133.
[23]Jacques Derrida, "Cartouches," in *The Truth in Painting,* p. 194.

like Derrida in the beginning of "Restitutions," one must face up to the fact that "Well, we've got a ghost story on our hands here all right," meaning that the specters of others who have passed are suggesting themselves in the brushing aside of leaves and twigs which have covered the path. This also means Long is entering that abyssal structure which Derrida sees in Titus-Carmel's coffins, and, moreover, it means that as in the case of the coffins, we may well notice the approach of something abject which Derrida addresses as cadavers, excrement, and ghosts. In Long's "brushed path" these phantoms are kept in abeyance, though one could project them into the scene from "outside."

Indeed, such a projection would come about at the moment someone brushes the path, at that moment the veil of leaves and twigs is lifted. Only then do we remember the others who have come before, both living and dead. To develop Derrida's notion of projection a little bit further, let us recall that all this could be read back into Claude Lanzmann's *Shoah,* a film which could be interpreted as a cinematic version

17 Richard Long, *Walking Lines Along the Footpath: A 12-Day Walk in the Zanskar Mountains of Ladakh, Northern India.*

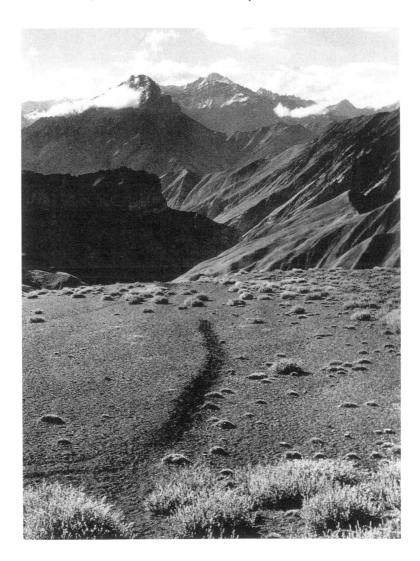

of the "brushed path." That is, the traces or tracks of those who have gone before involve a hallucinatory apparatus of imaginary projection in which the absent returns to tell the story of crossing, walking, marching, staggering, and so forth. By making people "come back" to where they once walked, Lanzmann lifts the veil, and the land, as it were, helps in narrating a terrifying history which has been covered over in a way similar to the paths of Nepal – that is to say, by the mere passage of time and change. Of course, the weight of Lanzmann's horror – the horrifying story he seeks to unconceal by brushing the leafy paths to Auschwitz – is absent from Long's *A Line in Nepal* (Fig. 18), in which the brushing of the path formalizes the forgetting of history, its sweeping aside, as it were, and the coming of a clearing in which the passage or turn from beings to Being is made wherein a restoration of beauty becomes thinkable once more. However, this restitution becomes thinkable only because something heavy has been lifted, because the phantoms do not return, even though the road has been cleared or prepared for them.

Derrida, I think, would not want to miss this restitution or return of the dead. He would find it very problematic if in brushing the path a veil were lifted that had the structure or stricture of an undecidable strip or stripping which is both violable and inviolable. Here, of course, we approach the structure of the hymen in its Sadean manifestation of a body or covering that remains intact and virginal no matter how many times it has been raped or otherwise tortured. In other words, when Long brushes the path in Nepal, he guarantees the forest path's invio-

18 Richard Long, *Brushed Path: A Line in Nepal.*

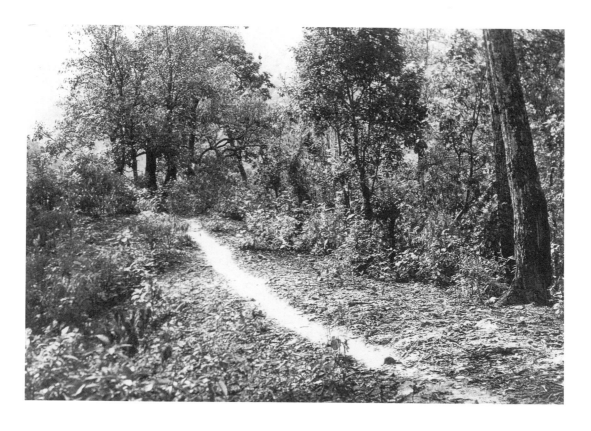

lability and its Heideggerian regioning, opening, or clearing in which we are released from representationality and, too, from the stories that those ghosts who have gone before have to tell. In short, for Long, the lifting of the veil is necessarily a releasement from ghosts, from the metaphysics or, better yet, phenomenology of those specters who haunt consciousness. To lift the veil in this way is to disclose the earth or path as yet a more authentic veil, as veil or hymen incapable of suffering molestation. If we may substitute the word "earth" for "woman," we can quote from Derrida's *Spurs* as follows: "Earth [woman], inasmuch as truth, is skepticism and veiling dissimulation."[24] That is, the earth, too, in our perception, may be capable of dissimulating in only a mimetological fashion, because it can never, in our consciousness, know anything of what Derrida calls "castration."[25] The brushing of the path, then, suggests a mimetology of veiling or dissimulation in which the veil is always being lifted in order that it affirm itself all the more as an inviolable covering. However, this lifting always and already suggests violation, as well, since something is being disrupted, penetrated, uncovered, denuded, or stripped – what we might call the rape of the earth. Even if the brushing is delicate, Long's "brushed paths" would appear to activate this dynamic of the veil as discussed in "The Double Session" and *Spurs*.

However, the brushing of the path by Long also suggests both the eradication and revelation of evidence or traces of where the human has come to pass. Derrida, in addressing the expropriated shoe which has been left behind on the *Feldweg*, notes that "there is persecution in this narrative," as if to say that what gets left behind on the path is always indicative of human conflict or travail.[26] Indeed, when Long brushes the path, it is not to expose such conflict or, when it occurs, human joy, but to clear away the traces of the human, as if to brush or sweep humanity aside so that a "region" can come to appearance as the granting of a hymn or ode to beauty. This would correspond to Derrida's hint that Heidegger has put persecution carefully aside with his metaphysics when speaking of the shoes and unconcealing the clearing of Being in the *Feldweg*. For Heidegger, in remembering Being, prefers to forget beings, and this, Derrida is saying, raises certain problems in the context of German history – particularly, as Philippe Lacoue-Labarthe explains in *Heidegger, Art, and Politics,* when Heidegger opts to forget the dead.[27]

Such a problematic cannot be said to express itself in the same way within the career of Richard Long, whose historical and cultural contexts are so remote from those of Heidegger. Nevertheless, I wonder if in lifting the veil by brushing the path in Nepal Richard Long does not walk

[24]Jacques Derrida, *Spurs* (Paris: Flammarion, 1976), p. 47.
[25]Here, of course, a whole area called environmental ethics comes into view insofar as that ethics must engage the double and undecidable logic of the veil in correspondence with the articulation of the notion of woman as Derrida describes it in the context of Nietzsche and Heidegger in *Spurs*. The earth, in particular, is a figure of that which is always already violated and inviolable. And our actions with respect to the earth are, in every case, determined by this double session. To examine environmental policy, discourse, and the management of environmental catastrophes in these terms would be essential as a precondition for any rigorous understanding of how we conceptualize our relation to the land.
[26]Derrida, *The Truth in Painting*, p. 274.
[27]Philippe Lacoue-Labarthe, *Heidegger, Art, and Politics* (Oxford: Blackwell, 1990).

in the footsteps of others in order to forget beings? The photograph of the line, like the vast majority of other photographs by Long, is devoid of people. And no doubt because of this, such photographs are also devoid of nightmare, hallucination, and phantoms. It is as if in detaching us from beings by an attentiveness to the erasure of the trace, Long has cleared the way for the return of the aesthetic in the persistence of that which has withdrawn from the human. The brushed path could be said, then, to be the formalization of this retreat, even as it exposes Long and the viewer to the traces (i.e., the erasure or effacement) of those who have passed through the region. If this is so, then we can say that Long has successfully performed what the discussants in "A Dialogue on Language" have proposed: a dropping of the metaphysical and a redirecting of the aesthetic within certain borders or boundaries which concern a trace that unveils itself as the erasure of the trace. But if what is given in this effacement and clearing is gracious, it is also a hymn which comes from the side of the inhuman, what Heidegger elsewhere calls the *Unmenschlich*.

Although traditionalists accuse Derrida of having advanced an anti-humanism, the fact is that "Restitutions" is quite reluctant to relinquish the human and its attachments to the metaphysical. Recall Derrida's opening remark in "Restitutions": "Well, we've got a ghost story on our hands here all right." And recall his insistence that what makes Heidegger's reading of Van Gogh so powerful is its very capacity to project a hallucination, to imagine something supplementary to the figure, to parergonally situate the image of the shoes in terms of a phantasmic scene. In other words, what characterizes the reading of Heidegger is a desire to pull the whole enterprise of "The Origin of the Work of Art" away from the inhuman, away from those lines I quoted earlier from "A Dialogue on Language" in which the aesthetic returns after metaphysics has been dropped and left behind.

In "Restitutions" Derrida demonstrates that metaphysics is not some "thing" that can be merely cast aside, but an appropriation or correspondence implicating the relation between beings which comes to pass in the very disappropriation (i.e., the detachment or unlacing) of a Kantian (or, if one prefers, a Cartesian) understanding of the work. Although Derrida is suspicious of the correspondence with phantoms – in speaking of Heidegger's famous passage on the peasant woman's shoes, he says that "I had always found this passage of Heidegger's on Van Gogh ridiculous and lamentable"[28] – he rehabilitates the shoes as a detachable projection or "accessory" which at once dismantles a realist or mimetic understanding of Van Gogh even as they clear the way for a restitution or reattachment to human spirit. Hence, the shoes reveal "Vincent as a peasant woman."[29] And Derrida asks, "Are they [the shoes] a ghost (a piece of ghost, a phantom member)? In that case are they the ghost of Van Gogh *or* the ghost of the *other I* of Van Gogh, and what does that *other I* mean then?"[30] Such questioning of gender, subjecthood, and the return of the dead rehabilitates, albeit in very radical terms, an existential analytic in Heidegger which Derrida initially dismissed as ridiculous and

[28] Jacques Derrida, "Restitutions," in *The Truth in Painting*, p. 292.
[29] Ibid., p. 370.
[30] Ibid., p. 373.

lamentable. That is, Derrida is willing to reanimate and wrestle with those parergonal ghosts who are attempting to appropriate or arrogate the shoes. He remains open to a reencounter with the metaphysical (the phantasmatic) as a means for critiquing Heidegger and the Kantian tradition. This reencounter could be said to mark a re-turning or coming back of an existential problematic whose metaphysics is accessory to its having been left behind. In Derrida, then, what emerges is a restitution of the human, a deconstructive restitution which reverses the Heideggerian turn from beings to Being.

For Richard Long and Martin Heidegger, the setting aside of metaphysics results in a reencounter or reappropriation of beauty situated in the emptiness of a space from which the human has been expunged. Like Anselm Kiefer's empty charred landscapes, the paths of Richard Long remind us of how alien earth is to the human and the extent to which the land is restored to beauty in the absence of human *Dasein*. Long's photographs, moreover, reinforce this difference or distance between the earth and ourselves. They are often of worlds utterly remote from our experience, worlds that show the traces of the wanderer largely in terms of their impermanence or transience. In such regions, Long suggests, the human is precisely that which does not abide. Rather, what abides is the Being of what remains after humankind has passed through. As "Die Sprache" suggests, Heidegger identifies such an orientation to the restitution of beauty with the "bidding call of stillness [*den heißenden Ruf der Stille*]" through which Being is disclosed.[31] Whereas Derrida hears the ghosts who tell of persecution and destruction, Heidegger and Long are attuned to silences through which one is released into the frameworks of beauty and grace, that regioning in which "everything is in the best order only if it has been no one's doing." Still, even if in the work of Heidegger and Long one can identify a movement from beings to Being which Derrida reverses in "Restitutions," are not all of these figures returning to Kant – to an aesthetic driven back within its boundaries? That is, even if one attempts to think the future or beyond of metaphysics and aesthetics, is this thinking not, in any case, determined by the dif-ference of beings and Being which is expressed not merely by the way in which beauty or the aesthetic undergoes restitution but also by the way in which that restitution is itself "bounded" by the horizons of the human and the inhuman?

In "Dossier de van Gogh," Antonin Artaud speaks directly to restitution for Van Gogh. Speaking of the mentality which led to the detachment of Van Gogh's ear, Artaud writes, with himself, too, in mind:

[N]on, les hommes n'ont pas de mental, mais il n'ont jamais pu se résigner à laisser cette fonction stupide intégralement aux animaux, de même qu'ils n'avaient à l'origine pas de sexe, ce qui ne veut pas dire qu'ils étaient des anges non plus, car le corps dit de l'ange fut à l'origine plus insipide, et sommairement simple, que celui de certains chimpanzés.[32]

[31]Heidegger, *Poetry, Language, Thought*, p. 209; idem, *Unterwegs zur Sprache*, p. 32.
[32]Antonin Artaud, "Dossier de Van Gogh," in *Oeuvres Complètes*, vol. 13 (Paris: Gallimard, 1974), p. 155.

Between these registers, of course, the restitution of the human is suspended, spectral, detached – concealed as a rift in the inhuman within the fold of a double session of angels and apes. Not so removed are Francis Bacon's studies of Van Gogh, in which we detect the simian faces of Van Gogh, the cinders of Van Gogh . . . the incineration of Van Gogh . . . of Van Gogh's holocausts . . . of Van Gogh's nights . . . of the vans of Van Gogh . . . the places, that is to say, from which the walking but annihilated figure in the landscape hails us . . .

as though she had never been . . . who flashed between us, through us, her face wet with tears and distorted, in her hands something . . . maybe her shoes?[33]

[33]Laura Mullen, *The Tales of Horror* (unpublished poem), p. 73: "This Actually Occurred, who flashed between us, through us, her face wet with tears and distorted, in her hands something . . . maybe her shoes? I think she may have been barefoot, or in her stockings – there was no sound of heels on concrete, as she came down heavily – and she was running, really, moving quickly, but her shuddering in-drawn breaths were not for that, but because she was screaming, screams without words in them, just screaming, loud enough to hear from a distance as she came toward us, and in the distance, as she went away again, until the darkness and the silence took her back as though she had never been. . . ."

FRANK STELLA AND JACQUES DERRIDA: TOWARD A POSTMODERN ETHICS OF SINGULARITY

CHARLES ALTIERI

FRANK Stella and Jacques Derrida are not obvious figures for comparison. Stella's early work, and arguably his entire career, constitutes contemporary culture's most intense and perhaps most successful effort to articulate principles of presence, self-determining objectivity, and lyrical self-celebration in the midst of critical climates increasingly sensitive to self-division, to the pervasiveness of simulacral effects, and to the impotence of finding one's subjection to culture shaping and undoing all dreams of self-possession. And Derrida's, of course, is the signature most responsible for creating that sensitivity and demonstrating the price that thinking and feeling pay when they yield to seductive ideals of presence. Yet both figures seem increasingly victimized by prevailing fashions, a condition suggesting the need to reconsider what they might have in common and why it might matter now to recuperate those aspects of their work under attack or erasure.[1]

The fundamental criticisms of both men stem from our culture's recent efforts to sublate poststructural themes under a much more politicized version of the postmodern, so that what first got exposed as fundamental slippages in Western thought now become unstable and destructive forces shaping that entire cultural heritage. And then poststructuralism's insistence on difference becomes the politics of heterogeneity, and its vision of criticism as writing becomes the basis for interventionist rather than descriptivist critical strategies. Consequently we have the promise of substantially more useful social dimensions for theoretical work in the arts, because these changes require locating values in a world in which master narratives seem no longer to hold, thereby putting pressure on artists and philosophers to make clear how their work accepts social responsibilities. Unfortunately we also have the attendant risk of demanding that all philosophers and artists understand those re-

[1] A good example of current attitudes toward Stella is Jean Fisher, "Modernist Fables," the introductory essay for Fisher's *Frank Stella: Works and New Graphics* (London: Institute of Contemporary Arts, 1985). For representative criticisms of Derrida, see Edward Said, *The World, the Book, and the Critic* (Cambridge, Mass.: Harvard University Press, 1983), and Paul Smith, *Discerning the Subject* (Minneapolis: University of Minnesota Press, 1987). And for the basic principles on which these criticisms are based within the art world, see Hal Foster, *Recodings: Art, Spectacle, Cultural Politics* (Port Townsend, Wash.: Bay Press, 1985), and Victor Burgin, *The End of Art Theory: Criticism and Postmodernity* (Atlantic Highlands, N.J.: Humanities Press, 1986). Finally, for support of the criticism of them asserted here, see Charles Altieri, "The Powers and the Limits of Oppositional Postmodernism," *American Literary History* 2(1990):443–81.

sponsibilities along the same often quite narrow and puritanical lines, as if what in Derrida and Stella remained in excess of the political agenda could easily be sacrificed for the social good. So I propose here to take the opposite view. I shall argue that it is precisely the speculative force of their "excesses" that most fully engages contemporary social life, because their work attempts to establish new relational structures necessary for any significant cultural change. In making these arguments I hope at the least to provide enough pressure on oppositional aesthetics to force it to resist its tendencies toward self-righteous moralism and its affinities for unreflexive empirical inquiries that simply repeat the old academicism in the name of different political ideals.

My case depends on using Stella and Derrida as if each provided a language for understanding crucial aspects of the other's enterprise. For then one can most effectively demonstrate how both figures elaborate and test values significant for contemporary life but marginalized by oppositional aesthetics. A Derridean vocabulary affords a philosophical background for Stella's abstraction. Its language for various structural permutations helps explain what is at stake in Stella's experiments with radically heterogeneous elements, and its speculations about what Levinas calls "the subjectivity of the subject" make it possible for us to characterize the agency at work in those experiments so that we show how destabilization allows modes of affirmation no longer based on traditional notions of intentionality, reason, and will (and, for abstract painting, no longer based on the spiritualist languages developed by modernist artists to provide a semantics for nonrepresentational syntax).[2]

Reading Derrida through Stella is the more difficult task, but it may prove also the more rewarding, for when we focus on such rich visual manifestations of how singularity can be maintained by the intelligent disposition of irreducibly heterogeneous elements, we flesh out the emotional and cultural urgencies informing Derrida's efforts to develop models for thinking and feeling and affirming values (which I shall call "psychic economies") not based on categorical thinking or idealized models of intentional agency. Indeed, we shall see a wide range of Derridean themes made materially manifest, almost as if Stella could be for

[2] At stake in this comparison is the issue of finding the most appropriate analogical language for the visual arts. The need for such language, I add, becomes apparent in two basic ways. At one pole, traditional critics with eyes as good as Robert Rosenblum's are likely to fall into far too humanistic languages, so that they end up speaking of a "religious dimension" to the "black paintings" by which "absence becomes a positive haunting presence," or endorsing other critics who speak of the polygon "portraits" in terms of "semi-icons for a spiritual blank" that make Stella a "Cézanne of nihilism." See Robert Rosenblum, *Frank Stella* (Baltimore: Penguin, 1971), pp. 18, 26. Given the poverty of such language, it is not surprising that most commentary on Stella remains formalist. One can break from that by turning to poststructural theorists like Deleuze and Guattari because their metaphors of rhizomes, nomadology, and an ethics of the "and" do provide a language of significance for many of Stella's formal emphases. But in my view, Derrida is the only one enabling us to capture the inner logic of these experiments, for he concentrates on the play of identity and difference that emerges within the stages of a career; he insists on showing how indeterminacy and contradiction can become conditions of affirmative power; he is fascinated by the powers of constructive will, while rejecting humanist interpretations of those powers, and he increasingly focuses his sense of values on the principle of singularity that I think is Stella's fundamental value.

Derrida what topological diagrams were for Lacan. More important, we shall see through this variety one crucial constant – the fact of Derrida's own force as a formal thinker. This is no minor matter. All the great metaphysicians define formal sites where we learn not arguments but ways of composing relations in the world so that we come to appreciate the systematic basis for the arguments and the expanse of a world they buy for us if we accept the way of thinking they dramatize. For Aristotle that site could be defined by a logic; for Kant, by principles of judgment; and for Wittgenstein, by the workings of grammar. But Derrida's site proves more complex because of his suspicion of even the most general received forms of inquiry:

When a philosopher repeats this question [about what is the meaning of art] without transforming it, without destroying it in its form, its question form, its ontointerrogative structure, he has already subjected the whole of space to the discursive arts, to voice and the logos.[3]

For Derrida, then, philosophy must introduce modes of formal thinking that at once undo fixities and map new possibilities of playing out relations between identity and difference and center and margin. So he turns from the models of site that are basic in traditional logic to the mobile and doubled identity of the parasite, whose enabling force at once depends on and alters the condition of its host. We remain, the etymology of "parasite" reminds us, still within spatial thinking – forms are inescapably distributions of sites – but now that spatial field becomes destabilized by the parasite's undoing of definitive presence into circuits of semantic energy continuously overflowing all discursive appropriations. For these fields, we need new visual principles enabling us to reconfigure the internal dynamics among the elements of psychic life – for example, by recasting the forces composing Freud's hydraulic model. Similarly, we need new models for conceiving the relations between boundaries and passages if we are to understand how deconstruction redefines the nature of interpersonal engagements, and hence of what can comprise ethical principles.

Stella proves crucial to those projects because this work offers a continuous meditation on intricate processes of territorialization and uneasy linkages that parallel Derridean writing against stable identities. Thus we find in that work concrete visual definitions of how formal thinking carries potential social force. In part, the social implications derive simply from the ways in which we learn to apply new relational principles among spatial metaphors fundamental to ethical life, metaphors like connection, interdependency, and separation. And in part these implications take shape in the ways that Stella and Derrida articulate fundamental contradictions in contemporary life between an unprecedented cultural wealth and freedom affording us enhanced access to everything intimate, lyrical, and proprial and an unprecedented vulnerability to external forces that threaten not only to deny us that intimacy but also to translate it into the mechanical, the arbitrary, and the simulacral. Neither figure can

[3]Jacques Derrida, *The Truth in Painting,* trans. G. Bennington and I. McLeod (Chicago: University of Chicago Press, 1987), p. 22.

tell us how to change that situation, but they at least define our condition and develop various means for affirming what we can become as agents responsive to those constraints. Thus they confront us with the challenge that anything less formal in its attention to how we can structure concepts and feelings may condemn us to repeating with slight differences the same logic of academic hierarchization and art-market manipulation that continues to appropriate the new into work that will sustain its internal machinery.

★ ★ ★

I shall presume that Derrida's overall arguments are well known. My purpose is not to explicate his work but to concretize it by showing how it gives us access to pressures and projections within Stella's art that, in turn, help clarify the implications of Derrida's development from an emphasis on the ontology of decenteredness to an ethical thematics based on ideals of singularity, work, and the crossing of borders. Let us begin, then, with the most obvious link between the two figures, their fascination with the force that centers hold, especially to suppress contradictions. Even the best criticism of Stella is insistently formalist in its account of that fascination. But though we shall require that formalist language, the haunting presence of Derrida should help us locate within the play of forms the pressures and pleasures of desire's working. In particular we shall see that from the beginning Stella's concern for the process of centering carries two fundamental thematic complexes. He dramatizes the arbitrary force underlying and undermining the traditional ontological and psychological roles that centers play, and he makes being subjected to such force the means of exploring strange and mysterious conjunctions between efforts to control one's situation and the pleasures of yielding to those obsessions that constitute one's marginality. Eventually these conjunctions lead him to more complex structures in which centers become virtual, the margins take on active compositional force, and distinctions between genres become themselves transformed into figures of and for the singularity that follows from heeding the work that margins do to establish a parergonal logic.

In traditional painting, an emphasis on the center of the canvas organizes depth of field and provides a fulcrum against which a variety of visual tensions can be established. In modernist abstraction, similar emphases sustain very different, but equally powerful, figures of containment. Dynamic balance takes on transcendental implications, as if the balances achieved saved the design from willfulness or ornamental status and anchored the work in something more resonant than the painter's will to design. Consider a typical Malevich painting, where tiltings away from an unstated center become testimonials to a nonobjective principle of balance linking desire to fundamental cosmic laws. For the early Stella, on the other hand, centers function in exactly the opposite way. Their task is to make visible the absolute power of a painterly will organizing design into a mechanical functioning that dispels all elements of illusory space and that can take overt logical responsibility for every aspect of

the canvas. So centers are in no way foundational. Instead, they serve as counterorigins, capable of defining space because of a cruelty willing to enforce exclusions and to compose its own alternative relational principles.

Stella's overt rationale introduces the basic project:

The painterly problems of what to put here and there and how to make it go with what was already there became more and more difficult and the solutions more and more unsatisfactory. Until finally it became obvious that there had to be a better way.

There were two problems which had to be faced. One was spatial and the other methodological. In the first case I had to do something about relational painting, i.e. the balancing of the various parts with and against each other. The obvious answer was symmetry – make it the same all over. The question still remained, though, of how to do this in depth. A symmetrical image or configuration placed on an open ground is not balanced out in the illusionistic space. The solution I arrived at . . . forces illusionistic space out of the painting at a constant rate by using a regulated pattern. The remaining problem was simply to find a method of paint application which followed and complemented the design solution. This was done by using the house painter's technique and tools.[4]

But why should he feel so strongly that available painterly solutions to problems of structure were so debilitating? The only plausible answer leads directly to the thematics of centering: No single choice can be justified, because all choices seemed suspended between the artist's performative or expressive desires and the dictates of illusionistic space. There was, in other words, no single external principle that could dictate or rationalize pictorial space. One needed a principle internal to the work, but at the same time one needed that principle to have a force that would lead beyond the work, so as to demonstrate the hold that the choice might have on painter and on audience. Neither expressivism nor formalism could do in themselves.

Paintings like *"Die Fahne Hoch!"*, *Tomlinson Court Park*, and *Jill* (1958–9) make clear the terms of Stella's initial solution. If there could be no one center, and if none of the possible centers could be rationalized by claims on the world or the psyche, one could nonetheless build the work outward so that what begins as arbitrary design comes to develop its own existential dynamics, and perhaps its own ontology of what now we can call "cyborgs," that is, figures of the mutants that contemporary rationality allows us to construct, or perhaps requires us to construct if we are to understand its power and its appeal. As these paintings break away from submission to expectations about external sanctions, whether these derive from the world or from the dictates of an inner life (which must be considered external to the degree that it takes the form of dictates), they seem to create fresh possibilities for how we might understand processes of choice, and hence orientations of desire. Whereas the determination of a center might be totally arbitrary, yet that

[4] I quote from a lecture Stella gave in 1960 that is reprinted in Rosenblum's *Frank Stella*, p. 57. For the later remarks by William Rubin on these paintings, see his *Frank Stella* (New York: Museum of Modern Art, 1970), pp. 19–37. I should also acknowledge that almost all my descriptive claims about Stella's career, and many specific observations about the paintings, derive from Rubin's account, although the reader will not miss the different, "literary" orientation shaping what I make of those descriptions. One will also find in Rubin's two books color reproductions of all the works I discuss here.

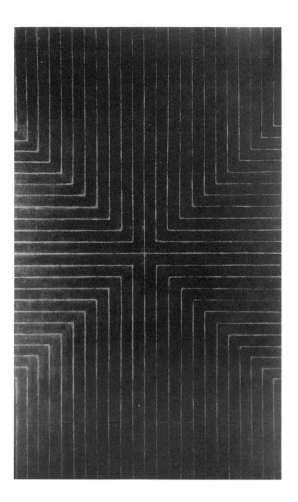

19 Frank Stella, *"Die Fahne
Hoch!"* Collection Mr. and
Mrs. Eugene M. Schwartz,
New York.

arbitrariness could become itself the center for intense visual experience.
Painting becomes a Nietzschean process – not quite because of the artist's
will to power but rather because the artist has learned to fill the vacancy
that haunts all wills to justified power, and so that he can mark painting
with the inescapable traces of an individualizing intelligence testing its
capacities to elaborate its own provisional centerings. Such freedom,
however, proves inseparable from obsession, as if painting that took ac-
count of its grounding moves had to encounter the same openings to
madness that for Derrida pervade philosophy.

Stella's most comprehensive critic, William Rubin, leads us into
the concrete specification necessary for such claims by calling atten-
tion to the sharp contrast between the movement outward from the
center that characterizes *"Die Fahne Hoch!"* (Fig. 19) and the process
of building in toward the center that *Tomlinson Court Park* (Fig. 20)
dramatizes.[5] Thus we have quite similar principles maintaining en-
tirely opposed movements. Yet both share at least the same equation
between logic and mad obsession. In each case, what the center or-

[5]Rubin, *Frank Stella*, p. 32.

ganizes becomes an absolute reflection of its design: All the details, even the constitution of the framing edges, are contained by the center that they contain. However grounded, the center is an imperial force demanding the complete submission of all details to its governing design. Even the choice of size, which seems at first an area for free play, seems dictated by a logic of geometrical progressions severely limiting the available options. We can say that the painter remains free to establish the design. But the effects of such setting warn us that for contemporary culture we need to hedge terms like "freedom" with quotation marks. Such choice demands, in trade for the power it confers and the distance it establishes from the old dependences on cultural seductions, absolute fidelity to a source at once arbitrary and total. For this center to hold, it must ruthlessly impose its own logic, thereby dismantling any equation of centered design with ontological stability. Instead, we are given only a chilling drama of the effort of intelligence to keep up with will and thus to give value to difference in the only way that can take full responsibility for itself.

This logic about logic becomes fully deconstructive when we begin to recognize how seductive this chilling drama can become, precisely because its refusals free the compositional activity to take on a form of mystery that cannot be translated back into either expressivist terms or those basic to a Heideggerian aesthetics of disclosure. Again I shall use Rubin to establish what I take to be an educated response to the work, so that we see clearly how it invites Derridean thematics. Rubin tells us that he was "almost mesmerized by [these paintings'] eerie magical presence"[6] – a state that he found intensifying the longer he concentrated on the movements produced by the designs. Thus, while the compositional intelligence seems ruthlessly committed to simplicity and to emptying the surface of all transcendental effects, it manages to make what the eye can plainly see take on an excess leading us to exotic reflective sites well beyond the sphere of ordinary experience. Notice in this regard how strange the edges of *"Die Fahne Hoch!"* become as they vacillate between invitations to extend the system and efforts to limit what could proliferate to infinity because it has pushed all otherness out of the painting. Conversely, the movement inward to the center in *Tomlinson Court Park,* second version, borders on a desperate introversion at once intensified and depsychologized by the regularity of the design. Yet this is an eerie invertedness. The rectangular form defers the very center that organizes it, because we cannot imagine how the design could continue so that it could articulate that organizing point. This sense of tension is then developed in several ways. Although the design insists on expelling any illusionary nesting of the rectangles, we are still tempted to read the image both as collapsing into itself and as pushing outward like the front of old cameras. That, in turn, yields an odd stillness in which the general surface manifestations of the design resist the sense of movement toward a

[6]Ibid., p. 42.

center, and so the triumph of will is oddly also its loss into an infinite suspension. And it opens the way to a second group of "black paintings" where works like *Jill* (Fig. 21) distribute the centering force into diverse spatial tensions that deepen the exotic push-and-pull effects.

★ ★ ★

I would like now to trace the peregrinations of the center through Stella's career, especially in relation to how his works in the early sixties break from the tradition of easel painting and how his experiments with over-the-counter house paints overthrow the seductive appeal of classical color harmonies, while defining an alternative structure of tonal differences. In pieces like his "irregular polygons," the shapes are three-dimensional, and yet they remain visually so bound to the wall that they allow none of the relief effects we expect from sculpture. So the dynamics of centering engages the third dimension, only to create an impossible union of self-assertive presence with a playful decompositional force freeing the work from the claims of gravity.[7] Such work makes it seem that active verbs can create a condition of intransitivity in which internal relations both elicit and deny the possibility of unequivocal indebtedness to what they refer to or depend on as material existence.[8] Similarly, Stella's experiments in color have a powerful deconstructive relation to the tradition they echo and transform: Exaggeratedly aggressive in their

[7] William Rubin, *Frank Stella 1970–1987* (New York: Museum of Modern Art, 1987), pp. 18–20, 102–5, is good on the importance of painting's war with sculptural modeling. For my more thematic account of that war, and for a defense of the claims I make here about modernism, see Charles Altieri, *Painterly Abstraction in Modernist American Poetry* (Cambridge University Press, 1989).
[8] Derrida, *The Truth in Painting*, p. 12.

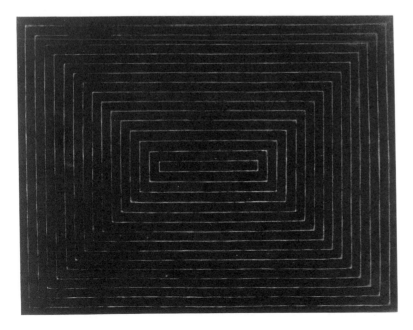

20 Frank Stella, *Tomlinson Court Park*, second version. Collection Mr. and Mrs. Robert Rowan, Pasadena, California.

composition and their interrelations, they nonetheless produce new combinations that exultantly occupy the field of differences they establish. But the best way to focus on the parallels with Derrida is to shift to the three moments in Stella's career that most fully elaborate the parergonal logic inaugurated in the early meditations on centering. These will lead us through complex transformations of centering force into a dialectic of passages between positive and negative spaces that ultimately defines how we can imagine an ethics based on ideals of singular responsibility.

Stella's series of purple polygons in 1963 provides a vivid example of how the will to centering now opens a fully deconstructive dynamics within which negation and assertion are in constant interplay. Earlier work like *Avicenna* had cut out the center to give the image a three-dimensional movement in relation to its supporting wall. In the purple polygons – represented here by a photo of their overall effect (Fig. 22) – he makes question of inside and outside fundamental functions of "a border which is itself double in its trait, and joins together what it splits,"[9] for now the absent center is in direct proportional relation to what surrounds it – forming half the area and echoing the

[9] Ibid., p. 331.

21 Frank Stella, *Jill.*
Albright-Knox Art Gallery,
Buffalo, New York. Gift of
Seymour H. Knox, 1962.

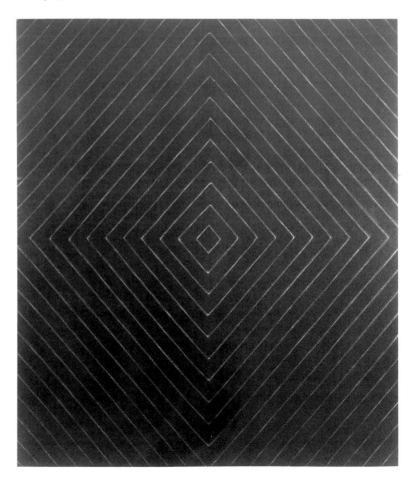

containing shape. So we must ask whether the void is an absence or a presence, and we must notice how both answers are always possible, each transforming our sense of the whole. Then, on a more metaphysical plane, we must ask how the center can move between those modalities. Is the center fundamentally an ideal entity, because there is no positive image for its working on us, or must we grant the power of the framing design to establish a material presence for what normally has only the modality of idea. Here, then, we have a rich version of the passe-partout that fascinates Derrida,[10] compounded by an insistent parergonal relation between the image and the wall that is itself within and without the work, for while the wall must be said to support the artist's image, the image also functions as a frame dynamizing the wall's distinctive supporting attributes. So the very ideal of support gets multiply defined and woven into complex interdependencies allowing no independent attributions. Even what we are invited to take as framed negative space has shadows fall upon it, thereby implicating the entire room in the play of frames and the dynamics of presences, absences, and the traces that each leaves upon the other. Finally, all these interrelations force on us once again the question of ultimate generic identities. Because the work carves out spatial absences, it has clear sculptural functions. But it lacks the presence of traditional sculpture because the effect of the inner absence is to pin the image to the wall almost as if it were crucified by its efforts to undo the traditional logic of fixed identities. Yet even as such metaphors of victimage tempt us, the work's relation to its wall is clearly an exaggeratedly affirmative gesture celebrating the intelligence that can utilize all this doubleness to possess its space with an intensity and a fascination not possible for any simpler mode of assertion.

[10]Ibid., pp. 7–13.

22 View of exhibition at Leo Castelli Gallery, New York, January–February 1964. Photo by P. Burchkardt. © 1992 Frank Stella/ARS, New York.

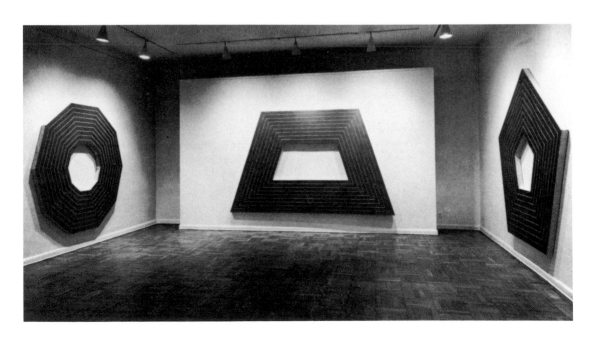

The second moment we shall consider shows Stella making far more monumental use of negative space, now combined with the experiments in mobile forms that he had explored in his "Notched V" and "Running V" series. *Effingham I,* for example (Fig. 23), develops polygonal structures out of color units now free from schematic design; so it places in conjunction the two basic lines of visual research that Stella had been pursuing separately. The effect of the combination is a complex play of binding, differing, and deferring, all epitomized in the blue band's affording a passe-partout between the self-defining intensity of the color fields and the pressures exerted on those fields from the surrounding space. Therefore, what identity the painting can maintain cannot stem from simple dialectical integration. There is no overall rationale for the design, no plan that makes sense of how the shapes proliferate or take on color. Instead, the painting's monumental claims depend on a destabilizing of overt equilibrium so that Stella can replace his emphasis on schematic designs by one on a compositional power located simply in a finely adjusted tactility. This destabilizing allows each section to seem on the edge of losing its balance, while at the same time leading us to recognize the power of the whole to maintain a fully stable relation to its supporting wall. More important, the deconstructive effects here refuse to yield to the intricate internal restabilizing adjustments generating the power in a typical Malevich or Mondrian. Instead, the organizing force seems to come from the "outside" – from the pressure of the negative spaces and from the remarkable vitality of the blue bands (whose corners gain enormously by being played against the one mitered link in the yellow, because then all diagonals seem oddly oscillating between decorative and structural functions). In fact, this "outside" proves so insistent that it leads us to recast the entire dynamics of identity and identification. Thus identity is not organic, but differential, with the blue bounding line then also joining what it splits and mediating the shaping force of outside pressures.

 When Derrida speaks about such outside forces, he must dwell on the activity of interpretive predicates making incursions upon that which they allow us to name; thus, for him, the richest visual examples involve a verbal dimension. Stella can be more intimate and more literal in his sense of how identity takes form, because we actually see how the boundary that establishes a distinctive working presence can function. We realize that without the blue line the active negative space at the margins would invade the color fields and distort the straight lines giving each its distinctive place. Yet at the same time the interaction with that negative space intensifies the distinctness of those units, because the blue defines its own set of containing contrasts, making the other colors vivid and mobilizing the differential force, setting buffered against unbuffered edges.

 This concrete drama grows more intense as we attend more carefully to the energies disposed by the color relations. Tonally these colors seem perversely incompatible in their tilting away from the primaries they suggest; yet they remain closely bound to each other in the high key they share and in the odd balances they achieve. Yet even these balances

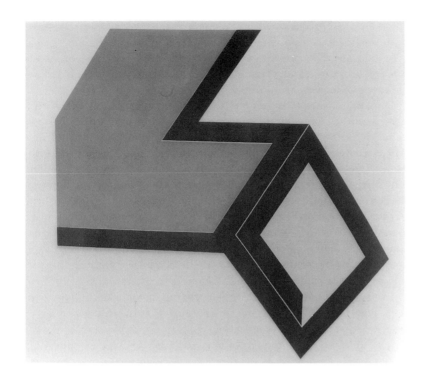

23 Frank Stella, *Effingham I*,
second version. Stedelijk van
Abbemuseum, Eindhoven,
The Netherlands.

depend on deconstructive destabilizings of the distinctions between in-
side and outside – preeminently in the way the unbounded orange seems
necessary to stand up to the more demanding yellow. Whereas every-
thing is in tension, everything manages to work together, although with
a strong sense that the reconciliations are only momentary. In fact, if we
look very closely at the spatial relations, we find a great deal of indeter-
minacy in terms of possible illusory spatial tensions. Yet such effects are
countered by the quite unambiguous overall flatness of the picture.[11]
Stella is even careful to refuse any collage effects by allowing no plane
to slip under any other and no edge to contain what it frames. (Notice
how the yellow manages to stand out from the blue without sitting on
it.) Such indeterminacy, then, does not so much undo identity as com-
plicate it, forcing us to take as one thing what nonetheless comprises
differences that are irreducible and irreconcilable as long as we focus
only on certain particulars without attending to the full logic of differ-
ential relations constituting the image for the mind. As Stella's ensuing
"Protractor" series would make even more emphatic, unity need not
involve dialectical synthesis. Instead, Stella takes to a philosophical ex-
treme what Edward Said's *Beginnings* calls the principle of adjacency fun-
damental to modernism.[12] Where collage conjunction had been, Stella

[11]Rubin, *Frank Stella*, pp. 121–4, provides a good summary of Fried and Rosenblum on
the indeterminacies Stella creates by these and other effects; then he makes shrewd qual-
ifying use of Stella's statements about minimizing the planar ambiguity these works create.
Rubin also makes helpful comments on the refusal of collage effects (pp. 114ff.).
[12]Edward Said, *Beginnings: Intention and Method* (New York: Basic Books, 1971), chap. 1.

insists on compositional activity that correlates incompatibility and co-existence. Identity is not synthesis; it consists simply in a struggle against negative space that energizes and eroticizes all the edges, making them function as irreducibly one despite their differences, or, better, because of those differences.

My third moment from Stella's career substantially deepens this sense of constitutive differential identity. Rather than enforce singularity by the intensity of a controlling design, he bases the distinct properties of the object as a whole on specific virtual processes of inviting, then refusing any conventional paradigm for establishing coherence – both internally and in relation to expectations about genre and medium. And in so doing, he provides visual means for understanding Derrida's recent efforts to recast traditional ethical models in terms of conditions by which singular workings affirm themselves and accept responsibility.[13]

For Stella, the forming of singularities becomes primarily a matter of engineering, that is, of orchestrating self-defining relations in a way that we are at once aware of the governing structural relations and unable to make them conform to the presuppositions we want structure to reinforce:

I have a gift for structure, and the strength of all the paintings I made in the sixties lay in their organization, their sense of what pictorial structure could be. Struggling through the Polish pictures opened things up for me so that I was able to use my gift for structure with something that modernism had not really exploited before, the idea that paintings could be constructed, made by picture-building. . . . Build it and paint it. It was a job I was well-suited for.[14]

In one respect these constructivist ambitions remain within radical modernism, because they make the constructive act the focus of meaning and because they still idealize transparency. But the transparency, or the invitation to transparency, also becomes his most effective deconstructive strategy, because it calls attention to the full differential working of the elemental features laid bare to its audience. Now architecture cannot maintain any claim to be the master art. It, too, enters a relational field in which the constructivist outlines not only enclose space but also offer surfaces so charged with seductive possibilities that they constantly draw the eye (and the artist's embodied hand) away from structural concerns to the intricacies of local texture. Picture building becomes inseparable from ideals of dwelling conceived far more literally and playfully than in Heidegger's aesthetics.

Mosport, 4.75x (second version, 1982; Fig. 24), a work from Stella's "Circuits" series, must suffice here to show how this new spirit allows Stella's concerns for engineering to engage the full panoply of recent

[13]See, for example, Jacques Derrida, *The Ear of the Other: Otobiography, Transference, Translation, Texts, and Discussions with Jacques Derrida,* ed. Claude Levesque and Christie McDonald (Lincoln: University of Nebraska Press, 1984), pp. 5–7; idem, "Biodegradables: Seven Diary Fragments," *Critical Inquiry* 15(1989):812–73.
[14]This statement is quoted by Rubin, *Frank Stella 1970–1987,* p. 40, within a discussion of engineering (pp. 37–43). Further on in my paragraph I elaborate a comment from page 79 of the same book.

Derridean themes. Let us begin with formal relations, because these give a new twist to the role of the center. At approximately the center we find an elliptical space cut out, as in *Avicenna*. But here the cut has almost no power. We glimpse through it another plane with its own somewhat different priorities. And we notice on the surface plane several similar cuts, each with at least as much power to organize the surrounding space. In other words, while there is a dramatic all-over design extending Pollock to three dimensions and yet keeping a pictorial emphasis, the design also has a tendency to break into several subsections, each with its relatively autonomous distribution of energies. The right part of the work seems to want to form quadrants, each with its center, but the left brilliantly subverts that by making the negative space more active than the painted surfaces and by melding the smaller curves and cuts with the two basic sweeping curves that pull the whole together without any recourse to a center.

When we ask how Stella makes what we see, we find that what seemed a casual freedom depends on at least two complex, self-reflexive factors substantially thickening the idea of "circuits" that governs this series. First Stella insists that his curves not be cut by hand, presumably because that would be too casual a means of constructing the overall site on which the painterly hand will play. Each curve is composed by a draftsman's tool, so that the discovery of new tools opens new lyrical possibilities for the paintings. Expressive freedom is both tempered and enabled by what a technological society can afford. And just as the painting lyrically inhabits sculptural form, the sculptural form in effect lyrically inhabits technology by winning from it such exotic shapes and, more important, such enticing rhythms among

24 Frank Stella, *Mosport,
4.75x*, second version. Private
collection, New York.

shapes. The artist's freedom is less a matter of pure creation than of appropriation.

Now our second factor enters. All the attention to process in this work redefines our sense of creative agency. Architecture builds the unfolding of temporal effects into painterly operations; so we are constantly aware of how certain choices in the work leave a residue limiting, but also enabling, subsequent inventions. All art, of course, does some of this. But Stella goes to extreme lengths, symbolized by his employing for his designs leftover patterns or cutout sections from maquettes he had used to block out previous work. Thus, both what he has invented and what he has had to reject from those inventions remain as traces available for recycling and for the constant reinforcement of signatures. What Pound called "this leaving out business" cannot be separated from the actual composing, thus further complicating the interplay of presence and absence, solid and void, relay and resistance, that composes the life of a surface that unfolds by constantly retracing itself in new dimensions and new relations.

Such self-conscious intricacy calls out for thematizing – not as the assertion of specific ideas but as the demonstration of powers and pleasures arguably significant for our cultural life. Much of the significance lies in the radical painterliness of these "Circuit" works, a painterliness so unconstrained that it seems as if the intricacy of the architecture allowed a version of free expression no longer dependent on any dramatic, psychological sense of the self. This luxury to explore color, spatial relations, and the compositional force of freely drawn marks makes it seem small-mindedly narcissistic to confine such freedoms to any specific urge for self-expression. Such urges depend on imagining a self that then mediates its states through the work. But Stella is less interested in referring to a self than in referring personal agency to possible states in which it can let itself go, exploring modes of fascination that I consider fundamental for a postmodern ethics and aesthetics of dwelling.

★ ★ ★

Derrida provides the conceptual model for this ethics; Stella complements that by offering material configurations demonstrating how such terms can fully take on physical, emotional, and cultural force. Consider first the striking way Stella establishes a rich deconstructive tension making visible and irreducible the competing claims on the artist of the high-culture traditions and of populist resistance to those traditions. His insistence on house paint, on machine-made forms, and on refusing all decorum flaunts any model of sensibility and of judgment based on cultivated taste.[15] Yet this takes place with such insistently inventive and excessive abstraction that Stella's project cannot be thematized in politically correct terms: Stella's is a populist individualism wary of all group identifications, because with the group come external principles of judgment and authorized allegories

[15]Rubin, *Frank Stella 1970–1987,* pp. 84–8.

to which the arts are expected to conform. This, we might say, is the logic of democracy presented with an "in-your-face" vengeance oddly demonstrating the problematic emotional force inseparable from ideals of honoring one another's differences.

Beneath this politics lies a rich material rendering of what is involved in shifting from traditional ideals of identity (and hence of community) to a parergonal model concentrating on complex interdependencies between positive and negative spaces. Thus, rather than separate beauty from truth, word from thing, writing from speaking, man from woman, we are invited to reflect on the various ways that each articulation of extensional space for any one concept implicates and depends upon its resistances. And rather than proceeding from stable concepts or images out to clear and distinct relations, the discriminating mind circulates through folds of implication, with their complex play of light and shade, distinction and dependency. What the eye sees then also becomes a model for how it sees, and for how it builds relationships among the materials it encounters. Stella asks us to consider in both domains – the world we see and the seeing we compose – the limitations fundamental to Western culture's dominant modes for conceiving boundaries and composing relations among particulars.[16]

In ethics, for example, the basic paradigms within this culture propose either a pragmatic rationality like that governing utilitarianism or various deontological and perfectionist views within which the fundamental concern is how agents can regard themselves as earning views of themselves as "authentic," that is, as being faithful to some underlying principles on which they stake their identity as moral beings. In both cases the ideals of judgment and models of nobility emphasize attention to clear principles and distinct individual identities, so we find ourselves unable to give full weight to the incommensurable differences among cultural groups, and we tend to substitute concerns about our own rectitude for reflection on the intricate dependencies shaping and shaped by our actions. These critical concerns do not occupy only Derrida and Stella. But most of the alternative postmodern models we are trying to develop seem to me severely limited, on the one hand, by Lacan's distrust of all efforts to maintain singularity and, on the other, by versions of Rorty's efforts to replace Kantian constructivism with elemental notions of solidarity and sympathy unable to take account of the mind's complex demands. Stella makes visible a very different, far more active way of appreciating deconstructive thinking as a frame for approaching ethical concerns. His recent work presents the establishing of values in terms of the constitutive interplay of opposites in several dimensions: solid and void, linking edges and tangential forces, processes of cutting out inseparable from processes of extending or filling up all-over designs in three dimensions, and, more thematically, a struggle between the mechanical and the lyrical sustained by the inescapable interdependence between stabilizing structures and the possibility of irreducible free play. This is parergonal thinking at its richest. We are invited to develop a self-consciousness that moves beyond any single structure of those op-

[16]Derrida, *The Truth in Painting,* pp. 296, 302.

positions to dwell within the continuous trading and adjustment of investments through which a range of oppositions maintain their dynamic interrelationship. Rather than establish rigorous categories to handle the conflicting pulls of the personal and the public or conventional (an effort that in a logic of specular identity produces a constant sense of bad faith), we can locate our values as ethical agents simply in what we bring to bear as we develop and negotiate the irreducible contradictions.

Once centers yield to the play of oppositions, it is necessary to speak of inescapable indeterminacies. But it is not sufficient to make indeterminacy in itself a value. Stella shows how the experience of indeterminacy has its fullest impact upon us when we grasp it as inseparable from a model of positive ethical and psychological assertion that retains much of what we sought in ideals of specular identity. And Derrida helps explain this by playing on differences (and dependencies) between the simple failure to achieve determinacy and an affirmative, controlled indeterminacy that in fact maintains a distinctive singularity and self-sufficiency in its resistance to the determinate. One might even say that Derrida turns to art precisely for its capacity to define an agency whose working in and through displacement develops "a sort of self-sufficiency" that is "not a self-identity, a proper meaning and body but a strange and haughty independence."[17] This independence is what Kant saw, then evaded, when he tried to restore conditions of agreement allowing him to have both an ontologically distinct site for art and terms for making that difference also a site for reinforcing social relations. Kant wanted a "*sans* without cut" giving the work properties of purposiveness without purpose that are nonetheless not experienced as a lack of meaningful identity,[18] but an evocation of something at once supersensible and social. Derrida, like Stella, realizes that the path to sociality must be more complex, but no less compelling. So long as the *sans* can be maintained by the internal play of energies, the work lacks in nothing and can "take absolutely new itineraries each time,"[19] because the working of art's play creates significant distance between the world imagined and the demands involved in postulating the logic of identity. Yet it is precisely in this cult of irreducible differences, all experienced as singular working, and hence as tending toward a Lyotardian sublime that postulates ideals of mutual recognition unutterable within language, that art continues to promise an intricate model of social interrelationships.

For Derrida, life must imitate art – not to track its idealizations but to pursue its capacity to hold off the allegorical paradigms (or "crypts") we try to impose on complex interrelationships, and hence to resist the seductions of specular identities without conceding the pleasure and power of working singularity. Thus Derrida calls attention to the ways that the *dynamis* of a vital philosophical system can maintain a "border-

[17] Ibid., p. 171.
[18] Ibid., pp. 88–118.
[19] Ibid., p. 171.

line between the 'work' and the 'life,' the system and the subject of the system" constituting a surplus value never consumable by explanatory apparatuses. We stake ourselves on the incompleteness of what the mind composes as images for where it dwells. And by making the *dynamis* of that staking fully visible, the power of our working generates a continuous "yes," an "unconditionality" whose affirmative power is defined simply by what it makes of given contexts.[20]

How, then, do we represent this staking, this simultaneous exceeding, dismantling, and displacing that a deconstructive aesthetics and ethics must weave into and against "the heritage of the great philosophies of art"?[21] Derrida can "relace" a Heideggerian vocabulary so that he fully articulates the ontological complexity emerging as we question what is involved in the Being of beings. But the richer the deconstructive intensity, the more difficult it is to develop the ethical or self-empowering dimensions of his work without risking the self-theatricalizing specular displacements to which self-referential speech is prone. So it is precisely at the point where Derrida most clearly projects his own excessive relation to Western philosophies of art that he may need works of art to demonstrate the full intensity of what he grasps. Yet the contemporary artists he invokes do not quite afford that demonstration. Because they remain obsessed by what they ironize, these artists remain in essentially decreative relations to representational art and the philosophy that authorizes it. Stella's uncompromising painterly abstraction, on the other hand, articulates a much fuller sense of the constructive powers available for a logic of nonidentity, and thus of the affirmative possibilities afforded by Derrida's conjoining Heidegger and Nietzsche.

On the dramatic, metaphoric level, Stella's work shows how both art and the metaphoric implications about agency that art can sustain exemplify potentially satisfying personal alternatives to the anxiety-prone dreams of subjective identity fundamental in our culture. And on the conceptual level his emphases on that logic of nonidentity set against his own enabling modernist heritage show why a Derridean recasting of the traditional relation between art and philosophy has important ethical implications. So long as art claims to serve truth, whether the truth be based on representation, on expressivist models of presenting states of the self, or on the Platonic models invoked by modernist abstraction, it also subordinates itself to the power that philosophy asserts because it casts itself as the arbiter of how such truths might be represented, assessed, and acted upon. Thus, by trying to develop discursive idealizations of their own products, the arts ironically surrender authority over the nature and ends of their own productive activities. But Stella's insistence that his art creates real, spatially dense, and conceptually ungraspable and unjustifiable workings in the world frees him from the need for any idealizations of identity. What we see is what we get, precisely because it invites a

[20]On *dynamis,* I quote from Derrida's *The Ear of the Other,* pp. 5–6, and on "unconditionality" I take my formulation from Derrida's "Afterword," to Gerald Graff, ed., *Limited Inc.* (Evanston, Ill.: Northwestern University Press, 1988), p. 152.
[21]Derrida, *The Truth in Painting,* p. 9.

dwelling that has no immediate rationale beyond the fascination it affords as we trace its activity.

More important, in defining material analogues for Derridean logic, Stella makes clear just how fully this model of working engages contemporary social conditions, on levels that may require the abstractions of both philosophers and visual artists. Ours is a society in which the threat is no longer simply from the dehumanizing force of technology. Instead, as Baudrillard and others have made clear, our danger is that we can no longer tell what are the borders of the technological, so that everywhere that it seems to give us freedom it also seems to become so pervasive that it requires our wondering where one can say we have agency and where we are simply mediations for forces that in traditional terms would be considered external to subjective life. The dismantling of traditional philosophical ideals is inseparable from a situation in which the instability of internal and external makes all distinguishing psychological traits reducible to simulacral effects of our information systems. Even the effort to state this dilemma seems little more than the evocation once more of romantic protests against dispossession that now, rather than rallying resistance, seem little more than clichés providing further proof of that dispossession. Similarly, our turning to a rhetoric of despair or rhetoric of authenticity by resistance seems to accomplish little more than acting out equally simulacral features within those governing social codes.

But even if we cannot escape the ironies and duplicities of an overmediated culture, Stella makes visible two possible means of recasting that cynical insistence on the ways our idealizings are recontained within dominant social factors. Minimally, he dramatizes the complex internal logic by which outside and inside become so inseparably woven into each other, in the process opening individual capacities to compose singular circuits among those unstable factors. This is the individualist phase of deconstructive thinking. Beyond that there lies its comprehensive phase, the phase in which it remains true to Heidegger's efforts to understand the Being of beings, even in a framework where the patterns of concealment and revelation must live one another's lives and die one another's deaths. So we retain for imagination a comprehensive sense of the forces that drive us, as if in mapping the logic that contains us we could also locate those seams and slippages and passages where new versions of singularity have the promise of offering potentially representative means of turning the logic of displacement against itself. Refused the possibility of justifying choices in categorical terms, and bound to an otherness we cannot dispel, we nonetheless can conceive that pursuit as itself a fatality inseparable from the opportunity to will a sense of the singularity of our own working. What we do with that fatality then remains the subject for an ethics we must construct in very much the same empiricist *bricolage* fashion that Stella's art demonstrates.

For Derrida, this fatality must be understood as itself divided into threes, mythology's reminder of the fundamental borders articulating any working singularity: "the fate it suffers, the fate cast upon it, the fate cast of it."[22] As it engages these three fates, parergonal thinking recuperates,

[22]Ibid., p. 246.

perhaps more truly and more strangely, the conditions enabling Western culture to treat art as its basic means of fully affirming what people must suffer. Even the question of the simulacral becomes the vehicle of an internal self-divisiveness in which we begin to forge new social relations no longer bound to any of the old, and increasingly destructive, dreams of pure identities and irrefutable reasons. By learning to read our own subjective agency constituted in our working within the interstices of what we are given, we may learn to weave our signatures within borders as complex as those that form Stella's increasingly bleak playful sites.

SKETCH

The text between the black lines is to be printed in different color inks, as indicated by the abbreviations in the margin: [Bl] blue; [DB] dark blue; [V] light violet; [Y] yellow. If there is no indication in the margin for that section, the text should be in black ink.

COUNTERPOINTS OF THE EYE

JOHN P. LEAVEY, JR.

[DB]

"4.6.

"Confidential tales [of Adami].

" . . . Counterpoint and not fragment in my narrative system. The image is not divided into fragments but on the contrary is united and takes form in the mechanics of counterpoint."¹

25 Valerio Adami, *Concerto a quattro mani*, acrylic canvas, 7 June 1975. Permission to reproduce, Valerio Adami. Photo Galerie Lelong.

HAND EYE COORDINATION: TRANSLATION AND . . .

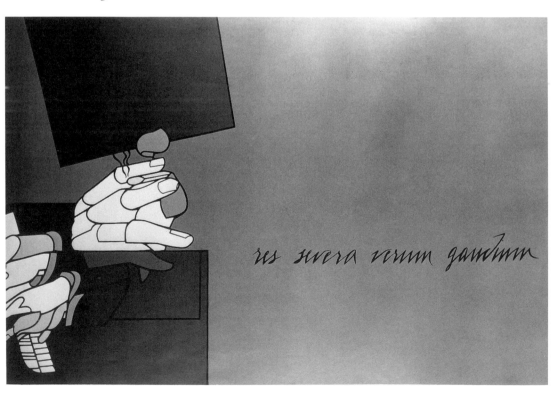

res severa verum gaudium

Adami 31.3.75 concerto + quattro mani

26 Valerio Adami, *Concerto
a quattro mani*, blacklead
drawing, 31 March 1975.
Permission to reproduce,
Valerio Adami. Photo Galerie
Lelong.

27 Valerio Adami, cover of
Derrière le miroir (no. 214,
May 1975). Permission to
reproduce, Valerio Adami.
Photo Galerie Maeght.

res severa verum gaudium

Valerio Adami, *Concerto a quattro mani* (Figs. 25–27)

DERRIDA: "Legend for what I should have liked to draw here: another Adami
portrait, a self-portrait."[2]

[Bl]

N.B.: When no reference is cited for a translation, the translation is my own.
[1]Valerio Adami, "Les Règles du montage," trans. Giovanni Joppolo, *Derrière le miroir*
220(October 1976):24.
[2]Jacques Derrida, *The Truth in Painting*, trans. Geoff Bennington and Ian McLeod (Chicago:
University of Chicago Press, 1987), p. 181; idem, *La Vérité en peinture* (Paris: Flammarion,
1978), p. 209.

[V] DERRIDA: "It is better to nickname in Italian this hypothesis of the *retrait en mémoire de soi à perte de vue* '(with)drawing in memory of the self lost from view': *l'autoritratto* of drawing."[3]

[Bl] Lines, whether drawn, written, or painted, separate color in Adami's paintings.

In the studies and blacklead drawings, there is no color; they are like pages in a coloring book waiting for hands to fill them in.

The images, Adami says, are counterpointed, not fragmented.

And there is writing – lines of writing.

[Bl] In this piece I now write and you now read, as in Adami's *Concerto a quattro mani,* lines also separate. They separate writing that is superimposed, hidden, conjectured as written, erased, painted over in this painting and this drawing of Adami. In other words, this writing, these lines here, I project, would be a subjectile of Adami's painting: the support, neither subject nor object, and the untranslatable of painting. Subjectile: according to the *Oxford English Dictionary* (*OED,* 1st ed.): "Of material: Adapted to receive a 'subject' or picture. . . . A material on which a painting or engraving is made." The citations, from 1859 and 1881, contain a reference to printing: " 'The previous modes of printing in which the ink is contained in incisions . . . or upon reliefs . . . and transferred thence to the paper or other subjectile material by pressure.' " In "Forcener le subjectile," on the subjectile Artaud (not simply on the subjectile of Artaud; not simply on what, according to Artaud, "is called the subjectile"; not simply on Artaud, his works, sketches, and his paintings as subjects or objects, what he himself does not describe; not simply on the subjectile of subjectile; but also the invention of an "idiom" and the "casting [*jeter*]" of a "signature otherwise"), Derrida explains that the "notion" of subjectile "belongs to the code of painting and designates what is in a way lying below (*sub-jectum*) as a substance, a subject, or a succubus." More precisely, the subjectile, "between the below and the above," is "at once a support and a surface, sometimes also the material of a painting or a sculpture, everything in them that would be distinguished from the form, as much as from the sense and the representation, what is not representable. Its presumed depth or thickness shows only a surface, that of the wall or of wood, but already that of paper, textile, panel. A kind of skin, pierced with pores."[4]

[Bl] The lines here separate what might also be designated, following Adami, as an *aide-mémoire* of *Concerto a quattro mani,* a series of memoranda addressed as an aid to memory, possibly a series of crib sheets "buried" on the painting. In other words, the painting's sudary (*OED:* "The napkin which was about Christ's head in the tomb; hence, a shroud or winding-sheet") unwrapped for reading.

[V] The relation of these lines here to *Concerto a quattro mani* I nickname "veronica," which designates in metonymy the counterpoints of metonymy (which "places

[3]Jacques Derrida, *Memoirs of the Blind,* trans. Pascale-Anne Brault and Michael Naas (Chicago: University of Chicago Press, in press); idem, *Mémoires d'aveugle: L'autoportrait et autres ruines* (Paris: Réunion des Musées Nationaux, 1990), p. 10.
[4]Jacques Derrida, "Forcener le subjectile," in Paule Thévenin and Jacques Derrida, *Antonin Artaud: Dessins et portraits* (Paris: Gallimard, 1986), pp. 56, 60.

us in the historical world of events and situations"[5]), of representation and su-
perimposition, finally of the self-portrait.

Veronica: metonymy of legend and vernicle

[V]

Legend: "it seems likely that the story of Veronica is a delightful legend without
any solid historical basis; that Veronica is a purely fictitious, not a historical
character."[6] Or: "Mabillon and the Bollandist Papebroch suppose that Veronica
came, by mere error, to be regarded as the name of a person, the word really
being a barbarous compound of *vera* and *icon* (*eikōn*), and meaning 'true image.' "[7]
Legend 1: The synoptics (Matthew 9:20–22; Mark 5:25–34; Luke 8:43–48) do
not name her. But in the various versions of the *Gospel of Nicodemus* (or *Acts of
Pilate*), chapter 7, Veronica (Latin version; from *veraiconica*, "of the true image")
or Bernice (Greek; from *pherenikē*, "bringer of victory") or Beronice (Coptic) is
the woman cured of hemorrhage after touching the hem of Jesus' garment.[8]
Legend 2: According to the interpolated medieval Latin fragment on *Mors Pilati,*
Veronica is the woman who, desiring an image of Jesus, was on the way to a
painter with a subjectile of linen when she met Jesus. On hearing her desire, he
takes the subjectile and imprints his face on it.[9] The *Golden Legend* (or *Legenda
Sanctorum*) of Jacobus de Voragine recalls this apocryphal legend.[10]
Legend 3: In the stations of the cross, Veronica is the woman who wiped the
sweat and blood from Jesus' face on the way to Calvary. The sudary or veil was
imprinted with his image. The subjectile is all that is preserved in the reliquary
in St. Peter's in Rome.

[V]

Vernicle, the subjectile for:

[V]

1. The representation: "As a matter of fact, mediaeval writers give the name
 Veronica to the image itself and not to a woman. Thus Matthew of Paris
 (ad. ann. 1216) speaks of 'the representation of our Lord's face, which is
 called Veronica.' "[11]
2. The relic: "the story was invented to explain the relic."[12]
3. The subjectile, the towel: "it is more likely that the towel was the primary
 instrument in the story, and the name Veronica was subsequently applied in
 an arbitrary fashion to the presumed owner of the towel."[13]

Veronica's portrait – Christ's self-portrait – would fall within the category of
likenesses made without the hand, *eikones akheiropoietai*.[14] Is the hand without

[V]

[5] Thomas McLaughlin, "Figurative Language," in *Critical Terms for Literary Study,* ed. Frank
Lentricchia and Thomas McLaughlin (Chicago: University of Chicago Press, 1990), p. 84.
[6] *Oxford Dictionary of Saints* (Oxford: Clarendon Press, 1978), s.v. "Veronica."
[7] *A Catholic Dictionary,* 16th ed., ed. W. Addis and T. Arnold (St. Louis: Herder, 1957),
s.v. "Christ, personal appearance and representations of."
[8] *The Apocryphal New Testament,* trans. Montague Rhodes James (Oxford: Clarendon Press,
1966), p. 102.
[9] Ibid., pp. 157–8.
[10] Jacobus de Voragine, *The Golden Legend,* part I, trans. Granger Ryan and Helmut Rip-
perger (London: Longmans, Green, 1941), p. 214.
[11] *A Catholic Dictionary,* s.v. "Christ, personal appearance and representations of."
[12] *Oxford Dictionary of Saints,* s.v. "Veronica."
[13] *The Saints,* ed. J. Coulson (New York: Hawthorn Books, 1958), s.v. "Veronica."
[14] *A Catholic Dictionary,* s.v. "Christ, personal appearance and representations of."

hand of this self-portrait the hand that writes on the wall at Belshazzar's feast (Daniel 5)? Is it, as Paul says, after his warning to look out for the empty deceit of worldly, human philosophy, the hand without hand that circumcises through the circumcision of Christ (Colossians 2:8–11)? Is it the hand of the Johannine *noli me tangere* that later tells Thomas to place his hand in the wounds and see, but better to believe without touching (John 20:17, 24–29)? Perhaps this category is why Veronica is the patron saint of photographers,[15] those hands that position the handless eye of the shutter.

[V] Veronica of veronica: metonymy of sudarium and sudary, napkin and shroud, Rome and Turin; according to Blanchot, the counterpoint of representation and superimposition.

"J.'s doctor. . . . called himself a Catholic, he meant a practicing Catholic. . . . On the wall of his office there was an excellent photograph of the Turin Sudary [*Saint-Suaire de Turin*], a photograph in which he saw two images superimposed on one another: one of Christ and one of Veronica; and as a matter of fact I distinctly saw, behind the figure of Christ, the features of a woman's face – extremely beautiful, even magnificent in its strangely proud expression."[16]

[DB] Or these lines could be considered as the painting's legends containing various citations, sometimes without explanation, of other writers, legends dated by the color of writing.

[V] For divers reasons, in these subjectile (i.e., untranslatable[17]) sheets, the relation of the sketch and the painting I nickname "translation."

(Isn't translation a translation of metonymy, at the level of the name? And wouldn't translation/metonymy repeat the situation of that relation – the transfer from sketch to painting – with the sketch remaining, not as original or copy, but as their *différance?* As does the painting?

In *Concerto a quattro mani* there is also the erased translation of Seneca's phrase, *res severa verum gaudium,* which Adami translates as *toute oeuvre difficile donne une vraie joie,* as well as the title, the date, and the signatures.)

[Bl] Translation: from Henry Le Chénier's interview with Adami: "The drawing can be richer in colors than a painting [*tableau*]; the line is so sensitive that it becomes color. . . . I cannot draw without thinking of color. Often I begin a drawing on an idea of color."[18] The line translates, not only writing, but color; not the original in the copy (as would the literary and its mimetic tendencies), but the color in the line. (Benjamin, fragmentation notwithstanding, is drawn in this relation of line and translation, where translation is based on a kinship without likeness.[19])

[15]*Enciclopedia Cattolica* (Vatican, 1954), s.v. "Veronica."
[16]Maurice Blanchot, *Death Sentence,* trans. Lydia Davis (Barrytown, N.Y.: Station Hill, 1978), pp. 8–9 (modified); idem, *L'Arrêt de mort* (Paris: Gallimard, 1980), pp. 18–19.
[17]Derrida, "Forcener le subjectile," p. 57.
[18]Valerio Adami, "Rencontre d'atelier. Propos recueillis par Henry Le Chénier," in *Adami: peintures et dessins* (Aix-en-Provence: Présence Contemporaine, 1984), p. 70.
[19]Walter Benjamin, "The Task of the Translator," trans. Harry Zohn, in *Illuminations* (New York: Schocken, 1969), pp. 73–4.

Journal entries of Adami on color ("Les Règles de montage"):

"7.1.

" . . . To draw color. . . . "[20]

The line will translate color in the line. Color would be a supplement of itself in the painting.

"3.2.

" . . . Color becomes writing in its relation with the idea. . . . "[21]

Color translates the line (of writing) in the idea.

"28.5.

"Color is the instrument for reading drawing as the voice is the instrument for reading writing. Passing from the drawing to the painting [*tableau*] is equivalent to passing from writing to reading.

"The painting defines the field of writing and reading simultaneously. Formula of synthesis between sign and speaking.

"Drawing, imitation of an object. Writing, imitation of speaking.

"Speaking precedes writing as *x* precedes the drawing."[22]

"Color is the eyes' voice."[23] The voices of *Right of Inspection* cite Giorgio Agamben's *La fine del pensiero* and respond:

"— ' . . . We can think, in language, solely because language is and is not our voice. . . . That is why, when we speak, we can't do without thinking, without keeping the words suspended. Thinking is the pending of the voice in language.'

"— You should speak of these photographs as of thought, as a pensiveness without a voice, with a voice forever suspended."[24]

[V]

What could Adami mean in these notes? The analogies appear simple and clear and repeat much of the mimetic tradition. Color reads the drawing as the voice reads writing. (What you read here is what the color reads – chromograph – the lines the color paints over and translates.) The translation from the drawing to the painting is the translation from writing to reading, but this translation in/as painting is simultaneous; painting reads as it writes – simultaneously; colors as it draws – simultaneously. What color draws and writing reads is preceded by – that is, imitates – something else: object and speech. But this precession and this imitation, in these confidential tales, are not so simple. "The thing looked at is different from what it is; so there is only one means to see it, that is to close the eyes and touch it. . . . a tear leaves the pencil – paradox between eye and hand. . . . the drawing that counts proceeds from touch more than from the eye. . . . "[25] Imitation and precession are not without translation; voice and phenomenon never leave the labyrinth of painting in order to perceive the object or speak; the hands touch.

[Y]

[20]Adami, "Les Règles de montage," p. 8.

[21]Ibid., p. 14.

[22]Ibid., p. 23.

[23]Valerio Adami, "Aide-Mémoire," trans. Françoise Gaillard, in *Adami* (Paris: Editions du Centre Pompidou, 1985), p. 113.

[24]Jacques Derrida, "Right of Inspection," trans. David Wills, *Art & Text* 32(Autumn 1989): 76 (with Marie-Françoise Plissart); Marie-Françoise Plissart, *Droit de regards, avec une lecture de Jacques Derrida* (Paris: Minuit, 1985), p. XXV.

[25]Adami, "Aide-Mémoire," pp. 114, 115, 119.

[V] "Il n'y a jamais eu de perception. . . ." [26]

"('Painting can change the form of an object, but it must preserve its name' V.A.)." [27]

[Bl] "There never was any 'perception. . . .' " [28]

[DB] Such a statement might be thought too bold. Never has there been perception, never was there any "perception." The quotation marks are precaution marks, according to one counterpoint of the eye. One might translate: there is always perception, but no "perception," no union of seeing and its object in intuition.

[Y] We could go in another direction, the direction of Freud, as Derrida points out in *The Truth in Painting,* where he cites in parentheses his earlier work on "Freud and the Scene of Writing": " 'At least two hands are needed to make the apparatus function, and a system of gestures, an organized multiplicity of origins. One must be several in order to write and already to "perceive." The simple structure of nowness [*la maintenance*] and manuscripture is a myth, a "fiction" as "theoretical" as the idea of the primary process.' " [29] This self-citation occurs right before the comments on Adami's *Concerto a quattro mani.*

[Bl] Derrida gives a warning about another phrase, this time with quotation marks and in italic. The phrase is from *Of Grammatology: "In a certain way, 'thought' means nothing."* [30] This is at the end of the first part of *Of Grammatology,* where Derrida announces "what we already know we have not yet begun" – thinking, "a perfectly neutral name, a textual (white) blank, the necessarily indeterminate index of an epoch to come of differance" (translation modified). In *Positions* he comments on this difficult sentence, but in my citation I falsify just a bit, substituting "perception" and its complex for thought: "It is now quite some time, permit me to recall, since I risked the following sentence, that is, that I *wrote* it, for the silent work of italics and quotation marks should not be subtracted from it, as happens too often (for instead of investigating only the content of thoughts, it is also necessary to analyze the way in which texts are *made*): 'There never has been perception.' 'Perception' (quotation marks: the word 'perception' and what is called 'perception') means nothing: it is the substantified void of a highly derivative ideality, the effect of a *différance* of forces, the illusory autonomy of a discourse or a consciousness whose hypostasis is to be deconstructed, whose 'causality' is to be analyzed, etc. First. Secondly, the sentence can be read thus: if there is perception – and there is, and it is just as suspect, for analogous critical reasons, to contest the authority of all 'perception' – then whatever will continue to be called perception, and which, for example, will designate the deconstruc-

[26]Jacques Derrida, *La Voix et le phénomène: Introduction au problème du signe dans la phénoménologie de Husserl* (Paris: Presses Universitaires de France, 1972), p. 116.
[27]Marc Le Bot, "Ombre et lumière dans la peinture de Valerio Adami," in *Adami: Peintures et dessins,* p. 18, citing Adami.
[28]Jacques Derrida, *Speech and Phenomena, And Other Essays on Husserl's Theory of Signs,* trans. David B. Allison (Evanston, Ill.: Northwestern University Press, 1973), p. 103.
[29]Derrida, *The Truth in Painting,* p. 152; *La vérité en peinture,* pp. 172, 175.
[30]Jacques Derrida, *Of Grammatology,* trans. Gayatri Chakravorty Spivak (Baltimore: Johns Hopkins University Press, 1976), p. 93; idem, *De La Grammatologie* (Paris: Minuit, 1967), p. 142.

tion of logocentrism, means nothing, for in the last analysis it no longer derives from 'meaning.' Wherever it operates, *'perception' never has been.*"[31] (On quotation marks, see the openings of Derrida's "Living On / Border Lines"[32] and *Limited Inc.*,[33] for example.)

Or, from a later text, this time from the reading (*lecture*) of *Right of Inspection:* "Yes, one can only read. I repeat, this work is only about looking and the right to it, but since everything is at war over this right, it becomes a matter of lines of demarcation, marks, limits, frames and borders which leave traces of having overstepped the mark, photographic imprints – but nothing to see, if by that one means perceive. There is no perception of a natural or naturally present reality. We thus learn that looking has nothing to do with perception, it doesn't see."[34]

[V]

double blind seeing: the transcendental (condition of possibility of seeing) and the sacrifice of the eyes

In *Mémoires d'aveugle,* one voice hesitates "between two paradoxes, two great 'logics' of the invisible at the origin of drawing," "two 'blindnesses.'" The first blindness, the transcendental, would be what could never be drawn or become a theme of drawing; it "would be drawing's invisible condition of possibility, drawing itself, the drawing of drawing." The second blindness, the sacrifice of the eyes, which can be drawn, "would represent this irrepresentable," would represent the impossibility of representing the transcendental.[35] This hesitation is also a "*translation.*" "What matters is the hesitation *between the two,* even if it appears overcome in the incisive decision, the decision that makes of the two thoughts the supplement or the vicar of the other. For there is neither pure transcendentality nor pure sacrifice." The event, the history toward which sacrificial thoughts tend – the eyes are violated in and violate representation, hence in our terms here, sacrificial thought is veronica's – comes round "to annul itself in structure, that is, in the circle of exchange. And that is why this historic logic resembles and can always be substituted for a transcendental logic that each time the *figure* or the *kind* of the event recalls to memory."[36]

[V]

the double bind of seeing, or a counterpoint of the eye

In *La folie du jour (The Madness of the Day),* the narrative voice (this *récit* is the *récit* of the narrative voice – "Right before their eyes, though they were not at all startled, I became a drop of water, a spot of ink. I reduced myself to them.") associates the terror of seeing with the demand for seeing, the injury to the eyes and speech. The narrative voice, which says "I" here while indicating the impossibility of saying "I" ("In haste, I would rid myself [*me dépouillais*] of my-

[DB]

[31]Jacques Derrida, *Positions,* trans. Alan Bass (Chicago: University of Chicago Press, 1981), p. 49; idem, *Positions* (Paris: Minuit, 1972), pp. 66–7.
[32]Jacques Derrida, "Living On / Border Lines," trans. James Hulbert, in *Deconstruction and Criticism* (New York: Seabury, 1979), pp. 75–176.
[33]Jacques Derrida, *Limited Inc.,* trans. Samuel Weber and Jeffrey Mehlman (Evanston, Ill.: Northwestern University Press, 1977, 1988).
[34]Derrida, "Right of Inspection," p. 53; *Droit de regards,* p. xvi.
[35]Derrida, *Mémoires d'aveugle,* p. 46.
[36]Ibid., p. 96.

self ''[37]), tries to tell the impossible story: "I nearly lost my sight, because someone crushed glass [*verre*] in my eyes. That blow unnerved me, I must admit. I had the feeling I was going back into the wall, or straying into a thicket of flint. The worst thing was the sudden, shocking cruelty of the day; I could not look [*regarder*], but I could not help looking [*ni ne pas regarder*]. To see [*voir*] was terrifying, and to stop seeing tore me apart from my forehead to my throat. . . .

"Once the glass had been removed, they slipped a thin film under my eyelids and over my eyelids they laid walls of cotton wool. I was not supposed to talk [*parler*] because talking [*parole*] pulled at the anchors of the bandage. . . . In the end, I grew convinced that I was face to face with the madness of the day. That was the truth: the light was going mad, the brightness had lost all reason [*tout bon sens*]; it assailed me irrationally [*déraisonnablement*], without control, without purpose. That discovery bit straight [*fut un coup de dent*] through my life."[38]

The double bind of seeing: to look is terrifying, not to look is terrifying. Blindness does not remove this double bind; rather, blindness implicates speech in the bind: the eye is covered; speech forbidden. Film covers the bandaged eyes; another hymen is introduced between eye and eyelid. The groping of the hand cuts in: "Even though my sight had hardly weakened at all, I walked through the streets like a crab, holding tightly onto the walls. . . . "[39]

[V] The two hypotheses of Derrida's *Mémoires d'aveugle* concern the translation of the blindness of drawing, the translation of eye and hand: Not only is the drawing blind, the drawing is of the blind. "Here is a *first hypothesis:* the drawing is blind, if not the one (he or she) who draws. As such and in its own proper moment, the operation of drawing would have something to do with [*à voir avec*] blindness. . . . " The first hypothesis is drawing's madness of the day. "*Second hypothesis,* transplant of the eye, graft of one point of view on the other: a *blind* drawing is a drawing *of* the blind [*un dessin d'aveugle est un dessin d'aveugle*]. Double genitive. There is no tautology in that, but a fatality of the self-portrait. . . . the drawn [*trait*] falls prey to *allegory,* to that strange self-portrait of the drawing handed over to the other's speaking and gaze. Subtitle of all the blind scenes, then: *the origin of drawing.* Or, if you prefer, *thought of the drawing,* a certain pensive pose, a *memory of the drawn* that speculates in dream on its own possibility. Its power always develops itself on the edge of blindness. Blindness breaks through there, precisely takes the advantage there *potentially:* angle of view threatened *or* promised, lost *or* restored, given. There is in this gift as a *with-drawing* [re-trait], at once the interposition of a mirror, impossible reappropriation or mourning, the intervention of a paradoxical Narcissus, at times lost *in abyss,* in brief a specular re-folding – and a supplementary drawing [*trait*]. It is better to nickname in Italian this hypothesis of the (with)drawing in memory of the self lost from view: *l'autoritratto* of drawing."[40]

[Y] "1.1.76.

" . . . Drawing is a literary activity. . . . "[41]

"5.1.

"I would like to be able also to use in painting the terms prose and poetry, and define my work as painting in prose.

[37]Maurice Blanchot, *The Madness of the Day,* trans. Lydia Davis (Barrytown, N.Y.: Station Hill, 1981), pp. 14, 27.
[38]Ibid., pp. 11–12, 24–5.
[39]Ibid., pp. 12, 26.
[40]Derrida, *Mémoires d'aveugle,* p. 10.
[41]Adami, "Les Règles de montage," p. 6.

"The narrative drive is essential, but the form modifies my conviction and my doubts. Just as a curved line or a broken line influences discourse."[42]

[Bl]

In *The Post Card* the "expert" reader of the postcard states that one must read " 'verbally.' " The signer of the card from "*January 1979*" writes: "Prose begins here, starting with the expertise of the doctor who comes to teach me how to read the card. I had called him in for a consultation and here is his answer (he is writing to J.C., you recall that he had offered to take on this mission to the *Kunstgeschichte* specialist): 'Dear Sir, your question can be answered quite simply. One has but to read the miniature verbally. Socrates is in the course of writing. Plato is beside him, but is not dictating. He is showing, with his index finger pointed toward Socrates: Here is the great man. With the left index finger he is drawing the attention of the spectators, who must be imagined more to the right toward the philosopher who is writing. Therefore he is rather subordinate, of lesser size and with a more modest head piece. Please accept my kindest regards.' He has to be believed, he is right. 'Read verbally' must mean 'literally.' "[43]

[DB]

What is it to read verbally? literally? Adami states that drawing is literary, that his painting is painting in prose. How is such a translation to be read? according to what letter? I am not sure such a question can be answered, assuredly not literally, because the counterpoints of the eye practice a modesty of the eye whose blinking rhythm will never equal the shutter of the most ideal or the realest of cameras. The modesty of the eye is veronica's. "*Veronique:* f. . . . a representation, image, picture, counterfeit, likenesse of. . . ."[44]

[Bl]

mise en abyme of the legible

[Bl]

Husserl writes of a complex example of the "encasement [*Ineinanderschachtelung*]" of objectivations in *Ideas I,* the encasement finally of the legible: "Let us take an example [*Beispiel*] with a very complicated and yet easily understandable objectivation-formation belonging to objectivations of higher level. A name reminds us, namingly, of the Dresden Gallery and of our last visit there: we walk [*wandeln*] through the halls and stand before a picture [*Bilde*] by Teniers which represents [*darstellt*] a picture gallery. If, let us say, we allow that pictures in the latter would represent [*darstellen*] again pictures which, for their part, represent legible inscriptions [*lesbare Inschriften darstellten*], and so forth. . . . But such very complicated cases [*so sehr komplizierter Fälle*] are not required for *eidetic insights* [Wesenseinsichten], in particular for the insight into the ideal possibility for continuing ad libitum the encasement of one objectivation into another."[45]

[Bl]

A picture represents a picture gallery within which the pictures represent again pictures representing legible inscriptions. One could say Husserl's encasement is

[42]Ibid., p. 8.

[43]Jacques Derrida, *The Post Card: From Socrates to Freud and Beyond,* trans. Alan Bass (Chicago: University of Chicago Press, 1987), p. 172; idem, *La Carte postale: de Socrate à Freud et au-delà* (Paris: Flammarion, 1980), p. 186.

[44]R. Cotgrave, *A Dictionarie of the French and English Tongues* (London: 1611); reprinted by University of South Carolina Press, 1950.

[45]Edmund Husserl, *Ideas Pertaining to a Pure Phenomenology and to a Phenomenological Philosophy: First Book: General Introduction to a Pure Phenomenology,* trans. F. Kersten (Boston: Nijhoff, 1982), §100, pp. 246–7; idem, *Ideen zu einer reinen Phänomenologie und phänomenologischen Philosophie: Erstes Buch: Allgemeine Einführung in die reine Phänomenologie,* ed. Walter Biemel, vol. 3 of *Gesammelte Werke* (The Hague: Nijhoff, 1950), p. 253.

grounded, that is, representation is outside the legible inscripting it finally represents twice removed. Yet if the representation represents its own encasement (the picture gallery), couldn't one say the opposite: the grounding is based on legible inscription? The representation represents representing its own legibility (an excessive complication for eidetic insight). Veronica as the legibility of inscription, its *mise en abyme,* is a counterpoint of the eye: representation as phenolegocentrism. The painting, once again, according to this expert, is to be read.

[Bl] Another phenolegocentrism, for another time, Heidegger's "Was heißt Lesen?" ("What Is Called Reading?"): "Without authentic reading we are also not able to see what has us in sight nor to gaze upon any appearance or semblance."[46]

mise en abyme of legibility and speech

[Bl] Much of the Husserl citation forms the epigraph to Derrida's *Speech and Phenomena.* And part of that epigraph is cited at the end of the text. The legibility of the Teniers case (Does this legibility encompass the designation of which painting by Teniers is meant? By which Teniers, Elder or Younger? Is one to track down the reference of Husserl, just as Meyer Schapiro supposedly does for the reference to the painting of shoes by Van Gogh in Heidegger's "Origin of the Work of Art" [see "Restitutions of the Truth in Pointing," in *The Truth in Painting*]? Both Teniers, David the Elder and David the Younger, father and son, painted *Kunstkamers,* or "paintings of art collections," the Elder at least one, the Younger at least several versions of *Archduke Leopold Wilhelm's Painting Gallery.*[47] Teniers, one or the other, would have had to have painted, according to Husserl's "worst-case" case, not a *Kunstkamer,* but a *Kunstkamer* of paintings of paintings of legible inscriptions of, etc., possibly a *Kunstkamerskunstkamerskunst* . . .) runs up against the *mise en abyme* of its own representation. The encasement, one could say, never takes place in the certainty of its perception, its legibility.

[Bl] Derrida reads Husserl's cave: the Dresden Gallery: "No doubt nothing has preceded this situation. Assuredly nothing will suspend it. It is not *comprehended,* as Husserl would want it, by intuitions or presentations. Of the broad daylight of presence, outside the gallery, no perception is given us or assuredly promised us. The gallery is the labyrinth that includes in itself its own exits [*issues*]: we have never fallen upon it as upon a particular *case* of experience – that which Husserl believes he is describing.

"It remains then, for us to *speak* [parler], to make the voice *resonate* [résonner] throughout the corridors in order to supply the counterpointed brilliance of presence [*suppléer l'éclat de la présence*]. The phoneme, the *akoumenon,* is the *phenomenon of the labyrinth.* Such is the *case* of the *phōnē.* Rising toward the sun of presence, it is the way [also, the voice; *voie* as *voix*] of Icarus.

"And contrary to what phenomenology – which is always phenomenology of perception – has tried to make us believe, contrary to what our desire cannot

[46]Martin Heidegger, "What Is Called Reading?" trans. John Sallis, in *Hermeneutics and Deconstruction,* ed. Hugh J. Silverman and Don Ihde (Albany, N.Y.: SUNY Press, 1985), p. vii; idem, "Was heißt Lesen?" in *Aus der Erfahrung des Denkens, 1910–1976, Gesamtausgabe,* Band 13 (Frankfurt am Main: Vittorio Klostermann, 1975), p. 111.
[47]Jane P. Davidson, *David Teniers the Younger* (Boulder, Colo.: Westview Press, 1979), p. 21.

not be tempted to believe, the thing itself always escapes [se dérobe: also, conceals itself, withdraws itself].

"Contrary to the assurance that Husserl gives us a little further on, 'the look' cannot 'abide.' "[48]

Never has there been perception. We are in the labyrinth of the gallery the outside of which there is no perception of or assured promise of perception of. "Perception" is within the labyrinth, and speaking/hearing falls under the same band. Perception and speech are labyrinthine; the voice falters, the eye blinks, the ear turns deaf, the hand gropes. Legibility, whether reading or hearing, hearing and reading, is the legibility of the labyrinth.

[Bl]

This " 'begins' then – 'beyond' absolute knowledge,"[49] whose closure has been sketched. Within that sketch we have not done reading Hegel – because reason is cunning – this time on translation and mimesis. Hegel draws an anthanalogy: the translation is to the original (here the ancient classics of Latin and Greek) as a fake rose is to a natural rose; no matter how similar the shape, color, even the scent, life is lacking. "Translations are like fake roses that can be similar to natural ones in shape, color, perhaps even scent, but they cannot attain the loveliness, delicacy, and softness of life [*Sie [die Uebersetzungen] gleichen den nachgemachten Rosen, die an Gestalt, Farbe, etwa auch Wohlgeruch den natürlichen ähnlich sein können; aber die Lieblichkeit, Zartheit und Weichheit des Lebens erreichen jene nicht*]." This life of the flower, its loveliness, delicacy, and softness, its innerness, the musical element of the language, is what fades away (*verschwindet*) in the translation (*in der Uebertragung*). After a dash, and seemingly parallel to the musical element of the language that fades away, Hegel adds: "the fine fragrance [*der feine Duft*], through which the sympathy of soul gives itself enjoyment, but without which a work of the ancients only tastes like Rhine wine that has lost its bouquet [*der verduftet ist*]."[50] The scent (*Wohlgeruch*), no matter how similar, lacks life and is the point of difference within the olanthanalogy. Yet the fine fragrance (*Duft*) is the life that fades in the translation. The nose and the ear decide what the eye cannot: the translation from the original, the copy from the original. In other words, veronica can only be heard and sniffed out.

[Bl]

In the subjective logic of the Greater Logic, concerning the teleology of objectivity, that is, on the way to the Idea and life, there are "*violence* [Gewalt]" in the relation of object and end, and "the *cunning* of reason [*die* List *der Vernunft*]" that interposes another object within that violent relation. "The teleological process is the *translation* [Uebersetzung] of the concept that has a distinct concrete existence as concept into objectivity; this translation [*Uebersetzen*] into a presupposed other is seen to be the meeting of the concept *with itself through itself* [durch sich selbst mit sich selbst]."[51] Translation is the relief (*Aufhebung*) of life

[Bl]

[48]Derrida, *Speech and Phenomena*, p. 104 (modified); *La Voix et le phénomène*, p. 117.
[49]Ibid., p. 102; *La Voix et le phénomène*, p. 115.
[50]G. W. F. Hegel, "On Classical Studies," trans. Richard Kroner, in *Early Theological Writings* (Philadelphia: University of Pennsylvania Press, 1948), pp. 326–7 (modified); idem, "Rede zum Schuljahrabschluß am 29. September 1809," in *Nürnberger und Heidelberger Schriften (1808–1817)*, vol. 4 of *Werke* (Frankfurt am Main: Suhrkamp, 1970), p. 320. "On Classical Studies" is Hegel's rectorate address of 29 September 1809 at the Nürnberg Gymnasium.
[51]G. W. F. Hegel, *Science of Logic*, trans. A. V. Miller (Atlantic Highlands, N.J.: Humanities Press, 1989), pp. 746–8 (modified); idem, *Wissenschaft der Logik II*, vol. 6 of *Werke* (Frankfurt am Main: Suhrkamp, 1969), pp. 452–3.

as idea and truth. What would be the fragrance of this translation? Does Genet apply (*Glas:* "the essence of the rose is its nonessence: its odor insofar as it evaporates. Whence its effluvial affinity with the fart or the belch: these excrements do not stay, do not even take form. . . . How could ontology lay hold of a fart? It can always put its hand on whatever remains in the john [*aux chiottes*], but never on the whiffs let out by roses"[52])? Or Adami ("The sense of color is like the olfactive sense"[53])? In any case, translation is the interposition of another object in the meeting of the concept with itself through itself – the concept's subjectile. Possibly the eye, the hand, the nose? the postcard? In any case, veronica.

double bind of the postcard

[V] Dated "*10 June 1977,*" there is the following postcard on the postcard: "and I do not believe that one can properly call 'post card' a unique and original image, if some such thing ever occurs, a painting or drawing [*une peinture ou un dessin*] destined to someone *in the guise* of a post card and abandoned to an anonymous third party, a neutral machinery that supposedly leads the message to its destination, or at least that would have its support make its way, for if the post card is a kind of open letter (like all letters), one can always, in time of peace and under certain regimes, attempt to make it indecipherable without compromising its making its way. Indecipherable, my unique one, even for the addressee [*destinataire*]. And yet there are but post cards, it's terrifying."[54]

[DB] Is *Concerto a quattro mani* a postcard? Is it "a unique and original image" sent under the guise of a postcard? Is there any choice? The double bind of transcendental parallels: the unique image and the indecipherable postcard? Front and back, both unreadable. Does this become a postcard in this writing?

[Bl] Derrida in *The Truth in Painting* on the relation of the line and color in Adami: "The rigor of the divide between *trait* and color becomes more trenchant, strict, severe, and jubilant as we move forward in the so-called recent period. Because the gush of color is held back, it mobilizes more violence, potentializes the double energy: first the full encircling ring, the black line, incisive, definitive, then the flood of broad chromatic scales in a wash of color.

"The color then transforms the program with a self-assurance all the more transgressive (perceptual consciousness would say 'arbitrary') for leaving the law of the trait intact in its inky light. There is, to be sure, a contract: between the drawing which is no longer an outline or a sketch, and the differential apparatus of the colors. But it only binds by leaving the two agencies in their autonomy. . . .

"In *Freud's Journey,* a single drawing, once put on the rails, lends itself, without moving in itself, or almost, to a whole series of different readings, each time transformed through and through across the redistribution of the chromatic values and all the differential versions proposed by Adami. And yet, 'the drawing, here, has none of the characteristics of a foundation' (Hubert Damisch)."[55]

[52]Jacques Derrida, *Glas,* trans. John P. Leavey, Jr., and Richard Rand (Lincoln: University of Nebraska Press, 1986), p. 58bi; idem, *Glas* (Paris: Galilée, 1974), p. 69bi.
[53]Adami, "Aide-Mémoire," p. 115.
[54]Derrida, *The Post Card,* p. 35; *La Carte postale,* p. 41.
[55]Derrida, *The Truth in Painting,* pp. 172–3; *La Vérité en peinture,* pp. 196–7.

Concerto a quattro mani, Valerio Adami (see Fig. 26)

Mémoires d'aveugle: "the staging of the blind is always inscribed in a theater or a theory of hands."[56]

The drawing is on the cover of *Derrière le miroir* that contains Derrida's "+R (par dessus le marché)" (see Fig. 27).[57] In that text, Derrida writes that "the *Concerto a quattro mani* is played twice by inverting the direction of the hands: in front of a mirror, under a mirror, behind the mirror. The strange manufacture diverts [*détourne*] speculation, it presents what presents it, *behind the mirror* [derrière le miroir], on the cover. This latter is thus a part of itself, a piece of a display shelf which, because it is situated both inside and outside, manipulates in several registers an object which, however, exceeds it. And pretends to represent a non-representational instrument (for example a piano)."[58]

Translation of *l'autoritratto* without eyes. The blacklead drawing is dated 31 March 1975; the acrylic canvas, 7 June 1975. I want to read the writing. The drawing contains a translation. On the lower middle, on the right, is the phrase *res severa verum gaudium.* After the signature at the bottom, the date, the title, and then the translation in French and another signature: *toute oeuvre difficile donne une vraie joie / seneca.* The canvas colors, and the signatures and the translation are painted over on the canvas. The background is a blue; four (how is one to count counterpointed hands?) hands of pink; the fifth, holding the cigarette in the mouth, is mostly yellow; the nose, mouth, and cigarette are other blues; two quasi-quadrilaterals, one dark blue, the other (a veil of eye and ear) light violet, and a black piano with pale keys complete the canvas. Hands, nose, mouth, but no eye (or ear).

What is the relation of the French translation and the Latin original – of *toute oeuvre difficile donne une vraie joie* (every difficult work gives true joy) and *Mihi crede, verum gaudium res severa est* (Believe me, true joy is a severe thing)? On the level of the letter, in a literal reading, the translation deforms, giving a possible chiasmatic reversal in its gift (although only in translation could such a question arise, as position in Latin is a difficult, if not deflecting, question). Yet on another, the level of the drawing, the translation is beyond fidelity, beyond any simple exchange of word for word, or sense for sense. Seneca's letter calls for a self-withdrawal "to soundness of mind" (*ad bonam mentem*), philosophy's *autoritratto.* Seneca advises Lucilius to learn joy (*disce gaudere*), but true joy is a severe thing (*verum gaudium res severa est*) more accessible within (*plus pateat introrsus*); it comes, he tells Lucilius, from you (*de tuo*), which is not the body, but you yourself, the best part of you (*Te ipso et tui optima parte*).[59] Not only, then, in this translation, is the withdrawal a withdrawing within memory as the self-portrait, but there is the withdrawing of the work – its *autoritratto* – and that gives true joy.

"19.2.

"Derrida asks me if the words written on the painting and superimposed on the image have a signification for me, even in their phonetic value. Caught short, I do not respond.

[56]Derrida, *Mémoires d'aveugle,* p. 33.

[57]Jacques Derrida, "+R (par dessus le marché)," *Derrière le miroir* 214(May 1975):1–23.

[58]Derrida, *The Truth in Painting,* p. 153; *La Vérité en peinture,* p. 175.

[59]Seneca, *Ad Lucilium Epistulae Morales,* trans. Richard M. Gummere, vol. 4 of Seneca (Cambridge, Mass.: Harvard University Press, 1979), Letter 23.

"Yes, the phoneme is part of the composition. Let us cite for example the numerous demonstrations that publicity ads offer us. The choice of a word can be made for its phonetic definition alone. I would like to develop this form of *Lied* that I have begun with the two lithos on the texts of Derrida.

"What is fascinating are the series of conjunctions that operate between the text and the image. The text gives life to the image and dies in it." [60]

res severa verum gaudium: according to veronica, there is another translation, a translation of the *Lied* as writing: Indo-European root *weros* ("true"). *Verus,* veronica; *severus:* "grave, serious (regarded by some as a compound of *se-, sed,* without . . . and *verus,* true, but the semantic difficulties make this explanation improbable)." [61] The thing without truth is true joy; joy, the thing, truth without truth: severonica.

[V] *L'autoritratto* "calls for and prohibits at once the self-portrait." [62]

[V] severonica's *autoritratto:* "close the eyes and touch" – the handless hand

[60] Adami, "Les Règles de montage," p. 15.
[61] *American Heritage Dictionary* (Boston: Houghton Mifflin, 1982).
[62] Derrida, *Mémoires d'aveugle,* p. 61.

THE DOMESTICATION OF THE HOUSE: DECONSTRUCTION AFTER ARCHITECTURE

MARK WIGLEY

I N recent years a lively interdisciplinary debate has developed around the question of "deconstruction and architecture." It is not possible to sift through all of its curious symptoms here and trace the elaborate weave of heterogeneous trajectories that constitute it, even if we limit ourselves, in terms of a theme of this book, to architecture as a "spatial art" – a concept that may, ironically, be one of the first fatalities, or at least victims, in architecture's engagement with deconstruction. After all, to deconstruct the most conspicuously spatial of the arts would precisely be, at the very least, to understand to what extent architecture is not spatial and actually derives its force from its capacity to conceal that which at once exceeds space and makes space possible.[1] My only concern here, therefore, will be to trace some of the preconditions for the current exchange between deconstructive discourse and architectural discourse, conditions that both made it possible and produced the sense of an event, inasmuch as they are variously brought to the surface, suppressed, or displaced.

It must immediately be noted that this interdisciplinary discourse, which began with the question of deconstruction and architecture and has developed in recent years into other questions in which the word "deconstruction" plays no role, did not simply emerge out of the highly publicized event of Derrida's involvement in a specific architectural project. On the one hand, several projects of reading Derrida's work within architectural discourse were already highly developed and would become increasingly nuanced.[2] On the other hand, the question of architecture did not simply emerge in Derrida's work with his first essay "about" architecture. His writing already depended on a certain thinking of architecture that even surfaces in the word "deconstruction." So it is necessary to step back, to retrace some steps and identify the role of architecture in Derrida's writing before his apparent turn to it. His earlier texts need to be reread in order to locate the architecture that is written into them and cannot be detached from them, the architecture that makes those texts possible and, indeed, makes the eventual turn to architecture possible, even if that turn ignores or transforms it.

[1] See Mark Wigley, *The Architecture of Deconstruction: Derrida's Haunt* (Cambridge, Mass.: MIT Press, 1993).
[2] I am particularly referring here to the work of my colleagues Jennifer Bloomer, Catherine Ingraham, and Jeffrey Kipnis.

To step back into Derrida's earlier work to address this question will be, at the same time, to step back into the writings of Martin Heidegger, not only because Heidegger is perhaps the most rigorous thinker of the relationship between philosophy and architecture but also because Derrida's work is itself an incessant stepping back into Heidegger, and, perhaps more than anything else, it is a stepping back into Heidegger's account of the necessity of such a stepping back, an account that is itself symptomatically presented in architectural terms. And this return to Heidegger must be made precisely when it might seem riskiest, given the current reexaminations of his association with National Socialism. But these revisions make the return even more necessary here and now, because, as I have argued elsewhere,[3] the question of architecture is implicated in them, at every turn.

THE ELUSIVE ARCHITECTURE OF DECONSTRUCTION

A certain thinking of architecture is central to Heidegger's work. It is not that he simply theorizes architecture as such, but that theorizing is itself understood in architectural terms. As is well known, one of the most famous of his later essays – "Building, Dwelling, Thinking"[4] – literally identifies thinking with building. In fact, this identification is already written into his earliest work, and, even then, he argues there that it is not so much his identification as it is that of the ancient and ongoing tradition of philosophy he is interrogating.

For Heidegger, the tradition of metaphysics has always understood itself as a kind of building, even before it started explicitly describing itself in these terms when René Descartes depicted philosophy as the construction of an "edifice," a sound structure erected on stable, well-grounded foundations – a description that would then be institutionalized, most conspicuously by the writings of Kant.[5] Furthermore, philosophy's original, but increasingly forgotten, object – "Being" (*Sein*) – is also a kind of construction, a "presencing" (*Anwesenheit*) through "standing" (*stehen*).

There is some kind of symptomatic transference between philosophy, as an institution that constructs arguments like a building is constructed, and the object it analyzes. At the very least, philosophy identifies with its object, seeing itself as a construction that reveals the construction of Being, not by simply representing that construction but by presenting its essential condition. The rules that organize the institutional practices of philosophy supposedly are provided by its object rather than by any

[3] Mark Wigley, "Heidegger's House: The Violence of the Domestic," *D: Columbia Documents in Architecture and Theory*, no. 1(1992):91–121.

[4] Martin Heidegger, "Building, Dwelling, Thinking," trans. Albert Hofstadter, in Martin Heidegger, *Poetry, Language, Thought* (New York: Harper & Row, 1971), pp. 143–61.

[5] "What the principle of reason [*Grund*] states in its ordinary formulation has in some fashion always resounded in Western thought. Yet measured historiographically, two thousand three hundred years were needed until the principle of reason came to light and let itself be set up as a fundamental principle." Martin Heidegger, *The Principle of Reason*, trans. Reginald Lilly (Bloomington: Indiana University Press, 1991), Lecture Seven, p. 53.

sociopolitical system, which is to say that, for philosophy, its rules are not institutional. Philosophy, in the strictest sense, does not even think of itself as an institution. The figure of architecture is therefore not simply one figure among the others that it chooses to employ. More than just philosophy's figure of itself, it is the figure by which that institution effaces its own institutional condition, an effacement that paradoxically defines philosophy's particular institutional location and sociopolitical function. It is philosophy's claim on that which precedes or exceeds the social that gives it unique social authority, the authority, precisely, to define and regulate the social. From the beginning, philosophy has represented itself as a source, storehouse, and arbitrator of order. This representation would not be possible without the architectural figure, which is to say a very particular figure of architecture, one that always has to be protected from damage even, if not especially, when it is not being explicitly invoked. Maintained in working order even when it is being held in reserve, the figure is always operative in the discourse and actually exerts the greatest force when it is in reserve. Philosophical discourse is more indebted to this architectural figure than it could ever say, even when it does become explicit. Indeed, the real force of the figure lies in those of its operations that philosophy cannot address.

For Heidegger, the tradition of philosophy, beginning with Plato, has forgotten its original task to raise the question of Being and thereby lost touch with the fundamental condition of beings. The identification it makes with its object, when both are understood as a kind of building that stands on a ground, is more a projection of its self-image onto its object than a recovery of the essential condition of that object. Metaphysics is a particular kind of construction that actually covers over the originary construction it ostensibly reveals. Inasmuch as authentic thinking is authentic building, the tradition of philosophy is at once an inadequate building and an inadequate thinking about building. Heidegger's attempt to "overcome" this tradition is necessarily a rethinking of building. This rethinking does not simply abandon the classical building of philosophy in favor of some superior construction technique but identifies the sense of building that philosophy attempts to cover, studying the classic building for the traces of what it effaces.

It is arguably this engagement with the question of building that determines both the form and content of Heidegger's writing. In *What Is a Thing?* (the text of the lectures originally entitled "Basic Questions of Metaphysics" that were given at the University of Freiburg in the winter semester of 1935–6), for example, Heidegger asks about the "inner structure" of the "building" that is metaphysics by looking at Kant's "exhibition of the inner construction of pure reason" that "draws and sketches" reason's "outline" and whose "essential moment" is the "architectonic, the blueprint projected as the essential structure of pure reason."[6] Heidegger has appropriated all of this architectural rhetoric directly from Kant as part of a general strategy of appropriation that is

[6]Martin Heidegger, *What Is a Thing?* trans. W. B. Barton and Vera Deutsch (Chicago: Henry Regnery Company, 1967), pp. 118–21.

itself described in architectural terms. The strategy is to occupy the philosophical structure with which Kant defines the structure of reason, identifying the limits of both these interrelated structures by inhabiting those very limits:

> In our interpretation we shall not try to examine and paraphrase the structure of the work from the outside. Rather, we shall place ourselves within the structure itself in order to discover something of its framework and to gain the standpoint for viewing the whole.[7]

This strategy of occupation derives closely from the "phenomenological reduction" of Edmund Husserl. It was already formulated in Heidegger's first lectures as Husserl's assistant in 1920 and was recorded in letters to his students as a matter of "destruction" (*Destruktion*) or "critical unbuilding" (*kritischer Abbau*) – the latter term being sometimes translated as "critical dismantling," or even, more recently, in a kind of reverse projection, as "de-construction." The concept was formally introduced in the celebrated *Being and Time* of 1927, but was then more fully elaborated in the lecture course at the University of Marburg in the summer of the same year that was intended to be published as its sequel:

> All philosophical discussion, even the most radical attempt to begin all over again, is pervaded by traditional concepts and thus by traditional horizons and traditional angles of approach, which we cannot assume with unquestionable certainty to have arisen originally and genuinely from the domain of being and the constitution of being they claim to comprehend. It is for this reason that there necessarily belongs to the conceptual interpretation of being and its structures, that is, to the reductive construction of being, a *destruction* – a critical process in which the traditional concepts, which at first must necessarily be employed, are deconstructed [*kritischer Abbau*] down to the sources from which they were drawn. . . . Construction in philosophy is necessarily destruction, that is to say, a deconstructing of traditional concepts carried out in a historical recursion to the tradition. And this is not a negation of the tradition or a condemnation of it as worthless; quite the reverse, it signifies precisely a positive appropriation of tradition.[8]

Authentic construction involves taking apart unauthentic constructions from within. It is not that the "un-building" of the old tradition is followed by a new construction. Rather, "destruction belongs to construction."[9] The tradition contains within itself the traces of the originary construction that it has forgotten, traces that can be gradually teased out. Philosophy is therefore no more than the writing of the history of philosophy, one that must be continuously rewritten. An originary construction is not something that simply lies behind the false structures of the tradition and can be revealed by demolishing them. Rather, it is built into those structures and can be addressed only by reappropriating the tradition in its own terms, taking them to their "limits."[10]

[7]Ibid., p. 123.
[8]Martin Heidegger, *The Basic Problems of Phenomenology*, trans. Albert Hofstadter (Bloomington: Indiana University Press, 1982), p. 22.
[9]Ibid.
[10]"But this destruction is just as far from having the *negative* sense of shaking off the ontological tradition. We must, on the contrary, stake out the positive possibilities of that tradition, and this always means keeping it within its *limits*. . . ." Martin Heidegger, *Being and Time*, trans. John Macquarrie and Edward Robinson (New York: Harper & Row, 1962), p. 44.

Just as Heidegger displaces philosophy's sense of itself as a construction standing on a stable ground in favor of philosophy as a constructing-through-unbuilding, he also displaces the sense of the structure of that which philosophy describes. While following the tradition's understanding of Being as a certain kind of "standing," it is no longer a standing on a stable ground (*Grund*), but is a standing based on a loss of ground, a construction built upon an "abyss" (*Abgrund*). The abyss, the rupturing of the fundamental ground of things, becomes their very condition of possibility.

These closely interrelated displacements of the institutionalized, and therefore familiar, sense of construction organize Derrida's texts long before architecture becomes a discrete subject within them. Heidegger's rethinking of building is everywhere operative in Derrida's work, which significantly began with an extended reading of Husserl. The term "deconstruction" itself derives directly from Heidegger's *Destruktion* and *Abbau*. In Derrida's own words, it is literally a "translation" of those terms. Furthermore, what is being translated is explicitly understood to be architectural. It involves "an operation bearing on the structure or traditional architecture of the fundamental concepts of ontology or of western metaphysics."[1] Deconstruction is likewise understood as an affirmative appropriation of structures that identifies structural flaws, cracks in the construction that have been systematically disguised, not in order to collapse those structures but, on the contrary, to demonstrate the extent to which the structures depend on both these flaws and the way that they are disguised. That is, it identifies the structural role of what traditional philosophy would identify as structural flaws and, in so doing, displaces rather than dismantles that philosophy. Following Heidegger, Derrida's texts repeatedly locate the abysses on which the structures they interrogate depend in order to call into question the dominant tradition of thinking that is organized by a certain image of building.

The displacement of that image, which is to say the displacement of a particular sense of structure that not only is embedded within heterogeneous cultural institutions but also organizes our sense of what an institution is, cannot be as easily detached from the question of architecture as it might first appear. This all-too-obvious, all-too-literal link cannot be discarded in the interests of a more nuanced reading of deconstruction without effacing a critical dimension of Derrida's work. I would argue that it is precisely within this very literal association, within its very literalness, the literalness of an architectural metaphor, that Derrida's writing is mobilized. At the very least, the strategic role of what seems to be but an incidental metaphor would be one of the central issues in any engagement between architecture and deconstruction, especially since Heidegger developed his rethinking of structure into a more explicit thinking of architecture, a development that plays an important but unacknowledged role in Derrida's texts.

[1]Jacques Derrida, "Letter to a Japanese Friend," trans. David Wood and Andrew Benjamin, in *Derrida and Différance,* ed. David Wood and Robert Bernasconi (Coventry: Parousia Press, 1985), pp. 1–5, 1.

Heidegger's "late" work develops his early motif of the edifice – the grounded structure – into that of the house. As his writing becomes increasingly committed to the question of language, the traditional architectonic structure of language discussed in the early work becomes a "house." Language as grounding becomes language as "dwelling" (*wohnen*). The figure of "standing" becomes that of "enclosing." The structural system binding signifiers to the ground becomes an enclosure. In the famous formulation of the 1947 "Letter on Humanism," "Language is the house of Being. In its home man dwells."[12] This focus on the house is often identified with Heidegger's so-called turn. In turning, he turns to the house. This is not so much a turn from the edifice of the early work toward the house. Rather, the edifice is turned into a house; building is now understood as housing.

In this way, Heidegger develops a whole architectural rhetoric out of the traditional architectural metaphor with which philosophy institutes itself. Philosophy becomes no more than thinking about housing, or, more precisely, the institutions of philosophy are to be displaced by a thinking that houses. This displacement is first and foremost a rejection of philosophy's construction of space. Beginning with the central argument of *Being and Time,* Heidegger's texts present an extended critique of the conception of space that has been progressively institutionalized since ancient Greece, a conception that is, for him, the institution of space itself. The moment that philosophy's central architectural metaphor becomes explicit as such – with Descartes – is also the moment its ancient basis in a certain account of space becomes explicit. To deconstruct this tradition, Heidegger employs a spatial rhetoric – "house," "enclosure," "shelter," "abode," "lodging," "inner," "proximity," "neighborhood" – but asks us not to hear it spatially. The familiar sense of architecture as the definition of space is invoked and then displaced, highlighted and then withdrawn. What we unproblematically take to be the space of the house (as the paradigm of space itself) is seen to both emerge from and veil a prior and more fundamental condition from which we have become alienated. But what distinguishes Heidegger's arguments from so many other similar-sounding critiques of modern life is that the process of alienation is understood to be an ancient one that is becoming manifest only with modernity, and furthermore, the basic condition from which it alienates us is itself one of profound alienation. The alienating space of the home veils a more fundamental and primordial homelessness. To be at home in such a space is precisely to be homeless.

In order to dismantle the tradition of metaphysics, Heidegger has to dismantle our most familiar experiences of architecture, which are but the products of the tradition of metaphysics and are therefore complicitous with the necessarily violent regime of technology that is its con-

[12]Martin Heidegger, "Letter on Humanism," trans. David Farrell Krell, in *Basic Writings* (New York: Harper & Row, 1977), pp. 193–242, 193.

temporary manifestation. He employs an architectural rhetoric in a way that dispels, among other things, the apparent innocence of architectural space. But this gesture, which has so much to say about architecture (and a certain dimension of it has been influential in architectural discourse), is susceptible to its own criticism in a way that opens further possibilities for that discourse. Indeed, it is precisely the dimension that has already been so eagerly appropriated by the discourse that is the focus of this criticism. In the end, Heidegger's architectural rhetoric sustains the very tradition it is deployed to displace.

Heidegger's work is almost always double-sided. It repeatedly performs a rigorous dismantling of some aspect of the tradition of philosophy, only later to revive that very aspect in a displaced form that consolidates whatever had been destabilized. The risk built into Heidegger's original argument that construction depends upon, and is no more than, an ongoing destruction from within ultimately, and perhaps necessarily, turns on his own writing, his critical unbuilding becoming constructive of the very system it places in question. As Derrida argues, when reading *Being and Time,* "At a certain point, the destruction of metaphysics remains within metaphysics, only making explicit its principles."[13] All of his many readings of Heidegger's texts locate this point by applying those texts' own strategies to themselves. Consequently, his relationship to Heidegger is, at the very least, "enigmatic," as he once put it.[14] He thinks through Heidegger in detail in order to depart from him, taking each text to the limit, elaborating each of its arguments further, but not simply as "an extension or a *continuous* radicalization," as he points out elsewhere.[15] He departs from Heidegger by following him in a maneuver that is far from straightforward. Heidegger's writing is seen both to exemplify the often subtle and elusive operations of the hegemonic tradition that needs to be unbuilt and to provide the strategies for doing just that.

I do maintain . . . that Heidegger's text is extremely important to me. . . . That being said . . . I have marked quite explicitly, in *all* the essays I have published, as can be verified, a *departure* from the Heideggerian problematic. . . . I sometimes have the feeling that the Heideggerian problematic is the most "profound" and "powerful" defence of what I attempt to put into question under the rubric of the *thought of presence.*[16]

Derrida is at once closer to and further away from Heidegger than is usually acknowledged. The "departure" is never simple or complete. His writing never simply moves beyond or outside Heidegger's discourse. Rather, it interrogates that discourse from within, locating and exploiting certain openings in it.

[13]Jacques Derrida, "*Ousia* and *Grammē:* Note on a Note from *Being and Time,*" trans. Alan Bass, in Jacques Derrida, *Margins of Philosophy* (Chicago: University of Chicago Press, 1982), pp. 29–68, 48.
[14]Jacques Derrida, "Deconstruction and the Other," in *Dialogues With Contemporary Continental Thinkers,* ed. Richard Kearney (Manchester: Manchester University Press, 1984), pp. 105–26, 109.
[15]Jacques Derrida, "The *Retrait* of Metaphor," *Enclitic* 2, no. 2(1978):5–34, 12.
[16]Jacques Derrida, "Positions," interview with Jean-Louis Houdebine and Guy Scarpetta, trans. Alan Bass, in Jacques Derrida, *Positions* (Chicago: University of Chicago Press, 1981), pp. 37–96, 54.

Architecture plays an important role in this interrogation. One of the key symptoms of Heidegger's allegiance to the very tradition he appears to displace – which Derrida identifies and which is equally, and necessarily, a point of departure for Derrida's own work, an opening for a radical displacement of that tradition – is the figure of the house. When reading the "Letter on Humanism," Derrida argues that it is by employing the chain of metaphors that surround the house that Heidegger "remains within" metaphysics:

Whence, in Heidegger's discourse, the dominance of an entire metaphorics of proximity, of simple and immediate presence, a metaphorics associating the proximity of Being with the values of neighboring, shelter, house, service, guard, voice, and listening. As goes without saying this is not an insignificant rhetoric; . . . the choice of one or another group of metaphors is necessarily significant. It is within a metaphorical insistence, then, that the interpretation of the meaning of Being is produced.[17]

By making the house thematic, Heidegger identifies the figure that organizes the tradition he attempts to dismantle, but in the end, he fails to dismantle the house. On the contrary, he repeatedly advocates a return to it, a withdrawal to the primal shelter, the site of unmediated presence, in order to take refuge from the modern, which is to say technological, age of representation that is condemned inasmuch as it produces a generalized "homelessness." He inhabits metaphysics in a way that does not threaten the authority of the house, succumbing to the risk implicit in his strategy of destruction, the same risk that faces the contemporary appropriations of that strategy by deconstructive discourse that Derrida pointedly describes in terms of the house:

To attempt an exit and a deconstruction without changing terrain, by repeating what is implicit in the founding concepts and the original problematic, by using against the edifice the instruments or stones available in the house, that is, equally, in language. Here, one risks ceaselessly confirming, consolidating, *relifting* [*relever*], at an always more certain depth, that which one allegedly deconstructs. The continuous process of making explicit, moving toward an opening, risks sinking into the autism of the closure.[18]

Secure housing is the greatest risk of deconstructive discourse. It is always possible to rearrange the stones of the house without, in the end, disturbing its capacity to house. Derrida's prolonged elaboration of Heidegger's displacement of the architecture of the edifice, problematizing the cumulative logic of building (ground-foundation-structure-ornament) that plays such a decisive role in organizing discourse in our culture, must therefore also be, in some way, a displacement of the architecture of the house.

But deconstructive discourse cannot simply reject Heidegger's use of the traditional figure of the house, or even its "dominance" in his work, because Heidegger's first argument, picked up so insistently by Derrida, is that it is necessary to inhabit metaphysics in precisely this way, exploiting all its resources, especially its central metaphorical figures, in order to overcome it. Such metaphors cannot simply be abandoned. Rather, they have to be affirmed, elaborated, and redeployed in order

[17]Jacques Derrida, "The Ends of Man," trans. Alan Bass, in *Margins of Philosophy,* pp. 109–36, 130.
[18]Ibid., p. 135.

to identify exactly what their use both constructs and covers over. Hei-degger's writing never simply upholds the tradition it occupies. Rather, it is "at once contained within it and transgresses it"[19] through an ever-shifting double movement. By occupying metaphysics, it establishes the strategic roles of the metaphors that organize it. Heidegger's appropria-tion of the house from the tradition is a key example of this. But in occupying that house, he has to transgress it in order to disrupt the tradition, appropriating it in a way that recovers that which even this forgotten image forgets, identifying the image's own transgressive po-tential. Heidegger does not, at first reading, appear to do this, despite his explicit rejection of the modern sense of the house as a spatial in-terior, a space that is itself understood as an alienating technology of control that operates as an agent of metaphysics. The house appears to be simply consolidated rather than deconstructed.

Such a deconstruction would be uniquely complicated, because the motif of the house, like that of the edifice, is not simply another met-aphor (if metaphors are ever simple), but is that which determines the condition of metaphor in the first place. Metaphor is supposedly defined by its detachment from a "proper" meaning. In "White Mythology," Derrida's most extended reading of the question of metaphor that is always at stake in his work, this sense of the proper is seen to be bound to that of the house. The essay points to "the economic value of the domicile and of the proper both of which often (or always) intervene in the definition of the metaphoric."[20] Throughout his writing, Derrida draws on the Greek association between the household (*oikos*) and the proper (*oikeios*). When speaking of Freud, for example, the house is described as "the familiar dwelling, the proper place."[21] And elsewhere Derrida notes that in Hegel, "the general form of philosophy, is properly familial and produces itself as *oikos:* home, habitation, . . . the guarding of the proper, of property, propriety, of one's own."[22] All of these read-ings follow a consistent trajectory from his point in "The Ends of Man" that it is precisely in Heidegger's writing that "the themes of the *house* and the *proper* are regularly brought together."[23] This point can be clab-orated by looking at the way Heidegger binds the metaphor of the house to language by linking it to his concept of "appropriation" (*Ereignis*). Building, understood as housing, is repeatedly described as appropria-tion.[24] Language is a house because it is a mode of appropriation whereby

[19]Jacques Derrida, *Of Grammatology,* trans. Gayatri Chakravorty Spivak (Baltimore: Johns Hopkins University Press, 1976), p. 22.
[20]Jacques Derrida, "White Mythology: Metaphor in the Text of Philosophy," trans. Alan Bass, in *Margins of Philosophy,* pp. 207–71, 24; cf. "This hearth is the heart of all meta-phoricity." Jacques Derrida, "Plato's Pharmacy," trans. Barbara Johnson, in Jacques Der-rida, *Dissemination* (Chicago: University of Chicago Press, 1981), pp. 61–172, 88.
[21]Jacques Derrida, "Le Facteur de la vérité," trans. Alan Bass, in Jacques Derrida *The Post Card: From Socrates to Freud and Beyond* (Chicago: University of Chicago Press, 1987), pp. 411–496, 441.
[22]Jacques Derrida, *Glas,* trans. John P. Leavey, Jr., and Richard Rand (Lincoln: University of Nebraska Press, 1986), p. 134.
[23]Derrida, "The Ends of Man," p. 129.
[24]To cite but one of the multiple examples of this association: "Language is the house of Being because language, as Saying, is the mode of Appropriation." Martin Heidegger, "The Way to Language," trans. Peter D. Hertz, in Martin Heidegger, *On the Way to Language* (New York: Harper & Row, 1971), pp. 111–36, 135.

thought recovers presence in the face of alienating representations, rather than a form of representation. It is a house because it appropriates, making proper by excluding representation and establishing a "proximity" to presence.

In these terms, the house is the metaphor of that which precedes metaphor. It determines the condition of the proper, from which the metaphorical is then said to be detached and inferior. As the traditional figure of an interior divided from an exterior, it is used to establish a general opposition between an inner world of presence and an outer world of representation that is then used to exclude that very figure as a "mere" metaphor, a representation to be discarded to the outside of philosophy. But the figure always resists such an exclusion. Inasmuch as the condition of metaphor is established by the metaphor of the house, the house is not simply another metaphor that can be discarded. And, more than this, although metaphor is understood as a departure from the house, it is still not a departure from housing. Rather, it is the temporary occupation of another house, a borrowed house. Metaphor is an improper occupation, a being at a home without being at home. Consequently, the figure of the house is neither metaphorical nor proper. It is, as Derrida argues in "The *Retrait* of Metaphor," "not only metaphoric to say that we inhabit metaphor . . . it is not simply metaphoric. Nor anymore proper, literal or usual."[25] As the figure of the house is what makes the distinction between metaphor and proper possible, it is not, according to "White Mythology,"

one metaphor among others; it is there in order to signify metaphor *itself;* it is a metaphor of metaphor; an expropriation, a being-outside-one's-own-residence, but still in a dwelling, outside its own residence but still in a residence in which one comes back to oneself, recognizes oneself, reassembles oneself or resembles oneself, outside oneself in oneself. This is the philosophical metaphor as a detour within (or in sight of) appropriation, parousia, the self-trajectory from the Platonic *eidos* to the Hegelian Idea.[26]

What Derrida, echoing Heidegger, refers to so often as "the metaphysics of presence" is sustained by the figure of the house in the same way as it is sustained by the figure of the edifice. Since Plato, the house has always been that tradition's exemplar of presentation. The governing concept of "Idea" as presence, and of the visible world as informed matter, the material presentation of immaterial ideas, is traditionally established with the metaphor of the house produced by an architect, the house as the presentation of an "idea," as can be seen in Marsilio Ficino's commentary on Plato:

If someone asks in what way the form of the body may be similar to the form and reason of the spirit and the Angel, I ask this person to consider the edifice of the Architect. From the beginning the Architect conceives in his spirit and approximately the Idea of the edifice; he then makes the house (according to his ability) in the way in which he has decided in his mind. Who will deny that the house is a body, and that it is very similar to the incorporeal Idea of the artisan,

[25]Derrida, "The *Retrait* of Metaphor," p. 7.
[26]Derrida, "White Mythology," p. 253.

in whose image it has been made? It must certainly be judged for a certain incorporeal order rather than for its matter.[27]

It is only possible to point abruptly to this canonic form of the metaphor here in lieu of tracing its long history in detail by following the curious trajectories and slippages between terms like "maker," "builder," "architect," "demiurge," *techne,* and so on. Such a detailed reading would show the way in which architecture, and, in particular, the house, is not simply the paradigm of the operations of the idea. Rather, the idea is itself understood as a paradigm, literally, for Plato, a *paradeigma,* or architectural model. This particular image plays an important role in the traditional analogy between the philosopher and the architect that has been exploited by both discourses.

Philosophy does not depart from itself to illustrate its concepts with the figure of the house. On the contrary, it forever circulates around the house, departing from it only in order to stage a return to it. This can be seen when, in defining the essence of technology, Heidegger notes that the original sense of *techne,* from which philosophy has departed, is "to be entirely at home [*zu Hause*] in something."[28] But to define essence, he uses the example of the "essence of a house [*Haus*]" and then draws on Plato's theory of "Ideas" to describe the house's condition. To determine the essence of *techne* as housing, he determines the sense of essence by reference to the house. The house is not simply an example of essence. It does not simply illustrate presence or essence. Rather, it is used to define them. Neither can be thought outside the house.

In such involuted circulations between concepts and the image of a house, which regularly punctuate the tradition of philosophy, the sense of the house as an interior never goes away, even in Heidegger's texts, despite their insistent attempt to discard it. The house is always first understood as the most primitive drawing of a line that produces an inside opposed to an outside, a line that acts as a mechanism of domestication. It is as the paradigm of interiority that the house is indispensable to philosophy, establishing the distinction between the interiority of presence and the exteriority of representation on which the discourse depends.

In all the binary pairs of terms with which metaphysics organizes itself, as Derrida argues when reading Plato, "each of the terms must be simply *external* to the other, which means that one of these oppositions (the opposition between inside and outside) must already be credited as the matrix of all possible opposition."[29] Consequently, the philosophical system is organized by spatial metaphors it cannot abandon. It is itself necessarily spatial. When noting the way in which Freud's theoretical system both invokes and discredits spatial metaphors, Derrida claims that "a certain spatiality, inseparable from the very idea of system, is irreducible."[30] This argument is even more explicit in his early reading of the

[27]Marsilio Ficino, "Commentary on the Symposium," chapter 5, cited in Erwin Panofsky, *Idea: A Concept in Art Theory* (New York: Harper & Row, 1968), p. 137.
[28]Martin Heidegger, "The Question Concerning Technology," trans. David Farrell Krell, in *Basic Writings,* pp. 283–317, 294.
[29]Derrida, "Plato's Pharmacy," p. 103.
[30]Jacques Derrida, "Freud and the Scene of Writing," trans. Alan Bass, in *Writing and Difference* (Chicago: University of Chicago Press, 1978), pp. 196–231, 215.

way Emmanuel Levinas identifies being as an "exteriority" only to argue that it is not spatial. Insisting on "the necessity of lodging oneself within traditional conceptuality in order to destroy it," Derrida argues that "one would attempt in vain, in order to wean language from exteriority and interiority . . . for one would never come across a language without the rupture of space."[31] Space is the very possibility of language and the tradition of thinking that believes it can transcend space and employ language as merely a temporary and necessarily inadequate vehicle for its pure (which is to say, aspatial) thought. Consequently, one must "inhabit" the spatial metaphor that is "congenital" to philosophy in order to question it:

[I]t is necessary still to inhabit the [spatial] metaphor in ruins, to dress oneself in tradition's shreds and the devil's patches – all this means, perhaps, that there is no philosophical logos which must not *first* let itself be expatriated into the structure Inside–Outside. This deportation from its own site toward the Site, toward spatial locality is the *metaphor* congenital to the philosophical logos. Before being a rhetorical procedure within language, metaphor would be the emergence of language itself. And philosophy is only this language. . . .[32]

Here Derrida is clearly following Heidegger's claim in *Being and Time* that spatial significations (*Raumbedeutungen*) are irreducible in language.[33] In a later reading of Heidegger, Derrida draws on this argument, briefly elaborating it by simply restating it but in a way that identifies a spatiality within the philosophical tradition in its very attempt to exclude spatiality: "The phenomenon of so-called spatializing metaphors is not at all accidental, nor within the reach of the rhetorical concept of 'metaphor.' It is not some exterior fatality."[34] The concept of metaphor cannot be thought outside that of exterior. Space cannot simply be excluded as any act of exclusion constructs a space by dividing an inside from an outside.

To this we can add that this spatiality turns around the figure of the house. The spatial metaphor that must be "inhabited" is actually the metaphor of inhabitation itself. The house is constitutionally bound into the metaphysical tradition and cannot simply be subordinated as a metaphor. It can never be exterior to philosophy, as it produces the very sense of interior on which that tradition is based. The edifice of metaphysics is necessarily a house. Within every explicit appeal to the necessity of stable construction is an implicit appeal to the necessity of a secure house. The philosophical economy is always a domestic economy,

[31]Jacques Derrida, "Violence and Metaphysics: An Essay on the Thought of Emmanuel Levinas," trans. Alan Bass, in *Writing and Difference*, pp. 79–153, 113.
[32]Ibid., p. 112.
[33]"Is it an accident that proximally and for the most part significations are 'worldly,' sketched out beforehand by the significance of the world, that they are indeed often predominantly 'spatial.' " Martin Heidegger, *Being and Time*, p. 209. "Both Dasein's interpretation of itself and the whole stock of significations which belong to language in general are dominated through and through by 'spatial representations.' " Ibid., p. 421. Derrida also refers to this argument when he says that "language can determine things only by spatializing them." Jacques Derrida, "Force and Signification," trans. Alan Bass, in *Writing and Difference*, pp. 3–30, 16.
[34]Jacques Derrida, "Geschlecht: Sexual Difference, Ontological Difference," *Research in Phenomenology* 13(1983):65–84, 78.

the economy of the domestic, the family house, the familiar enclosure. Deconstructive discourse must therefore be first and foremost an occupation of the idea of the house that displaces it from within.

THE DOMESTICATION OF
THE HOUSE

TAKING SHELTER IN THE UNCANNY

A rhetoric of the house can be found throughout Derrida's texts without its ever being their ostensible subject. It is a kind of subtext that surfaces in radically different contexts and usually in small and scattered fragments. A sense of this house and its strategic role can be built up by assembling some of these fragments here.

In Derrida's work, all of the associations with the traditional figure of an edifice on secure foundations slide into that of the secure domestic enclosure. If to ground a structure is to build a house, to constrain the unruly play of representations is to house them, to domesticate them. Just as Derrida's sporadic but multiple references to the edifice identify speech as structural and writing as superstructural, his references to the house identify speech as inside the house, whereas writing is outside. In his account of Plato, for example, the *logos* "does not wander, stays at home," whereas writing is "unattached to any house,"[35] such that "in nothing does writing reside."[36] To sustain the tradition that privileges presence by rejecting the "other" is therefore, as he puts it in another essay, "to take shelter in the most familial of dwellings."[37] And in another context, the *"law of the house,* the initial organization of a dwelling space," represses play when difference is "enclosed."[38] Elsewhere, the economy of metaphysics literally attempts to "arrest, domesticate, tame"[39] the other. In these terms, all his work " 'analyzes' philosophical power in its domestic regime,"[40] as he once said about his earliest readings of Husserl. This domestic regime is both the space that philosophy claims for itself and the arguments made within that space. In appropriating the space as its own and delimiting its territory, it is defining its law, defining it precisely as a law of domesticity, philosophical law as the law of enforced domesticity. The space of philosophy is not just a domestic space; it is a space in which a certain idea about the domestic is sustained and protected.

The house's ability to domesticate is its capacity to define inside and outside, but not simply because that which is located inside is domesticated. For Derrida, the "outside" of a house continues to be organized by the logic of the house and so actually remains inside it. By being placed outside, the other is placed, domesticated, kept inside. To be excluded is to be subjected to a certain domestic violence that is both

[35]Derrida, "Plato's Pharmacy," p. 144.
[36]Ibid., p. 124.
[37]Jacques Derrida, "Tympan," trans. Alan Bass, in *Margins of Philosophy,* pp. ix–xxix, xvii.
[38]Jacques Derrida, "La Parole Soufflée," trans. Alan Bass, in *Writing and Difference,* pp. 169–95, 192.
[39]Derrida, *Of Grammatology,* p. 157.
[40]Jacques Derrida, "Entre crochets: entretien avec Jacques Derrida, première partie," *Digraphe* 8(1976):97–114; my translation.

215

MARK WIGLEY

organized and veiled by metaphysics.[41] Metaphysics is no more than a determination of place, the production of the sense of a pure interior divided from an improper exterior, a privileged realm of presence uncorrupted by representation. Whatever disrupts metaphysics disrupts this sense of interior. Derrida's work is concerned with that which "threatens the paternal *logos*. And which by the same token threatens the domestic, hierarchical interior."[42] His texts everywhere, albeit obliquely, question the sense of the house ultimately reinforced by Heidegger.

But, significantly, Derrida's "departure" from Heidegger is not a departure from the house. The interior space of presence is not simply abandoned for that of representation, nor is the realm of representation simply seen to occupy the interior. Rather, the economy of representation is seen to structure the interior as such. The sense of interior is actually an effect of representation. It is produced by what it supposedly excludes. Derrida departs from Heidegger by tacitly locating a violation within the structure of the house that is repressed by a systematic domestic violence that is itself in turn concealed by the apparent structure of the house. The constitutional violation of the edifice by the abyss that Heidegger demonstrated to be necessary for that structure to stand is equally the constitutional violation of the house that makes its capacity to house possible. The fracturing of the ground is equally, in Derrida's hands, a fracturing of the walls. The house of metaphysics is deconstructed by locating the "traces of an alterity which refuses to be totally domesticated"[43] and yet cannot be excluded, that which resists metaphysics because it cannot be placed either inside or outside and is therefore "undecidable," and yet is indispensable to the operations of metaphysics.

In a footnote in "The Double Session," Derrida identifies its account of undecidability as a "rereading" of Freud's essay "The Uncanny" (*Das Unheimliche*), which, as is well known, describes the uneasy sense of the unfamiliar within the familiar, the unhomely within the home. Freud pays attention to the way the term for homely (*heimlich*) is defined both as "belonging to the house, not strange, familiar, tame, intimate, friendly, etc." and as what seems at first to be its opposite: "concealed, kept from sight, so that others do not get to know of or about it, withheld from others."[44] In this structural slippage from *heimlich* to *unheimlich,* that which supposedly lies outside the familiar comfort of the home turns out to be inhabiting it all along, surfacing only in a return of the repressed as a foreign element that strangely seems to belong in the very domain that renders it foreign. Derrida's footnote goes on to say that "we find ourselves constantly being brought back to that text."[45] But despite, or perhaps because of, the unique attraction of this text, or, more

[41]"This philosophical, dialectical mastery . . . is constantly put into question by a family scene that constitutes and undermines at once the passage between the pharmacy and the house. 'Platonism' is both the general *rehearsal* of this family scene and the most powerful effort to master it, to prevent anyone's ever hearing of it, to conceal it by drawing the curtains over the dawning of the West." Derrida, "Plato's Pharmacy," p. 167.
[42]Ibid., p. 167.
[43]Derrida, "Deconstruction and the Other," p. 117.
[44]Sigmund Freud, "The Uncanny," *The Standard Edition*, vol. 17:217–56, 222.
[45]Jacques Derrida, "Double Session," trans. Barbara Johnson, in *Dissemination*, pp. 173–285, 220.

likely, its subject, it is never explicitly analyzed in the essay other than as a brief point in another footnote. Nor is it read in depth anywhere else in Derrida's writings. Like the figure of the house to which it is bound, it is a theme that can be traced throughout Derrida's work without ever becoming a discrete subject within it, as if it is itself repressed, returning only occasionally to surface in very isolated and what seem, at first, to be minor points. But precisely for this reason it can be argued that its effects actually pervade all the texts that are unable or unwilling to speak about it.

Derrida repeatedly – one might almost say compulsively – identifies the undecidables that uncannily intimate the violence within the familiar domain, which is to say, the domain of the family, the homestead, the house. Being, as he puts it, "domestic but utterly foreign,"[46] the uncanny exposes the covert operations of the house. For this reason its constitutional violation of the ostensible order of the house is itself repressed, domesticated by the very domestic violence it makes possible. Metaphysics is no more than the disguising of this domestic violence, which in turn represses the fundamental strangeness of the house. The house of metaphysics represses the violation that made it possible. More than a domestic violence, this is the violence of the domestic itself. Derrida locates within the house that which is actually, as *Of Grammatology* puts it, the "sickness of the homeland, a homesickness."[47] Heidegger's sickness for the home is displaced by Derrida's sickness of the home.

As their shared insistence on the necessity of a strategic inhabitation of the tradition would lead us to expect, this revision of the status of the house still closely follows Heidegger. Indeed, it goes even further into his work. Long before Heidegger explicitly raised the question of the house, his *Being and Time* had argued that the familiar everyday world is precisely a "fleeing in the face of uncanniness" that "suppresses everything unfamiliar."[48] The concept had already been introduced in his 1925 lectures at Marburg in terms of the feeling of dread when "one no longer feels at home in his most familiar environment."[49] Through the systematic concealment of the uncanny in everyday life, the familiar is actually a mode of uncanniness.[50] Just as the alienation of modern life is not simply produced by the abyss underlying all structures, but by the cov-

[46]Jacques Derrida, "Living On / Border Lines," trans. James Hulbert, in *Deconstruction and Criticism*, ed. Harold Bloom et al. (London: Routledge & Kegan Paul, 1979), pp. 75–176, 121.

[47]Derrida, *Of Grammatology*, p. 313.

[48]Heidegger, *Being and Time*, p. 137.

[49]"Indeed, what threatens in this indefinite way is now quite near and can be so close that it is oppressive. It can be so near to be feared by way of a definite reference of the environing world in its meaningfulness. Dread can 'befall' us right in the midst of the most familiar environment. Oftentimes it does not even have to involve the phenomenon of darkness or of being alone which frequently accompanies dread. We then say: one feels *uncanny*. One no longer feels at home in his most familiar environment, the one closest to him; but this does not come about in such a way that a definite region in the hitherto known and familiar world breaks down in its orientation, nor such that one is not at home in the surroundings in which one now finds himself, but instead in other surroundings. On the contrary, in dread, being-in-the-world is totally transformed into a 'not at home' purely and simply." Martin Heidegger, *History of the Concept of Time: Prolegomena*, trans. Theodore Kisiel (Bloomingon: Indiana University Press, 1985), p. 289.

[50]"Uncanniness is the basic kind of Being-in-the-world, even though in an everyday way, it has been covered up." Heidegger, *Being and Time*, p. 322.

ering over of that abyss, it is equally produced by covering over the uncanniness behind and of the familiar.[51] The apparent innocence of the familiar is but a mask that alienates by masking a more fundamental alienation: "the obviousness and self-assurance of the average ways in which things have been interpreted are such that while the particular *Dasein* drifts towards an ever-increasing groundlessness as it floats, the uncanniness of this floating remains hidden from it under their protecting shelter."[52] The mask of the familiar is a primitive shelter, a house, or rather a pseudohouse, that veils a fundamental unfamiliarity. The uncanny is literally a "not-being-at-home," an alienation from the house experienced within it. With its discovery, "everyday familiarity collapses," and the "not-at-home" concealed by this familiarity "must be conceived as the more primordial phenomenon."[53] Heidegger attempts to interrogate the familiar in order to discover what he later describes as the "danger" concealed within it: "Such questions bring us into the realm of what is familiar, even most familiar. For thinking, this always remains the real danger zone, because the familiar carries an air of harmlessness and ease, which causes us to pass lightly over what really deserves to be questioned."[54] From the beginning, his work attempts to displace the familiar, or at least place it at risk, in a way that raises the question of the danger in and of the familiar house. This question would be tacitly raised but symptomatically never answered by his later work.

To comprehend Derrida's thinking of the house, we need to go even further into Heidegger's thinking about it. Instead of simply rejecting Heidegger's ultimately reactionary use of the figure, we have to locate the circuitous openings within his argument that can be used to displace it.

[51]Heidegger's 1942–3 lectures on Parmenides elaborate his specific use of the word "uncanny" in the most detail: "But where, on the contrary, Being comes into focus, there the extraordinary announces itself, the excessive that strays 'beyond' the ordinary, that which is not to be explained by explanations on the basis of beings. This is the uncanny, literally understood and not in the otherwise usual sense according to which it rather means the immense and what has never yet been. For the uncanny, correctly understood, is neither immense nor tiny, since it is not to be measured at all with the measure of a so-called 'standard.' The uncanny is also not what has never yet been present; it is what comes into presence always already and in advance prior to all 'uncanninesses.' . . . it surrounds, and insofar as it is everywhere surrounds, the present ordinary state of things and presents itself in everything ordinary, though without being the ordinary. The uncanny understood in this way is, with regard to what is ordinary or natural, not the exception but the 'most natural,' in the sense of 'nature' as thought by the Greeks, i.e., in the sense of φύσις. The uncanny is that out of which all that is ordinary emerges, that in which all that is ordinary is suspended without surmising it ever in the least, and that into which everything ordinary falls back. . . . For those who came later and for us, to whom the primordial Greek experience of Being is denied, the uncanny has to be the exception, in principle explainable, to the ordinary; we put the uncanny next to the ordinary, but, to be sure, only as the extraordinary. For us it is difficult to attain the fundamental Greek experience, whereby the ordinary itself, and only insofar as it is ordinary, is the uncanny. . . . We are divesting from the word any representation of the gigantic, the overpowering, the exaggerated, the weird. Of course the uncanny can also, in its excessiveness, hide behind such figures. But it itself in its essence is the inconspicuous, the simple, the insignificant, which nevertheless shines in all beings." Martin Heidegger, *Parmenides,* trans. André Schuwer and Richard Rojcewicz (Bloomington: Indiana University Press, 1992), p. 101.

[52]Martin Heidegger, *An Introduction to Metaphysics,* trans. Ralph Manheim (New Haven: Yale University Press, 1959), p. 214.

[53]Ibid., pp. 233–4.

[54]Martin Heidegger, *What Is Called Thinking?* trans. J. Glenn Gray (New York: Harper & Row, 1968), p. 154.

The symptomatic way in which Heidegger's questioning of the familiar through a questioning of home begins to slide into a questioning of the house can be seen when the 1935 essay "The Origin of the Work of Art" locates the uncanny danger within the very comfort of home:

We believe we are at home in the immediate circle of beings. That which is familiar, reliable, ordinary. Nevertheless, the clearing is pervaded by a constant concealment in the double form of refusal and dissembling. At bottom the ordinary is not ordinary; it is extraordinary, uncanny.[55]

This sense was developed in the same year by *An Introduction to Metaphysics,* which again argues at length that metaphysics is the mechanism of the concealment of the uncanny by the familiar, but does so in a way that redefines inhabitation. A reading of Sophocles' *Antigone* (itself described as a "poetic edifice") is used to affirm that "man" is the "uncanniest of all beings"[56] and to identify two sides of this uncanniness, each of which involves a certain violence. On the one hand, man is violent, violating both enclosure and structure ("he who breaks out and breaks up"[57]) and violently domesticating things with technology ("he who captures and subjugates"[58]) in defining a home. On the other hand, there is the "overpowering" violence of Being that the familiar space of the home attempts to cover over but that compels a certain panic and fear within it, and inevitably forces man out of it. The endless conflict between these two forms of violence is constitutional rather than simply a historical event. And it is not that one is an act of violence by a subject while the other is an act of violence against that subject. Rather, the conflict between them is the very possibility of the subject's existence, indeed, the existence of any thing as such. "Man" does not build a home in the same way that man does not build a language. Rather, man is built by the home. But, equally, it must be emphasized here, man is built by its destruction.

Heidegger is not speaking about literal houses, that is, spatial enclosures erected on particular sites. Significantly, he always describes the home as a kind of interior, but it is the very sense of spatial interior that masks the interiority he is describing. From his earliest texts, Heidegger always insists that the fundamental sense of the word "in" is not spatial in the sense of the occupation of a "spatial container (room, building)."[59]

[55]Martin Heidegger, "The Origin of the Work of Art," trans. Albert Hofstadter, in Heidegger, *Poetry, Language, Thought,* pp. 15–87, 54.
[56]Heidegger, *An Introduction to Metaphysics,* p. 152.
[58]Ibid.
[57]Ibid., p. 157.
[59]In the middle of Heidegger's lectures at the University of Marburg in 1925 he rejects the idea that to be "in" refers to a "spatial container (room, building)" and refers to an etymological study by Grimm (which compares the archaic German words meaning *domus,* or "house," that have the same form as the English word "inn") to argue that "in" primarily refers to "dwelling" rather than the occupation of space: " 'In' comes from *innan,* which means to dwell, *habitare; 'ann'* means: I am accustomed, I am familiar with, I take care of something – the Latin *colo* in the sense of *habito* and *diligo.* Dwelling is also taken here as taking care of something in intimate familiarity, being-involved with [*Sein-bei*]. . . . 'in' primarily does not signify anything spatial at all but means primarily *being familiar with.*" Heidegger, *History of the Concept of Time,* p. 158. He then employs this key argument in the same form at the beginning of *Being and Time* in a way that organizes the whole text that follows. Heidegger, *Being and Time,* p. 80.

Through the endless double movement of the "fundamental violence" (*Gewalt-tätigkeit*), man "cultivates and guards the familiar, only in order to break *out* of it and to let what overpowers it break *in*"[60] (my emphasis). Man both occupies the enclosing structure and "tears it open," but cannot master the overpowering and so is "tossed back and forth between structure and the structureless,"[61] between using the structure to violently master and violating it – both of which "fling him *out* of the home" (my emphasis), the "homeland," the "place," the "solid ground," and into the "placeless confusion" of the "groundless" "abyss" as a "homeless" "alien."

This is not just an argument using spatial metaphors to make a point that is not itself spatial. The text becomes an explicit argument about space. Its rejection of the sense that material building is an act of man, rather than its possibility, is developed into a rejection of the familiar sense that a building is produced in space, as distinct from producing space (*Raum*), or, more precisely, place (*Ort*). For Heidegger, this sense is seen to be sustained by the basic claim of metaphysics inaugurated by Plato that material objects stand in a preexisting space, offering surfaces to the eye of a subject who also occupies that space, an "outward appearance" that presents an immaterial idea. The degeneration of philosophy is seen to begin with its ancient account of space. Heidegger argues that the Greeks had no word for "space" and refers to Plato's *Timaeus* to demonstrate that the theory of ideas as models (*paradeigma*) is actually the original theory of space.[62] In speaking of ideas, Plato is seen to have invented space and thereby initiated the degeneration that is only reaching its most extreme and explicit form with modernity.

This argument was picked up in Heidegger's lectures on Nietzsche of the following year. At one point they closely follow a section of Plato's *Republic* that explains the doctrine of the ideas with examples of objects produced by a craftsman (*demiourgos*). Plato's tripartite distinction between the idea, the way the craftsman's object presents the idea, and its representation in a painting is exemplified for Heidegger in the way that "the amassed stone of the house" is a "presencing" that acts to "bring the *idea* into appearance" differently than its representation in a painting.[63] Against Nietzsche, Heidegger attempts to argue that for Plato this difference is, in the end, but one of degree. The house itself becomes an image, albeit a superior one because it is closer to truth. But Plato's text does not actually talk about the house. It refers to objects that, as

[60]Heidegger, *An Introduction to Metaphysics*, p. 163.
[61]Ibid., p. 161.
[62]"The Greeks had no word for 'space.' This is no accident; for they experienced the spatial on the basis not of extension but of place [*topos*]; they experienced it as *chōra*, which signifies neither place nor space but that which is occupied by what stands there. The place belongs to the thing itself. Each of the various things has its place. That which becomes is placed in this local 'space' and emerges from it. . . . the transformation of the barely apprehended essence of place [*topos*] and of *chōra* into a 'space' defined by extension was initiated by Platonic philosophy, i.e. in the interpretation of being as *idea*." Ibid., p. 66.
[63]Martin Heidegger, *Nietzsche, Vol. 1: The Will to Power as Art*, trans. David Farrell Krell (New York: Harper & Row, 1979), p. 180.

Heidegger notes, "we find commonly in use in many homes,"[64] namely, tables and bedframes, but not the home itself. And Heidegger does not just add this example. He begins and ends his reading with it, reframing and refocusing the original argument. Clearly, he cannot separate the question of metaphysics from the question of the house. His argument about the violence of home inevitably heads toward the house.

The violent construction of a home and exile from it that he describes are not simply historical events. They are built into the home as its very structure, in the same way that the abyss is the possibility of any edifice erected upon it. Like the loss of ground, this violence is "fundamental" but is covered over by the interdependent senses of secure structure and secure enclosure. The house is made possible by the very violence that it conceals. Heidegger's revision of the condition of building – such that structure rises rather than falls with the loss of ground – is also a revision of the condition of enclosure, as can be seen when he addresses the question of the house more directly in a later essay: "Language speaks. If we let ourselves fall into the abyss denoted by this sentence, we do not go tumbling into emptiness. We fall upward, to a height. Its loftiness opens up a depth. The two span a realm in which we would like to become at home, so as to find a residence, a dwelling place for the life of man."[65] It is the absence of the ground that makes a residence. Housing, like building, is abysmal.

Just as the edifice conceals itself in concealing the abyss, the house conceals itself in concealing the uncanny (the theme of the abyss being entangled with that of the uncanny throughout Heidegger's work). It is because the house conceals the unhomeliness that constitutes it that the "mere" occupation of a house, which is to say the acceptance of its representation of interior, can never be authentic dwelling. Those "residing" *in* the home – "the merely casual possession of domestic things and the inner life"[66] – are not *at* home. Home is precisely the place where the essence of home is most concealed.

Homecoming is therefore not simply the return to the space of the home, because it is within that space that the home most "withdraws" itself, "shuts away" its own essence. Within the spatial interior there is another kind of interior within which the essence of the home resides. The home is therefore "mysterious" to those who occupy it: "proximity to the source is a mystery."[67] To be at home is precisely to be at home with this irreducible mystery. Heidegger plays on the way the word for mystery – *Geheimnisvoll* – has the home's capacity to conceal, to make secret (*Geheim*), built into it. It is therefore the homeless who come nearest to the essence of home that can never simply be occupied. Just as it is only by falling into the abyss that a poet can determine the condition of the structure, it is only the poet's exile from the home that can establish its strange condition, the unfamiliarity of its apparently fa-

[64]Ibid., p. 173.
[65]Martin Heidegger, "Language," trans. Albert Hofstadter, in *Poetry, Language, Thought*, pp. 187–210, 191.
[66]Martin Heidegger, "Remembrance of the Poet," trans. Douglas Scott, in Martin Heidegger, *Existence and Being* (Washington, D.C.: Gateway, 1949), pp. 233–69, 267.
[67]Ibid., p. 259.

miliar enclosure: "In his exile from home, the home is first disclosed as such. But in one with it and only thus, the alien, the overpowering, is disclosed as such. Through the event of homelessness the whole of the essent is disclosed. In this disclosure unconcealment takes place. But this is nothing other than the happening of the unfamiliar."[68] In the end, it is only the alien who dwells.

In this way, the origin around which the tradition of philosophy organizes itself is not a "primitive" innocence: "A beginning, on the contrary, always contains the undisclosed abundance of the unfamiliar and extraordinary, which means that it also contains strife within the familiar and ordinary."[69] Which is to say that the origin itself becomes uncanny. It is already defined by an exchange between internal violation and external violence. The original sense of *logos* on which metaphysics is based necessarily participates in this violence. It is itself, for Heidegger, an "act of violence."[70]

This fundamental sense, however, has been lost. Metaphysics is institutionalized by repressing the originary violence, making familiar that which is actually a departure from the familiar, a departure from the original sense of the house. Metaphysics produces homelessness by repressing the originary homelessness "insofar as the home is dominated by the appearance of the ordinary, customary, and commonplace."[71] "Man" is detached from the house and the ground precisely by following philosophy in thinking of them as secure. The radical insecurity of the uncanny is concealed by the familiar sense that man speaks language rather than language speaking man, that man builds rather than building constructing man as such. Man occupies the familiar, which is "out of" his essence rather than being "at home in" it. Which is not to say that his essence lies elsewhere, in some other interior. On the contrary, it is the uncanniness that "resides" in the familiar that is his essence.

Heidegger's argument convolutes traditional thinking about space. Spaces are not simply built and occupied. It is only with metaphysics that a stable ground is seen rather than an abyss, a secure house rather than an exile from it. Because of the very familiarity of these images, their violence is concealed. And more than this, they become generic figures of the exclusion of violence. For Heidegger, the "supreme" act of violence is to conceal the originary violence behind the mask of the familiar.

It is this constitutional violence of the house that is the opening within Heidegger's discourse that could be exploited to displace the philosophical tradition from within. But whereas Heidegger explicitly identifies the violence of the figure of the edifice, associating violence with the uncanny and arguing that it is precisely because violence is built into the apparent innocence of building that violence is itself uncanny, he never directly identifies the violence of the house itself. He identifies the

[68]Heidegger, *An Introduction to Metaphysics,* p. 167. "In the familiar appearance the poet calls the alien." Martin Heidegger, ". . . Poetically Man Dwells . . .," trans. Albert Hofstadter, in Heidegger, *Poetry, Language, Thought,* pp. 211–29, 225.
[69]Heidegger, "The Origin of the Work of Art," p. 76.
[70]Heidegger, *An Introduction to Metaphysics,* p. 169.
[71]Ibid.

uncanniness of "housing," but not the uncanniness of the house. Like Freud, he seems to preserve the familiar status of the house while defining an unfamiliar scene within it. The house becomes the site of a violence of which it is innocent.

INTERIOR VIOLENCE

It is in these terms that we must reread Derrida's work before it explicitly addressed architecture as a subject, let alone engaged with specific architectural projects. The question to be asked of that writing becomes something like this: If Derrida locates the uncanny within the house by following Heidegger, who, in the end, restores the very space of the house he repeatedly undermines, what about the house itself in Derrida's work? But, of course, the question is still too hasty. Can we even speak of such a thing as "the house itself"? To expose houses to deconstruction, which is actually to expose ourselves to the deconstructive movements that are the very possibility of the house, would surely be to problematize the distinction between the literal house and the metaphorical house. To raise the question of the material house, and therefore of architectural spaces and practices in general, in Derrida's writing would not be to look for "houses" as such but to look for the problematization of such an idea.

Yet again, such a gesture can first be found in Derrida's reading of Heidegger. He appropriates that dimension of Heidegger that neither consolidates the traditional space of the house nor dismantles it, but is the side effect of an oscillation between these gestures. Heidegger's repeated attempts to detach the literal sense of the house from his argument have already radically transformed the house in a way that is covered over when he equally repeatedly slips and restores the literal figure. The literal sense is never simply abandoned in favor of the metaphorical. In "The Ends of Man," Derrida argues that the "Letter on Humanism" makes the house uncanny by locating it beyond or before that opposition. The house is no longer simply the site of the uncanny, the familiar space within which the unfamiliar resides. It is itself already uncanny.

Just as Heidegger had argued in 1935 that Kant's architectural rhetoric is no "mere 'ornament' "[72] of his philosophy, he argues in the "Letter on Humanism" that his own thinking about the house is not an independent ornament added to an otherwise self-sufficient philosophy in order to reveal its inner structure; the house is no "mere" image for philosophy. The relationship between the figure and the philosophy that appears to employ it is subtle and convoluted: "[it] is no adornment of a thinking. . . . The talk about the house of Being is no transfer of the image 'house' to Being. But one day we will, by thinking the essence of Being in a way appropriate to its matter, more readily be able to think what 'house' and 'to dwell' are."[73] This displaces the traditional status of architecture, radically subverting the tradition of philosophy that is de-

[72]Heidegger, *What Is a Thing?* p. 121.
[73]Heidegger, "Letter on Humanism," p. 236.

fined by its determination that the architectural images it employs are "merely" metaphorical, temporary supplements to the main body of the argument that will eventually, and necessarily, be abandoned. Philosophy's familiar image of presence – the house – becomes doubly unfamiliar when it is no longer seen as an innocent image of innocence, separable from the arguments it is attached to, but is a construction of those very arguments whose dependence on them is veiled in order that it can act as their guarantee, an independent witness to their truth, a testament to their very innocence.

In this way, that which is most familiar becomes unfamiliar. The house is no longer the paradigm of presence. It is first and foremost a representation (albeit of the absence of representation). It is not just that the house's status as an institutionally produced and sustained image is simply exposed, but that the familiar itself becomes an image. The ostensible realm of proximity, immediacy, nearness, and so on, becomes a realm of extreme detachment. To remove the metaphorical status of the house fundamentally displaces the tradition of metaphysics that maintains it as such. The whole economy turning around the house is disrupted. "Being," that which is, by definition, nearest, is no longer simply explained by the image of that which is nearest, the house. But, as Derrida points out, nor is the house to be simply explained by the study of Being. Both are made strange. The opposition between that which is known and that which is unknown, that which is near and that which is far, is radically disturbed. And the loss of the innocence of the house is somehow written into the structure of the philosophical tradition that constitutes itself by endlessly denying that loss.

"House of Being" would not operate, in this context, in the manner of a metaphor in the current, usual, that is to say, literal meaning [*sens*] of metaphor, if there is one. This current and cursive meaning . . . would transport a familiar predicate (and here nothing is more familiar, familial, known, domestic and economic, one would think, than the house) toward a less familiar, and more remote, *unheimlich* (uncanny) subject, which it would be a question of better appropriating for oneself, becoming familiar with, understanding, and which one would thus designate by the indirect detour of what is nearest – the house. Now what happens here *with* the quasi-metaphor of the house of Being, and what does *without* metaphor in its cursive direction, is that it is Being, which, from the very moment of its withdrawal, would let or promise to let the house or the habitat be thought. . . . One could be tempted to formalize this rhetorical inversion where, in the trope "house of Being," Being says more to us, or promises more about the house than the house about Being. But this would be to miss what is most strictly proper in what the Heideggerian text would say in this place. In the inversion considered, Being has not become the proper of this supposedly known familiar, nearby being, which one believed the house in the common metaphor. And if the house has become a bit *unheimlich,* this is not for having been replaced, in the role of "what is nearest," by "Being." We are therefore no longer dealing with a simple inversion permutating the places in a usual tropic structure.[74]

[74]Derrida, "The *Retrait* of Metaphor," p. 24.

It is this double displacement that organizes the figure of the house in Derrida's writing. The link between the house, law, economy, and family is an important theme throughout his work. The house is always invoked as the familiar abode, the abode of the family but equally the abode of the familiar. But whereas he repeatedly identifies the chain of house-economy-law-family with metaphysics, the family scene he reconstructs is not simply a metaphor of metaphysics, a familiar image that offers access to an unfamiliar conceptual structure. On the contrary, metaphysics is, if anything, a kind of metaphor of the family, the familiar means of access to the endlessly strange structure of the family. In this Heideggerian gesture, the very familiarity of the family is the product of metaphysics that is no more than the institution of domestication itself. It is the violence of the "household" of metaphysics that produces the family in producing the image of individual subjects independent from the house whose interior they occupy — that is, of subjects as that which can be housed, violently domesticated by a structure that can dissimulate that violence. Derrida's displacement of metaphysics' capacity to domesticate must also be a displacement of the figure of the house that is its paradigmatic mechanism of domestication. To displace metaphysics is already to displace domesticity. The house no longer simply houses. The paradigm of security becomes the site of the most radical insecurity — indeed, the very source of insecurity. Security becomes but the uncanny effect of the repression of insecurity.

Yet again it is important to note that this displacement of architecture in Derrida's work does not occur in explicitly architectural terms. To raise the question of the unfamiliarity of architecture, the strangeness of even its most routine definitions of space, the terms of the discourse must shift. It is not a question of simply applying the discourse to something seemingly outside it, like "material space," but of rethinking the space of discourse itself. That which seems most proper to material architectural practices, the articulation of space, is actually the product of multiple systems of representation that construct the very sense of a material world that can be shaped or read by discourses detached from it. Architecture is first and foremost the product of mechanisms of representation that seem to be independent of it and whose disguise produces this sense of independence on which its unique cultural role is based. These mechanisms are exemplified by the institution of philosophy but are also embedded within the multiple cultural practices of so-called everyday life.

The deconstruction of this institution, therefore, does not simply have architectural consequences. It must be architectural from the beginning, which is to say that as long as architecture is seen to remain outside, or even after, the "unbuilding" of philosophy, then that philosophy is actually being consolidated by what appears to deconstruct it. It is precisely when deconstructive discourse "turns to" architecture — by describing particular buildings or even by simply raising the question of buildings — that it runs the greatest risk of reestablishing the tradition of metaphysics that defines itself by keeping architecture in a certain place. The tradition's capacity to domesticate literally depends on the domestication

of architecture. In the end, the philosophical economy turns on the domestication of the idea of house. But, equally, deconstructive discourse is bound to run the risk of domesticating architecture, as any refusal, or even delay, to engage with buildings also reinforces their traditional status. Buildings can no more be isolated from deconstruction than particular houses can be isolated from Heidegger's writing and its politics. It is in terms of the risk of architecture, which is necessarily a political risk, that Derrida's engagement with architecture must be read.

It is important to note here that before it begins to speak of architecture, all of Derrida's writing is a rethinking of interiority and a displacement of "place." It will be necessary to discuss elsewhere at length the endless circling around the question of "place" in Derrida's texts.[75] But at least it can be noted here that this rethinking had already begun with his original appropriation of Heidegger, when "deconstruction" is itself understood as a certain way of inhabiting the tradition. When Heidegger says "we shall place ourselves within the structure itself,"[76] "keeping it [*destruction*] within its [the tradition's] *limits*,"[77] he has already given the edifice of philosophy an interior. In fact, it is already a house. In rethinking that space, both Heidegger and Derrida address the question of housing long before either uses the word "house." They already participate in the tradition organized around a certain image of housing inasmuch as they describe that tradition as something that can be occupied, something that has an interior and can be inhabited:

The movements of deconstruction do not destroy structures from the outside. They are not possible and effective, nor can they take accurate aim, except by inhabiting those structures. Inhabiting them *in a certain way,* because one always inhabits, and all the more when one does not suspect it. Operating necessarily from the inside, borrowing all the strategic and economic resources of subversion from the old structure, borrowing them structurally. . . .[78]

Deconstructive discourse, if it is anything, is no more than a rethinking of inhabitation. It never involves a simple departure from an enclosure. On the contrary, it goes further into the structure, running the risk of consolidating it in order to locate the cracks that both hold it up and produce the sense of interior in the first place. In so doing, it locates the subtle mechanisms of institutional violence, which is to say the violence that makes institutions possible but is concealed by them in a way that produces the effect of a space. There is no violence without institution, no institution without space, no space without violence. And more than this, violence is always domestic, but not because it goes on within an interior. Rather, it is the violence of the interior as such, a violence that is at once enacted and dissimulated by familiar representations of space, representations that are so familiar that they are not even understood to be representations. The question of deconstruction is therefore first and

[75]Wigley, *The Architecture of Deconstruction,* chapter 7.
[76]Heidegger, *What Is a Thing?* p. 123.
[77]Heidegger, *Being and Time,* p. 44.
[78]Derrida, *Of Grammatology,* p. 24.

foremost a question of the uncanniness of violence. To speak here of "deconstruction and architecture" is not to speak simply of an uncanny or violated architecture, but of the uncanniness of architecture as such, the violence of even, if not especially, the most banal of spaces, spaces that are violent in their very banality.

TABBLES OF BOWER

JENNIFER BLOOMER

[S]tyle is an indispensable adjunct to architectural knowledge, and . . . the cultivation of a sense of appropriate detail is immensely more significant than any pursuit of pure "proportion" or "form". . . . [O]nly certain approaches to form and detail answer to the demands of the aesthetic sense, and these approaches all lead away from prevailing fashions to some more settled "classical" style. – Roger Scruton, *The Aesthetics of Architecture*

A true understanding of the self led us to uphold, not only the primacy of aesthetic values, but also the objectivity which they implicitly claim. It became possible to arrive at a conception of critical reasoning, reasoning which is at once aesthetic and moral but which remains, for all that, free from the taint of moralism. We were drawn tentatively to conclude that some ways of building are right, and others (including many that are currently practised) wrong. – Roger Scruton, *The Aesthetics of Architecture*

To be probative is not to be trivial.

– Jeffrey Kipnis, conversation

PREFACE

To bring forth allegory as a construct for theory is to point to a deconstruction of theory itself, and particularly to a disacknowledgment of a separability of theory and practice. Theory and practice are suspended in the construction; theory is embedded, or disseminated, in the construction itself. Theory becomes a potentiality, a possible pattern, uncircumscribed by such concepts as foundation, rules, or validation. Theory

This essay is a condensed version of the 1990 Swanson Fund Lecture given at the Cranbrook Academy of Art in December 1990. A version of it appears in *Assemblage* 17(1992): 6–29.

 The text and the project it attends were made possible in large part by a fellowship granted in 1989–90 by the Chicago Institute for Architecture and Urbanism (CIAU). I would like to express special appreciation to John Whiteman, former director of the CIAU, for his support and criticism of this work. Under the terms of my fellowship I was given the benefit of an intern, Nina Hofer, currently of Pei, Cobb and Fried, Architects, and I remain in her debt for substantial and vital contributions to the project. Acknowledgments must also be made to Bob Heilman, Jimmie Harrison, and Mikesch Mücke for their considerable collaborative assistance; to the members of my graduate studio at the University of Florida – Wendy Landry, Julio LaRosa, Judy Birdsong, Dave Karpook, Mikesch Mücke, and Bob Heilman – for the camaraderie and joy and pain of tangential and supportive research; to Michael Peyton, wood-shop superintendent at the University of Florida, for good advice and criticism and for stretching the rules of the shop to allow us creative latitude; to Whitey Markle, metal-shop superintendent, for his disciplined toler-

is viewed not as foundation or relic, but as dynamic, tracing a fragmentary process of object-making. This essay and the project it attends are about such a tracing and are, as well, objects resulting from the process.

★ ★ ★

One of the times when it becomes abundantly clear what a peculiar construct time is, is during the so-called nine months in which one holds a tiny, developing project within one's own body. Toward the end, time, which yesterday flew, like a hurricane, full of the debris of everyday life, flows like the proverbial molasses in January. And this restructuring of time does not go without its concomitant reconfiguration of space. By this I mean something beyond the very present fact that one can no longer reach the triangle back there on the far side of the drafting table, or the normal, permanent press, and delicate buttons on the now far horizon of the clothes drier. It is more metaphysical than that; it is how the space takes on an anticipatory otherness. I tell you (many of you I do not need to tell, for you know well already), the furniture waits. Stark, empty, ticking. Waiting, waiting, waiting for "something that is about to happen."[1]

In the room where my husband and I slept and waited, there is a particularly compelling piece of furniture on each side of our bed. On his side (the right, nearest the door) there is a small bench, which, when it is not festooned with cast-off underwear and socks, is recognizable as the handicraft of Gustav Stickley: a simple, unornamented dark-stained oak frame with recessed pad cased in a rather overly sat upon, tanned and oiled hide of a cow. On my side (the left, nearest the gapingly empty, nagging space of the bassinet) there is an ancient wicker rocker. Festooned with the elaborate twisting and interlacing lines and swollen rolled edges of its own structure, and not recognizable as the work of any proper name, it is known simply as "Miss Eleanor's rocker." The fact of the matter is that both of these pieces belonged to Miss Eleanor in another place in time. Miss Eleanor, you see, was our child's great-grandmother's closest and dearest friend – in the Athens, Georgia, that existed before REM and the B-52s were even born, before their parents and even grandparents were born.

A photograph of Miss Eleanor. She is the very picture of turn-of-the-century southern femininity: young, demurely posed, eyes cast downward, dressed in white, layers of fabric so light it could float, and edged with gossamer lace that also encrusts her prettily held fan. Beneath the airiness and lightness of the fabric and facial expression, her body is deformed in the fashion of the time: confined in a posttensioned construction of bone, metal, and fabric, her chest is thrust upward and outward from a waist so tiny it is no wonder Mr. Bishop's son fell in love with her and married her. An entirely artificial construction, she, so

ance of a very pregnant beginning welder in his domain; to Liza Karpook for allowing us access to her vast collections of junk; to Ann Bergen, Catherine Ingraham, Jeff Kipnis, Amy Landesberg, and Pat Potter, for stimulating and useful critiques; to my daughter Sarah Elizabeth Cox, for cheerfully giving over her basketball court to serve as a construction site; and to Robert Segrest, architect and husband, for contributions above and beyond.

[1] The words of Aldo Rossi, now well-worn by a generation of architecture students.

beautiful and horrible it is hard to take one's eyes away. She is said to have been the picture of grace and loveliness.

Miss Eleanor was given by her father (in marriage) to Mr. Bishop's son. Mr. Bishop had once owned the house on Milledge Avenue in Athens in which my child's great-grandfather and grandmother and father lived and grew up, the house that now hosts the Phi Mu sorority at the University of Georgia. Family legend has it that Mr. Bishop, having moved to Athens from Chicago on the advice of his physician, detested the un-Chicago-like summer browning of the grass on his lawn and had a railroad car of evergreen nutgrass shipped from Africa. The wind-borne seeds of the nutgrass took it all over the South, where it is currently viewed as a great regional pest.

Before becoming an importer of deleterious plants, Mr. Bishop had been a Chicago merchant, the proprietor of A. Bishop and Company, purveyors of fine furs. (Mr. Bishop sold habitable and ornamental constructions made from the hides of animals.) And this is where the nine-months-plus "project" – that I, my feet propped for leverage on the Stickley bench, now on many evenings soothe to sleep in Miss Eleanor's rocker – meets another project[2] that has been inhabiting the same space in time.

Mr. Bishop provides a joint between the two, for Mr. Bishop and his hides were survivors of the Great Chicago Fire. The story goes that Mr. Bishop, minding his store when the fire came whipping down the way, realized that he hadn't enough time to procure a conveyance to rescue his merchandise, and in desperation he offered one of the fleeing throng who crowded the street just outside a very large sum of money to dump the contents of his wagon, his own domestic treasures, and take on the furs. Keepsakes, heirlooms, and necessities went out; sable, mink, and chinchilla skins went in. Mr. Bishop and his furs set up shop in another part of Chicago before the smoke had cleared.[3]

That other enterprise, the subject of this essay, is a project for and about Chicago and is an effect of the Great Fire of October 1871. I shall address the matter of the fire shortly, but first let us return briefly to those two pieces of restive furniture, which, after all, were not presented to you simply as benign objects merely decorating this manuscript. You will recall that the one is solid, rectilinear, and sturdy, and the other is airy, curvaceous, and lacy. And so you will begin to perceive, had you not already, a certain dichotomy in the works, a duo that might be construed as some sort of metaphor, were one so disposed to do.

The ornament–structure pair has intrigued architects for many centuries and certainly has been a great architectural bugaboo of this one, and so I am by no means the first, nor will I be the last, to consider this pair of, for some reason, uneasy bedfellows. I have no interest in making yet another argument for the privileging of one over the other. What

[2] I have been criticized for using this word, "project," on the basis of its "phallocentrism." Although I prefer the words "construction" and "assemblage" to refer to complex inventions of various media, I have chosen here to remain within the convention of architecture that maintains a distinction between a project (unbuilt) and a construction (built).
[3] I am grateful to Laura Ann Segrest, my mother-in-law, for the story of Mr. Bishop and his furs.

interests me is the why and how of the urge to privilege, and the possibilities of architecture when this urge is absent. I am interested in how the work of Louis Sullivan, which had more to do with structure (e.g., the articulation of the basic structures of classical orders in the stacking of tall buildings, and the development of the Chicago window and its freeing up of the structural frame to expose itself), has given more weight to his reputation as the "dean of American architects" than has the prodigious body of work on ornament, for which the former has served more or less as an excuse to forgive. I am interested in how the ornament–structure pair has had, throughout the history of Western culture, an acritical relationship to the pair "feminine–masculine" and in the ramifications of this for architecture as cultural production. As Naomi Schor points out, neoclassical aesthetics and its successors are bound up in the conventions of classical rhetoric, in which the ornamental and the idea of feminine duplicity are practically in identity. She writes:

This imaginary femininity weighs heavily on the fate of the detail as well as of the ornament in aesthetics, burdening them with the negative connotations of the feminine: the decorative, the natural, the impure, and the monstrous.[4]

A brief excursion into the canonical works of two architectural writers on ornament will suggest the particular territory. But I would like to suggest from the beginning that that which is construed as "feminine" is also readable as a much broader category. For the degeneracy and duplicity of the feminine is a metaphor for many forms of alterity to the dominant. This convention is mined and exploited throughout the project. And so, in the Joycean (Wakean) mode, the not male, the not Caucasian, the not heterosexual, the not a homeowner or head of house, the not Christian, and so forth, slide into identity under this metaphor.

In reading Alberti's *De re aedificatoria,* the "Ten Books," four of which are devoted to the subject of ornament, it is easy to construe ornament as a *supplément* to beauty. (I am using this French word *supplément* in the sense in which it is exploited by Jacques Derrida, that is, an entity that is added to an "original" entity such that the former is in excess of that to which it is added, i.e., is excessive, and, by nature of its being added, points to, by supplying, a lack in the putative original entity.) In Alberti's Sixth Book, "beauty" is defined as "that reasoned harmony of all the parts within a body, so that nothing may be added, taken away, or altered, but for the worse."[5] But then, he goes on:

[O]rnament may be defined as a form of auxiliary light and complement to beauty. From this it follows, I believe, that beauty is some inherent property, to be found suffused all through the body of that which may be called beautiful; whereas ornament, rather than being inherent, has the character of something attached or additional.[6]

Thus, if the "inherent property" is a sufficient condition for beauty, ornament, as an addition that for Alberti is a positive one ("Who would not

[4]Naomi Schor, *Reading for Detail: Aesthetics and the Feminine* (New York: Methuen, 1987), p. 45.
[5]Leon Battista Alberti, *On the Art of Building in Ten Books* (ca. 1450), trans. Joseph Rykwert and Robert Tavernor (Cambridge, Mass.: MIT Press, 1988), p. 156.
[6]Ibid.

claim to dwell more comfortably between walls that are ornate . . . ?"[7]), is in excess of the conditions for beauty, while at the same time pointing to a lack in the essentially beautiful (unornamented) object.

There is the suggestion of a temporal condition here also: The beautiful object is first beautiful without ornament; ornament is added after the establishment of the beautiful object. When this occurs, there must logically be a slipping away of beauty, because for the object to possess beauty in the first place, "nothing may be added . . . but for the worse." So when something (ornament) is added, the beautiful object becomes both worse (no longer its pure self) and better ("more delightful").

Our second canonical writer demonstrates great faith in the intimate connections of architecture with all aspects of cultural production, from ladies' fashion to plumbing. Adolf Loos, who as a young man visited Chicago for the 1893 World's Columbian Exposition and remained in Chicago for some time thereafter, and who left an invisible mark on the history of the city with his entry to the 1923 *Chicago Tribune* competition, is peculiarly incisive on the topic of ornament, femininity, nature, and degeneracy:

The lower the cultural level of a people, the more extravagant it is with its ornament, its decoration. The Indian covers every object, every boat, every oar, every arrow with layer upon layer of ornament. To see decoration as a sign of superiority means to stand at the level of the Indians. But we must overcome the Indian in us. The Indian says, "This woman is beautiful because she wears gold rings in her nose and ears." The man of high culture says, "This woman is beautiful because she does not wear rings in her nose and ears." To seek beauty only in form and not in ornament is the goal toward which all humanity is striving.[8]

Although Loos here indulges in the classical identification of the feminine and ornament, he elsewhere "excuses" woman for her barbaric degeneracy, claiming that in turn-of-the-century European society, because of her forced economic dependency, woman must fetishistically adorn herself as a sexual object in order to "hold on to her place by the side of the big, strong man."[9] In the famous "Ornament and Crime" essay, Loos writes that "the urge to decorate one's face . . . is the babbling of painting. All art is erotic."[10] He goes on to explain how the first ornament ever invented, the cross, was pornographic in its intentions: "A horizontal line: the woman. A vertical line: the man penetrating her. The man who created this felt the same creative urge as Beethoven. . . ."[11] Regardless of what this wonderful passage tells us about Loos's own peculiar psychological makeup, it is of enormous import to the topic at hand because it marks a connection of the sacred-profane pair, writing, and ornament-alterity in the tidy conjunction of

[7]Ibid.
[8]Adolf Loos, "The Luxury Vehicle" (1898), in *Spoken into the Void: Collected Essays 1897–1900,* trans. Jane O. Newman and John H. Smith (Cambridge, Mass.: MIT Press, 1982), p. 40.
[9]Adolf Loos, "Ladies' Fashion," in *Spoken into the Void,* p. 103. Note that this passage reiterates the gendering of the ornament–structure pair.
[10]Adolf Loos, "Ornament and Crime" (1908), in *The Architecture of Adolf Loos* (catalogue of an exhibition organized by Yehuda Safran and Wilfried Wang, London Arts Council, 1987), p. 100.
[11]Ibid.

a drawing, a hieroglyph that is also a symbol, that offers itself up, in oversignification, to florid undecidability. And this leads us directly into the territory of allegory.

Naomi Schor writes:

[T]he detail with an allegorical vocation is distinguished by its "oversignification" (Baudrillard); this is not a matter of realism, but of surrealism, if not hyperrealism. Finally, the allegorical detail is a disproportionately enlarged ornamental detail; bearing the seal of transcendence, it testifies to the loss of all transcendental signifieds in the modern period. In short, the modern allegorical detail is a parody of the traditional theological detail. It is the detail deserted by God [an un-Miesian detail, certainly]. . . . The allegorical detail is a disembodied and destabilized detail.[12]

Roger Scruton underscores, from another viewpoint:

Certainly, there is nothing more meaningless or repulsive in architecture than detail used . . . outside the control of any governing conception or design.[13]

What happens when we assemble such Nietzschean details into construction?[14] The mode of such assembly must, in order to preserve the destabilized aspect of the detail, be something akin to collage. In writing of collage and allegory, the realm of both Walter Benjamin and Jacques Derrida, Gregory Ulmer cites Derrida on the resulting undecidability of reading the assembly that is a collage. Each heterogeneous element, or detail, of the collage, because of its position both as a fragment that can be connected to its original context and as a part of a new whole, shuttles between "presence and absence"[15] and thus disallows a linear or univocal reading of the whole.

The phenomenon cited by Schor and labeled "oversignification" by Baudrillard is one of the mechanisms of the *gram,* that which is to grammatology as the *sign* is to semiology. One of the corollaries of the *gram,* as Derrida approaches it, is the notion of the *supplément.* Ulmer notes that Craig Owens, in a definitive article identifying the allegorical mode with postmodern art,[16] identified allegory with the *supplément,* and thus with writing, in its supplementarity to speech. This is, of course, an identification that Walter Benjamin had made long before, when he identified baroque allegory with hieroglyphs and other forms of script in which the sacred comes to be embedded within forms of the profane.[17] This paradoxical relation is one of the processes at work in the project

[12]Schor, *Reading for Detail,* p. 61.
[13]Roger Scruton, *The Aesthetics of Architecture* (Princeton: Princeton University Press, 1979), p. 207.
[14]In the present context, it is interesting to note the closing of Nietzsche's 1887 preface to *On the Genealogy of Morals,* where he writes of the necessity to decipher, not simply to read, his work: "To be sure, one thing is necessary above all if one is to practice reading as an *art* in this way, something that has been unlearned most thoroughly nowadays – and therefore it will be some time before my writings are "readable" – something for which one has almost to be a cow and in any case *not* a 'modern man': *rumination.*" Friedrich Nietzsche, *On the Genealogy of Morals* (1887), trans. Walter Kaufmann and R. J. Hollingdale (New York: Vintage Books, 1969), p. 23.
[15]Gregory Ulmer, "The Object of Post-Criticism," in *The Anti-Aesthetic: Essays on Postmodern Culture,* ed. Hal Foster (Port Townsend, Wash.: Bay Press, 1983), p. 88.
[16]Craig Owens, "The Allegorical Impulse: Toward a Theory of Postmodernism," *October* 12(1980):67–86; 13(1980):59–80.
[17]For further discussion of this, see Jennifer Bloomer, *Architecture and the Text: The (S)crypts of Joyce and Piranesi* (New Haven: Yale University Press, 1993).

and is, of course, not unrelated to *supplément*arity. The things of the conventionally constituted profane world of the other, in being foregrounded into signification, are brought out of convention into expression, that is, are simultaneously elevated and devalued, and shuttle between the sacred and the profane.

This phenomenon of foregrounding the profane world into signification in the domain of the sacred is at work in George Hersey's *The Lost Meaning of Classical Architecture: Speculations on Ornament from Vitruvius to Venturi*. In a nutshell, Hersey's thesis is that the elements of the classical temples were derived from the residual constructions of pagan sacrificial rites – that is, the remains of sacrificial victims and the attendant accoutrements of the ritual of sacrifice, as they were arranged about the sacred place, were the origins of the structure and arrangement of the ornamental parts of the Greek temple. Hersey carries out this work via operations by rhetorical tropes upon the words for the various elements and both their accepted etymologies and some creative (Viconian) etymologies. As in Vico's philosophy of history, words become the historical documents that provide evidence of the thesis. Here is an example that will remain germane to the larger topic at hand. In writing of the caryatid as woman punished for sexual misconduct, he notes what he calls the trope between "caryatid" and "Corinthian," which contains the phoneme *cor,* meaning both "heart" and "horn," body parts of a sacrificed animal.[18] Here, language is a switching mechanism, a time machine. Regardless of how such creative scholarship and the ends to which it is applied might be judged, the fact remains that these kinds of moves, which treat words almost as material constructions themselves, suggest a methodology of assembling architectural material itself.

Hersey writes:

For an inhabitant of the Hellenistic world, the words "Doric," "echinus," or "Ionic fascia," in Greek, did not have the purely workaday associations they have for us. They suggested *bound and decorated victims, ribboned exuviae* set on high, gods, cults, *ancestors, colonies.* Temples were read as concretions of sacrificial matter, of the things that were put into graves and laid on walls and stelai [written]. This sense of architectural ornament is very different from the urge to beauty. But indeed the word ornament, in origin, has little to do with beauty. It means something or someone that has been equipped or prepared, like a hunter, soldier, or priest. [Or a woman, with fashion, makeup, jewelry, manners.] [emphasis added][19]

Classical ornaments, for Hersey, are trophies/tropes of sacrifice. The assemblage of details in our project mimes this, but indulges in tropes of the tropes, letting them slide from their origins in classicism and become allegorical and richly undecidable. (We have used elements that both do and do not adhere to the ideas of the classical temple in Hersey's terms, for example.)

In its exploration of and play in the territory between the sacred and the profane, sanctity and sensuality, the project is tied to baroque art and architecture.[20] A historical assemblage of the uses of the word "baroque"

[18]George Hersey, *The Lost Meaning of Classical Architecture: Speculations on Ornament from Vitruvius to Venturi* (Cambridge, Mass.: MIT Press, 1989), pp. 72–3.

[19]Ibid., p. 149.

[20]Although it is Walter Benjamin's text on baroque drama that forms the notions of allegory

serves as an approximate description of the aesthetic milieu in which it is situated:

The word *baroque* appeared in current speech in France at the end of the sixteenth century, to designate something unusual, bizarre, even badly made. Montaigne uses it in this sense in his *Essais*. It is still used by jewellers to describe those irregular pearls known . . . in Portuguese as *barroco;* in the mannerist and baroque periods these odd shapes were used . . . in precious settings to form figures of sirens, centaurs and other fabulous creatures.[21]

The Swiss historian Jacob Burckhardt characterized the baroque as "wild" and "barbarous" (cf. Loos) when comparing it with the ideal beauty of the Renaissance. Quatremère de Quincy called it "bizarre to a degree," a definition that Milizia repeated. In the *Dictionnaire de la Musique,* Jean-Jacques Rousseau used it to suggest a "confused harmony." In the twentieth century, Benedetto Croce called it "the art of bad taste."[22]

However, it is the project's generative tie to baroque tragic drama, the *Trauerspiel,* the subject of Walter Benjamin's *Habilitationsschrift,* that is most profound:

The *Trauerspiel* . . . is not rooted in myth but in history. Historicity, with every implication of political-social texture and reference, generates both content and style. . . . [T]he baroque dramatist clings fervently to the world. The *Trauerspiel* is counter-transcendental; it celebrates the immanence of existence even where this existence is passed in torment. It is emphatically "mundane," earth-bound, corporeal.[23]

THE PROJECT

The project consists of a constellation of parasitical corner structures that explore the structure–ornament pair in two significant areas. First, they are constituted as parasitical and habitable and are therefore by conventional definition both ornamental and structural; they exist in a territory of blurred boundaries. Second, they are constituted as structures of significance; that is, they convey messages. They serve two functions: They serve as possible places for human beings, who might otherwise be on the street, to rest and be out of the wind and rain, and they serve as signs of the condition of rampant homelessness in the city – at the most general level, they signify the presence of alterity to the status quo.

This project is figured as Louis Sullivan's revenge – a Louis Sullivan who serves as trope of the *alter.* Sullivan and Freud's "Dora,"[24] both of

that have informed my work over the past seven years, it took Laura Ann Segrest's sharp eye to bring to my attention 'the "baroqueness" of this project, and, once again, I am grateful to her.

[21] Germain Bazin, *The Baroque: Principles, Styles, Modes, Themes* (London: Thames & Hudson, 1968), p. 15.

[22] Ibid., pp. 15–17. It seems significant to the context of the work that Eugenio d'Ors was (along with Heinrich Wölfflin) one of the twentieth-century redeemers of the aesthetics of the baroque.

[23] George Steiner, "Introduction" to Walter Benjamin, *The Origin of German Tragic Drama,* trans. John Osborne (London: NLB, 1977), p. 16.

[24] The pseudonym of the subject of Freud's *Fragment of an Analysis of a Case of Hysteria* (1905), in *The Standard Edition of the Complete Psychological Works of Sigmund Freud,* ed. and trans. James Strachey (New York: Norton, 1961), vol. VII, pp. 1–122.

whom had their "unconscious" homosexual tendencies treated – Dora's by Freud, Sullivan's by a herd of architectural historians – become tropes for each other. They are also connected through their given names, both of which allude to gold. The project of joyous revenge is also a twisted delivery of Adolf Loos's promise to the world, given when his entry to the 1923 *Chicago Tribune* competition, an enormous black Doric column, failed to win: "The great, Greek Doric column will one day be built. If not in Chicago, then in another city. If not for the *Chicago Tribune*, then for someone else. If not by me, then by another architect."[25] This Greek gift, this (now) disseminated rage of Louis/Dora, this other Doric *colon*, by *other* architects, appears, mapped onto Chicago as a great mantle of "Tabbles of Bower." The center of this maelstrom is the site of the *Chicago Tribune* building.

THE PROJECTION OF THE (DISORDERED) METAPHORIC ONTO THE METONYMIC STRUCTURE OF THE PROJECT

This structure is a web with five major nodes, all of which are interconnected. There is no linearity to this structure, and it is impossible to denote the flows among the nodes sufficiently in this temporally perceived text. The five nodes, or joints, are as follows: colon, fire, cow, temple, and Dora. The flows among them are suggested next by lists of generative facts and ideas that adhere to them and begin to build conduits among them.

1. *Colon:* In "colon" the French word for column is condensed with the surname of Cristobal Colon, "discoverer" of America, inaugurator of its European colonization and the corollary displacement and murder of existing native communities. This "discovery" was commemorated by the World's Columbian Exposition, held in Chicago in 1893. The root of the word "columba" is suggestive of color: *kel,* black or gray; *umbra,* shade. Color is an omnipresent coding device for difference in this culture, especially racial and sexual difference, and "the first thing a person who is not an architect notices about a building."[26] Contributions to American history by persons of color were not commemorated in the Chicago exposition. "Colony" and "bucolic" share the same Indo-European root, *-kwel,* which suggests circling. Thus the Greek *-kolos,* herd, and the Latin *colere,* to cultivate or inhabit. The Latin *colonus* is a farmer, for which the German word is *Bauer. Bau,* in the same language, is a building or construction.

2. *Fire:* According to legend, the Great Chicago Fire of 1871 was started when Mrs. Patrick O'Leary left a burning lantern in the shed that housed Mr. O'Leary's other dull-witted and clumsy domestic animal, his cow. The spread of the fire was abetted by balloon-frame constructions – whose design originated in Chicago – light timber constructions surrounded by lots of oxygen. In the multitude of etchings that document the fire, it is virtually impossible to find a black face in the fleeing throngs, despite the fact that this was the decade following the mass

[25]Y. Safran and W. Wang, *The Architecture of Adolf Loos* (London: London Arts Council, 1987), p. 60.
[26]Craig Saper, private communication.

236

exodus of former slaves from the South to Chicago. After the fire, one hundred thousand people lived on the street. Homelessness became an impetus to immediate and local acts of building.

3. *Cow:* The cow represents a crucial joint between the two American construction modes that originated in Chicago: balloon-frame construction and skeletal construction. The Indo-European root of "corner" is *ker,* horn, with derivatives that refer to horned animals, horn-shaped objects, and projecting parts. The corner, then, has intimate associations with the grotesque body. Everyone knows that cows are stupid, placid, contented, but sometimes stubborn. A cow is "a fat and slovenly woman."[27] Louis Sullivan speaks of an architect who will "turn to a book of plates, pick out what he wants, and pass it on to a draughtsman who will *chew this particular architectural cud* for a stipend."[28]

4. *Temple:* From the Latin *templum,* from a root meaning "to cut." *Templum* suggests both a place cut out (a special, sacred place) and a small piece of wood cut out from a larger one. Thus, in English, "temple," as a container of the sacred, is related to the device in a loom that keeps the cloth stretched to a consistent width. For Shirley Cothran, a former Miss America, adapting St. Paul, "my body is the temple of the Lord." The metaphor of the body has persisted as a ruling paradigm throughout the history of Western architecture, more generally a consistent male body than a messy assemblage of flows, both material and immaterial.[29] Consider the balloon frame. How easy it might be to see its economical beauty as a construction while gutting and cleaning a chicken for Sunday dinner. Balloon-frame construction is a metonymy of the body: not the image of the body, but the stuff of the body, the economy, the *oikos,* of the body. This is not the Renaissance body or the Corbusian body. Consider also the temple Melville describes in *Moby-Dick,* consisting of the skeleton of a great sperm whale: "The ribs were hung with trophies; the vertebrae were carved with Arsacidean annals in strange hieroglyphics; in the skull the priests kept up an unextinguished aromatic flame, so that the mystic head again sent forth its vapory spout."[30] The chrysalis, a body enclosure formed from the body's own secretions, receives its name from the Greek *khrusos,* gold. One day, when this project was only a "gleam in the eye," we chanced to find an enormous fat caterpillar in our herb garden. We brought it inside for our nine-year-old Sarah, to watch it do what comes naturally. The skin of the caterpillar was so beautifully variegated with subtle spots of color that I named her "Helen of Troy." Some weeks later the caterpillar was nowhere to be found. Instead, on the corner of the window frame, a symmetrical, grotesque golden-gray figure, with the headpiece bowing out vertiginously from the frame, but held in place by a gossamer cable: the chrysalis of Helen of Troy. A parasitical corner construction with a body inside. And two weeks later, the wet, messy emergence of the imago.

5. *Dora/Doric/d'or:* Dora, like the original Helen of Troy, was treated

[27]*American Heritage Dictionary* (Boston: Houghton-Mifflin, 1962).
[28]Louis H. Sullivan, "A Roman Temple (2)," in *Kindergarten Chats and Other Writings* (New York: Dover, 1979), p. 39.
[29]See Diana Agrest, "Architecture from Without: Body, Logic, and Sex," *Assemblage* 7(1988):29–41.
[30]Herman Melville, *Moby-Dick* (New York: Norton, 1967), p. 374.

by her father as an object of exchange, as a gift, as gold. "Dora" was a pseudonym for a young woman whose real name was Ida Bauer. The Middle English "bour" is a dwelling or inner apartment. A "bower" is an inner chamber, locked up, where family secrets are encrypted. When the chamber gets too full, it moves around; this is the classical cause of hysteria, or "wandering womb." "Doric" is the adjectival form of "Dora." Also of "gift." Loos's great Doric column, now readable as Dora's missing phallus, become Louis Sullivan's return of the repressed. This project takes up Louis's beef with classicism and, through Hersey, meets it on its own terms in a doubling, reversing move.

THE THIRTEEN PARTS OF THE CONSTRUCTION

The full-scale construction (Fig. 28) is an assemblage of thirteen allegorical details that together form a laboratory condition of the project as a whole. The thirteen parts are the residual of an exploration of techniques of blurring the ornament–structure boundary that would be used on the corner parasites were they built. In their assemblage, they serve as an exhibitional armature for models and drawings, as well as an allegorical emblem of the "Tabbles of Bower."

Cowslab

The "cowslab" constitutes the floor of the construction. It is a 2.5-inch-thick concrete slab in the shape of two cows placed nose to nose so that they mime the symmetrical form of Louis Sullivan's seedpod motif and recall his use of paired animals at the corners of buildings. The figure of each cow is taken from a photograph that appeared on the front page of the *Gainesville Sun*. The photograph depicts the plight of two cows that fell into a sinkhole, a ubiquitous local geological condition.[31] Each cow is divided into four parts, suggestive of the drawings that demonstrate the way in which cows become cuts of beef; together with the steel cornerstone that marks their common nose, the cowslab is made of nine parts. The bellies of the cows are incised with slits that receive door posts. The cows are gilded; they are golden calves. The undulatory orifice between them is filled with red seed.

Let us note that many of these myths about reconstructed victims are foundation myths for religious rituals; in other words, they are a precondition for the erection of temples.[32]

Cowhide

A map of the project is "drawn" on a cowhide (Figs. 29 and 30) suspended belly-out and down from a lacy steel frame before and above

[31] I have explored the sinkhole, and its suggestions about vessels and voids, in "Big Jugs," in *The Hysterical Male: New Feminist Theory,* ed. Arthur and Marilouise Kroker (New York: St. Martin's Press, 1991), pp. 13–27.
[32] Hersey, *The Lost Meaning of Classical Architecture,* p. 16.

the opening into the construction. The frame (Fig. 31), welded together from short lengths of #2 rebar,[33] then wrapped in treated muslin and coated in shellac, is modeled on a hybrid construction of bustles and steel bridge construction (back-to-back camelback trusses triangulated so as to accommodate the bending moment of a swinging bridge) and bears traces of Sullivan tympani, mammalian skeletons, and the imago, the ultimate state of the chrysalis. It is bound in the position of a vertiginous canopy by the steel "centerline," which is stabilized laterally by tension cables emerging from the bases of two concrete ("tabby") columns, and from which is suspended a great, ornamental plumb bob that maintains the steel frame in tension.

The cowhide map connects simultaneously to the traditional drawing medium of parchment (the skin of a sheep or goat) and to the "ribboned" exuviae to which Hersey refers. It merges as well with one of the famous constructions of Daedalus, "the first architect," the hollow cow that he made for Pasiphae to facilitate her copulation with the father of the Mino-

[33]One of the more satisfying discoveries of this project was the liberating potential of "drawing in the air," i.e., making large, three-dimensional line drawings with these 0.25-inch strands of steel and an arc welder, drawings that inscribe a spatiality that ink drawings or even computer drawings cannot approach.

28 Full-scale construction. Photo by King Au, Au Studio, Des Moines, Iowa.

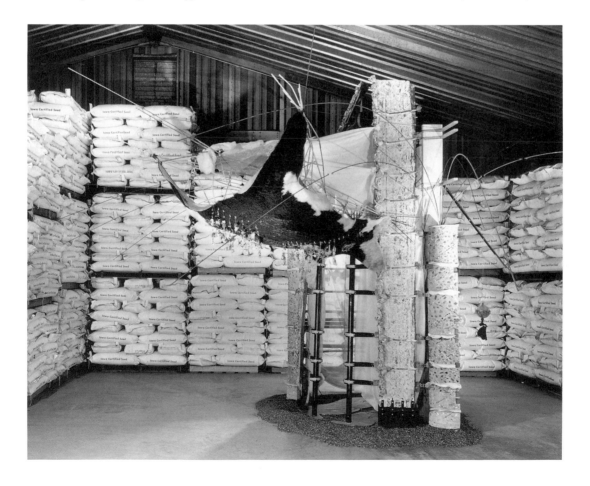

taur.[34] The cowhide was a weapon of braided leather, related to the cat-o'-nine-tails, used to beat disobedient slaves during the considerable portion of the history of this continent in which African slaves were exploited.

Upon the cowhide are three superimposed maps of three scales:

1. A map of the globe, cut as a globe's surface (and the skin of the cow, which, after all, is not a two-dimensional animal)[35] must be in order to render it flat. This map, however, is "cut" so that all the oceans remain intact as one body of water, rendering the continents reconfigured in such a way as to fling them, cut into unfamiliarity, out to the edges of the map. The oceans are depicted as flows painted into the twisted cow hair in gold. Upon the now marginal scraps of land are mapped, in their correct locations, the origins of all the stony fragments that are embedded in the base of the *Chicago Tribune* building. Each origin is denoted by a gold map tack punched through the hide and secured on the back by an earring post.

2. A map of the Chicago Loop and North Michigan Avenue and surrounds as far north as Lincoln Park. This map consists of the points of the street intersections marked by brass fishhooks. Particular historical sites germane to the project (the locations of Sullivan's buildings, both extant and demolished, for example) will be noted by amulets suspended from the hooks. The remainder of the hooks are embedded in "Cretan skirts," small corks coated in sea-green wax and wrapped and knotted with delicate brass wire. Lures. The whorl from which the hair pattern originates locates the *Tribune* building. The longer white hair that occurs on the hide at what was the back of the cow marks the flow of the Chicago River. This longer hair is exaggerated by being twisted and braided into a large *fascinus* full of signifying accretions, thus both bringing the Chicago River into identity with the feminine figure of *Finnegans Wake*,[36] – Anna Livia Plurabelle – the river Liffey, and all others, and underlining Freud's explanation for women's one contribution to the industry of civilization: weaving.[37]

3. A map of a Sullivan tympanum woven in brass wire as an exoskeleton over the entire belly of the hide.

When we first went to Mr. L's, they had a cowhide which she used to inflict on a little slave girl she previously owned, nearly every night. . . . As they stinted us for food my mother roasted the cowhide. It was rather poor picking, but it was the last cowhide my mother ever had an opportunity to cook while we remained in his family.[38]

Cornerstone

> The stone which the builders refused is become the headstone of the corner.
> — *Psalms* 118:20–2

[34]A canny move on the part of Daedalus, as it necessitated an even larger commission: to design the labyrinth in order to contain the horrible offspring of this coupling.

[35]I would like to thank Jimmie Harrison for pointing out this fact to me as we pondered the relationship between the flat hide and the rounded form that it was to take.

[36]And thus pointing to a major methodological source of this project, the last work of James Joyce, the generator and subject of *Architecture and the Text*, which lays out the territory from which this material project emerges.

[37]The explanation being that woman invented weaving in order to mask what she lacks, i.e., by plaiting her pubic hair into a masking phallus.

[38]Mattie Jackson, "The Story of Mattie J. Jackson Written and Arranged by Dr. L. S. Thompson as given by Mattie (1866)," in *Six Women's Slave Narratives,* ed. Henry Louis Gates, Jr. (Oxford: Oxford University Press, 1988), p. 10.

The steel[39] cornerstone, which forms the common nose of the two cows of the cowslab (or the germ of the seedpod of Sullivan), is in form an extruded plan of a *vesica piscis,* the fish's bladder, a Euclidean device for the generation of an equilateral triangle. One side of the *vesica* is extruded more than the other. The interior is lined with small copper tubes that

[39]It is important to note that the major component of steel is iron, and that is all I shall have to say on that subject. Decoders will find here a secret as proper as the name of the father. *J'appelle un chatterer un chatterer.*

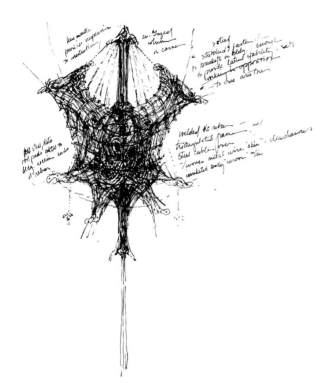

29 (*above left*) Jennifer Bloomer, corner barnacle sketch, from my sketchbook.

30 (*above right*) Jennifer Bloomer, corner barnacle study, from my sketchbook.

31 (*left*) Steel frame with pink lace triangle/transom and centerline, before the cowhide was attached (full-scale construction).

JENNIFER BLOOMER

receive the warp[40] of the interior mantle. It is filled with Portland cement topped off with plaster carved in significant relief and encrusted with gilded seeds.

No house worth living in has for its cornerstone the hunger of those who built it.[41]

Maple Frame

The framing condition (Fig. 32) that occurs at the corner is suggestive of a balloon frame, but clearly is not. Built of planed and beveled maple members of graduated sizes on the vertical and the horizontal that have been sanded and given nine coats of tung oil, the L-shaped frame is assembled with cross-lapped joints, with perforated end-lap joints at the corner, which is suspended above the center point of the cornerstone. The vertical members that occur on the interior side are 10 feet 8.5 inches tall; the horizontal members, on the exterior, are 5 feet 2 inches long. The geometry of the structure is taken from the layers of the local geological catastrophe called the Devil's Millhopper, a sinkhole that has fallen thirteen times and has as many distinct layers.[42] The cross-lapped joints are bound by nylon and cotton cord dyed scarlet, reminiscent of flayed flesh, bound around the joint, tied with surgeon's knots, and wrapped with brass wire. These bindings provide points of attachment for the armature of the interior mantle.

Tabby Columns

This first pair of two pairs of *colons* is described by a word, "tabby," that refers at the primary level to the material from which they are constructed. Tabby is a type of concrete that has been used in domestic construction in the southeastern coastal regions of the United States for a long time, a concrete the aggregate of which is composed of oyster shells. The surfaces of tabby walls have a sensuous texture and a faintly pearlescent glow in dim light. According to the *American Heritage Dictionary,* "tabby" also means

a rich watered silk,
a plain weave fabric,
a striped or brindled domestic cat,
a female domestic cat,
an old maid, and
a prying woman, a gossip [who chatters or babbles].

[40]Note that the placing of a foundation stone is called "fixing the warp."
[41]Ursula LeGuin, "Hunger," in *Dancing at the Edge of the World: Thoughts on Words, Women, Places* (New York: HarperCollins, 1990), p. 50.
[42]The Devil's Millhopper also plays a large structuring role in the unpublished video "Greg Ulmer Reads Reading on TV." The millhopper's presence in the project is as a structurally suggestive "other" to the "great . . . Doric column." Its particular references will be elaborated in a book in progress, Jennifer Bloomer, *Abodes of Theory and Flesh,* which will document this project in detail.

In a word, then: material, pattern, weave, domestic animal, derogatory female stereotype referring to domestic animal. Further, the domestic animal is Louis Sullivan's cat. Tabby houses are cat houses. "Scratching the eyes out" is a feline activity.

The plan configuration of each column is an irregular segment of a circle. The column consists of seven segments of reinforced concrete of varying sinkhole-derived heights. Each column was poured into a horizontal Sonotube with six particle-board dividers and Styrofoam ribs laid in to create the slots and ledges into/onto which the maple frame members and bony ribs rest. The tabby column is a receiver of ribs. Before the pour, the tube was prepared by smearing on a ⅜-inch layer of clay into which the ornamental aggregate (the crisscrossing lines of buttons with intersections marked by alligator vertebrae and the thirteen layers of aggregate representative of the sinkhole's geological layers' constituents – coal, bone, terra-cotta, phosphorescent marbles, glass, shell) was laid. Over this was distributed a coating of ground graphite in a tabby pattern. Chicken-wire reinforcement was distributed through the segments, and the concrete was poured. As it began to set up, a ¼-inch layer of cement and plaster pigmented gray was poured onto the concrete, so as to render a smooth drawing surface on one side of each column.

32 Corner detail of full-scale construction.

The heavy concrete column is the least stable part of the construction; because of its slender proportions, it relies on structural bracing by other parts (the cowhide frame, the maple frame, and the door) for its stability. Its seven parts are strung, like beads, on a threaded posttensioning rod whose cap emerges from a flat perforated steel top plate. A slotted steel base receives the rod, which is tightened at the bottom through the slot, which is then filled with grotesquerie ("base" objects). Seven bound #2 rebars spring from the top plate. Some provide lateral bracing for the cowhide map frame, and the others simply quiver and tremble in space, like insect antennae.

Tower of Babel Columns/Lallypop Columns

The base of each of these columns is composed of a steel disk to which has been welded, on one side, a short steel post that may be inserted into any one of the belly slits of the cowslab and, on the other side, a longer threaded steel tube that receives a large eye screw. Onto the eye screw are bound eighteen lengths of twisted copper wire that are threaded up through the tubular steel shaft of a 7-foot Lally column. From six trios of wire are suspended, at intervals corresponding to the ribs of the door (described later), six steel rings with protruding double ribs. As are all the steel elements, the column shafts and rings are ground and polished, rubbed with asphaltum in a tabby pattern, and given three coats of polyurethane. The result is a staged pole festooned with decreasing densities of wire, formally suggestive in many directions.

The Tower of Babel is the emblem of the relationship between architecture and language, and of that between the sacred and the profane. The urge to decorate one's face and everything in reach . . . is the babbling of painting. All art is erotic.[43]

Column Capitals

The column capitals function as pads over which the tension wires traverse the verges of the shafts. Their undecidability is clear: udders, Medusas, fingers, sea anemone, the feeders of the barnacle, Vitruvius' tale of the origin of the Corinthian column, hysterical catalepsies. Cut from pink Lycra Spandex using a newspaper pattern cut from the stock-market page, stitched, and stuffed with quilt batting, they are reinforced with steel wire and beeswax and bound to the lallypops with lead fillets. The "fingers" are covered with gold reinforcing rings.

Dory Door

Although he claimed he called "*un chat un chat,*" Freud made much of the metaphor of door and key as displacements of certain gendered body

[43]Loos, "Ornament and Crime," p. 100.

parts. In this project, the door, which opens onto Dora, Doric, and *d'or*,[44] is figured as an unsullied object of exchange: a figure in white on the outside that, once entered, shifts to living color. This door is made from the sides of a "dory," a boat with deep sides and a V-shaped transom; only, not having access to a dory, we used the sides of a cast-off flat-bottomed boat and rendered it a dory otherwise, as described in the next section.

The sides of the boat are removed from their original context and reinforced with fiberglass resin. All barnacles are lovingly retained. The ribs and straps are attached to the structural ribs of the boat; the steel footing of each side, fitted with a rolling caster to allow the door to move, is bolted in place. The outside of each side is coated with two layers of fine, white papier-mâché, sanded down to reveal the barest top layer of the bare boat. Then it is covered with an elegant lace pattern of a ghostly gray. An astute observer will note that this pattern is that of the "bad ornament"[45] of Louis H. Sullivan, the ornamental pattern on the soffits of the arches at the National Farmers' Bank at Owatonna, Minnesota.[46]

This door swings both ways.

V-shaped Transom

The addition of the transom makes the boat a proper dory and the door a proper door. The transom is a pink triangle of lace stretched and bound within a V-shaped portion of the steel frame from which the cowhide map is suspended.

Ribs and Straps

The sides of the dory are secured to the Babel columns on one side and to the tabby columns on the other by two series of bonelike ribs, one long and one short. The ribs are constructed from flat steel plates to which wood strips are epoxied, smoothed over with joint compound, wrapped in gauze soaked in wood glue, then slathered with alternating layers of a fine, strong papier-mâché-and-amber shellac. They are sanded, incised, and wrapped in "Hot Mama Pink" cord triangles. The steel plates protrude slightly from each end and are here perforated for receiving bolts and hinges.

[44]The further ramifications of *d'or* are explored in a companion piece to this one, "*D'or*," in *Sexuality and Space,* ed. Beatriz Colomina (New York: Princeton Architectural Press, 1992), pp. 162–83.

[45]This is the appraisal of George Elmslie, Sullivan's assistant and chief draftsman, who designed all of the ornament for this bank except for this particular motif. The motif significantly involves a repetition of an OXOXOXOX pattern. See Larry Millett, *The Curve of the Arch: The Story of Louis Sullivan's Owatonna Bank* (St. Paul: Minnesota Historical Society Press, 1985), p. 80.

[46]A bank notable in this context for its large mural, commissioned by Sullivan, by the Viennese painter Oskar Gross. The mural depicts a herd of cows grazing. See Millett, *The Curve of the Arch,* p. 98. I am grateful to Amy Landesberg for bringing this cowfact to my attention.

The ribs are held in place by a series of Hot Mama Pink resin-reinforced canvas sleeves held in suspension by a brassiere-inspired strap detail of Hot Mama Pink nylon straps bolted to the boat structure and secured by rows of aluminum angles.

Mantle

The mantle forms the interior lining of the construction. It suggests the mantle of the barnacle, the middle of its three layers, the one that generates the outer shell. Related etymologically to *mantilla,* it is a lacelike textile. From the *American Heritage Dictionary:*

Lace: . . . [Middle English *lace, laas, las,* ornamental braid, cord, from Old French *laz, las,* from Vulgar Latin *lacium* (unattested), from Latin *laqueus,* noose, trap, probably related to *lacere,* to allure. See "delight".]

The mantle is a diaphanous cocoon of white organza. It is supported by an interior frame of bustlelike construction, consisting of wrapped aluminum ribs tying into three vertical wrapped wooden busks[47] from which the swaths, "laced with gilt," radiate.

Freud's project was to dismantle Dora's anger.[48]

The master's tools will never dismantle the master's house.[49]

Plumb Bob/Lodestone

This large and weighty amulet serves as the counterweight to the cowhide in its bony steel frame. It is formed of sea detritus – an ancient buoy filled with lead, sea glass – and petrified mammoth bones, woven together by a crocheted mantle of brass wire and glass beads from which other small accretions are suspended. Referring both to the *cathetos,* the invention of Daedalus, and to the "dead man" of conventional construction, it is also a bower, the heaviest anchor on a seagoing vessel. Cantilevered and suspended away from the corner of the construction, it is a lure and a lodestone.

[G]uided by the wondrous North Star, that blessed lodestone of a slave people, my mother finally reached Chicago. . . .[50]

Centerline

Swerving out of the center of the steel frame is a 20-foot-long bundle of gilded steel pipe and #2 rebar that marks the centerline of the con-

[47]A busk is a thin strip of bone, wood, or metal that stiffens a woman's undergarments so that her body is held in its proper place.

[48]From Philip Rieff's introduction to Sigmund Freud, *Dora: An Analysis of a Case of Hysteria,* ed. Philip Rieff (New York: Macmillan, 1963), p. 13.

[49]Audre Lord, "The Master's Tools Will Never Dismantle the Master's House," in *This Bridge Called My Back: Writings by Radical Women of Color,* ed. Cherrie Moraga and Gloria Anzaldua (New York: Kitchen Table: Women of Color Press, 1983), p. 99.

[50]Lucy A. Delaney, "From the Darkness Cometh Light, or The Struggle for Freedom (1891)," in *Six Women's Slave Narratives,* p. 22.

struction. It rests on a wooden cradlelike acroterion on the top of the corner of the maple frame and projects, taillike, behind. From the "tail" is suspended the plumb bob. This counterweighting assemblage serves to hold the steel frame in place. The repetitive bindings of brass wire that hold it together consist formally of short and long segments (dots and dashes) that both identify it as the centerline and encode half of the key to the project.[51]

POSTFACE

The building, or other artifact of the creative impulse seen as offspring, as childbearing surrogate, is clean, whole, and ordered. It appears, complete and full-blown, at the end of an uncertain period of gestation. The "real thing" is not only a triumphant production of a complete but still developing project at the end of nine months but also a messy, bloody, erotic event. An other architecture is an architecture of abjection (the thrown away). At the moment of birth, the body gives forth excrement, vomit, blood, and mucus, as well as human being. Abject offerings, gifts, they are the products of flows. The abject products of the body might be metaphorized in the abject products of the body politic – detritus of street and home – toward a project of positive fetishizing, supplementing blood, excrement, and vomit to the phallus.

P.S.: Laura Barrett Bloomer-Segrest emerged, wet and messy, fearless and hungry,[52] on 8 April 1991. Both projects continue in ever unfolding collaborations.

[51] The Morse Code centerline appears in one other location (on the door, in red, where it bisects the OXOXOXOX ornament), and there provides the other half.
[52] I thank Herb Gottfried for this perfect phrase.

CINEMA-GRAPHIA: EISENSTEIN, DERRIDA, AND THE SIGN OF CINEMA

LAURA R. OSWALD

I N the 1950s, Alexandre Astruc coined the term *caméra stylo* to describe the expressive function of cinema freed from its ties to theater and prose fiction, a type of writing having the fluidity and semantic complexity of written speech.[1] The notion of the camera as pen not only defined the aesthetic priorities of New Wave cinema in France but also implied a theoretical stance toward the ontological status and semiotic specificity of cinema with regard to the other arts. Although his contemporary, André Bazin, took a very different approach and defined cinema with reference to its origins in photography, Astruc suggested the limitations of such an approach in view of the dynamic aspect of film discourse, writing-in-movement:

I would like to call this new age of cinema the age of *caméra-stylo*. By it I mean that the cinema will gradually break free from the tyranny of what is visual, from the image for its own sake, from the immediate and concrete demands of the narrative, to become a means of writing just as flexible and subtle as written language.[2]

Though the notions of *caméra stylo* and its correlative, film authorship, shaped the aesthetic concerns of an entire generation of French filmmakers and critics,[3] the notion of film writing remains a difficult theoretical issue, largely because of an orientation of film semiotics toward the image.[4] Though Astruc did not possess the philosophical vocabulary for clarifying the radical philosophical assumptions of his position, writing as he did during the heyday of phenomenology, his approach anticipates Derrida's critique of the Western metaphysical tradition.

Differences between Astruc's *caméra stylo* and Bazin's *camera obscura*, between the camera as implement for shaping meaning through film space–time and the camera as instrument for seizing visual reality in the film image, open onto broad questions about the origin of cinematic

[1]Alexandre Astruc, "The Birth of a New Avant-Garde: La Caméra Stylo," in *The New Wave*, ed. Peter Graham (Garden City, N.Y.: Doubleday, 1968), pp. 17–23.
[2]Ibid., p. 18.
[3]Andrew Sarris imported auteur theory to the United States, both in articles written for the *Village Voice* in the 1960s and in his book *The American Cinema* (New York: Dutton, 1968).
[4]Writers such as Marie-Claire Ropars-Wuilleumier developed theories of film writing that focused on the personal style of individual filmmakers and supported the notion of the filmmaker as auteur. See, for example, her *De la Littérature au cinéma* (Paris: Armand Colin, 1970).

representation, its relation to the Aristotelian tradition of mimesis, and its semiotic function. Bazin claimed that the origins of cinema in photography determined a priori the subservience of film discourse to laws of photographic realism, including the codes shaping an illusion of unbroken space and a coherent and complete composition within the frame.[5] Astruc, on the other hand, shifted focus away from the image as such to the movement between sounds and images in the film chain, suggesting means of locating the "essence" of cinema in the play of difference and contrast between elements of the film enunciation.

Bazin's position is firmly anchored in the Aristotelian tradition determining the production and interpretation of artistic representation in the West, specifically in the assumption that art is a mirror for reflecting transcendent truth or reality. In *What Is Cinema?* Bazin not only obscures formal differences between photography and cinema but also claims that films that conform to the unity and coherence of the single image by means of narrative realism fulfill the ontological destiny of cinema:

> Photography and the cinema on the other hand are discoveries that satisfy, once and for all and in its very essence, our obsession with realism.[6]

By contrast, Astruc, like Derrida, undermines the force of the copy in order to highlight the production of meaning by means of graphic composition. Although Astruc does not underscore the radical implications of his theory of film writing for the Aristotelian order of mimesis, his shift in focus from the image to the enunciation nonetheless replaces the coherence of the image as origin with the slips and slides of the unrepresentable traced by the frame. Writing-in-movement transcends the image as such, because writing traces meaning production across the flickering alternation of presence and absence, of past and presence, in film space–time.

Beginning with the critique of Husserl in *Speech and Phenomena*,[7] Derrida systematically challenges the very notion of origins – of the subject and meaning of discourse – by addressing the importance of the graphic representation of speech in textual writing. Derrida replaces the ontological interpretation of semiosis, an interpretation that ties the production of meaning to the dialectical closure of internal speech and consciousness – "I think, therefore I am" – with an interpretation of semiosis that takes into consideration the radical externalization of speech in textual writing – "I speak, therefore I am taken up in an endless movement between being-for-myself and being-for-others across language."

On the one hand, the cinema seems the ideal object for the application of a theory of textual writing, not only because the polyvalence of the image and the heterogeneity of the film material defy reduction to the signifier–signified model but also because the illusion of movement itself depends on the retention of past and future images upon the present and presence of meaning to consciousness. Such "memory

[5]André Bazin, "The Ontology of the Photographic Image," in *What Is Cinema?* trans. Hugh Gray (Berkeley: University of California Press, 1970), vol. I, pp. 9–16.
[6]Ibid., p. 12.
[7]Jacques Derrida, *"Speech and Phenomena" and Other Essays on Husserl's Theory of Signs,* trans. David B. Allison (Evanston, Ill.: Northwestern University Press, 1973).

traces" in film time and space strain the relation between form and meaning in film discourse.

On the other hand, Derrida's critique of the metaphysical tradition provides means for a radical reorientation of film theory from its current focus on the image to the spacing of difference, division, and resolution in film discourse. In this framework the question of cinema concerns not so much the ontological or even semiological specificity of "what is cinema?" as the textual practices shaping meaning production and subject-address in specific films.

At the risk of imposing a finality or yet another theory of origins upon this very fluid conception of cinema, I propose the neologism "cinema-graphia" to describe both the textual deployment of film writing and the philosophical shift that it implies. Whereas the conventional term "cinematography" names "the art or science of motion-picture photography,"[8] "cinema-graphia" names a kind of writing freed from the tyranny of the image for its own sake. The hyphen joining/separating "cinema" and "graphia" performs here a dual function: It draws attention to an original division of the conventional signifier, a duality that would be masked by the grammatical bridge "-to-," and it entails a division of the signified by highlighting etymological meanings of each term taken separately, movement and writing. The play between the terms "cinematography" and "cinema-graphia" embodies the very difficulty of the question of cinema for sign theory. It is necessary to deconstruct the conventional sign *for* cinema in order to rethink the notion of the sign *of* cinema. Rather than signifying a theory and a practice of cinema founded on the presence of meaning to consciousness *within* the frame, cinema-graphia designates a theory and a practice of cinema focused on relations between elements of the enunciation, *across* the frame. The logocentric space of the photographic image is thus superseded by the precarious movement of meaning and being in the space–time of cinema-graphia.

Perhaps the most serious objection to Bazin's interpretation of the evolution of film language concerns the collapse of differences between a theoretical model for cinema and the evolution of genres and styles.[9] For Bazin, the material origin of film in photography determines both the spectator's belief in the truth of the representation and the filmmaker's responsibility to reveal rather than manipulate visual reality through montage. According to this logic, film discourse fulfills its ontological destiny in narrative realism.[10] The ontological argument leads to the marginalization of film styles and genres that break with the model and perpetuates belief in a universal subject of cinema that transcends its inscription in specific films. The concept of cinema-graphia, beginning

[8] *Webster's Third New International Dictionary of the English Language* (Springfield, Mass.: Merriam-Webster, 1986), p. 407.
[9] An important contribution of Christian Metz was the articulation of differences between "cinema" and "film," between the cinema as an abstract system of codes and film as the concrete deployment of codes in discourse. See his *Language and Cinema,* trans. Donna Jean Umiker-Sebeok (The Hague: Mouton, 1974).
[10] See André Bazin, "The Evolution of Film Language," in *What Is Cinema?* vol. I, pp. 23–40.

as it does with a negation of the very idea of an origin of meaning and subject-address, embraces a plurality of film practices and even underscores the futility of one theory or another that would attempt to contain the question of cinema within logical boundaries. By freeing the question of cinema from the question of origins, the notion of cinema-graphia offers a more complex interpretation of the place of film discourse in the history of mimesis and disengages the philosophical question of cinema from the politics of dominant film practice and its others.

The notion of cinema-graphia falls somewhere between theory and practice. On the one hand it suggests the impossibility of locating the question of cinema within a coherent theoretical system; on the other it opens onto a philosophical examination of the force of dynamic spacing, driving the meaning and subject of textual writing. Cinema-graphia thus stems from a critique of a theoretical tradition grounded in the image, a tradition originating in Eisenstein's formalism and leading to Bazin's phenomenology and Metz's psychosemiology.

To the extent that we view film discourse as the realization of a theory of the cinematic, and to the extent that we tie a theory of the cinematic to its technological origins in the photograph, we attribute a false ontological destiny to film discourse: Classical narrative film would embody the aspirations of an entire civilization for a perfect copy. Alternative film practices, in turn, end up in the margins of dominant cinema. Films that expose the effects of the cinematic apparatus on the construction of narrative, thereby exposing an original division of the sign and subject of cinema, take the position of supplements to or perversions of classical narrative cinema, under the guise of "avant-garde" or "experimental" film.

Technical similarities between the photograph and the film image — they are both produced by light touching a chemically treated celluloid surface — must not be mistaken for a *semiotic* similarity. Photography carries a "message without a code,"[11] whereas films produce messages by means of codes governing the organization of point of view, continuity, and rhetorical associations between elements of film discourse. The frame around the photographic image holds vision in the logical and self-sufficient space of Renaissance perspective, whereas the film frame articulates both a break and the melding of a juncture with the context referred to offscreen or in other images. The film frame thus constitutes a figure for an original division of the field and fiction of film space and the subject's implication in that space.

Eisenstein provides a valuable case in point because his theoretical writings, his teaching, and his work in film and theater seem to have played off each other: It is clear that for Eisenstein, artistic practice generated theory, and theory informed artistic practice.[12] Nevertheless, Eisenstein's writings lean toward the Russian formalist project of defining

[11]Roland Barthes, "The Rhetoric of the Image," in *Image, Music, Text,* trans. and ed. Stephen Heath (New York: Hill & Wang, 1977), p. 43.
[12]See the notion of "vertical montage" that Eisenstein developed in tandem with the composition of *Alexander Nevsky* (1938): "Form and Content: Practice," in *The Film Sense,* trans. and ed. Jay Leyda (New York: Harcourt, Brace & World, 1947), pp. 157–216.

the ontological essence and semiological specificity of cinema;[13] they fail to admit the influence of futurist notions such as "trans-sense" that defied logical interpretation and reflected the victory of the senses over language as such.[14] In line with the work of the "Moscow linguistic circle," Eisenstein strove to theorize a linguistic model for cinema and outline codes for producing meaning in film discourse. Though Eisenstein seems to have undermined the photographic model when he defined the single shot as a "cell" interacting with other shots in the complex organism of the film, he also systematically called for the reduction and assimilation of semantic differences and ambiguity into the logic of discourse.[15] Eisenstein also suggested means of explaining the difference between photography and cinema in the notion of conflictual montage, but he privileged the moment in which the conflict between shots is resolved on the level of an abstract meaning or signified.[16]

Ironically, Eisenstein's own films transcend the model and exceed the logic intended by the formal organization of shots. For example, in the opening sequence from *Ivan the Terrible,* the opening titles declare the unification of Russia with the coronation of Ivan. This discourse is subsequently prey to the fragmentation of the enunciation by means of discontinuous editing. As Ivan is crowned, a montage sequence of close-ups on different members of the court, including friend and foe, chops narrative space into units having unclear relations to each other and to the overall space of the coronation. Conflicts on the levels of camera angle, the direction of looks offscreen, and verbal text signal something of the discord facing Ivan, whose coronation marks the beginning of his struggle for unification, not its conclusion. Disjunctive montage builds to a climax in the scene of Ivan's illness, where cuts between eyes looking and objects of the look signify the paradoxical blindness to which the characters looking are prey and also point to the role of the film frame – a figure of absence and blindness – in the very formation of the cinema signifier and subject. This kind of montage throughout the film shifts attention from the depth of the historical narrative to the surface play of cinema-graphia producing the subject and meaning of film discourse.

Whereas disjunctive sound and image montage functions forcefully to dismantle the logic of the single image in the sound cinema, Eisenstein achieves something of this effect in his silent film, *The Battleship Potemkin* (1925). In the famous Odessa steps sequence he intercuts shots of the inexorable movement of soldiers down the steps with close-up shots of victims crouching, waiting, and suffering in locations whose precise relations to the soldiers are not indicated. Eisenstein cuts from the primary,

[13]See, for example, the essays by Eichenbaum, Tynjanov, and Piotrovsky in *Russian Formalist Film Theory,* trans. and ed. H. Eagle (Ann Arbor: University of Michigan Press, 1981).

[14]Boris Eichenbaum discusses the importance of futurism for theories of the purely phonological value of language divorced from meaning in "The Theory of the 'Formal Method,' " in *Russian Formalist Criticism: Four Essays,* trans. and ed. L. T. Lemon and M. J. Reis (Lincoln: University of Nebraska Press, 1969), pp. 106–11.

[15]See Sergi Eisenstein, "The Cinematic Principle and the Ideogram," in *The Film Form,* trans. and ed. J. Leyda (New York: Harcourt, Brace & World, 1949), pp. 28–44.

[16]Ibid., pp. 38–41. The notions of conflict and resolution are further developed in the 1929 article "A Dialectic Approach to Film Form," in *The Film Form,* pp. 45–63.

unifying action of the soldiers descending the stairs to the close-ups without providing the spatial relationship of part to whole. The movement between center and off-center is reiterated by the articulation of mismatched trajectories traced across the surface of the screen as the image cuts between soldiers shooting and their victims. Whereas the movement of the soldiers shapes either a line from top to bottom of the frame or from upper right to lower left on a diagonal with the frame, the composition of the close-ups shapes (either by means of movement or by the direction of looks) lines going in every other direction: diagonally, horizontally, and vertically. This kind of editing decenters vision from the space of narrative to the place of film writing, scattering the look all over the screen. Herein lies the emotional force of this sequence, as the collapse of narrative film space disorients the spectator and highlights the senseless brutality of the soldiers.

Thus the film frame has the potential to deconstruct Renaissance perspective in the manner of Cézanne, not, as Bazin claims, to take up where conventional painting left off.[17] The organization of this sequence also points to a fundamental discrepancy between Eisenstein's theories and his films. Eisenstein's theoretical writings form part of the debate among Russian formalist critics in the 1920s, including Eichenbaum, Tynjanov, and Jakobson, who sought the essence of cinema in both its material and structural specificity and its ability to shape "internal speech," a kind of predicative operation in the spectator.[18] On the other hand, in all of his films Eisenstein takes up problems of the radical art practiced by Meyerhold, Mayakovsky, and other futurists who sought to destroy the conventional meaning of signs in favor of the agitational force of trans-sense, the sensory attraction produced by the clash of artistic forms. In films such as *Potemkin,* the force of the frame undercuts the linearity of discourse, destabilizes spectator identification, and disturbs, in its turn, the predication of meaning by the spectator.

In Eisenstein we discover disparities between theory and practice that problematize his relation to Russian formalism on the one hand and to the aesthetics of Russian futurism on the other. His writings strain toward the elaboration of a science of the signs of cinema that would confirm the unity of the subject and meaning of film discourse. His semiotics would both account for the organization of meaning in specific films and transcend the analysis of specific films and film genres. However, Eisenstein's films demonstrate the difficulty of using the linguistic model to embrace the question of cinema. They indeed pose important questions as to the very notions of the cinematic and the sign of cinema.

[17]Bazin says: "So, when form, in the person of Cézanne, once more regains possession of the canvas there is no longer any question of the illusions of the geometry of perspective. The painting, being confronted in the mechanically produced image with a competitor able to reach out beyond baroque resemblance to the very identity of the model, was compelled to the category of object." *What Is Cinema?,* p. 16.

[18]Eichenbaum defines the tasks of montage in "Cinema Stylistics": "In order to study the laws of cinema (and in the first place, of montage) it is very important to realize that the perception and understanding of films is inseparably linked to the formation of internal speech, which chains the individual shots together. . . . One of the principal concerns of the director is to create things in such a way that the shot 'reaches' the viewer, i.e. that the viewer figures out the significance of the episode, or, in other words, translates it into the language of his own inner speech." In *Russian Formalist Film Theory,* trans. and ed. Herbert Eagle (Ann Arbor: University of Michigan Press, 1981), p. 62.

Ivan the Terrible, for example, calls not so much for a formalist approach as an approach that would tease out the disturbing effects of cinemagraphia on the coherence of the subject and meaning of film discourse.

Although problems of meaning and subject-address were already being raised by neoformalists in Prague in the 1930s, including Jakobson, Tynjanov, and Mukarovsky,[19] Jacques Derrida has developed these kinds of problems into a full-blown critique of the metaphysical assumptions shaping structural linguistics.[20]

Derrida challenges the metaphysical assumption of an original unity of meaning and being in discourse and suggests means of introducing the effects of passion, irony, and ambiguity into the semiotic study of representation. He thus enables us to locate the limitations of (Saussurian) sign theory for the study of cinema and to resolve the conflict between theory and practice in Eisenstein. "Deconstruction" is Derrida's term for the critical maneuver that reveals the moment of negation inscribed in any notion of presence, including the presence of the subject to consciousness as the condition of possibility of meaning, the presence of signifier to signified, and the presence of reality to perception. Deconstruction calls into question metaphysical hierarchies that allow self-presence, meaning, and reality supposedly to transcend the moment of their inscription in representations. Derrida argues that because metaphysical philosophy defines being with reference to its other (nonbeing), defines the meaning of discourse with reference to its negation in graphic notation, and defines reality in terms of its capacity to be copied in representations, then nonbeing, writing, and representation can no longer be considered supplements to an original reality or perversions of an original closure of the subject in spoken discourse, but as moments in the very constitution of the subject and signified of discourse.

Derrida's notion of textual writing as "the becoming-space of time and the becoming-time of space"[21] accounts for those aspects of texts that elude codification, segmentation, and binary classification, aspects that defer indefinitely the full presence of a signified to consciousness.

Spacing as writing is the becoming-absent and the becoming-unconscious of the subject . . . and the original absence of the subject of writing is also the absence of the thing or the referent.[22]

Such aspects do not constitute transgressions of the code in its textual deployment (which are nonetheless a function of the code), but trace the movement of difference producing the enunciation.

Derrida criticizes Saussure in terms of the problem of origins. By constructing a model for semiosis according to the presence of a concept to a phonetic signifier, Saussure perpetuates, in the realm of linguistics, the Platonic ideal of closure between meaning and voice produced in spoken discourse. Writing, the visual, externalized articulation of signifiers in space, outside the body, occupies a position of marginality if not

[19]See, for example, Peter Steiner, ed. and trans., *The Prague School Reader* (Austin: University of Texas Press, 1982).
[20]Jacques Derrida, *Of Grammatology,* trans. Gayatri Chakravorty Spivak (Baltimore: Johns Hopkins University Press, 1976).
[21]Ibid., p. 68.
[22]Ibid., p. 69.

downright subversion in this system,[23] for writing is considered not only a cheap imitation of voice in the Platonic tradition but also a dangerous supplement to spoken discourse – dangerous because witness to the troubling division between inside and outside upon which being, meaning, and speech are contingent.[24] Derrida's notion of a textual "writing" that includes not simply graphic recording or imitation of speech but also the process of semiosis, which delays indefinitely the full presence of a signified to a signifier, posits a fundamental shift in our understanding of representations. "Writing," the process by which a signified becomes a signifier for another signified, and so on indefinitely, would constitute a model for a general semiotics or grammatology and would embrace linguistics, rather than being modeled after linguistics.

In the section of *Of Grammatology* entitled "Writing Before the Letter," Derrida draws attention to the ideogram – an alternative to the linguistic sign as a model for semiosis occurring in space, outside the body, in a visual medium. Each ideogram taken in isolation has a meaning based upon its iconic function – for instance, a figure of a dog. This signified becomes a signifier in its turn in a kind of chain reaction. Ideogrammatic writing produces meaning across relations of difference between ideograms organized in time and space. In ideogrammatic writing the movement of *différance* traces the disappearance of a signified in its emergence as a signifier, and the anticipation of a future signified in the appearance of a new signifier, and so on ad infinitum. For example, the figure of the dog becomes a signifier for a new meaning when juxtaposed with a figure of a mouth, signifying "bark." In this way ideogrammatic writing defers the presence of meaning and the unity of the subject of discourse indefinitely.[25]

For sign theory, in the beginning is the concept, married to a signifier by social convention. For a theory of textual writing, the tracing of an absence/presence in the enunciation replaces the transcendental signified as the origin of semiosis: In the beginning is a play of *différance* constructing and deconstructing the subject and meaning of discourse. The focus on the movement of difference in film montage would resemble Derrida's focus on the articulation of difference and the deferral of meaning in textual writing. Because the film image is "meaningful" only by way of the relations of difference and/or conflict it engages with other images, the film image is closer to the ideogram than to the Saussurian sign. At the origin of film discourse is montage or film writing, which in turn produces the concept. As Eisenstein puts it, "Montage is an idea that arises from the collision of independent shots."[26]

By foregrounding parallels between the ideogram and the film image, Eisenstein himself shows how the "concept" is not indissolubly tied to a signifier in the cinema as it is in the linguistic sign, but is the result of

[23]Ibid., p. 8.
[24]Ibid., p. 149.
[25]Marie-Claire Ropars-Wuilleumier cites Gelb, who clarifies that some ideogrammatic systems, such as Chinese, are more conventional and phoneticized than others, such as Aztec hieroglyphs, and are thus less vulnerable to the pull of the figurative dimension. *Le Texte divisé* (Paris: Presses Universitaires de France, 1981), pp. 28–63.
[26]Eisenstein, "A Dialectic Approach to Film Form," p. 49.

the combination of images created by montage. In "The Filmic Fourth Dimension," he says that

the film-frame can never be an inflexible letter of the alphabet, but must always remain a multiple-meaning ideogram. And it can be read only in juxtaposition.[27]

Eisenstein demonstrates how the concept is in fact produced by the rhetorical association of two or more filmic elements in montage. Whereas at face value the notion of a dual signifier would appear to favor a deconstruction of the linguistic sign, Eisenstein does not capitalize on the instability of meaning and being implied by montage, but focuses rather on the reduction of ambiguity and instability in visual representation by means of markings for the precise interpretation of any filmic figure. In this sense Eisenstein anticipates Gérard Genette's structural model for the "poetic sign" that defines a kind of marriage between metaphorical figures and their meanings.[28]

In the essays collected in *The Film Form, The Film Sense,* and *Non-indifferent Nature,*[29] Eisenstein does not undermine sign theory, but creates a metalinguistic model for signification in cinema based upon the imitative relation between poetic signifier and signified. In this sense Eisenstein's semiotics is clearly in line with a formalist poetics of cinema. He begins by clarifying differences between words and images in order to arrive at an understanding of how filmic figures signify like words. Signs signify by shaping coded relations between a concept and a sound. Film images signify only by means of internal (in the composition of the shot) and external (in juxtaposition with sounds or other images) relations they engage with other terms of the enunciation.

The early Eisenstein places more emphasis on the play of conflict between or within shots than does the later Eisenstein. A "dialectic approach" to film form, according to his 1929 article, produces rhythms, tensions, and dynamism that cannot be reduced to a simple signified.[30] The later Eisenstein argues rather for the ability of cinema to produce abstract concepts in the manner of linguistic discourse.[31] Whereas film images, in a general sense, imitate their objects, images juxtaposed in montage signify meanings that cannot be reduced to the sum of the two images taken individually. Hence Eisenstein's famous formula "one plus one equals three" describes the imitation of meaning in the filmic figure.

Representation A and *representation* B must be so selected from all the possible features within the theme that is being developed, must be so sought for, that their *juxtaposition* – that is, the juxtaposition of *those very elements* and not of alternative ones – shall evoke in the perception and feelings of the spectator the most complete *image of the theme itself.*[32]

Whereas the linguistic sign joins a signifier and a concept, the semiotic function of cinema creates a concept by the association of two signifiers. Eisenstein does not "deconstruct" the signifier–signified relationship in-

[27]"The Filmic Fourth Dimension," in *The Film Form,* p. 65.
[28]Gérard Genette, "Langage poétique, poétique du langage?" in *Figures II* (Paris: Editions du Seuil, 1969), pp. 123–43.
[29]Sergei Eisenstein, *Nonindifferent Nature,* ed. Herbert Marshall (Cambridge University Press, 1987).
[30]Eisenstein, "A Dialectic Approach to Film Form."
[31]Eisenstein, "Word and Image," in *The Film Sense,* pp. 3–65.
[32]Ibid., p. 11.

itiated in the linguistic model, does not highlight the underlying duality of the cinematic signifier, but distinguishes cinema from language on the basis of the ways they both produce closure between the form and meaning of discourse. Whereas the signifier–signified relation is codified in language, this relation is motivated by the discourse in cinema, producing the kind of mimetic relationship that would later define the "poetic sign," the cornerstone of structural poetics.

Because the cinematic "signified" is produced by means of a dual signifier (the association of two or more elements according to similarity, contiguity or conflict), from the start, the process of signification in cinema is inscribed with division and threatened with erasure. Thus cinema may well outweigh literary discourse as a model for the kind of writing Derrida defines as "the becoming-space of time, the becoming-time of space."[33] Eisenstein, in any case, does not develop or highlight this aspect of cinema in his writings. Though on a purely formal level Eisenstein suggests a theory of film writing when he opposes a visual model to the phonetic sign, though he privileges an economy of difference as the source of meaning in cinema, and though he emphasizes the kinesthetic function of film form, a closer look at the essays reveals the structuralist bent of this model, this economy, and this kinesthesia.

If we were to locate a "Derridian" gesture within Eisenstein's poetics, we would have to focus on the extent to which Eisenstein seeks to suspend closure between cinematic figuration and its meaning in order to delay indefinitely the full presence of a signified to consciousness. Ironically, differences between Eisenstein and Derrida are nowhere more evident than in their different interpretations of ideogrammatic writing. In Derrida's critique of Saussure, the ideogram serves as an alternative to the phonetic sign as a model for semiosis. Ideogrammatic writing upsets the metaphysical hierarchies that posit unity, self-presence, and logic as origins by introducing the supplement, the graft, the outside into the inside of meaning.[34] For Eisenstein, on the contrary, the ideogram is not the site of a deconstruction of meaning, presence, or being. His reference to ideogrammatic writing usually is shaped within an ideal of closure between form and meaning in filmic figures. In the following statement, Eisenstein provides a cinematic variation on the "dominant," the semantic element that would reduce polyvalence, attempt to close the space separating signifier and signified in film time, and focus attention on the linear, logical development of meaning in ideogrammatic discourse:

[the montage cell] can only be read in juxtaposition, just as the ideogram acquires its specific significance and even pronunciation . . . only when combined with a separately indicated reading – an indicator for the exact reading – placed alongside the basic hieroglyph.[35]

Thus Eisenstein's use of the ideogrammatic model differs radically from Derrida's by accenting the process by which a single meaning prevails over the systematic destabilization of meaning in textual writing. Moreover, Eisenstein minimizes the sequential and spatial aspects of

[33]See Jacques Derrida, "Writing Before the Letter," in *Of Grammatology,* p. 68.
[34]Derrida, *Of Grammatology,* p. 26.
[35]Eisenstein, "The Filmic Fourth Dimension," pp. 65–6.

filmic figures by privileging the moment in which terms of the figure are superimposed in the mind because of the persistence of the first term on the retina. In this moment, commonly known as the persistence-of-vision phenomenon, the spatial duality of the cinematic signifier (the two terms of the figure) and the delayed time of the production of a cinematic signified (the time of the projection) are resolved in the full present and presence of a signified to consciousness. Eisenstein supports this notion with reference to the illusion of movement produced by the rapid succession of segments of an action in the projection:

> For in fact, each sequential element is perceived not *next* to the other, but on *top* of the other. For the idea (or sensation) of movement arises from the process of superimposing on the retained impression of the object's first position, a newly visible further position of the object. . . . From the superimposition of two elements of the same dimension always arises a new, higher dimension.[36]

He continues:

> In another field: a concrete word (a denotation) set beside a concrete word yields an abstract concept – as in the Chinese and Japanese languages, where a material ideogram can indicate a transcendental (conceptual) result.[37]

At this juncture it is important to distinguish between Eisenstein in theory and Eisenstein in practice. I have already shown how the practice of cinema-graphia dislocates the sign and subject of cinema in Eisenstein's films themselves. Whereas the films systematically demonstrate the difficulty of containing film semiosis within sign theory, Eisenstein's writings fit squarely within the historical and theoretical continuum leading from the work of the Moscow linguistic circle to the work of Christian Metz and the French structuralists.

Furthermore, the ideogram is not an appropriate alternative to the linguistic sign, because the ideogram, like the Saussurian sign, fails to account for the dual function of the film image. The film image not only copies its object more nearly perfectly than any other mode of representation but also points to the former presence of the object before the camera and implicates the spectator's look in the camera's point of view. Thus the film image is not simply an icon, a means of representing an object according to imitation, but an index. As an indexical icon, the film image both produces a perfect copy and also inscribes subject-address, point of view, and reference in film discourse.[38]

To the extent that Eisenstein sought a theory of film language that would possess the rigor of linguistic discourse, he obscured the problem of the difference between narrative "voice" and image, between index and icon, that constantly threatens to undermine film discourse.[39] Moreover, in the "Statement on Sound," where Eisenstein, Pudovkin, and Alexandrov anticipated a decline of film art and a return to naturalism with the introduction of sound in the 1930s, in no sense did these authors advocate the articulation of the difference between sound and image

[36]Eisenstein, "A Dialectic Approach to Film Form," p. 49.
[37]Ibid., p. 50.
[38]Umberto Eco defines indexical icons in the framework of an interpretation of Peirce in *A Theory of Semiotics* (Bloomington: Indiana University Press, 1979), pp. 151–313.
[39]Derrida locates this kind of discord in spoken discourse itself. See Derrida, *Of Grammatology*, pp. 55–7.

tracks in terms of a doubling of narrative point of view.[40] Whereas they called for an expressive use of sound that would have an independent semantic function (rather than simply accompanying the visuals or imitating theatrical dialogue), the relation between sound and image was to be dialectical inasmuch as it shaped a synthesis of formal and semantic conflicts in a given sequence.

The reduction of the fundamentally unruly, disjunctive, and fragmented elements of cinema to the rigor and coherence of linguistic discourse seems a betrayal of the promise of cinema, rather than its fulfillment. Although theories of the origin – the origin of film in the photograph, the origin of narrative closure in visual perception – support the view that cinematic discourse constitutes but another stage in the human quest for a perfect copy, such theories can also be interpreted in the framework of a culturally and ideologically determined ideal of the form and function of representation, namely Aristotelian poetics.[41] The Aristotelian model for mimesis reduces disjuncture, discontinuity, and difference to the rigor of a well-formed plot, in keeping with a reduction of the plurality of culturally determined subjectivities to the monolithic order of man. "The play's the thing" in *The Poetics:* By eliminating theatrical performance from the realm of poetics, Aristotle elides the question of the spectating subject's production in the time and space of visual representation. Aristotle posits the purity of the undivided subject of poetic discourse by privileging the internal closure between sounds and meanings in a kind of internal speech.[42]

Because the cinema signifier is not a conventional sign, but an indexical icon, the philosophical implications of cinema-graphia can perhaps best be understood with reference to Derrida's critique of classical mimesis. In *Dissemination,* Derrida shifts attention away from the ideal closure of the dramatic text to the subject's performance in textual writing. Theater is a metaphor for the staging of the subject in the space of the poetic text by means of deixis.[43] Because this staging does not operate by making present a signified in a signifier, but by tracing the presence/absence of the subject in the markings for subjectivity and reference in discourse, it resembles the working of the mime play or *mimo-drame.* As a model for the inscription of the subject-traces in discourse, the mime play reconciles the separation between text and performance, between the representable and the unrepresentable, that semiotic theory traditionally maintains.[44]

In this account of mimesis the figure of the double consists not of the copy but of the boundaries joining/separating the actor and his role,

[40]S. Eisenstein, V. I. Pudovkin, and G. Alexandrov, "Statement on Sound," in *The Film Factory,* trans. Michael Taylor, ed. Ian Christie (Cambridge, Mass.: Harvard University Press, 1989), p. 234.
[41]Aristotle, *The Poetics,* trans. James Hutton (New York: Norton, 1982).
[42]Ibid.
[43]As Alessandro Serpieri et al. claim in another context, "Theatrical discourse makes explicit a drama inherent in every deictic utterance, a drama diachronically traceable and underlying the very grammar of the language." "Toward a Segmentation of the Theatrical Text," *Poetics Today* 2, no. 3(1981):174.
[44]See, for instance, Keir Elam, *The Semiotics of Theater and Drama* (New York: Methuen, 1980), pp. 32–97.

joining/separating male and female, past and future, subject and object. The articulation of these junctures in the enunciation manages to delay indefinitely the full (re)presentation of a signified to consciousness, hence to suspend the subject's closure with the discourse. By drawing attention to the (de)construction of the subject in the (non)signifiers articulating the terms of the enunciation, such a poetics perverts the Platonic ideal of mimesis by catching the subject in a hall of mirrors that confuses origin, presence, and the "real" with the supplement, absence, and imitation. This approach replaces the metaphysical ideal of the perfect copy with the paradoxical figure of the hymen, "tainted with vice yet sacred, between desire and fulfillment, perpetration and remembrance: here anticipating, there recalling, in the future, the past, under the false appearance of a present."[45]

In *Screen/Play,* Brunette and Wills take up the problem of mimesis as a means of locating the Derridean critique within film theory. They orient their study around a critique of the mirror joining the image and its referent.[46] The play between the conventional term "screenplay" and the neologism "screen/play" signifies a movement between verbal text and performance in film writing and dismantles the hierarchy in which the written text claims a status of origin. The film screen is posed as the locus of a problematic of mimesis − of imitation lacking an anchor in transcendent reality, of a pure movement of the trace. "We shall not hesitate to call cinema the deconstruction of the mimetic operation rather than the confirmation of it, and it is in this sense that the screen can be called a hymen."[47] The figure of the hymen stands not so much for the biological realm of feminine desire as for a position toward theories constructed around an assumption of the original unity of the subject and meaning of poetic discourse.

Whereas the notion of "screen/play" charts a significant departure from a tradition of film theory grounded in the photographic image, the concept of cinema-graphia suggests an even more radical move, because it questions the very possibility of locating the site of the subject's construction and deconstruction in film space at all.[48] In this context, the hymen corresponds to the elusive trace of the film frame joining/separating elements of the film chain, constructing/deconstructing meaning and subject-address in film discourse. Cinema-graphia traces the slips and slides of meaning and subject-address across the film frame and reveals the fragile hold of logic over the unruly nature of the cinema signifier.

The cinema, even more than literature, seems to invite this kind of approach, because the movement between desire and fulfillment, be-

[45]Derrida, "The Double Session," in *Dissemination,* trans. B. Johnson (Chicago: University of Chicago Press, 1982), p. 175.

[46]Peter Brunette and David Wills, *Screen/Play: Derrida and Film Theory* (Princeton: Princeton University Press, 1989).

[47]Ibid., p. 85.

[48]In the chapter "Film as Writing" in *Screen/Play,* Brunette and Wills come closer to the notion of cinema-graphia when they rescue the cinema from the traditional realm of analogical representation or mimesis and posit a cinema of anagrammatical representation. While analogic representation copies the thing represented, anagrammatic representation simultaneously copies and works against the grain of the thing represented. "Anagram is the outer limit of the relation between speech and writing, the figure of excess, the hymen of mimesis with radical shift or difference" (p. 89).

tween anticipation and memory, past and future, male and female, goes into the very constitution of the cinematic apparatus. For Metz, the primary identification of the spectator with the film image by means of the look parallels the child's identification with his or her other and the (m)Other in the mirror phase of development and constitutes the sine qua non of secondary identification, the moment when the spectator internalizes the subject-positions of characters in the diegesis.[49] The imaginary mirror holding together eye and I guarantees the logic of narrative film discourse. Thus Metz, like Bazin, seems to privilege narrative closure with a kind of inevitable destiny shaped by the cinema's ontological and technological foundations.

The notion of cinema-graphia locates the question of cinema in the spaces between the terms of the enunciation, with those traces of non-presence variously called the splice, the cut, or the frame depending upon whether one is referring to the articulation of difference or the melding of a juncture, or to the outside or inside of cinematic representation. This shift in focus entails an even more important departure from structural theories of narrative oriented around the "suture." "Suture," a term borrowed from psychoanalysis to name the spectating subject's implication in continuity editing that closes gaps in the enunciation, locates the subject in the folds of the film as the guarantee of the fullness and coherence of discourse.[50] Cinema-graphia, on the other hand, names the endless production/deconstruction of the meaning and subject of film discourse across the film frame. In this context, the categories of primary and secondary identification,[51] of origin and supplement, of reality and representation, lose their meaning. Cinema-graphia shatters the mirror in which the subject is held as a unity by defining the image as a trace for another image, a moment in the relentless movement of semiosis across the frame. In this sense, the cinema, rather than realizing the aspirations of classical mimesis, exposes mimesis as the endless pursuit of an illusion: imitation imitating itself.

Film practices that expose the performance of the subject of the enunciation in the cut/splice/frame tracing the work of semiosis in film discourse would not constitute aberrations of a norm or violations of a promise of specular plenitude. The films of contemporary filmmakers such as Duras, Godard, and Tarkovsky, for example, reveal the mise-en-scène of radical politics implied by the very notion of writing and are witness to the original doubling of meaning and being in representation.

Eisenstein's films were censored specifically with reference to their difficulty for the spectator, or, in Russian formalist terms, for their celebration of the trans-sense dimension of film form at the expense of internal speech.[52] After the 1960s, Soviet filmmakers took up problems of the political dimension of film form where Eisenstein left off in the

[49]Christian Metz, *The Imaginary Signifier,* trans. Celia Britton, Annwyl Williams, Ben Brewster, and Alfred Guzzetti (Bloomington: Indiana University Press, 1982).
[50]Stephen Heath discusses the psychoanalytical implications of the Oudart and Metz "suture" in "On Suture," in his *Questions of Cinema* (Bloomington: Indiana University Press, 1981), pp. 76–112.
[51]See Metz, *The Imaginary Signifier,* pp. 155–6.
[52]Eichenbaum states that "without [the formation of internal speech], only the trans-sense elements of cinema would be perceived." Eichenbaum, "Cinema Stylistics," p. 62.

1940s, only to be censored during the Brezhnev regime, but recently rehabilitated under *glasnost*.[53] Whereas Eisenstein did not anticipate the philosophical implications of cinema-graphia for the sign and subject of cinema, filmmakers such as Askoldov, Abuladze, and Tarkovsky manipulate montage precisely to criticize history in the context of a critique of mimesis and its subject.

Andrei Tarkovsky (1932–86) is an important case in point. Tarkovsky pushed montage beyond its subservience to discourse per se in order to dismantle the logical priorities of the dominant ideology. Specifically, in a film entitled *The Mirror* (1975), Tarkovsky deploys codes conventionally used to guarantee narrative closure in cinema only to short-circuit the code and elude the formation of a definitive meaning or reference of discourse.

The film is about the representation of memory and utilizes time frames overlapping three generations located roughly during the periods of the Russian Revolution, World War II, and the present. This overlapping is achieved by means of quick cutting between scenes from the narrator's (Aloysha's) past. In a typical sequence, located in the time of the youth of Aloysha's parents, his father asks his mother, "What do you want, a boy or a girl?" The image holds for a long time on the mother's face, waiting for a response. She looks offscreen in the direction of an open field; then the film cuts to a medium close-up of her grown son in another time frame, himself looking back at the camera as if to meet his mother's look across an expanse of some twenty years. Moreover, as the film cuts from the mother looking offscreen to the shot of Aloysha "looking back," the meaning of the sequence moves from the depth of the diegesis to the surface of cinema-graphia. This shift is marked by a dramatic visual contrast: Whereas the scene between Aloysha's parents was shot in color, the image of Aloysha was shot in monochrome, with high contrasts between black and white, giving an eerie, unearthly cast to that "vision." The film itself answers the question his mother fails to answer by presenting the son as a fait accompli. As her look seems to meet her son's look in a different time and space, codes for organizing *spatial* continuity between shots in the cross-cut bridge the time gap in a sort of "future past tense" of cinema. Tarkovsky appropriately names this kind of montage "sculpting in time."[54]

Tarkovsky molds time according to the dictates of the film's memory, producing a film that seems to turn inward, to take the spectator inside the mind's eye of the camera-cum-narrator's "I." To the extent that the force of cinema-graphia systematically deconstructs codes for narrative continuity, the position of the narrating I/eye constantly shifts between various planes of film space–time, eluding a stable hold on the events of the narration. The movement of the narrative point of view dislocates the position of spectating I/eye in turn. The spectator no sooner finds a footing in the events of the fiction than the editing breaks the terms of scopic identification and opens up yet another space–time and yet

[53]Anna Lawton discusses changes in film production and distribution in the Soviet Union since *glasnost* in "Soviet Cinema Four Years Later," *Wide Angle* 12, no. 4(1990):8–25.
[54]Andrei Tarkovsky, *Sculpting in Time* (New York: Knopf, 1987).

another locus in which the spectator must insert himself or herself. The intrication of narrating and spectating subjectivities never quite achieves a coherent unity in the present and presence of the film image, but follows a movement without origin, present, or presence, a movement that perpetually postpones the closure of I and eye to an unlocatable future-past. The endless movement between desire and fulfillment, between anticipation and remembrance in *The Mirror* is dictated by the film frame marking junctures between vision and blindness, between reality seen and imaginary scene in film discourse.

Although it could be argued that Tarkovsky did not invent this type of film montage – Alain Resnais, for example, had made similar use of narrative codes in *Hiroshima Mon Amour* (1959) – Tarkovsky's style takes on important political implications in the context of Soviet semiotics and politics. The problem of relations between semiotic codes and the production of internal speech in the reader or spectator claims unusual importance in Soviet semiotics, from the inaugural period of Russian formalism to the present day.[55] Thus Eisenstein's theorization of the precise marking that would reduce a filmic figure to the desired ideological meaning[56] and Eichenbaum's designation of the cinema as an art form "grandiose in its prospects for influencing the masses"[57] are symptomatic of the political appropriation of the form and content of film discourse. In this context the political censorship of Tarkovsky comes as no surprise. Tarkovsky's poetics challenged dominant theories of the Soviet subject and meaning of film discourse, inasmuch as it replaced the ideal of the unified meaning and subject of internal speech with the real division and fragmentation of the subject in the space–time of cinema-graphia. Moreover, by doubling indefinitely the subject-position of the film narrator, Tarkovsky rewrote the problem of the socialist realist hero, the universal Soviet Man, in terms of the troubling question of the personal and historical identities of contemporary Soviet men and women.

This brief encounter of Eisenstein and Derrida suggests important ways in which history, theory, and film practice converge the moment film criticism moves away from the limiting framework of the ontological, mimetic model. The notion of cinema-graphia provides means of addressing important questions as to the history of film theory, the theory of filmed history, and the relation of film theory to practice. By situating cinema semiotics within the critique of the metaphysical foundations of structural linguistics and poetics, the study of cinema-graphia leads the question of cinema into broader debates about the representation of history, the history of representation, and the place of cinema in those debates.

[55]Juri Lotman, for example, reviews problems of internal speech for Soviet theory in "Two Models of Communication," in *Soviet Semiotics,* trans. and ed. Daniel P. Lucid (Baltimore: Johns Hopkins University Press, 1977), pp. 99–102.
[56]Eisenstein, "The Cinematic Principle and the Ideogram," p. 37.
[57]Eichenbaum, "Cinema Stylistics," p. 58.

HERMES GOES HOLLYWOOD: DISARTICULATING THE COPS 'N' ROBBERS GENRE

TOM CONLEY AND JOHN M. INGHAM

ONE wonders nowadays if popular culture has become an invention of higher education. Jacques Derrida probably would argue that the learned and popular worlds have always been two sides of the same surface. If so, it can be wagered that Hollywood producers seek profit from everyone who pays money both to enjoy and to analyze their films. In the same malls are seated everyday viewers, film historians, critics, ethnographers, and adepts of deconstruction. Viewing would seem to be preempted by the strategies of the industry. In this collection of essays on deconstruction and the arts, the stakes involve the invention of a type of viewing that allows spectators to reduce to a minimum their roles as consumers. The viewer is asked to disengage from single films whatever is needed to dispense with review of many others.

We should first remark that, as the final pages of Peter Brunette and David Wills's *Screen/Play* contend, collaborative research summons issues of origin, style, signature, dialogue, and orientation. Upon cursory view, if discourses of anthropology and deconstruction were compared, one mode would quickly be taken seriously and the other seen as gay, unreliable, or contorted. Differences of style and orientation would require renewed appraisal of what Jacques Derrida long ago remarked about affinities of deconstruction and ethnography. Anthropology would tend to locate its observations outside their field of articulation. Like any other discipline, anthropology could be deemed logocentric wherever it projects its conclusions outside of language or does not account for its own investments in the materials it studies. Deconstruction, impoverished in respect to a body of work or canon it can call its own (since it mostly pertains to methodology), would study the philosophical and discursive bases of any science by heeding the ways "institutional styles" betray practices and agendas. Our work that follows is located squarely in the tensions of the two adjacent disciplines. Our intention is not to dwell on the merits of one practice as opposed to another. We prefer to see how collaborative endeavor can disarticulate a genre – the cops 'n' robbers film – and how, through the temper of analysis, a nascent politics of analysis can emerge.

A term at the core of the problem is *desire*. In his writings on psychoanalysis, Derrida suggests that in our culture desire is mistaken either as a transcending truth or as a subject's critical agency: To desire is to

be human, to strive for the ends of an illusion (or vision), but to be human is to feel real or self-present. In mass media, desire conveys scenes of epiphany and sublimity that allow consumers to go above and yet descend into "events" that make up the hills and valleys of "life itself." Desire can be generated by its own doubling, or by a "desire to desire" at the same time it is born of a will of negation, through a subject's "desire not to desire."[1] In the same vein, popular culture deploys narrative mechanisms that elicit and direct affect in both directions at once, toward *more* desire (by virtue of plot lines that cannot end, thus prompting spectators to buy tickets for more films) and toward *less* (with false endings that resolve enigmas and bring ambivalence to a terminus at once sought and avoided, hence prompting purchase of tickets for more films).[2] Seen in these tourniquets, desire is co-opted.

Now if desire were replaced by Freud's concept of *Trieb* or drive, narrative would have to be understood as whatever semiotizes force for ideological ends. Narrative is synonymous with framing insofar as artificial limits are imposed. Manipulation of visible borders produces separation and difference that also inspire narrative. Diegesis (narrative) and mimesis (framing) appear to be agents aimed at transforming force into desire. Derrida shows that desire is elicited by way of framing, a means of producing *effects* of truth, castration, or absence.[3]

The difference between desire and drive will serve to theorize a relation of narrative and framing. That relation can serve, too, as a mode of entry to *Beverly Hills Cop*. Desire pertains to the narrative, but is glimpsed everywhere through structures – at once cinematic and economic – that display choices of inclusion and exclusion. For this reason the plot of the film can be easily summarized, whereas, as we shall note, its modes of framing require more extensive discussion.

Axel Foley (Eddie Murphy), about whom the film turns, engineers a deal with a hooligan who is delivering two truckloads of contraband cigarettes at a pickup point in an alley in Detroit. The police arrive. After a frenzied chase, Foley is arrested by his own cohorts. Admonished by the lieutenant, the hero is told to "go home." Returning to his apartment, he meets Mikey Tandino (James Russo), a friend and car thief from times past. Mikey has stolen bonds from the warehouse of the eminent Hollis Benton art gallery in Beverly Hills, where he is employed as a security guard. No sooner do the men revive memories of

[1]Elaborated in Piera Aulagnier, "Désir, demande, souffrance," part two of *Un Interprète en quête de sens* (Paris: Ramsay, Coll. Psychanalyse, 1986), pp. 143–264, esp. 168–71.

[2]"Narrative and its critical apparatus tend to presuppose an ontology of division of the two kinds just noted. In his preface to Didier Coste, *Narrative as Communication* (Minneapolis: University of Minnesota Press, 1989), Wlad Godzich insists that a "cleaved consciousness" (p. xiii) remains at the origin of narratology. When Tzvetan Todorov invented the term "narratology," he was responding to the "hope, or perhaps more accurately, *desire* to lift all literary and cultural studies to the dignity of science" (p. ix, emphasis added). Desire thus stands even at the origins of the science of narrative.

[3]As Leo Bersani and Ulysse Dutoit note in comparing the Nürnberg parade in *Triumph of the Will* to narrative, "the military march could be thought of as a simplified display of certain narrative principles. The march abstracts from any narrative content the formal narrative principle of an ordered succession or unfolding, and in so doing it suggests that the pleasure of following a narrative lies less in the story being told than in the security of being passively carried along by an unfolding order." *The Forms of Violence* (New York: Schocken Books, 1985), p. 87.

TOM CONLEY AND
JOHN M. INGHAM

a dubious past and of a common friend, Jenny Summers (Lisa Eilbacher), than Foley is mugged and Mikey is murdered. Determined to solve the crime, Foley drives to Beverly Hills. Thanks to Jenny, a secretary in the Benton gallery, he learns the name of the owner, Victor Maitlin (Steven Berkoff). Because Foley disrupts the order of investigation in the town, the Beverly Hills Police Department tries to restrain him from continuing with his free-lance detection. Only when Foley convinces the police that Maitlin uses art to launder a cocaine-smuggling operation, and that Mikey was indeed murdered by Maitlin's henchmen, do the police turn against the criminal. Lieutenant Bogomil (Ronny Cox) kills Maitlin at the moment Foley faces him in a standoff in a hallway of his mansion. The lieutenant and sergeants Taggart (John Ashton) and Billy Rosewood (Judge Reinhold) lie to the chief of police (Stephen Elliott) about what happened and are congratulated for their heroism.

The narrative leads to the resolution of the crime with Aristotelian precision. But the modular construction of the narrative discloses a pattern of redundancy and amplification. Each of its episodes reiterates the elements of what preceded. However, one short sequence strikes the viewer as a moment that, by contrast, displays the film's overall composition. When Mikey avows his love for Foley, just before the wretch is abruptly murdered, the two characters embrace. The filmic style diverges from the prevailing deep-focus photography and fast-paced editing. With sixteen extreme close-ups the film counterpoints itself as if to insist on a *truth* that is born of the protagonists' attraction for each other. The sequence appeals to what collective advertising exploits in repetitious shots of emotive hugs, where the magic words "I love you" are uttered in soft focus to convey an intimate and everlasting bond. When the two men hold each other in their arms, they signal that a commercial "spot" is being placed within the film and that its structure will determine a good portion of the narrative.

When Foley asks Mikey why he covered for his friend during a former theft, Mikey confesses that it was because he "loves" Foley. The hoodlum exudes emotion while the hero expresses affable curiosity. Recourse is had to classical editing, the shots cued to change with the speech-*on* of each interlocutor. Lip-synch conveys expression of fraternity that stretches over and across the line of the law. With "I love you," an aura of desire is patented, but only to threshold the opposite (or identity) of murderous violence. For an instant, two races are united, and so are the roles of criminal and cop. Where the visual style changes, an erotic structure is sighted – and confirmed – at the instant the couple is broken asunder. Right after the men share an affective exchange, sadism ensues.[4] The replacement of affection by aggression follows a visual

[4] The scene is hardly new. Sadism is substituted for sexuality in a stereotypical scenario that Gershon Legman had mapped through American popular culture long ago. As of 1930, the mass media, he stated, were feeding a fantasy of death and torture to children in doses so great that they could be seen as an institution replacing official forms of schooling. By being fed blood, the child "can be drugged into acquiescence while we break his spirit, distort his bones and his character and, in a word, civilize him. Fantasy violence will paralyze his resistance, divert his aggression to unreal enemies and frustrations, and in this way prevent him from rebelling against parents and teachers busy abnormalizing him." *Love and Death: A Study in Censorship* (New York: Hacker Art Books, 1949), p. 32. Legman

pattern of rupture, not unlike substitutions in advertising that foreground an erotic play before putting the name of a product in its place. That name is a signature that will be taken or purchased outside of any dialogic conflict that might impugn its essence.

Paradigmatic of the entire film, the shift from love to violence determines the narrative order. Each sequence is patterned according to an accretion of desire and affect that is immediately replaced with signs of murder. When Foley leads sergeants Taggart and Rosewood into the nightclub where a disco-stripper jumps and curls around a barber pole (to the tune of "Nasty Girl"), the visual plane raises tension according to the same model. The three men are seated below the stripper, in whose G-string Rosewood stuffs some bills. Foley is framed in frontal view, such that his interlocutor can be both the sergeants and the viewers. He utters, "You don't have to be embarrassed if your dick is hard." A few seconds later the sequence ejaculates with gunfire.

The narrative of the displacement of affect by violence appears to be coordinated with the inscription of rebuses of trademarks.[5] Brand names articulate many of the elements of the story line. The film opens in the deep corridor of an alley when the first hooligan and the hero bicker over a shipment of boxes of contraband loaded in the semitrailer. Deep-focus shots establish a frame of the four walls that gives onto the corridor of the alley. In one-point perspective, the lines of the street converge from opposite sides to an axis that a police car comes to occupy (from the right, and then back to the left) as the two interlocutors – one black, one white – do their business. The police car in the distance becomes the visual point of synthesis that mirrors the viewer. In the overall rhetoric the car is a narrative object located between the men's faces and the medium close-up. The vehicle assumes a common allegorical identity that focalizes the opposites of the law and the outlaw on either side of the frame.

The sequence is set in place in order to be followed by another of the same order. A second chase ensues, now on foot, in tracking shots in the closed space of the precinct. A crony pursues Foley down the corridors. The tracking shot leads to another vanishing point. Inspector Todd (Gilbert Hill) catches Foley in the locker room. They argue over the antics – just seen – that have made mayhem of Detroit. More shots, of deep space that recedes to more vanishing points, are taken in the labyrinth of the halls of the precinct and the men's locker room. Far and near establish a visual opposition that cues a distance between father and son: The bad boy, Murphy occupies the foreground, while his boss enters through a doorway and down a hall.

Each of these sequences betrays a common aspect. In the alley in Detroit, the police are located at a vanishing point in the illusion of

observes that as a general rule "there is no mundane substitute for sex except sadism" (p. 8).
[5]Miller beer is inscribed in the narrative and the final shot of the film. When he is followed by two sleuths (one white, the other black) on the outskirts of Maitlin's mansion, Foley invites two officers to share a beer. He opens the trunk of his jalopy and displays, at the vanishing point of the shot, a can of Miller Lite. Its position in the frame indicates that the object remains out of reach and is thus a figure of desire. As he drives away from Beverly Hills, Murphy tells the police to "lighten up." So ends the narrative.

distance; in the locker room, Todd's posterior is seen about to disappear in the depth of the corridor. A focal point in the frame is occupied by a figure of the law, that is, the police or a father (and, as we shall observe, a brand name). The simple opposition that results between a child and a feared object generates the narrative reiterating the conflict of good (but bungling) fathers at odds with their recalcitrant (but witty) children. The film *frames* an ambiguity to show what the narrative takes as its task *not* to resolve; it sets its sight on a transitional figure, in visual configuration, that shunts between the law and the outlaw, between the father and the son, or between an enigma and the reassuringly common form or trademark.

If Guy Rosolato's concept of the perspectival object is recalled,[6] the vanishing points in the prevailing deep-focus photography appear to map the metaphors that determine the film's narrative strategies. For Rosolato, clinical experience shows that patients under analysis tend to project visual cues in the tabular areas of their speech. They stage figures in literal terms that focalize traumatic memory and give an unyielding structure to discourse. Like a vanishing point, the *objet de perspective* is located in movement between a past and a present and between the elements of a discourse seen and heard. It tends to spot the conjunction of what is visible with what is invisible. *Beverly Hills Cop* appears to negotiate the art of naming and narrative according to this principle, especially wherever deep focus becomes a function of the Oedipal structure of the story line.

The perspectival object locates ambiguities that determine the ends and means of the narrative. The latter visually marks structural operations that go beyond the borders of the film and lead into both a convention – an L.A. cops 'n' robbers film of the 1980s[7] – and a program of desire and violence. Each of the ambiguities can be discerned through a perspective common to anthropology and psychoanalysis. The first locates Eddie Murphy as a *trickster,* an errant figure who delineates the surface and frontiers of a social group by dint of roaming about its margins.[8]

[6]Elaborated in *Eléments de l'interprétation* (Paris: Gallimard, 1985), pp. 123–32, and in "L'Objet de perspective dans ses assises visuelles," *Nouvelle Revue de Psychanalyse* 33(Spring 1987): 151ff.

[7]Thomas M. Kavanagh has surveyed the genre in terms of a relation between the Western and film noir in the productive discussion in "The Dialectic of Genre: *True Confessions* and the Los Angeles Film," *Criticism* 26, no. 1(1984):71–82. Sharon Willis deals with the violence and racism that inform *To Live and Die in L.A., American Gigolo,* and other avatars of *Beverly Hills Cop* in "Seductive Spaces," in *Seduction and Theory,* ed. Dianne Hunter (Urbana: University of Illinois Press, 1989), pp. 47–70.

[8]Roger Bastide, "Le rire ou les courts-circuits de la pensée," in *Echanges et communications: Mélanges offerts à Claude Lévi-Strauss à l'occasion de son 60e anniversaire,* vol. 2 (Paris: Mouton, 1970), pp. 954–63; Victor Turner, *The Ritual Process: Structure and Anti-Structure* (Chicago: Aldine, 1967), pp. 125ff. Recently, Emiko Ohnuki-Tierney has developed the figure along lines that weave multiple ties between the trickster, shaman, scapegoat, and mediator in *The Monkey as Mirror: Symbolic Transformations in Japanese History and Ritual* (Princeton: Princeton University Press, 1987), pp. 226ff. The classic study is by Paul Radin, *The Trickster: A Study in American Indian Mythology* (London: Routledge & Kegan Paul, 1955). Michael P. Carroll, in "The Trickster as Selfish-Buffoon and Culture Hero," *Ethos* 12, no. 2(1984):105–31, finds that many trickster figures seem to mediate socially disruptive desires for immediate sexual gratification, on the one hand, and, on the other, for the benefits of culture and self-restraint. Yet the creativity of culture heroes derives in part from their excess libido.

Murphy teeter-totters and zigzags from one side of the law to the other, and across a line of difference that defines not only geographical, social, and erotic axes but also a collective mental space. Everywhere limits are affronted, and as Derrida has also shown, the same limits have to be mimed or reiterated in order to be held: *la limite l'imite* (the limit imitates it). In other words, the play of imitation – the film – defines social limits. The imposing order of a common limit is affronted; the trickster tampers with it, crosses it, and comes back over and again.

The trickster's identity owes to disturbing erotic capacities. In the Western tradition the trickster is Hermes, at once a thief, a messenger, a mediator, an interpreter, a liar, a joker, and a crafty businessman. He embodies "the acquisitive way of life." What is it, notes Norman O. Brown, "if not the doctrine that 'money is the man'?"[9] Thus Foley is a supplement to the messenger of the gods. The past that Foley and Mikey shared reveals that the two scoundrels had stolen cars together. The initial shots confirm that Foley is a go-between. When his interlocutor chides him for his impatience about selling a truckload of cigarettes ("Why don't you go into business yourself if it's such a great fuckin' deal?"), Foley responds, barking, "I'm a businessman, ya know, this is my thing. I'm in a business line." In three shots taken from opposite sides of the truck, vanishing points are established of a tax stamp on the cigarettes Foley holds in his hand, the police car that moves left and right in the deep background, and a wad of bills that Foley holds in the center of the frame. They are complemented by the sound track that insists on business while implying that exchange is a matter of anal eroticism. As the crook shouts at Foley, "You wanna be a fuckin' asshole, you can take the whole load. . . ." The viewer cannot tell who is tricking whom, or on what side of the law Foley is placed. Elsewhere Foley succeeds wherever he eroticizes a milieu and, with the allure of stimulation, wherever he can negotiate, interpret, lie, and steal. Yet, at the same time, he is marked as a child whose antics are sanctioned by his myriad father-substitutes.

Here a second structure is discerned. The trickster is determined by Oedipal tensions. He is a businessman aspiring to enter a white market, but his success depends on mediation with paternal figures defined according to traits of black and white and to signs that are either benevolent or malevolent. Just as Foley is divided between himself and Mikey, each paternal figure splits into "good" and "bad" elements that mirror one another.[10] The black father Todd in Detroit is replicated by the white Bogomil of Beverly Hills. That couple is in turn countered by the evil Victor Maitlin of the underworld. A great white father comes in the gruffy but "good" chief of police in California, who must believe all the lies his children tell in order to bring the story to a happy end.

[9]*Hermes the Thief: The Evolution of a Myth* (New York: Vintage, 1969), p. 80; see also Jean Papin, "L'Herméneutique ancienne," *Poétique*, no. 23(1975):291–300.
[10]Here the reading recoups Robert Paul, "Lina Wertmüller's 'Seven Beauties': A Psychoanalysis and a Reevaluation," *Journal of Psychoanalytic Anthropology* 9, no. 4(1986):447–82. Decomposition of characters in literature is taken up in Robert Rogers, *A Psychoanalytic Study of the Double in Literature* (Detroit: Wayne State University Press, 1970).

TOM CONLEY AND
JOHN M. INGHAM

The film follows a paradigm of authorities mirroring each other from opposite sides that define a line of the law.[11] In the last sequence, set in Maitlin's mansion, the montage has the good cop and bad boss follow their child's antics from opposite sides of the frame. Looking *left,* the lieutenant follows the path of Foley's car en route to Maitlin's residence. Looking *right* through a television monitor, Maitlin watches Foley rummaging through the garden of his estate. Each father surveys the activities of his son from opposite sides of a system of televised security (a metaphor of the film itself). Foley pursues Maitlin, who threatens Jenny, hostage and erotic object. Finally, Foley slays the evil genius with the help of Bogomil, who suddenly appears behind the hero's back. As Jenny breaks free from Maitlin, Bogomil, standing over the kneeling Foley below, opens fire, thereby condoning the patricidal moment and reiterating the prevailing erotic scenario.

It follows that the Oedipal configuration so dear to the cops 'n' robbers genre disrupts the ideology of "character" in the film, and that character amounts to a relation of tensions where humans become points of stress that determine social time and space. Foley is both black and white, just as his fathers are a part of himself, a son, by spiritual procreation.[12] Because the trickster is a mediator, he represents the very evil that he wishes to exterminate. The law at work in the order of the psychomachia dictates that *it takes one to know one* and that *it takes a thief to catch a thief.* Foley is in Oedipal rapport with Maitlin and Beverly Hills, just as are children with their parents, and vice versa.

A third structure appears folded into the Oedipal and commercial dimensions of the film. The scenario confuses fraternal and erotic relations for the sake of blurring and retracing strict lines of conduct. Trickery and the Oedipal drama are optically coded. The first lover-brother is eradicated so that violence can supplant affect; the second group of brothers, Taggart and Rosewood, is shaped in the couple of affably bumbling sergeants, obedient cops, who foil the activities of their prodigal brother. A female is introduced to give clearer definition to the males. Jenny's position is defined by extraneousness. She appears to be an Oedipal object – cast in colors both innocent and pure – but remains a figure of desire. She plays both sororal and maternal roles but is held in the focus of Maitlin's and Foley's desiring gazes. Foley keeps a siblinglike relation with her that remains sexually charged.

Because the paintings in the gallery are tantamount to cocaine or figure self-stimulation, the focus upon Jenny's body heightens the more commanding homoerotic tensions of negotiation at work between fa-

[11] It is faithful to an order traced in the work of Fritz Lang, from *M* (1930) up through *The Big Heat* (1953). Lang does not, as Reynold Humphries argues, develop a structure of purge (an anti-Nazi genre) or a generic convention, such as film noir, but tends to work across genres and "elaborate the dimension of the double." Cf. Reynold Humphries, *Fritz Lang: Genre and Representation in His American Films* (Baltimore: Johns Hopkins University Press, 1989), p. 15.

[12] Anthropology and media effects converge in the figure of Foley. As he mediates black and white characters, the hero maps a world that will be without social contradiction. Vincent Canby observed (*New York Times,* December 16, 1984) that "one doesn't have to be a specialist in movies, in the merchandising of special products or in race relations to detect how carefully Mr. Murphy's career is being shaped to satisfy the largest possible audience without offending anyone."

thers and sons. Jenny remains the *other* whose role as observer lends urgency and precariousness to the sadistic activities. Erotic and virginal, she assures that libidinal energies will be invested in social and commercial relations. A cipher for heterosexual lust (a bodice is carefully opened, her buttocks are prominent in telephoto shots of her abduction by thugs . . .), Jenny lays stronger emphasis on the womanless world of males. The sign of impotence that she brings to the structure is shunted, at the end of the narrative, onto that of the hero-trickster, who can reach orgasm only in the murder of the bad father through the supplement offered by Bogomil, who shoots over Foley's head.[13]

The erotic configurations call the apparent narrative into question. None of the episodes leads to resolution, but rather exacerbates the same tensions. The narrative does not, therefore, *work through* a problem, but turns and rolls it over and over again. Each segment acts out an erotic relation that veers toward sadism. Sex-substituted violence occupies each minimal narrative unit, and as in Freud's scenario of the spool-and-thread retrieval recounted in *Beyond the Pleasure Principle,* the plot unwinds only by dint of repetition. Each diegetic unit becomes a mode of production celebrating and explaining the entire paradigm.

For this reason the love scene between Foley and Mikey locates the areas that shift between narrative (the suturing agency) and the film's erotic agenda. The visual style changes abruptly in order to tell the spectator that truth is a mechanism of desire: Close-ups excise all information that might detract from the diegesis, so that the image can attend to its ideological mission that puts sadistic violence in the place of affect. The sixteen close-ups (noted earlier) draw the *visual* elements of the realistic style into the *aural* discourse that makes fraternal affection a prelude to Mikey's demise. The moment cues what becomes the script of a scenario of regression. The film has the appearance of a model application of a dutiful, Oedipal, thematic projection of Freud's *Three Essays* onto a cops 'n' robbers convention: Psychogenesis develops through three "stages" or theaters in which conflict gives way to dramas in which "progressive" and "regressive" elements struggle with each other. The median field that demarcates the oral from the genital phase, an anal arena, is marked by various ambivalences that skitter in the same blow from expression of tenderness to violence, and from maternal aura to sadistic pleasure. It appears that the sequences and storyboards are sketched from the same font of inspiration. Aural and visual forms rivet the spectator to a world where regressive eroticism is equated to good business.

The elements of the scenario are ubiquitous. Foley uses a banana trick to befuddle the sergeants staked out by the Beverly Hills Hotel. In order to elude them, Foley (who in the first sequence was marked as not

[13]Viewers familiar with Jacques Derrida, *The Post Card,* trans. Alan Bass (Chicago: University of Chicago Press, 1987), see immediately in the rapport of the father and the son, mediated as it is by the dummy, a politics of what Derrida calls the "SP" effect, that is, an imaginary phallus because it is an agency that marks or signs. Derrida undoes the stress of the phallic symbol (*sp* in French) by turning it into a rebus. With *espée,* we can ask indeed if it is a "phallus." *Est-ce p?* – i.e., one half of the doublet of *pp, principe de père,* and *pé-pé, principe de plaisir,* etc. In the line of Derridean surface writing, the *espée* is the acronym for Socrates–Plato, (S)ocrate–(P)laton, or the *Psyché* syndrome that defines lines of infinitely mutual dependencies of fathers and sons in collusive conflict.

TOM CONLEY AND
JOHN M. INGHAM

dealing with "Johnny Bananas") obtains bananas from a waiter tending a grandiose fruit salad – a rebus of the organs displayed on a table in front of the man's midsection. Foley exits from the hotel, sneaks up behind the police car, and shoves the three bananas up its tailpipe. A suppository, the bananas arrest them in what might be called their attentive phase. The joke blueprints the narrative but also arches back what had taken place in the visual rhetoric of the Detroit sequences. In the deep-focus shots taken in the city precinct, Foley's first father threatens his "son": If he is prone to more bad behavior, fate will deal the child a brutal blow. With the next misdemeanor, the father will have no piece of "his ass" remaining at the bottom of his spine. But as the father is under the purview of another superior, an unnamed chief of police, the son's flagrant disobedience will erode even more of his father's bottom. As the rectal epithet of fate ("my ass") is sounded twice in quid pro quo, the stern words that are doubled on the sound track draw the spectator's eyes to Todd's buttocks, which bounce down the aisle after he has taken Foley's parting shot. The lieutenant saunters away, his buttocks spotting the vanishing point because the sound track tells spectators where to briefly rivet their eyes.[14]

The same rhetoric prevails elsewhere. Two shots precede the affective reunion of Mikey and Foley in close-up in the hallway by the hero's apartment. The two friends have been shooting pool in Harelli's bar. In an abruptly inserted establishing shot, in close-up, a stick hits a cue ball on a field of green felt. We are not told that the men have left the apartment, nor are we given any sign of the proximity of Foley's place and the bar. All of a sudden, a stick strikes the white ball and breaks the triangle of solids and stripes. Several medium shots are then taken from the front of the table. Because straight cuts are used, the origin of the action in the first shot of the sequence is not marked by a transition.[15] Behind the pool table are seen the midsections of the two friends who banter and chalk their sticks. The men are seen between the waist and upper thighs, as the table covers the lower parts of their legs. The initial close-up of the stick hitting the cue ball gains meaning only after the deeper, more characteristic perspective of the bar is shown. A cutaway shot records the trajectory of the balls that are struck after the stick hits the cue and pulls back. Following the trajectory of an eight ball that rolls and falls into a side pocket, the camera pans right very quickly, then left, and then right again.

The viewer's attention is immediately divided by a rebus that informs the scene. On the one hand, the names of the objects selected to be

[14]As in the Socrates–Plato syndrome of ambivalence that holds between master and student and cause and effect, authority is marked by a generally anal view of erogeny. If not heeded, the law will penetrate its subject's posterior, and the final sign of mastery will be left on those who climb to the top of the human ladder by dealing with others in the same way. See also Willis, "Seductive Spaces."

[15]Mark Crispin Miller remarks that Hollywood films of the past decade have abandoned dissolves and tend to favor less dialogical transitions: "These devices seem too slow and (in different ways) too suggestive of morality for the movies' bright mall atmosphere, and so they have been dumped in favor of the most basic of connectives, the simple cut, whose overuse has helped transform the movies into adlike serial displays." "End of Story," in *Seeing Through the Movies* (New York: Pantheon, 1990), p. 206.

seen – cue, stick, ball, felt, cushion – all form analogues of the recurring anal scenario that had marked the convergence of the Oedipal relation of authority and its deep-focus framing. Language is invested into the objects in order to jolt them. But the eight ball falls into a pocket just below the bulge of Foley's genitals, which are held in view for the duration of the zigzag pan. Foley is marked as a figure who is literally "behind the eight ball," but at the same time the eight ball is an icon of visibility cuing to the bulge of his jeans; it is also a black ball, or what "blackballs" Eddie Murphy in terms of ultimately triumphal white supremacy, as an overcharged erotic unit, or a set of eminent black testicles. The entire scene and the ricochets in close-up form a hieroglyph of erotic units. The unmarked status of the combination of the eight ball and Foley's genitals forces the naming of the objects seen to be products of "our" imagination, such that a transgression is elicited in order to encourage an association that will yield a pleasure of guilt on the part of whoever puts into language what should remain in the security of ambiguity.

In the shot that records the men's exit from the pool table to the corridor where they will embrace (again, no transition being offered other than a straight cut), Mikey mimes a moment of paroxysm. He has just bet a large sum of dollars against a shot that a black player has made against all odds. Mikey unpacks the bills from his pocket, casts them on the green surface of the table, and raises his arms to register the comic dismay of his loss. When he pivots about and exits, the cue stick that is placed against the table bisects the image and points to a deeper space. Mikey walks away but is divided by the stick that is placed over his body. As he leaves, he thrusts his hips up and down as if he were being entered and thrilled by the cue stick that is cleaving his buttocks. Both here and in the next sequence Mikey's body is arched to receive a charge in his rectum.[16]

So goes the sadism that defines the visual field. A more literal type of writing locates a similar redundancy early in the film, in the first sequence that has no narrative function. In the first, the inner space of the semitrailer is filled with boxes of cigarettes. Upside down, next to the hero's body, is seen a plethora of labels printed Lucky Strike and Pall Mall. These items are not just local color: They are part of the same grammar that the film elaborates through conjunctions of bodily figures with speech and iconic language. The brand names of the cigarettes are set adjacent to Eddie Murphy in order to script it as "Eddie Murphy," the commodity being sold. Documents show that because the cigarette industry is proscribed from advertising on television and in theaters, it seeks nonetheless to insinuate mention of its products into narrative. It pays Hollywood handsome fees for the right to be inscribed in a passing

[16]Eroticism of this kind is common money of cinema. In the context of the commemoration of Martin Luther King and the movement of integration in the 1960s, *Mississippi Burning* has one of the three Klansmen who murdered the civil-rights worker report an especially delightful event: He took his magnum and shoved it into the ass of the black worker before pulling the trigger. The "jolt" on the sound track is based on what Hollywood clearly scripts as its preferred erotic mode. It works identically within the comic cops 'n' robbers genre and, it can be added, with the same blatant racism.

motion that will, in turn, mark the experience of the spectator's desire.[17] The industry pays to have Lucky Strike and Pall Mall associated with the "character" of Foley, such that anyone who purchases the products can accede to the imagination of obtaining his wit and ingenuity. From the first shot of the film, Eddie Murphy is trademarked as a brand of stimulant.[18]

Here pragmatic and deconstructive readings show at once that the brand names are allegorical units spelling out the "truth" of the film to be a fusion of monetary and libidinal drives. In the first shot, seen next to Eddie Murphy, upside down, Lucky Strike would obviously indicate, like Pall Mall, a world turned topsy-turvy, in carnival. The inverted writing next to the solidly poised figure of Foley recalls the topos of the world-upside-down, whose thematics broach ambiguities that historians and ethnographers study in terms of disruption and continuity.[19] One interpretation might argue that the world is inverted at intervals so as to mollify social contradiction or keep a population of movie viewers aware of the cycles and seasons of life. In another, the unmitigated violence played out in what follows would provide a "fake" inversion that lasts as long as the duration of the movie. In turn, the private space of viewing would co-opt the public manifestation of carnival, thus robbing the festival of its basis in the name of the controlled convenience of a theater or a television monitor.

The inverted writing of the brand names suggests, further, that cigarettes form a link in a concatenation that goes from one stimulant to another. Luckies lead to alcohol that leads to cocaine that leads to sadism that leads to stimulation that leads to narrative. Every ring in the chain is a piece of currency that the cinematic agency puts into circulation. Icons of desire, the stimulants concretize everything the film sets about selling. In addition to cigarettes and beer, included are social status, Oedipal and homoerotic pleasure, and vengeance. Their negotiation becomes the topic that the narrative embodies no less than the boxes of cigarettes that literally spell out Foley's "character." Seen thus, Eddie Murphy is

[17] See "Smoking in Movies: License to Kill," *University of California, Berkeley Wellness Letter* 6, no. 7(April 1990):7. It reports that Philip Morris paid $350,000 to feature Lark cigarettes in *License to Kill* and contributed $42,500 "to have Lois Lane smoke Marlboro cigarettes in *Superman II*," adding that *Beverly Hills Cop* and other films also feature brand-name cigarettes. Miller, "End of Story," develops the history (pp. 188–201).

[18] In his argument with the white hooligan, Foley jibes that he does not smoke Lucky Strike but Kent – already known for its appeal as a cigarette of "distinction," its smokers being able to imagine themselves in a higher social stratum than they currently are. But the brand also encodes genital fantasy, because the predominant device of the long-lasting advertisement, "Coffee 'n' Kent," had been what jokes had turned into "coffee 'n' cunt." (The trademark was no doubt chosen to elicit that response.) The slogan is obliquely recalled when, held captive in the warehouse, Foley tells Maitlin to let Jenny know that, instead of being tortured and murdered, he'll be enjoying "coffee 'n' cocaine." No matter whether Kent is high or low on a social scale, the linkage of stimulants reproduces the order of the film. Thus: coffee = cigarettes = cocaine = detached sex organs = cops 'n' robber films, etc.

[19] Such as Ernst Robert Curtius, *European Literature and the Latin Middle Ages* (Princeton: Princeton University Press, 1973), pp. 94–7; Natalie Z. Davis, *Society and Culture in Early Modern France* (Stanford: Stanford University Press, 1975); Victor Turner, *The Ritual Process;* Roger Chartier, *The Cultural Uses of Print in Early Modern France* (Princeton: Princeton University Press, 1987), pp. 13–31; Samuel Kinser, *Rabelais's Carnival* (Berkeley: University of California Press, 1990).

a product being sold (no matter what its logo may be, like the father substitute, something both "good" and "bad") as well as an agency that produces and distributes it. The credits announce that the film is part of "Eddie Murphy Enterprises": As a trickster or a figure under the aura of Hermes, the god of commerce, Foley is identical with the ideal that the film emblazons. An aspiring businessman whose roguish ways will assure success, a David, he schemes against a corporate Goliath – Maitlin – and covers the market with a repertoire of sexy tricks.

It might be said that the inversion of writing in the first shot of the film signals the carnival to follow, as well as the allure of a character, cast in erotic terms, having "what it takes" to make a "lucky strike" or a lucrative deal. To "strike it rich" seems to be the perspectival object imposed upon the spectator. Because it is associated with the law, the spot works according to an Oedipal circuitry, but now is seen as a form striking a surface (defining thus an erogenous zone) and then pulling away from what it has marked. That area becomes the site of a festive mock exchange that exalts violence. It stimulates because it simulates, and it copulates because it breaks – off – what it touches, or makes a deal – a joke – as it leaves the scene of its performance. Every piece of wit follows this pattern, whose measure of success resides in striking rather than in changing its object.

This reading began with attention to an unusual sequence that dwelt on close-ups ostensively expressing two males' transcending love. The style of the film changed abruptly to record that moment, but only then to put sadism in the place of fraternity. From there we saw that indeed the shooting style depends on calculated placement of vanishing points that mark ambiguities designed to capture the viewer's gaze. Their tensions, however, put in view seemingly archaic structures that inform the ideology of the genre. First, the hero is an avatar of the trickster who interprets and negotiates the social space that his movement simultaneously defines. He is a liminal but central force set in the patently Oedipal terms of a psychomachia of fathers and sons of alternately good and bad configuration. And third, the Oedipal scenario is coded in masculine terms, while the female figures as a cipher in a festive theater of sadism and anal eroticism passed off in the name of comedy and fast-paced narrative.

The reading could rest here with the political argument that this film peddles consumerism and free enterprise through an engaging machinery of humor, sadism, and violence; that the media have given them an attractive allure and that they program collective desire in this fashion has been obvious since D. W. Griffith. *On sait bien, mais quand même:* Ambiguities happen to be commodities that produce subjectivity and can be potent as military hardware. They are ubiquitous and can be marshaled as one wishes. Evident is an articulation of "desire" that superimposes narrative conventions, anthropological types, that mixes generic conventions, that promotes a model of sadistic exchange. The film allows a definition of liminality to emerge, and it promotes a hermeneutics in its own devices and structures. Apart from whatever pleasures it affords, *Beverly Hills Cop* might be seen loosening its grip where it represents liminality. While traversing a slippery slope, the "hermeneute"

nonetheless maintains a deft balance, and like other Oedipal heroes, he or she works within and against an established order of relations. The lesson is that the trickster in Beverly Hills – like other culture heroes – has to be, to some degree, a poet who knows language and action in ways that the local authorities do not.

What seems to be a more complete conclusion can be set next to some of the consequences of Jacques Derrida's work for film and criticism. Because it speculates on its own nonreturn, and because its politics is couched in its practice of ambivalence through unbeknowing labors that play with meaning (but do not attend to any finality), his writing bears comparison with Hermes. At stake is not Hermes the capitalist, but Hermes the poet. Derrida is closer, we hope, to the second of these Hermes, for we see that his movements entail hermetic tactics taking mercurial, irrecuperable positions with respect to the media. Recently Derrida has spoken of a *géo-psychanalyse*[20] for the sake of giving perspective to the future of the world. In general, the symbolic efficacity of criticism appears minimal in view of media culture, but nonetheless – *quand même* – Derrida's brand of psychoanalysis remains a material practice that studies the plasticities and tensions of language. Following Nicolas Abraham, Derrida has elsewhere shown that real works of art owe their authenticity to an unconscious that cannot be controlled by any economic agency.[21] In our time, whatever does not bear evidence of betrayal by unconscious expression tends to be an object aimed at obtaining a return from its articulations, and hence becomes a commodity. In popular cinema, it is a controlled, impoverished, fabricated unconscious. Through Derrida's relations with Hermes the poet, we can see how the movie industry deploys anthropological structures to pattern its narratives and, in turn, how they are controlled in a market-based cinematic rhetoric. A politics of analysis can be discerned where we align his play with and against the media. By discovering the means the industry uses to name and to frame the unconscious, we see how it manufactures desire and strives to produce subjectivity.

[20] *Psyché: Inventions de l'autre* (Paris: Galilée, 1987), pp. 327–52.
[21] "To Speculate – on Freud," in *The Post Card*.

THE SIGNATURE EXPERIMENT FINDS ANDY HARDY

ROBERT B. RAY

In that which I now propose, we will discard the interior points of this tragedy, and concentrate our attention upon its outskirts. Not the least usual error in investigations such as this is the limiting of inquiry to the immediate, with total disregard of the collateral or circumstantial events. It is the malpractice of the courts to confine evidence and discussion to the bounds of apparent relevancy. Yet experience has shown, and a true philosophy will always show, that a vast, perhaps the larger, portion of truth arises from the seemingly irrelevant. It is through the spirit of this principle, if not precisely through its letter, that modern science has resolved to *calculate upon the unforeseen*. But perhaps you do not comprehend me. The history of human knowledge has so uninterruptedly shown that to collateral, or incidental, or accidental events we are indebted for the most numerous and most valuable discoveries, that it has at length become necessary, in prospective view of improvement, to make not only large, but the largest, allowances for inventions that shall arise by chance, and quite out of the range of ordinary expectation. It is no longer philosophical to base upon what has been a vision of what is to be. *Accident* is admitted as a portion of the substructure. We make chance a matter of absolute calculation. We subject the unlooked for and unimagined to the mathematical *formulae* of the schools.

> – Poe, "The Mystery of Marie Rôget"

THE INTRIGUE

In 1939 – the annus mirabilis of what has come to be known as classical Hollywood cinema, the year of, among others, *Gone with the Wind*, *Stagecoach*, *The Wizard of Oz*, *Ninotchka*, *Mr. Smith Goes to Washington*, *Wuthering Heights*, *Destry Rides Again*, *Young Mr. Lincoln*, and *The Roaring Twenties* – something strange happened. An actor, who had not previously been taken very seriously by either his studio or the public, became the movies' number-one box-office attraction, a position he would hold for three years. That actor was not Gable, Garbo, Tracy, Hepburn, Garland, Stewart, Cooper, Davis, Power, Flynn, Bogart, Crosby, or Cagney.

For their generous help to me while I was writing this essay, I want to thank Ann Rutherford (formerly of MGM) and Ned Comstock (the archival assistant managing the MGM collections at the University of Southern California Library). Thanks also to my students who participated in this experiment.

ROBERT B. RAY During 1939–41, the most popular performer in the American cinema was Mickey Rooney. Although Rooney starred in a dozen movies during that period, his success rested primarily on a low-budget series initiated by Metro-Goldwyn-Mayer (MGM) as a way of profiting from the surprising success of *Ah, Wilderness!* – the studio's 1935 version of Eugene O'Neill's small-town comedy. The series, whose first film, *A Family Affair,* appeared in 1937, quickly came to focus on Rooney's character, Andy Hardy.

The problem posed by this event (Rooney's succeeding Gable as the king of Hollywood) begins with the vehicle that made it possible – the Andy Hardy series. From our point of view, more than fifty years later, the striking thing about these movies is their *ordinariness.* Expecting a correlation between box-office appeal and major roles in "major motion pictures," we are surprised to find Rooney's success depending on what his own studio classified as B movies. But what makes the Hardy movies significant is precisely their typicality. Because film history concentrates on masterpieces, we forget that when the studios were releasing almost five hundred movies a year, most of them had far more in common with the Hardy pictures than with *Citizen Kane.* Thus, if we want to try to understand the Hollywood studio system, the prototype of all twentieth-century media apparatuses, we might do well to start with its *average* product. When two out of every three Americans went to the movies at least once a week, they were, after all, likely to see something like an Andy Hardy movie.

Because we are not used to studying (or even seeing) *ordinary* studio pictures, their appeal seems not precisely specifiable. Indeed, to the extent that certain of their charms have receded from us, the Andy Hardy movies (and their enormous popularity) have become slightly odd, illegible, *mysterious.* We know, of course, that between 1937 and 1946, MGM made fifteen Andy Hardy movies, seven in 1938–9 alone. But how do we account for the immense success of stories whose reliance on stock situations (Andy's fights with Polly Benedict, sister Marian's amorous misadventures, Judge Hardy's always imminent financial ruin), overt moralizing (the "man-to-man talks"), and fortuitous coincidence (the map found in the attic that legitimizes a claim) must have seemed anachronistic even to 1930s audiences?

We can always mount the obvious explanation: the Hardy series as escape from the Depression. We could also suggest (emphasizing the uncanny connections) that even while working quickly and sticking to a formula, the Andy Hardy filmmakers had accidentally plugged into the main tradition of American culture. The mischievous good-bad boy, Andy was the descendant of Huck Finn (played by Rooney in 1939). On the other hand, his entrepreneurial energy identified him with Huck's chief rival, Tom Sawyer, and with the line of American promoters, impresarios, and inventors: Horatio Alger, P. T. Barnum, Booth Tarkington's Penrod, and even Edison (also played by Rooney in 1940's *Young Tom Edison*). The Hardy movies themselves belong to a group of films about American small-town families whose productions influenced each other: *The Magnificent Ambersons* (based on Tarkington's novel), *It's a Wonderful Life, Meet Me in St. Louis, Since You Went Away, The Human Comedy, Babes in Arms.* The most important film of the group, *It's a*

Wonderful Life, appears in hindsight as a dark Andy Hardy movie, making explicit certain themes that the Hardy movies had repressed: money, prostitution, suicide, hopelessness.

This kind of cultural history, though accurate enough, began in the 1970s to seem inadequate. At that point, literature and film scholars started responding like Borges's detective when confronted with a policeman's too straightforward explanation for a murder:

"Possible, but not interesting," Lönnrot answered. "You'll reply that reality hasn't the least obligation to be interesting. And I'll answer you that reality may avoid that obligation but that hypotheses may not. In the hypothesis that you propose, chance intervenes copiously. Here we have a dead rabbi; I would prefer a purely rabbinical explanation, not the imaginary mischances of an imaginary robber."[1]

The rabbinical explanation settled on by the academic critical establishment became what David Bordwell has called "symptomatic interpretation,"[2] a practice (derived primarily from Freud, a kind of secular rabbi) devoted to *policing* texts for their political correctness. Having committed itself to this particular way of doing business (which we might call "semiotic," using that term to stand for an amalgam of structuralist, psychoanalytic, ideological, and feminist methodologies), film studies have, since roughly 1970, constructed an enormously powerful theoretical machine for exposing the ideological abuse hidden by the apparently natural stories and images of popular culture.

With their extravagant devotion to archaic gender roles, stereotyped characters, and simplistic homilies, the Hardy movies seem made for symptomatic interpretation, but in fact they are not. To display their skills, semiotic critics have always preferred subtler game: texts that offer themselves as having no politics, or, even better, those that pretend to a leftism that analysis can discredit. The three masterpieces of this tradition are Barthes's *S/Z,* the *Cahiers du Cinéma*'s "John Ford's *Young Mr. Lincoln,*" and, less well known, but equally brilliant, Charles Eckert's "The Anatomy of a Proletarian Film: Warner's *Marked Woman,*" three symptomatic readings that have stimulated an entire tradition of revolutionary scholarship.[3]

This tradition, however, now runs on automatic pilot, producing predictable essays that round up the usual suspects for the ideological third degree; conference papers, journal articles, and books all seem to share the same few titles: "The Construction of Gender in _____ ," "Form and Ideology in _____ ." The semiotic approach, in other words, has hardened into what Roland Barthes as long ago as 1971 called a new "mythological doxa," a "stock of phrases, catechistic declaration,"[4] a

[1] Jorge Luis Borges, "Death and the Compass," in *Labyrinths* (Harmondsworth: Penguin, 1971), p. 107.

[2] David Bordwell, *Making Meaning* (Cambridge, Mass.: Harvard University Press, 1989), pp. 71–104.

[3] The *Cahiers du Cinéma* and Eckert articles are most readily available in *Movies and Methods,* ed. Bill Nichols, volumes I and II, respectively (Berkeley: University of California Press, 1976 and 1985).

[4] "Change the Object Itself: Mythology Today," in *Image—Music—Text,* trans. Stephen Heath (New York: Hill & Wang, 1977), p. 166. The whole passage is worth citing: "the new semiology – or the new mythology – can no longer, will no longer be able to, separate so easily the signifier from the signified, the ideological from the phraseological. It is not that the distinction is false or without its use but rather that it too has become in

diagnosis implying that at stake in this impasse is the status of critique itself. "From the 17th century onward," Octavio Paz observes, "our world has had no Ideas, in the sense in which Christianity had ideas during its time of apogee. What we have, especially from Kant on, is Criticism."[5] But criticism has never been particularly good at answering some of the most compelling questions about the movies, especially about movies like the Andy Hardy series, whose mechanism, like the purloined letter, lies invisible while in plain sight. Why do certain movies become popular? Why do individual scenes in otherwise forgettable movies fascinate us? Why have two decades of rigorous critique done nothing to undermine the cinema's glamour and seductiveness? Why is someone willing to spend $165,000 to own only one of the five pairs of red slippers worn by Judy Garland in *The Wizard of Oz?* And, perhaps most important, how do ordinary movies like the Andy Hardy films get made?

These are mysteries like the purloined letter that may not be solvable with the police's standard procedures. But what is the alternative to critique? In talking about the story of "The Three Little Pigs," Jonathan Culler suggested

that almost every *proper* question, such as "what happened next?," will be critically less productive (less productive of critical discourse we find worth reading) than marginally improper questions, such as "why three little pigs?"[6]

What would these "improper questions," alternatives to critique, look like? One source for them might be that branch of the humanities that since the nineteenth century has served as the humanities' equivalent of science's pure research: the avant-garde. If we think of the avant-garde as a field, committed to no single set of strategies, but only to experimentation itself, we could begin to apply some of its devices for the sake of knowledge.

In this context, we might reimagine Derrida as less philosopher than avant-gardist.[7] Certainly, beginning with *Spurs* in 1972, he has relentlessly

Footnote 4 (*cont.*)

some sort mythical: any student can and does denounce the bourgeois or petit-bourgeois character of such and such a form (of life, of thought, of consumption). In other words, a mythological doxa has been created: denunciation, demystification (or demythification), has itself become discourse, stock of phrases, catechistic declaration; in the face of which, the science of the signifier can only shift its place and stop (provisionally) further on – no longer at the (analytic) dissociation of the sign but at its very hesitation: it is no longer the myths which need to be unmasked (the doxa now takes care of that), it is the sign itself which must be shaken; the problem is not to reveal the (latent) meaning of an utterance, of a trait, of a narrative, but to fissure the very representation of meaning, is not to change or purify the symbols but to challenge the symbolic itself" (pp. 166–7).

[5]Octavio Paz, *Marcel Duchamp* (New York: Seaver Books, 1978), p. 153.

[6]Jonathan Culler, "At the Boundaries: Barthes and Derrida," in *At the Boundaries,* ed. Herbert L. Sussman, proceedings of the Northeastern University Center for Literary Studies (Boston: Northeastern University Press, 1983), p. 28.

[7]I am aware, of course, of this proposition's controversial nature. Since its beginnings in nineteenth-century France, the avant-garde has repeatedly been criticized as lapsing into a formalism that serves conservative interests. In film studies, that position appears in its most strident form in Noël Burch's famous "Foreword" (written twelve years after the text it precedes) to his own *Theory of Film Practice* (Princeton: Princeton University Press, 1981). On the other hand, I note that every twentieth-century totalitarian regime has banned the avant-garde arts, seeing in them a threat to the established order. Derrida has, characteristically, observed the relationship between these two extremes. While warning against an "obscurantist irrationalism" that, as a posture, "is completely symmetrical to, and thus dependent upon, the principle of reason," he has also encouraged an academic commit-

thrown into question the academic essay's conventional forms. With their exotic typographies, collagist quotations, and commitment to an investigative method relying on the accidents of language (puns, homonyms, etymologies), *Glas* (1974), *Signsponge* (1976), "Limited Inc abc" (1977), *La Carte postale* (1980), *Otobiographies* (1984), and "My Chances/ *Mes Chances*" (1984) (to cite only the most obvious works) have less and less to do with traditional philosophy. When these books and essays are mentioned at all, however, they are typically discussed for their "content," as if their unusual forms were at best only irritating impediments to arguments capable of being glossed in plainer language.[8] In fact, they seem to share the ambition that John Cage announced for his lectures: "My intention has been, often, to say what I had to say in a way that would exemplify it; that would, conceivably, permit the listener to experience what I had to say rather than just hear about it."[9]

Take, for example, "My Chances/*Mes Chances:* A Rendezvous with Some Epicurean Stereophonies."[10] Commissioned to lecture to the Forum on Psychiatry and the Humanities, Derrida begins by speculating about the *chance* that brings him to this place, that causes him to *fall* upon a particular topic, that enables his words to be used in ways beyond his control. "There," he announces after only six brief paragraphs; "I have just *enumerated* the themes of my lecture. They are all presented in what I have just said, including the theme of numbers."[11] This proposition, worthy of Holmes or Dupin in their most confident (and least explaining) moods, gives way to a meditation on the relationship of chance to the unpredictable swerve (*parenklisis*) of Epicurus's atoms, and to a question: Why do words having to do with chance have etymological roots in terms for downward movement or *falling?* A particular example, the Greek *symptôma,* is typical, meaning both a sinking or depression (a *lapsus,* a "slip" or fall) and a coincidence or unforeseen event.

Returning to Epicurus, Derrida observes how a certain view of the creation explicitly connects chance and falling in the theory of swerving, scattering, "destinerring" atoms. And then, "First Stroke of Luck: Première Chance": When Poe's narrator *slips* on a pile of street *stones,* Dupin imagines the associative logic that prompts him to arrive at the name "Epicurus." In doing so, Derrida proposes, the detective anticipates Freudian analysis, whose texts, "when they deal with the question of chance, always revolve around the proper name, the number, and the

ment to experimental research, which by admitting a "margin of randomness," would "interrogate the essence of reason and of the principle of reason." Jacques Derrida, "The Principle of Reason: The University in the Eyes of Its Pupils," *Diacritics* 13, no. 3(Fall 1983):14–15, 16. " 'Thought'," Derrida concludes, "requires *both* the principle of reason *and* what is beyond the principle of reason, the *arkhe* and an-archy" (pp. 18–19).

[8] For an example of this tendency, see Christopher Norris, *Derrida* (Cambridge, Mass.: Harvard University Press, 1987). Norris's frequent *London Review of Books* (LRB) updates on Derrida's work display the same reluctance to admit form as a contributing element of Derrida's meaning. Someone, for example, knowing only Norris's review of *Signsponge* (LRB, 20 February 1986, pp. 10–12), would have almost no notion of that book's fundamental strangeness.

[9] John Cage, *Silence* (Middletown, Conn.: Wesleyan University Press, 1973), p. ix.

[10] Jacques Derrida, "My Chances/*Mes Chances:* A Rendezvous with Some Epicurean Stereophonies," in *Taking Chances: Derrida, Psychoanalysis, and Literature,* ed. Joseph H. Smith and William Kerrigan (Baltimore: Johns Hopkins University Press, 1984), pp. 1–32.

[11] Ibid., p. 2.

letter.'"[12] What is the chance, for example, that makes the French name "Pierre" the same word that signifies the *stones* cut for cobblestone streets? And what is Derrida's "luck" to find that when Freud wants to understand the forgetting of a proper name, he tells a story:

> When I was examined in philosophy as a subsidiary student I was questioned by the examiner about the teachings of Epicurus, and after that I was asked if I knew who had taken up his theories in later centuries. I answered with the name of Pierre Gassendi, whom I had heard described as a disciple of Epicurus while I was sitting in a café only a couple of days before. To the surprised question how I knew that, I boldly answered that I had long been interested in Gassendi. The result of this was a certificate *magna cum laude,* but also unfortunately a subsequent obstinate tendency to forget the name Gassendi.[13]

By this point in Derrida's essay, the piling up of linguistic coincidence has become uncanny – and for an extraordinary effect, because "My Chances" ultimately turns on the vexed relationship between psychoanalysis and chance. As Freud acknowledged, his own method hinged on its ability to account for what had previously seemed only accident: slips of the tongue, forgettings, dreams. But entirely to deny randomness, Freud knew, was the sign of paranoia, that compulsive sense of determinism and interpretability perfectly conveyed by the form of Derrida's essay.

When compared with the flourishing trade in canon revision, ideological critique, and theoretical self-scrutiny, the conspiracy of silence about Derrida's formal innovations confirms his own observation: "What this institution cannot bear is for anyone to tamper with language. . . . It can bear more readily the most apparently revolutionary ideological sorts of 'content,' if only that content does not touch the borders of language and of all the juridico-political contracts that it guarantees."[14] The academy, in other words, will tolerate even radical ideas presented as a dissertation; departures from the *form* of the dissertation, however, it will not accept.

One of the best ways of understanding what Derrida has been up to is to see his work as a continuation of French surrealism.[15] The tolerance of chance, the investment in verbal games, the Mallarméan yielding of the initiative to words – these tactics seem less sui generis when placed

[12]Ibid., p. 15.

[13]Ibid., p. 17.

[14]Jacques Derrida, "Living On / Border Lines," in *Deconstruction and Criticism* (New York: Seabury, 1979), pp. 94–5.

[15]Whether Derrida would acknowledge this connection I cannot say. Surrealism, of course, has often been criticized for its implicit misogyny, romantic spiritualism, and theoretical diffidence. See, for example, Rosalind Krauss and Jane Livingston, *L'Amour fou: Photography and Surrealism* (New York: Abbeville Press, 1985), and Daniel Cottom, *Abyss of Reason: Cultural Movements, Revelations, and Betrayals* (Oxford: Oxford University Press, 1991). On the other hand, while Walter Benjamin warned of the movement's proximity to "the humid backroom of spiritualism," he also insisted on its systematic "substitution of a political for a historical view of the past" and its determined "pushing the 'poetic life' to the utmost limits of possibility." Walter Benjamin, "Surrealism: The Last Snapshot of the European Intelligentsia," in *One-Way Street and Other Writings,* trans. Edmund Jephcott and Kingsley Shorter (London: NLB, 1979), pp. 228, 230, 226. For my purposes, I wish to approach surrealism in the spirit of Brecht's interest in the theater – as the *Messingkauf,* the buyer of brass whose willingness to purchase an object depends less on its original function than on its other possibilities. Bertolt Brecht, *The Messingkauf Dialogues,* trans. John Willett (London: Methuen, 1965).

in the tradition of the exquisite corpse, Dali's "paranoiac-critical activity," *frottage,* the irrational enlargement of the object, and automatic writing. "You may think that I am juggling," Derrida admits in "My Chances," in a passage that could be mistaken for one of Breton's:

For when chances increase steadily, and too many throws of the dice come to fall well, does this not abolish blind Chance [*le hasard*]? It would be possible to demonstrate that there is nothing random in the concatenation of my feelings. An implacable program takes shape through the contextual necessity that requires cutting solids into certain sequences (stereotomy), intersecting and adjusting subsets, mingling voices and proper names, and accelerating a rhythm that merely gives the *feeling* of randomness in those who do not know the prescription – which, incidentally, is also my case.[16]

Surrealism was above all an experiment in attentiveness, a set of strategies for noticing clues that would otherwise have been missed. If these clues did not exactly solve the mystery of how to live, they at least promised future revelation to an alternative logic developed to use them. From the start, Breton made explicit his debts to psychoanalysis, whose analytic situation (itself requiring a new kind of listening) depended simultaneously on the patient's free associations and the analyst's undirected, "evenly-hovering attention," both marked by their acceptance of chance. "Cases which are . . . destined at the start to scientific purposes and treated accordingly," Freud warned, "suffer in consequence; while the most successful cases are those in which one proceeds, as it were, aimlessly, and allows oneself to be overtaken by any surprises."[17]

Freud, of course, was a scientist. We often neglect, however, the extent to which Breton, himself a former medical student, conceived surrealism in the spirit of scientific research. Denouncing the constraints on experimentation exacted by the criteria of "immediate utility" and "common sense," and pointing to the failure of "absolute rationalism," Breton, in *The Manifesto of Surrealism,* praises Freud for "enabl[ing] the explorer of the human mind to extend his investigations." And if Breton always emphasized experimental freedom, he was also willing to write up the lab report:

If the depths of our minds conceal strange forces capable of augmenting or conquering those on the surface, it is in our greatest interest to capture them; first to capture them and later to submit them, should the occasion arise, to the control of reason.

Until then, Breton demanded a lifting of the proscriptions that had discouraged pure research:

[I]t is important to note that there is no method fixed *a priori* for the execution of this enterprise, that until the new order it can be considered the province of poets as well as scholars, and that its success does not depend upon the more or less capricious routes which will be followed.[18]

This proposition might serve as the manifesto for all of Derrida's formal experiments, the hybrids of poetry and scholarship that Breton

[16]Derrida, "My Chances," p. 14.
[17]Sigmund Freud, "Recommendations for Physicians on the Psychoanalytic Method of Treatment" (1912), in *Therapy and Technique,* trans. Joan Riviere (New York: Collier Books, 1963), p. 120.
[18]All quotations from Breton come from André Breton, *The Manifesto of Surrealism* (1924), in Patrick Waldberg, *Surrealism* (Oxford: Oxford University Press, 1965), p. 66.

predicted fifty years ago. Certainly, the Derridean "signature experiment" practiced in *Glas* and *Signsponge* has seemed to many academics one of even poststructuralism's *most* capricious routes. In the context of surrealism and Freud, however, it begins to appear as simply another method of *scanning,* a way of attending to a text that descends from automatic writing, irrational enlargements, Freudian free association, and the analyst's freely hovering attention. Like Dupin, Derrida has learned how to notice precisely what the police ignore: the information, in this case the names, resting on the writing's surface, hidden in plain view. In performing the signature experiment, Derrida assumes the roles of both the patient who generates an associative discourse and the analyst who reads it. As a result, *Glas* and *Signsponge* produce a *shuttling* effect as they alternate between performing a decipherment and producing the very enigma to be solved. As a method of studying texts, therefore, the signature experiment satisfies Michael Taussig's goal for a nonreductive criticism, one that suggests the seductiveness of the object or behavior under analysis: "*to penetrate the veil while retaining its hallucinatory quality.*"[19]

Taussig's formulation implies enlightenment's chronic dilemma: Criticism, like the solution in detective stories, almost always proves less compelling than the mysterious circumstances it purports to explain. In his film *Clues,* Christian Keathley rephrases Taussig's challenge: How to tell stories whose explanations are as exciting as their mysteries? How to relate knowledge so that an intellectual idea is as charged as a clue? The signature method may be one possible answer to both questions. By embedding his revelations within the very texts under investigation, by making suspense itself a kind of knowledge, Derrida has invented a new way of simultaneously studying something and re-presenting its appeal. This capacity makes the signature method particularly useful for film criticism, whose objects of study, the movies, remain the most seductively mysterious cultural form yet discovered. The flickering images of beautiful men and women, projected at enormous size in darkened theaters – no police work so far has managed to explain this phenomenon away.

THE ASSIGNMENT

By chance (but what is chance? Derrida asks), American academic film study developed out of a debate about the signature. The auteur theory, with its insistence on locating what Andrew Sarris called "the directorial signature," enabled an institution (the university) organized around single-authored works to begin talking about ones that resulted from efforts so thoroughly collaborative as presumably to prohibit the very attributions of responsibility on which criticism depended. After auteurism, however, film study would no longer be confined to communications departments; taking advantage of in-place technology, language professors could now discuss Ford and Hawks with the same methodologies designed for Keats and Faulkner.

[19]Michael Taussig, *Shamanism, Colonialism, and the Wild Man: A Study in Terror and Healing* (Chicago: University of Chicago Press, 1987), p. 10.

In fact, the signature experiment, with its representation of *diffusion,* may be more appropriate to film study than its opposite, auteur theory. Whereas auteurism centripetally (and misleadingly) gathers filmmaking's disparate work into one proper noun ("Hitchcock," "Capra"), a book like *Signsponge* works centrifugally, amending structuralism's "death of the author" by perversely using the author's name to scatter his effects. If names are the raw material, then a film scholar faces an overabundance of riches: Anyone who stays to watch the almost endless scroll of names that now unrolls at the end of each movie will begin to feel like the detective in Ellery Queen's *The Chinese Orange Mystery,* who complains that "from the start, there were too *many* clues."

Where, indeed, would a cinematic signature experiment begin? With the name of the director? The producer? The scriptwriter? The cameraman? Even the people in the movie pose a problem. Do we use the names of the characters or of the actors? And if the latter, the real or the stage names? In this proliferation of possibilities, however, lies a great advantage: By providing multiple entrances into any single movie, the choice of names allows the signature experiment to spread feelers out in every direction. The metaphor is deliberate: A book like *Signsponge* enacts Deleuze and Guattari's theory of the rhizome that "always has multiple entrances," that "can be cracked and broken at any point" but "starts off again following one or another of its lines, or even other lines."[20] The rhizome, insist Deleuze and Guattari, is "*a map and not a tracing* . . . because its whole orientation is toward establishing contact with the real experimentally."[21] As a form, the rhizome responds perfectly to film study's greatest responsibility, its need to comprehend the movies' simultaneous involvement in the ongoing histories of technology, economics, competing commercial forms, filmmakers, other media, politics, the audience, and sheer chance. "In a rhizome," Deleuze and Guattari point out, "semiotic chains of every kind are connected . . . according to very diverse modes of encoding, chains that are biological, political, economic, etc., and that put into play not only regimes of different signs, but also different states of affairs."[22]

With its rhizomatic structure, the signature experiment offers an alternative to critique, a way of achieving a *hermeneutic effect* without practicing hermeneutics. For cinema studies, it has a particular advantage: When combined with other chance techniques, the signature approach provides a method of writing whose mingling of accident and determination exactly mirrors the conditions of filmmaking. I have experimented with this possibility in several classes, from graduate seminars to freshman introductions, by giving the following assignment:

1. Drawing on your readings of *Signsponge* and the "Signature" chapter of *Text Book,*[23] write a text exploring the words and information that can be gen-

[20]Gilles Deleuze and Félix Guattari, *On the Line,* trans. John Johnston [New York: Semiotext(e), 1983], pp. 26, 17–18.
[21]Ibid., p. 25.
[22]Ibid., p. 11.
[23]Robert Scholes, Nancy R. Comley, and Gregory L. Ulmer, *Text Book: An Introduction to Literary Language* (New York: St. Martin's Press, 1988), pp. 236–85. This chapter is by far the best way to introduce even advanced students to the signature experiment, and the model student essay, James Michael Jarrett's "A Jarrett in Your Text," is the most accessible example.

erated out of the names involved in *Andy Hardy Gets Spring Fever,* including those of characters, actors (real or stage), producers, directors, scriptwriters, etc.[24] As *Text Book* instructs (p. 267), your text should be "organized as much for aesthetic effect as for the exposition of your discoveries," but you should not avoid the goal of achieving knowledge about some aspect of the movies.

2. Combine this signature experiment with a specific procedure, influenced by John Cage, but proposed explicitly by Brian Eno with his cards *Oblique Strategies,* produced with painter Peter Schmidt. Here are their instructions:

> These cards evolved from our separate observations of the principles underlying what we were doing. Sometimes they were recognized in retrospect (intellect catching up with intuition), sometimes they were identified as they were happening, sometimes they were formulated. They can be used as a pack (a set of possibilities being continuously reviewed in the mind) or by drawing a single card from the shuffled pack when a dilemma occurs in a working situation. In this case the card is trusted even if its appropriateness is quite unclear. They are not final, as new ideas will present themselves, and others will become self-evident.

> Draw at least five *Oblique Strategies* instructions and use them as headings for sections of your paper. While carrying out the signature experiment, follow their instructions.

[24]Like nearly all of the series, *Andy Hardy Gets Spring Fever* begins in Judge Hardy's courtroom, where he acknowledges spring by suspending sentence on a man arrested for romantic parking. Irritated by taxes due on his aqueduct land ("that pile of gravel"), the judge is ripe for two men's proposition to extract that property's 8 percent bauxite, a mineral necessary for aluminum production. Driving home with the news of this windfall, the judge passes Andy, outfitted (as he is throughout the movie) in his Carvel letter sweater, en route to girlfriend Polly Benedict's house. But Polly is entertaining an older man, a navy lieutenant, Charles Copley, sent to oversee Carvel's road-building. Snubbed, Andy goes home to sulk. Judge Hardy, however, is delirious with the anticipation of profits. His good mood makes him receptive to daughter Marian's desire for a job, and he dictates so she can practice shorthand.

At school the next day, Andy is handed a letter from Polly Benedict advising that she no longer wishes to see him. Planning a reply of his own, he is distracted by the introduction of the substitute drama teacher, Rose Meredith, who proposes that the class write and produce its own play, preferably one modeled on a classic. For Andy, it is love at first sight, and Polly is forgotten. While the judge meets with the two businessmen, agreeing to raise (with his friends) the $17,000 necessary to build an aluminum plant, Andy is at home composing his play (a cross between *Romeo and Juliet* and *Madame Butterfly*), *Adrift in Tahiti,* which is chosen to be performed. At rehearsal, however, Andy (playing a naval officer) is too embarrassed to kiss Polly (playing a native girl, Tahula, who is to throw herself into a flaming volcano after Andy rejects her). Remaining after practice, Andy finds Rose crying, but she refuses to explain.

By now, tipped off by Marian (who has been working as an unpaid secretary), Judge Hardy is aware that he has been swindled, that the surface of the earth everywhere contains 8 percent bauxite. He goes to the bank to alert its president, Polly's father, and there runs into Rose. He asks for her help in dealing with Andy's infatuation, and she promises to do the correct thing. But back home, in a man-to-man talk, he learns that Andy has proposed to Rose, and that she will give him her decision the next night, after the play. In despair, less at this news than because of his financial ruin, the judge tells wife Emily that he has lost everything. But the next morning, he accidentally overhears that the city is buying the very kind of gravel of which his aqueduct property has so much. He and his friends are saved.

That same evening, just before going onstage, Andy sees Rose kissing a strange man. His anger and jealousy motivate his performance, which is undercut, however, by a malfunctioning moon and a misfiring volcano. Afterward, Rose explains that the man is her fiancé, her former professor, separated from her by financial pressures. Reconciled to losing Rose, Andy arrives a hero at the cast party, where, as always, he makes up with Polly.

Judge James K. Hardy (Lewis Stone), Emily Hardy (Fay Holden), Andy (Mickey Rooney), Marian (Cecilia Parker), Aunt Millie (Sara Haden), Polly Benedict (Ann Rutherford), Rose Meredith (Helen Gilbert).

What follows are the results of this investigation.

TAKING NAMES

Use an Old Idea

Signsponge's philosophical contribution (which will not much concern us here) involves, among other things, a demonstration of the profound instability of the syntactical unit we call the *proper noun*. Supposed to have no meaning in itself, to be able to designate even some*one* only in a given context, the proper name in fact finds itself perpetually drifting, slipping (by accident? by fate?) into becoming a noun of the *improper* kind. "Ponge," referring (and only when we already know it) to a particular French poet, steals away into *éponge,* the ordinary word for "sponge," just as *Glas*'s "Hegel" and "Genet" threaten continually to vanish into *aigle* (eagle) and *genêt* (broomflower). At stake in this oscillation is the power of any given language to control its signification, to delimit where meaning begins and where it leaves off.

Always determined to govern the meanings attributed to its product, Hollywood from the start worried about names. Studios routinely transformed Jane Peters into Carole Lombard, F. McIntyre Bickell into Fredric March, Phylis Isley into Jennifer Jones, Julius Ulman into Douglas Fairbanks, Constance Ockleman into Veronica Lake, Gladys Greene into Jean Arthur, and, most famously, Marion Michael Morrison into John Wayne and Norma Jean Baker into Marilyn Monroe. Often, the change was intended to conceal an undesirable ethnicity: Marian Levy becomes Paulette Goddard, Julius Garfinkle gives way to John Garfield, Betty Joan Perske to Lauren Bacall, and Margarita Carmen Cansino to Rita Hayworth. But in other cases, the motivation seems aesthetic: the awkward mouthful G. G. Hallward transmutes into Gloria Grahame, the plain Lucy Johnson into Ava Gardner.

In the obsessive circles of studio publicity, all slippages between proper and improper names were to be anticipated and policed. "Lucille LeSueur" too closely resembled "sewer" and had to become "Joan Crawford." Even "Greta Garbo" barely survived MGM's fear that "Garbo" ("spirit" in Swedish) sounded too much like "garbage." "McMath" was too schoolmarmish for Ginger Rogers, and even Cary Grant could not have overcome "Archibald Leach." But other homonymic slides appear to have been encouraged: "Harlean Carpentier" seems safer than "Jean Harlow," but evoking the cluster of connotations attached to "harlot" was precisely the point. "Beery" was right for the character actor whose persona wouldn't have touched champagne, and "Astaire" (real name, Austerlitz) seemed destined for the man who would dance down several.[25]

By coincidence, at the beginning of *Andy Hardy Gets Spring Fever* (as always, the first scene occurs in the courtroom), a stern lesson regarding

[25]See Christopher Finch and Linda Rosenkrantz, *Gone Hollywood: The Movie Colony in the Golden Age* (New York: Doubleday, 1979), pp. 207–10.

the proper: Judge Hardy lectures a man apparently in his twenties: "Seems ridiculous to me that a man of your age should be arrested for kissing a young lady in a parked car. This is not only a legal question; it's a question of good taste." Later, the movie will specifically conflate the use of a proper name with issues of propriety – Andy's attempt to call Miss Meredith "Rose" will be promptly checked by her admonishment:

Well, I'm sorry Andrew, of course we're friends, but if you called me Rose, it might slip out in class. . . . You know I'm a teacher, and you're my student. Neither of us must step over that line of teacher–student.

Here, the movie merely displays the concerns that everywhere surround its production (and that its plot undercuts, because Rose has herself stepped over that line, having fallen in love with her professor):

1. Joseph I. Breen, head of Hollywood's self-censoring Production Code Administration, writes to MGM head L. B. Mayer after reviewing *Spring Fever*'s script: "Here and elsewhere," referring specifically to the play-within-a-play set in Tahiti, "please see that the persons of the various characters are adequately covered at all times."

2. But the studio has anticipated this concern for propriety: A week before, production supervisor J. J. Cohn had written to producer Lou Ostrow:

 While out with Mr. Van Dyke [*Spring Fever*'s director] on Lot 2, going over the sets, he very definitely and very vehemently said that he does not see Rose Meredith [the school teacher] living at an hotel, as:

 #1 Small town school teachers cannot afford to live in hotels;
 #2 School teachers never live alone so that they won't be talked about by the children;
 #3 They usually live or board with some small town old maid or family.

Behind the Andy Hardy series lies another court action that defines the proper name as *property:* The movies' star, Joe Yule, Jr., disposed by patronym to holidays, had his first movie success at age six years playing the *Toonerville Trolley* character Mickey McGuire. Having seen the success of fifty Mickey McGuire shorts (1926–32), the studio insisted that Yule's name be changed to the character's. Already called Mickey by his mother (who herself had adopted McGuire for her last name), six-year-old Joe (previously called Sonny) was happy to oblige. But *Toonerville Trolley*'s author, Fontaine Fox, claimed the name as his own, and won his case in a two-year suit. When his new employer, Universal Studios, found "Mickey Yule" unpleasing, the publicity man tried

Mickey Maloney
Mickey Downey
Mickey Looney
Mickey Rooney [26]

What are the consequences of this shedding of identity, this assumption of a new fate? The shooting logs reveal that on some Hardy pictures,

[26] Arthur Marx, *The Nine Lives of Mickey Rooney* (New York: Berkley Books, 1986), pp. 18–27.

Joe Yule, Jr., would have only his own day off, working until 7 P.M. on Christmas Eve, and returning for duty the morning of the 26th. Having surrendered his name and the childhood freedoms that might have accompanied it, he would at one point during the series be instructed by MGM that a promotional visit to Omaha on behalf of the movie *Boys' Town* would be counted against his vacation time.

At the margins (or the center?) of every Andy Hardy movie is a story of property-in-crisis: Andy's debts, the family's potential ruin. In *Spring Fever,* Judge Hardy (Lewis Stone) innocently convinces his friends to invest in what he discovers to be a phony aluminum deal. Convinced that he has lost his family's savings, and probably its house, he worries about how *properly* to break the news to his friends. Endangered by capitalism, he is saved by property: His aqueduct land provides gravel (stones) that can be sold to the city. Exhilarated by this discovery, the judge (for the first and only time in the series' sixteen films) breaks into a run, thereby prefiguring his own end and the fatality of the proper: In 1953, at the age of 53, and less hardy than he thought, he dies of a heart attack while chasing vandals, whom he had surprised in the act of assaulting his property with stones.

What is the Reality of the Situation?

The reality is that chance plays a greater role in filmmaking than criticism has imagined. The Hardy series depended on Mickey Rooney, whose becoming established at MGM depended, by accident, on criminals: His first MGM movie, *Manhattan Melodrama,* poorly reviewed and going nowhere at the box office, happened to be the film from which John Dillinger emerged on July 27, 1934, when he was shot dead by the waiting Chicago police. Overnight, everyone wanted to see it, and when they managed to do so, they saw Mickey Rooney playing Clark Gable's character as a child. His next step depended on Hitler's rise to power in Germany, and the resulting emigration to America of theatrical director Max Reinhardt, who cast Rooney as Puck in the famous Hollywood Bowl version of *A Midsummer Night's Dream,* as well as in the subsequent film.

In "My Chances/*Mes Chances,*" looking for another example of psychoanalysis's relation to chance, Derrida falls upon an anecdote that, he points out, "is not a story about vacations":

When he returns from vacation Freud thinks of the patients that he will see again and initially of an elderly, ninety-year-old woman . . . whom he has already given several years of medical treatment. Each year he wonders how much time remains for the old woman. One particular day, Freud, being in a hurry, hires a coachman who, like everyone else in the neighborhood, knew the address of the patient. He knew the destination. . . . The coachman – who knows the address, the correct one – stops, however, in front of another house, which has the same number (always a question of number) but on a parallel street. Freud reproves the man, who then apologizes. Is the error concerning the address simply an accident or does it actually mean something? Freud's answer is clear and firm, at least in appearance: "Certainly not to me, but if I were superstitious, I should see an

omen in the incident, the finger of fate announcing that this year would be the old lady's last."[27]

Here is a story about how movies get made. One morning in 1933, MGM's story editor, Samuel Marx, arrived at his office to find script-writer F. Hugh Herbert waiting for him. Herbert had worked in Hollywood since the silent days, and he loved MGM so much that he had been married in a church set on the back lot; but with the coming of sound, his career had waned, and although still on salary, he was rarely used. Marx tried to brush him off, but Herbert said that Thalberg himself had told him to come for an assignment. "When did Thalberg say that?" Marx asked skeptically. Herbert: "Last night. He dropped in to see me at my house." Convinced that Herbert was inventing an excuse, Marx persisted: "How was he dressed?" Herbert: "In a tuxedo." Marx: "And does he usually dress like that when he drops in on you?" Admitting that Thalberg had never paid him a visit before, Herbert nevertheless insisted that Irving had come calling around ten o'clock the previous night and that, after drinking some brandy, had asked whether or not Herbert was working. Told that he wasn't, Thalberg suggested that he go to Marx for a job. "When I woke up the next morning," Herbert confessed, "I thought I had dreamt it, so I went downstairs and there was the brandy bottle, with two glasses, on the dining room table." Still skeptical, Marx saw Thalberg later that day and asked him about Herbert's story, which, surprisingly, Thalberg confirmed: "I went to see someone who lives on the same street, but I rang the wrong doorbell. He asked me in and I couldn't refuse." "It seemed odd," Marx remembers, "he didn't explain what happened and go on to his planned destination." "Hughie's not a bad writer," Thalberg said. "See if you can find something for him." Marx bought a story from Herbert that became a B movie, *The Women in His Life,* the first picture at MGM for George Seitz, the director of the Andy Hardy series.[28]

Make an Exhaustive List of Everything You Might Do, and Do the Last Thing on the List

Discuss the sequence in the darkened classroom, the teacher (Rose Meredith) in silhouette, Andy watching, the grids of light and shadow made by the venetian blinds. What happened there in that room?

Van Dyke's name, Seitz's name.

Andy's two girl friends, Polly Benedict and Betsy Booth: their traitors' names.

Irving Thal*berg,* running MGM as if it were a small town (like the Hardy movies' Carvel), personally supervising every production, watching every foot of rushes, giving way to L. B. Mayer, who changed his first names (Eliezar Lazar) so that his new one would perpetually be arrogating power (I'll be mayor). Why, then, are Carvel's politicians, including its mayor, inevitably represented as corruptible, indifferent to Judge Hardy's moral positions?

The letter, the mystery.

[27]Derrida, "My Chances," pp. 20–1.
[28]Samuel Marx, *A Gaudy Spree: Literary Hollywood When the West Was Fun* (New York: Franklin Watts, 1987), pp. 75–6.

The name "Rose" (Meredith) and *Spring Fever*'s trailer (preview), with its emphasis on flowers. The trailer form as the embodiment of Deleuze and Guattari's call for a work made up entirely of plateaus, "a vibrant and continuous area of intensities that develops by avoiding every orientation toward a culminating point or external end."[29]

"Lewis Stone" (Judge Hardy) as self-contradicting: a *lewis*, "an attachment for lifting heavy *stones*" – his first name eliminates his last.

The polymorphic possibilities with *Polly* (Benedict): the French *poli* (polite), but more important, the words formed from her-as-prefix (*poly*: "many, several, much, hyper, containing an indefinite number"):

Polyandrous: "given to having more than one male mate at the same time" (the character's fickleness), but also, "having an indefinite number of stamens" (again, the theme of flowers, picked up in *Andy Hardy Meets Debutante,* where Andy feigns an interest in botany and meets Daphne Fowler, her last name an anagram of the real concern?)

Polynesian: Polly's character Tahula, in Andy's play, *Adrift in Tahiti*

The actress (Ann Rutherford) and the character (Polly) anticipating the age to come: *rutherford* (a unit of radiation), *poly* (a polymorphonuclear leukocyte)

Draw another card.

Don't be Afraid of Things Because They're Easy to Do

In the mail comes a flier from the publisher of the book you are reading now, an advertisement for John M. Ellis's *Against Deconstruction,* equipped with a blurb from Frank Kermode noting Ellis's conclusion that deconstruction "gives its adherents 'a routine way to a feeling of being excitedly shocking.' They get the feeling that might attend a genuine piece of original thinking, but *here it can be achieved without comparable effort* [emphasis added]." But hasn't this objection always been made to the avant-garde, whose point, at least since Duchamp's readymades, has been precisely to show that anyone can invent? And besides, do we need discoveries that will make thinking *harder?* Gregory Ulmer has demonstrated that Derrida's methods, however arcane their appearance, are in fact artificial-intelligence machines as accessible as the computer games they sometimes mimic.[30] The signature experiment as ready-made research technique, in Derrida's words, "what can be done with a dictionary."[31]

Toward the Insignificant

In "The Third Meaning," Roland Barthes describes a kind of attention prompted by film stills, which have almost, but not exactly, the status of photographs: Whereas the latter offer themselves as autonomous, stills

[29]Deleuze and Guattari, *On the Line,* p. 49.

[30]See Gregory L. Ulmer, *Applied Grammatology: Post(e)-Pedagogy from Jacques Derrida to Joseph Beuys* (Baltimore: Johns Hopkins University Press, 1985), pp. 3–153; idem, *Teletheory: Grammatology in the Age of Video* (New York: Routledge, 1989).

[31]Jacques Derrida, *Signéponge/Signsponge,* trans. Richard Rand (New York: Columbia University Press, 1984), p. 120.

ROBERT B. RAY

have been extracted from a suppressed sequence that, however absent, remains always implied. This kind of attention *resists* the informational (denotative) and symbolic (connotative) meanings, but as Barthes points out, "it compels an interrogative reading."[32] What if Barthes's essay offers a model for a new kind of thinking derived from photography and film, one absolutely of a piece with the signature experiment? In fact, Derrida's uses of the accidents of language (the verbal equivalents of the details that strike Barthes – a lock of hair, an eyebrow's turn, a woman's kerchief) represent a particular, linguistic elaboration of Barthes's approach. *Signsponge,* therefore, is also cinematic, because it works from exactly the type of chance detail always available in photography. It practices a "third meaning strategy" resembling the one used by *Blow-Up*'s photographer, who begins his "interrogative reading" with the arresting details he cannot explain: the woman's ambiguous expression, the splotch of white in the hedges behind the fence. By coincidence, *Spring Fever* offers an anticipation of *Blow-Up*'s voyeurism in a troubling shot (significantly missing from television prints) of Andy hiding in the darkness, spying on Polly's rendezvous with the naval officer.

Once the Search Is in Progress, Something Will Be Found

In the Hardy series, always multiple plots and the need to find the points of intersection. "This is the Judge's story . . . ," "This is Marian's story . . . ," "This is Andy's story . . . ," writes script supervisor and producer Carey Wilson in a memo outlining each of *Spring Fever*'s three strands. While Andy pursues Rose, the judge digs for another quarry, bauxite. But concealed in *Rose* lies its anagram, *ores,* suggesting that even a woman can metamorphose, as in Andy's beloved Shakespeare: "Here's metal more attractive," Hamlet says, referring to Ophelia, mine-ing his claim. At the point where the two plots *meddle* (mix, mingle), Judge Hardy does not himself *meddle* (interfere). Happening upon Rose in the bank (a site crucial to the Depression, a place offering to guarantee paper money with precious metals), the judge entrusts Andy's fate to Rose, certain that she will not (under)mine his future. The plots resolve in metallic rhyme, with Andy consoled by thinking of Rose as "*a milestone* in my career," and the judge (himself a *Stone*) saved by his aqueduct land's abundance of gravel, *stones* that can be sold to the city.[33]

What Are You Really Thinking About Just Now?

This scene – when the first rehearsal for *Adrift in Tahiti* ends at nine one night, the classroom empties. Andy sits down furtively, pretending (he is improvising) to be writing, unnoticed by Rose Meredith. Quietly rising, he turns to watch her as she switches off the lights. Still unaware

[32]Roland Barthes, *The Responsibility of Forms,* trans. Richard Howard (New York: Hill & Wang, 1985), p. 43.
[33]From Amy Slaughter, "Disciplined Self-Indulgence," unpublished undergraduate paper, Department of English, University of Florida.

292

of his presence, she walks slowly across the schoolroom, seen at a distance (Andy's point of view?) and in silhouette, moving in the darkness through a latticed network of shadows and light made by the half-opened venetian blinds behind her desk (Fig. 33). This shot, with its extraordinary chiaroscuro, its eerie surrealism (worthy of Joseph Cornell's *Rose Hobart*), is unique in the Andy Hardy series, movies characterized by high-key lighting and avoidance of long shots. At this moment, we might say, in its seventh film, the series has finally begun to operate under the signature of Rooney and his homonym: *rune* – mystery, magic.

The investigation points to W. S. Van Dyke II, *Spring Fever*'s director, whose name sticks out in the credits for a series whose other films were all directed by one man, George B. Seitz.[34] Having made *Trader Horn* (1931), *Tarzan, The Ape Man* (1932), *Manhattan Melodrama*, and *The Thin Man* (both 1934), Van Dyke is the only director associated with the Hardy series who might have any interest for *auteur* critics. MGM, of course, was never a director's studio. Its commitment to a strict division of labor, to extensive retakes shot by different crews, to the rotation of employees among different kinds and classes of productions, all diluted its directors' signatures, which disappeared into films memorable principally (and by design) for their stars.

Unlike Seitz, whose name suits a visual art, *Van Dyke* (appropriately for a Flemish master) offers only suggestions of *confinement, blocking:* "a barrier preventing passage," "a bank, usually of earth, constructed to control or confine water." For the scene in question, marked by an unusual darkness, we note that light has been impeded, checked from entering the area in front of the camera. But dikes leak (the story of the boy), and this Dyke has allowed some streams of light to slip through

[34]Seitz died in 1944. The two postwar Andy Hardy movies, *Love Laughs at Andy Hardy* (1946) and *Andy Hardy Comes Home* (1958), were directed by Willis Goldbeck and Howard W. Koch, respectively.

33 Frame enlargement, *Andy Hardy Gets Spring Fever* (1939). Scene shot by W. S. Van Dyke.

cracks in the venetian blinds. Around Van Dyke's name, therefore, cluster notions of water, impedimenta, light, and leakage.

At the beginning of Van Dyke's MGM career, he was sent to the real Tahiti as studio representative for a movie, *White Shadows in the South Seas* (1927), that he had wanted to direct himself, but that had been assigned to Robert Flaherty, auteur of *Nanook of the North* and among Andrew Sarris's "Pantheon Directors." From the outset, the production was hampered by difficulties, *impedimenta:* Tahitian police arrested the unit's interpreter within twenty-four hours after his arrival (for a previous visit's behavior), and the natives' suspicion spread to the rest of the crew. More important, the movie's most important scene, to be shot under a *waterfall,* could be filmed only in a particular canyon, whose steep walls permanently blocked the sun*light* needed for filming. Without portable lights and generators, then rarely sent on location, the cast refused to work in the waterfall, whose mysterious darkness made shooting dangerous. Flaherty resigned. Van Dyke replaced him and immediately ordered lights from Hollywood. The completed film established Van Dyke at MGM, where he became Mayer's own favorite director.

And what of *Andy Hardy Gets Spring Fever,* which Van Dyke has signed, whose classroom scene, with its restricted flows of light, so appropriate to his signature, seems nevertheless to re-create precisely the Tahitian canyon's semidarkness whose negation had made his name? Here is a story that is about names and about signing, and about what they have to do with filmmaking and with film criticism: By 1939, the extraordinary success of the Hardy movies had attracted L. B. Mayer's attention. The series' two previous films, *Out West with the Hardys* and *The Hardys Ride High,* had both been among the year's top twenty money-earners. It was time, Mayer concluded, to upgrade their production, and as part of that scheme, he assigned his favorite A-budget director, Van Dyke, to *Spring Fever,* nominally still a B movie. The night before shooting was to begin, cast members were called by the assistant director and told to report to the set an hour earlier than usual. Arriving the next morning for the first scene, Ann Rutherford and Mickey Rooney (as had been their habit working under Seitz) presented themselves in neither costume nor makeup to walk through the scene. No, they were told, Mr. Van Dyke is ready to shoot. Hurried into their clothes and into their positions on Polly's front-porch swing, they did a take, a close examination of which reveals Rutherford's haste: One arm has missed a sleeve. Having virtually codirected his own scenes with Seitz (whom he called Uncle George), typically by suggesting bits of business that might be added in retakes, Rooney approached Van Dyke with advice. "Don't bother me, kid," Van Dyke said, as he ordered the cameras and lights moved to the next location.

"We worked this way for two weeks," Rutherford remembers, "until the picture's producers saw the rushes and decided that they weren't getting a Hardy movie."[35] Having begun his career at MGM by replacing

[35]Information about Van Dyke's work on *Spring Fever* comes from an interview with Ann Rutherford. See her similar account in Walter Wanger, *You Must Remember This* (New York: Putnam, 1975), p. 199.

Flaherty, Van Dyke was now himself replaced by Seitz, whose name, however, does not appear in the credits. At first glance, an invalidation of *auteur* theory, *Andy Hardy Gets Spring Fever* in fact confirms Andrew Sarris's notorious proposition that "interior meaning is extrapolated from the tension between a director's personality and his material."[36] By flooding a waterfall with light, Van Dyke allowed his signature to be subsumed in a movie whose title (*White Shadows in the South Seas*) prefigures the decisive elements of *Spring Fever:* the night scenes, the school play's Tahitian setting. By stopping light, by constricting its flow, he reaffirmed his own name and signed the most visually arresting shot in the Andy Hardy series. And for doing so, he was fired.

[36]"Notes on the Auteur Theory in 1962," in *Film Theory and Criticism,* ed. Gerald Mast and Marshall Cohen (Oxford: Oxford University Press, 1979), p. 663.

SENDING POSTCARDS IN TV LAND

RICHARD DIENST

THE television is already on – we know that much.
Television studies has not yet located its object, and it is be-
ginning to look as if it never will. That television is here, that
"there is television," seems only too obvious. It is just as clear that
television has gone global, that it collects and scatters culture, that it is
capable of generating a new layer of time crossing through our everyday
lives. In its attempts to figure out what television is, to constitute a
proper object of inquiry, television studies has multiplied its methods
and points of entry: While many critics with an appetite for interpreta-
tion classify and decode wherever they can, others shift their attention
to the practices of surveyable audiences (the route of most current British
cultural studies), and still others choose to elaborate various post-
McLuhanist theoretical poetics (as with those influenced by Baudrillard).
If the possibility of a general theory of television now seems remote,
because of either a persistent epistemological modesty or a genuine crit-
ical failure, there is perhaps still some hope that the diffused study of
television will confront, as if for the first time, many theoretical issues
that seem obscure and obstinate elsewhere.

Here I want to offer one way, among many that are possible and
necessary, toward a new engagement with these old (or not so old) issues.
As a first step, the "obviousness" of television must be resisted in the
formation of our concepts and analyses – meaning that it cannot be easily
defined as a "medium of communication," as a "discursive practice," as
"institution" or "apparatus," or even as "text." Its economy is not re-
stricted to language, money, commodities, or images. Its limits, in a
word, are undecidable: At least they should remain undecidable as long
as the study of television keeps itself open to all of television's matrices,
as long as the theory moves as fast and in as many directions as its elusive
and inexhaustible object.

CARDS

Jean-Luc Godard, at the moment when he starts switching between film-
making and television, happens to describe his work this way: "To make

I would like to thank Fredric Jameson, Barbara Herrnstein Smith, Kenneth Surin, Jane
Gaines, and Janice Radway for their helpful and detailed comments on this project, which
is a portion of my dissertation.

cinema or television, technically, is to send twenty-five postcards per second to millions of people, either in time or in space, of that which can only be unreal."[1] He goes on to say that nobody has the economic and technical means to send such postcards, so many and so far, except those who are "everybody and nobody" at once, that is, corporations, networks, the state. Then there is the direct cost of *receiving* these postcards: the financial outlay for a theater seat (rent) or a TV set (fixed capital), the market price of spectatorship.

Five years later, in *The Post Card,* Jacques Derrida lets the postcard, the post, and the card become the (no longer metaphorical) organizing figures for a discussion of images, messages, and systems of transmission.[2] At one point, almost as a detour, all culture is cast as an immense number of postal transmissions, each stamped by authorities and traditions, each cultural artifact/card "taking a position" by imposing itself, even superimposing itself, on the others. Every cultural act thus pays a social and historical price.[3] One of Derrida's words, neither the first nor the last, for this jostling circulation of words and pictures is "telecommunication."

What do Godard's televisual postcards have to do with Derrida's telecommunicated ones? For both, the postcard is another name for an image in transit, subject to regulation, misdirection, and profit. Because "image" here can mean any message, sign, or figure, these postcards serve as emblematic frozen moments in the ceaseless transmission of culture, visible to the naked eye only when a single card is isolated, slowed down, decomposed. In such a theoretical laboratory scene, everything specific about the postcard refers to the general economy of texts. For Derrida, the postcard bears many duties at once: carrying not only its image and message but also the obligation of a sufficient address, of a legible signature, and of a tax or investment paid to the delivery apparatus. The postcard is always responsible (along with its senders and receivers) to the system that sends it. In fact, it will pay for its own sending twice: once by framing its form and expression so that the system will transmit it (everything must fit on the card, including the address, the signature, the additional stamp), then again by suffering the possibility of failure (or, as Godard puts it, unreality). Everywhere its path can always be interrupted, its image can always be defaced, its message smeared. Insofar as the postcard submits itself to these necessary inscriptions of sending, it is a telecommunication in Derrida's sense; and insofar as the postcard is an image made for unlimited transmission, it is televisual in Godard's sense. Both postcards remind us of the prices we pay (to culture, to the state, to capitalism) for our images and messages.

The figure of the postcard can go a long way. Here I shall launch it in one direction: toward a discussion of some concepts currently being used in television studies, such as "communication," "text," and

[1] Jean-Luc Godard, "Faire les films possibles là où on est," in *Jean-Luc Godard par Jean-Luc Godard,* ed. Alain Bergala (Paris: Cahiers du Cinéma/Editions de l'Etoile, 1985), p. 385. The interview originally appeared in *Le Monde* on September 25, 1975.
[2] Jacques Derrida, *The Post Card: From Socrates to Freud and Beyond,* trans. Alan Bass (Chicago: University of Chicago Press, 1987). Original edition published by Flammarion, 1980.
[3] Derrida, *The Post Card,* pp. 100–1.

"flow."[4] ("Pleasure" and "reality," two other big-money terms in the current manuals of popular culture, will be excluded here on principle: They offer reassuring destinations exactly where critical suspicion should be most alert.) For the purpose of a critical estrangement from the prevailing terms of analysis, it will be simpler (if nothing else) to examine Derrida's postcards rather than Godard's, although it would be difficult to say which set has been circulated more widely over the years. It should also be pointed out that other writers have been running Derrida in this general direction recently, finding in his work the impetus for a new video pedagogy (as in Gregory Ulmer's *Teletheory* [5]) or for a reevaluation of film theory (Peter Brunette and David Wills's *Screen/Play* [6]). If I do not address those works directly here it is because I am looking for something else: a reading of Derrida that hinges on the question of television "as a whole," as a general economy of culture. If that question can be opened, others will follow – especially questions concerning politics, ideology, and the world.

TELECOMMUNICATION

Now what can this word "telecommunication" signify in Derrida's work? Not only does it appear on the inscribed, inverse side of *The Post Card* (something we shall return to), but it occupies a crucial position in "Signature Event Context," the essay that closes *Margins of Philosophy* (1972).[7] The earlier, "deconstructive" work of *Of Grammatology* (1967)[8] and its contemporary texts had developed a critique of the metaphysics of writing, indicating the ways "writing" was not merely a technical appendage of language, distinct from speech, but instead a perpetual production of differences ("textuality") built into language itself. It immediately turns out, of course, that language is not the only textual system, nor even the primary one: "Writing" overpowers the problematic of language. "Writing" is a machine, Derrida sometimes suggests, or a machinic function – but instead of faithfully capturing spoken language and preserving it for later use, the machine operates in every mark, utterance, and thought, always producing an excess (and therefore a loss) of signifying potential that cannot be boxed into the linguistic or semiotic model of the sign.[9] The ideal of the perfectly functioning writing

[4] "Flow" appears in Raymond Williams's ground-breaking *Television: Technology and Cultural Form* (New York: Schocken, 1974). It has since been taken over by many television theorists, primarily as an experiential term. Fredric Jameson, in "Surrealism without the Unconscious," in *Postmodernism: The Cultural Logic of Late Capitalism* (Durham: Duke University Press, 1990), begins a formal reading of "flow" in terms of experimental video.

[5] Gregory Ulmer, *Teletheory: Grammatology in the Age of Video* (New York: Routledge, 1989).

[6] Peter Brunette and David Wills, *Screen/Play: Derrida and Film Theory* (Princeton: Princeton University Press, 1989).

[7] Jacques Derrida, *Marges de la philosophie* (Paris: Minuit, 1972). English translation: *Margins of Philosophy,* trans. Alan Bass (Chicago: University of Chicago Press, 1982).

[8] Jacques Derrida, *De la Grammatologie* (Paris: Minuit, 1967). English translation: *Of Grammatology,* trans. Gayatri Chakravorty Spivak (Baltimore: Johns Hopkins University Press, 1976).

[9] Jacques Derrida, "Signature Event Context," in *Limited Inc.,* trans. Samuel Weber and Jeffrey Mehlman (Evanston, Ill.: Northwestern University Press, 1988), p. 8. See also

machine (like that of cybernetics) is the ideal of all communications theory: a perpetual-motion machine in which expression – the material sign itself – would be self-sufficient, fully adequate to all its signifying values. But this never works. Whenever writing tries to control its own meanings, or fix a representation of its own reality, or determine its own interpretations, it disrupts the "restricted" economies of meaning and broaches the general economy of *différance*.[10] And this happens all the time. Any arrangement of signs throws out a restless movement of references, a movement that cannot help but open each text onto the textual system itself (however illimitable that may be).[11] It is safe to say that the status of the "textual system" has been one of the most controversial problems for any historical or formal "application" of deconstruction, because on the one hand any totalizing impulses seem threatened by the microscopic corrosion of textual dissemination, whereas on the other hand Derrida's refusal to "delimit" textuality to "the text" (let alone the "book") opens the analysis to everything ("*Il n'y a pas de hors-texte*"). This rather too famous comment should now serve as a warning: There was never just a text, or just an image. These things are made possible by, and make possible, other texts. As Derrida put it in 1988: "What I call 'text' implies all the structures called 'real,' 'economic,' 'historical,' socio-institutional, in short: all possible referents."[12]

With the appearance of the word "telecommunication" in "Signature Event Context," another kind of textual mechanics comes into view. If *différance* is the movement of the text as it tries to pin down – inscribe – its signification, then "telecommunication" involves a movement of transmission, so that the writing machine also becomes a mobile broadcasting device. The word spells itself out: The prefix "tele" makes plain what was true all along, that "communication" is something that is always *sent,* or emitted, or diffused, or circulated. The notion of "sending" allows us to imagine a certain temporal and spatial gap in the movement of reference: A sign, even as it refers elsewhere, is somehow "itself" moving (elsewhere). The sign, in other words, communicates nothing but an uncertain movement of reference: We can never be sure where it came from or where it is going. Officially, a sign is supposed to function as a *repetition* of a *certain* reference, so that communicating a sign would be a way of reproducing a particular movement of meaning (the *same* meaning available to the one who sends it). "Signature Event Context" questions the ontological possibility of such continuities within any (tele)communication process. Derrida questions not only the identity of senders and receivers ("signatures") but also the installation of meaning or intention within the sign (an "event"), and especially the stability of all "codes" or "rules" that would regulate writing absolutely ("con-

Jacques Derrida, "The Pit and the Pyramid: Introduction to Hegel's Semiology," in *Margins of Philosophy,* pp. 106–8. I owe the latter reference to Fredric Jameson.
[10]Derrida, *Of Grammatology,* p. 91.
[11]Ibid., p. 45.
[12]Jacques Derrida, "Afterword: Toward an Ethic of Discussion," in *Limited Inc.,* p. 148. The entire essay greatly clarifies Derrida's position on this point. For contrast and continuity, see Jacques Derrida, " 'Genesis and Structure' and Phenomenology," in *Writing and Difference,* trans. Alan Bass (Chicago: University of Chicago Press, 1978), esp. p. 166 (on *logos*). The essay was originally published in 1959.

texts"). To put it in another framework, we could say that the essay cancels, at different points, McLuhan's dictum that "the medium is the message":

1. "The medium" cannot be a transparent and homogeneous operation outside of effects of writing – all media are writings.
2. "Is," the copula indicating identity, can do no more than graft one term onto another without enforcing an equality or transparency.
3. "The message" cannot remain a singular, ideal entity – there is never just one.[13]

Derrida lands a direct blow against McLuhan at the end of "Signature Event Context":

[A]s writing, communication, if we retain that word, is not the means of transference of meaning, the exchange of intentions and meanings, discourse, and the "communication of consciousness." We are witnessing not an end of writing which would restore, in accord with McLuhan's ideological representation, a transparency or an immediacy to social relations; but rather the increasingly powerful historical expansion of a general writing.[14]

There it is: What is at stake in the complexities of "writing" are precisely "social relations." It is *writing,* not meaning or consciousness, that moves through the social text. Furthermore, writing's historical expansion has nothing to do with McLuhan's prosthetic "extension" of the human sensorium. The new technologies have not delivered us to a spiritual transcendence of power relations,[15] but have instead actualized, accelerated, and ramified the whole scriptural economy and all its relations of force, its programmings, regulations, and calculations. Telecommunication sends its illimitable texts through a stratified network of differential relays, best recognized as the receiving subjects ("everybody") and sending institutions ("everybody and nobody") evoked by Godard. As with all systems of writing before it, this one is unable to enforce a regime of meanings; yet it has achieved the capacity to circulate texts faster and farther than ever. The acceleration and expansion of the system do not "unify" it; instead, inversely, they make possible a greater distanciation, what Sartre called the "serial absence" of each point to all the others, or what in Derrida becomes the radical and volatile indeterminacy of context.[16]

The absences of agency – of sending and receiving – that surround the mark are not homogeneous and strictly formal: They are absences that unfold unevenly and appear contingently. Because the absence of the sender and the receiver to each other is always possible – indeed,

[13]See Fredric Jameson, *The Prison House of Language* (Princeton: Princeton University Press, 1972), pp. 175–6; the argument is made that Derrida and McLuhan present two sides of the same "cultural reality." Because this book was published the same year as "Signature Event Context," Jameson could not have taken account of Derrida's powerful critiques of the postulates of communications and media theory since 1972.
[14]Derrida, *Limited Inc.,* p. 20.
[15]Marshall McLuhan, *Understanding Media* (New York: Signet, 1964), p. 67.
[16]This comparison merits further investigation. See Jean-Paul Sartre, *Critique of Dialectical Reason,* trans. Alan Sheridan-Smith (London: Verso Books, 1976), pp. 256–77, for Sartre on seriality and broadcasting. See also Derrida, *Limited Inc.,* pp. 136–7, where he speaks of a constantly shifting textual "experience" of history, reality, etc. To this picture we could also add Herbert Schiller's work, especially *Information and the Crisis Economy* (Oxford: Oxford University Press, 1986), for a sense of the legal-economic regime that attempts to regulate all transmissions.

these absences are the "positive condition" of the appearance of any mark, any writing – we would expect different arrangements of senders in general and receivers in general to produce specific kinds of representations, built to endure different kinds of absence and the demands of an expanded iterability. A given mode of representation must cross several absences at once: not only the dispersion of its potential recipients ("addressees" or "audiences") but also the dispersion of its potential "objects" or "referents." Weaving these distinct absences together, electronic telecommunication transmits a regime of representation proper to our *general socius*, a writing that now crosses through all possible objects and all possible audiences without necessarily representing or reaching any of them.

This would be one way to put it. All of this comes back again into focus when Derrida starts sending postcards.

POSTS

According to Derrida's conceit, part of *The Post Card* is supposed to have been written on the backs of many postcards, all of which bore the same image, the same one that now appears on the front cover and again three times inside the finished product. This image reproduces a thirteenth-century drawing of Plato dictating to Socrates, who sits at a desk, writing: an old cartoon of deconstruction (but not of deconstruction *avant la lettre,* because there's no such thing). On the back cover there is a signed and dated message from J.D., promising a book that plays with "addresses, postal codes, crypted missives, anonymous letters . . . modes, genres, and tones . . . dates, signatures, titles or references, language itself." A postcard book: text on one side, image on the other. Even inside, one of the reproductions is folded into the book so that it can remain visible whenever the book is open, so that the text always faces, and backs, the image that it designates and that designates it.

Before we open the book to read, then, all these reproductions tell us something: The image is a point of reference with a different status than any of the text's "own" referents; no longer an illustration or an example to be explicated, this image runs alongside the act of reading without directing or exhausting it. And at the same time, no matter how much it swells, the text can never fill up the reverse of the image. What the book immediately gives us to think is the displacement of images and texts: the gap between the picture and whatever we could write about it, the obstinacy of appearances against the waffling efforts of textuality. But it is not as if this image, acting for all images, thereby claims some final primacy over writing. It does not present the truth or even a dirty little secret about the history of Western metaphysics. It makes just one little slip and loses track of the philosophical tradition – proving to Derrida how easy that is and how it has always been possible. And together with its backing text, this image opens onto a deconstructive circuit, a loop of uncertainty about the path of presence in representation, where the thing that is made visible is neither an image nor a text, but the tension between their forces.

Now if the cover manages to make itself a postcard and thereby start up speculation about the relations among oral, written, and pictorial representation, the texts inside scatter their own speculations. *The Post Card* is a notoriously difficult book to summarize: It makes good its threats about the instability of its positions, its subjects, its modes, and so forth. It also makes many lists of everything it says it is hiding. There is no time to attempt an outline here, or to account for all the book's traps, knots, and skips. For the moment, I shall simply assemble from the text several fragments or diverging vectors – features of the postcard – that together can function as a set of themes or slogans for a discussion of television, held together by the conceptual critique of "communication" already under way. I hope to justify, at each point, the special pertinence of Derrida's text to such study, though it should never be suspected for a moment that his book provides a media theory. Everything that it has to tell us about television it says *in passing,* which is why it can say so much.

(I shall add, as a flat provocation, that *The Post Card* is already "televisual" in the specific sense I am developing here, precisely because it deploys and switches between so many textual registers. Though *Glas* might also be called "televisual," that text resembles nothing so much as the programming grid itself, which the reader must negotiate by scanning and choosing. Though it may be of limited heuristic value to imagine what a televisual book might look like – because the terms cancel each other at so many points – Derrida's own experiments with "the end of the book" have already inspired Gregory Ulmer and Avital Ronell to build their own kinds of transmitting devices.[17])

Like all of Derrida's famous coinages (*différance,* dissemination, etc.), the postcard is both offered and withdrawn as a figure for figuration itself. But unlike some of the earlier, linguistically inspired terms, the postcard figures the process of transmission rather than inscription, sending rather than writing. In a word, it is a figure of diffusion. Is it possible to speak of a text or an image being "diffused" without positing a previous moment of stability when it was only just "written"? What happens to the notion of "textuality" if it is cast as a matter of transmission rather than writing down or recording? What are the possible relations or ratios between circulation and production in a textual economy? These are the theoretical stakes when television theorists want to speak of "flow" as a metatextual term for television itself: "Flow" would have to be subject to a principle of diffusion that precedes or overrides both the production and the reception of discrete texts. Televisual flow is not a textual object that can be simply read or seen; instead, it is always an entire network of transmissions, both linear and erratic, humming with excess referential power and clattering with unfinished representational frames, whose very law of visibility is that everything can be seen but nobody can see it all. In this sense, "flow" names a kind of pregiven instability that is constitutive of television in its very existence, from the scanning cathode ray to the complex potentials of remote-control zapping.

[17]Gregory Ulmer, *Teletheory,* and Avital Ronell, *The Telephone Book: Technology, Schizophrenia, Electric Speech* (Lincoln: University of Nebraska Press, 1989).

To think television as a postcard (like Godard) means to acknowledge that transmission is the only law of production,[18] that culture itself is therefore not produced piecemeal but is sent through circuits, and that all this demands a fundamental shift in our textual ontology, away from the "text itself" and the hermeneutic tradition, toward a conception of the textual system as an illimitable matrix, crossing through all cultural, political, and social dimensions. For Derrida, who had been on the trail of a general theory of transmission since "Signature Event Context," if not before, the deconstruction of writing was not enough to reach this conceptual scope. It had not yet escaped from the scale of the singular text, no matter how many times it crossed its own border.

With *The Post Card* and its related work, Derrida's analysis of "sending" (along with its privileged figure, the postcard) exceeds the deconstruction of writing in two directions: First, ontologically, he looks through Heidegger to find how "sending" is the essential dynamic of representation itself;[19] second, he claims that "sending" initiates another field of work, a "programmatology." As Derrida describes it during a discussion of chance and psychoanalysis: "Open to a different sense of the sending [*envoi*] and of sendings [*envois*], programmatology should always take the situation of the marks into account; in particular that of utterances, the place of senders and addresses, of framing and of the sociohistoric circumscription. . . . "[20] This "pragrammatology" offers a retrofitted deconstruction adequate to the study of transmissions, granting simultaneous attention to the constraining logics (the forces of programming) and to possibilities of discontinuity between any of the elements (situation, frame, etc.). When the transmissions in question are grouped under the sign of television, it might be better to speak of a "programmatology": an analysis of the controlled diffusion of textual marks, where an uncertainty of contexts and a flexibility of meaning are the basic conditions that television must reproduce for itself. Programmatology, in other words, takes as its first task the inventory of enforced regularities and calculable slippages within the televisual regime, given that its transmissions deploy many different signifying frames across many different concrete situations. It is not the transmission that conveys the program; it is the program that propels the transmission. In order to function, the logics of sending are bound to leave visible traces, and all of these traces can be found right there on the postcard.

[18] Jean-Luc Godard, "Godard parle," interview with Christian Perrot and Léon Mercadet, *Actuel* 103(1988):76. He distinguishes loosely between "producing for diffusion" (television) and "shooting an image" (cinema).
[19] Jacques Derrida, "Envoi," in *Psyché: Inventions de l'autre* (Paris: Galilée, 1987), pp. 109–43. An English translation exists but is unreliable: trans. Mary Ann and Peter Caws, *Social Research* 49, no. 2(1982):294–326. This paper, delivered in 1980, is essential to any reading of *The Post Card*, as is "Telepathy" (a "misplaced" addition to *The Post Card*), also in *Psyché*, and translated by Nicholas Royle in the *Oxford Literary Review* 10(1985):3–41.
[20] Jacques Derrida, "My Chances/Mes Chances," trans. Irene Harvey and Avital Ronell, in *Taking Chances: Derrida, Psychoanalysis, and Literature*, ed. Joseph H. Smith and William Kerrigan (Baltimore: Johns Hopkins University Press, 1984), p. 27. See also Derrida, *Limited Inc.*, pp. 151, 159.

As we saw in the beginning, acts of transmission pay a price: perhaps a small service charge to the rules of sense or a large mortgage to multinational capitalism. Derrida sees the stamp as a payment to tradition, to heritage and authority: All pay this kind of tax whenever they "do anything whatsoever" (he adds a long list).[21] (Deconstruction often performs this service, as a cost analysis of metaphysical debts.) On the postcard, the stamp is already an image, an official one that carries the most determined kinds of ideological marks. All television everywhere is regularly punctuated by such stamps. In nationalized systems, the state will continue to stamp the transmission with signs of its governance. In commercial systems, the place of the stamp is taken by the advertising itself, which can strike a range of distances from the other messages at hand. In either case, the stamp bears the image of finance and the proof of the system's power to exchange one kind of delivery for another, money for messages. Any kind of response − and there will always be a response if a message is delivered − will require another payment, a reinvestment in the process.[22]

THE "MATERIAL SUPPORT"

A postcard must, after all, be made of something. As Derrida says of his cards, "the cardboard . . . preserves, it resists manipulations; and then it limits and justifies, from the outside, by means of the borders, the indigence of the discourse. . . . "[23] The card is already a functional item, a thing designed for efficiency: The places of the public messages and the private are drawn openly on its two faces. But, Derrida says, "a certain form of support is in the course of disappearing."[24]

This material change can be grasped only historically. Reading a long excerpt from an official report, Derrida is struck by the postmaster's ambition to extend the function of the post to a pure mediation between "THE population and THE Administration," that is, to achieve "omnipresence."[25] The tendential movement toward an instrumental totalization brings, in a reciprocal motion, the abstraction of all postal transmissions. Not only is the card threatened by electronic transmissions, but it must remake itself increasingly on the data-processing model in order to survive. In submitting all previous forms to the same general law of transmissibility, television behaves as the postal network has: It does not simply "transport" previous forms (theater, film, radio) but rather translates and recombines them. (Perhaps this is a good place to recall that the first television screen was the size of a small card, that the *first* American televised drama bore the backward-looking postal title *The*

[21]Derrida, *The Post Card,* p. 100.
[22]Ibid., pp. 109–10.
[23]Ibid., pp. 21–2.
[24]Ibid., p. 104.
[25]Ibid., p. 106.

Queen's Messenger, but that the *second* was a forward-looking science-fiction simulation of a guided-missile attack on New York City.[26]) This shift to a new technology is not just a matter of changing delivery speeds, but in the case of television is a dual process of dematerialization (everything decomposed into a single electronic stream) and deliteralization (suspension of all codes under a general rule of visible writings). The system dreams, if it does, of an immaterial world.

(Derrida would speak of the postal system's "apocalypse," but that, as Godard would say, is another story.[27])

THE ADDRESS

"The essential, if possible, is that the address be unique," writes Derrida, indicating the most problematic feature of postal transmission: the place of (receiving) subjects.[28] My remarks will be necessarily schematic. The question of the address bears upon both the "destination" and the "legibility" of the message. Neither can be singular or unique: That is why the postcard cannot help but be legible in more than one way and in more than one situation, and why the moment of reception is divided in advance and absorbed into the process of transmission, always remaining incomplete: "The condition for it to arrive is that it ends up and even that it begins by not arriving."[29] If destinations could be perfect, and addresses unique, messages too would be perfect and unique, that is, illegible. Derrida's insistence on the "adestination" of postal transmission as a condition of their sending has to be read as part of his broader ontological critique, here and elsewhere, of "communication" and "representation" as the impossible conveyance of a value of "presence" through a "medium" or post. Because diversion and interruption are always possible, no message can ever arrive fully, which is to say that no message can ever be made visible as a message without chancing itself.[30]

The notion of "address," then, marks a complex intersection of representation and subjectivity. This crossing provides the terms of Derrida's reading of Heidegger on the delimitation of "the epoch of representation in modern times." Assuming that such an epoch can be marked off, one of its consequences or permutations is, for Derrida, "the world of the mass media": a nightmare regime of "calculable and representable subjectivity," the "inverse of the democratic and parliamentary ethics of representation."[31] As soon as subjectivity has been inserted entirely within the order of representation (a punctual historical event, according to Heidegger), the notion that representation makes objects visible to

[26]Eric Barnouw, *Tube of Plenty: The Evolution of American Television* (Oxford: Oxford University Press, 2nd rev. ed., 1989), p. 61.
[27]See Jacques Derrida, "No Apocalypse, Not Now," trans. Catherine Porter and Philip Lewis, *Diacritics* 14, no. 2(1984):20–31; idem, "Of an Apocalyptic Tone Recently Adopted in Philosophy," trans. John P. Leavey, Jr., *Oxford Literary Review* 6(1984), esp. p. 27.
[28]Derrida, *The Post Card,* p. 12.
[29]Ibid., p. 29.
[30]Ibid., pp. 65, 121, 123.
[31]Derrida, "Envoi," p. 127.

subjects doubles back on itself, leaving subjects open to representation in turn. The scene is this: Caught in the act of representing themselves to themselves, "modern" subjects place themselves in the "open circle of the representable," in a "shared and public representation." Thus a subject is defined as "what can or believes it can offer itself representations," that is, as something formed by the imperative to be an image, in order to receive images.[32] "Address" includes both vectors of representation – enunciation and perception – by which subjectivity addresses itself to and is addressed by the world. Just as subjectivity organizes itself as an object of self-knowledge through its representing activity, so too representation is organized through subjects, rendering each series of images limited and calculable. (Hence the Heideggerian problematic, where "representation" as a particular and encompassing historical phenomenon owes its existence to a prior ontological, nonsubjective "sending," a big bang of Being.) As Derrida draws it out, the program of representation regulates itself through *an ensemble of sendings* that traverse from the offer of singular and distinct subjective identities to the multiplication of forms of representation necessary to service them all. The concept-metaphor "sending," then, shakes the enclosure of the representational–subjective matrix.

Television would be the place where "calculable subjectivity" and "profoundly calculated approximations of verisimilitude" (Godard's phrase from *Passion*) are combined into a single differential circuit of representation. Television's "calculation" does not consist in the perfectibility of its programming, but in the thoroughness with which it translates all values into representational terms, so that all traffic (of politics, aesthetics, desire, etc.) passes through the televisual post. Television makes representations visible and accessible to each other and makes a profit only when that visibility can be approximated, calculated, programmed. Addresses, or what used to be called subject-positions, in fact function as the transfer points of this network, where the representational forces of selves, others, and objects negotiate. This relay of representations is just what Raymond Williams described as televisual "flow": This term should now be taken as a figure not only of an observable televisual text (the phenomenological moment, though inadequate, remains inescapable) but also of the absorption back into the televisual network of all subjective centerings. There can be no flow of televisual representations without an ebb of subjective ones.

To find another set of coordinates, we can look back to Althusser's great essay "Ideology and Ideological State Apparatuses," where the word "telecommunication" appears precisely where the concept of "interpellation" is introduced.[33] "Interpellation" is supposed to confirm the subject in its identity and place through the receipt of messages. Althusser writes: "[The] practical telecommunication of hailings is such that they practically never miss their man."[34] But – and here is the moment of

[32]Ibid.
[33]Louis Althusser, "Ideology and Ideological State Apparatuses," in *Lenin and Philosophy*, trans. Ben Brewster (New York: Monthly Review Press, 1971), pp. 127–86.
[34]Ibid., p. 174, translation modified. See the original version in Louis Althusser, *Positions* (Paris: Editions Sociales, 1976), p. 126.

slippage in Althusser's text – what if one does miss? What if, in practice, an ideological sending does not arrive? *How could it miss?* In Althusser, everything depends on the correct functioning of interpellation, its un-erring aim: It is the interpellation that "always already" forms individuals as subjects.[35] But ideology cannot be, in this account, the transmission of a meaning to the subject. It could not be a message or a representation. Althusser's concept can be made rigorous only by Derrida's postulate of misdirection: In that case, ideology (as a system) must be conceived as a mass of sendings or a flow of representations whose force consists pre-cisely in the fact that they are not perfectly destined, just as they are not centrally disseminated. Far from always connecting, ideology *never does:* The subjects look in on a message as if eavesdropping, as if peeking at someone else's mail, unsure if the address might turn out to be apostro-phe. (This is also always the route of desire.)

To express it in a formula: Ideology is the circuit between a reception of a representation and a sending back – a representation of a reception.

Like the constant barrage of electronic signals that insensibly cross through our bodies, the saturation of the social field by ideological trans-missions becomes organized and visible only when it reaches an address or reception device, like a television set or a subject-position. To say that such points of reception are local or contextual does not mean that they are individual – rather, television forces us to think the difficulty in assigning contextual determinations to the most widely disseminated transmissions. Televisual transmission is not sent in general, nor is it received in particular. There are always addresses, but none of them is unique. Simultaneously specific and general, television's realm is above all *ordinary*.

THE POSTAL AXIOM

The final word: "Above all, say or think nothing that derails, that jams telecom."[36] With this mock imperative, Derrida sums up everything that programmatology would want to reveal and unravel. Telecom – the mission of Being, the horizon of sense, the final destination of every-thing, or the immense extension of a system, economic on all levels, whose global logic can be glimpsed in the smooth but crackling flow of televisual images – traces a circuit of positivity and rationalization. Jam-ming telecom requires a signal of its own, neither negative nor irrational, but one that dis-integrates the circuits and postpones our accession to the program.

And the television has been on all this time – we know that much.

[35]For a development of Althusser's position in linguistics, see Michel Pécheux, *Language, Semantics and Ideology: Stating the Obvious,* trans. Harbans Nagpal (London: Macmillan, 1979), esp. pp. 103–9. Commentators on Pécheux include Colin MacCabe, John B. Thompson, Guy Houdebine, and Slavoj Zizek.
[36]Derrida, *The Post Card,* p. 20.

INDEX OF NAMES

Deconstruction and
the visual arts